# SEXING THE GROOVE

Why is record collecting associated with men and not women? Why are female singers well-known but female guitarists and drummers overlooked? Are record companies misogynistic? What different ideas about masculinity are represented by Bruce Springsteen and the Pet Shop Boys? Can there be such a thing as a female Elvis?

*Sexing the Groove* discusses these issues and many more, bringing together leading international music and cultural theorists to explore the relationship between popular music, gender and sexuality. Using a variety of methodologies and a wide range of case studies, from Mick Jagger to Riot Grrrls, the contributors describe and debate how popular music performers, subcultures, fans and texts construct and deconstruct 'masculine' and 'feminine' identities.

*Sexing the Groove* is structured into sections focusing on rock music culture, masculinities and popular music, women and popular music, and music, image and identity. Each section is contextualised by an informative discussion which situates the individual chapters within the overall argument of the collection: that there is nothing 'natural', permanent or immovable about the regime of sexual difference which governs society and culture. *Sexing the Groove* also includes a comprehensive annotated bibliography for further reading and research into gender and popular music.

Contributors: Mavis Bayton, Stella Bruzzi, Norma Coates, Sara Cohen, Sean Cubitt, Charlotte Greig, Stan Hawkins, Mary Celeste Kearney, Marion Leonard, Paul McDonald, Keith Negus, Gareth Palmer, David Sanjek, Will Straw.

Editor: **Sheila Whiteley** is Senior Lecturer in Popular Music and Associate Director of the Institute for Social Research at the University of Salford. She is author of *The Space Between the Notes: Rock and the Counter-Culture*.

# SEXING THE GROOVE

## Popular music and gender

### Edited by Sheila Whiteley

London and New York

To the International Association for the
Study of Popular Music

First published 1997
by Routledge
11 New Fetter Lane, London EC4P 4EE

Simultaneously published in the USA and Canada
by Routledge
29 West 35th Street, New York, NY 10001

Typeset in Joanna and Bembo
by M Rules

Printed and bound in Great Britain by
T.J. International Ltd, Padstow, Cornwall

British Library Cataloguing in Publication Data
A catalogue record for this book is available from the British Library

Library of Congress Cataloging in Publication Data
Sexing the groove: Popular music and gender/edited by Sheila Whiteley.
p. cm.
Includes bibliographical references and index.
1. Popular music—Social aspects.
2. Sex in music.
I. Whiteley, Sheila
ML3470.S46 1997
306.4'84—dc21 97–5416

ISBN 0–415–14670–4 (hbk)
ISBN 0–415–14671–2 (pbk)

# CONTENTS

List of contributors     viii

Acknowledgements     xi

INTRODUCTION     xiii
Sheila Whiteley

**Part I Rock music culture**     1

1 SIZING UP RECORD COLLECTIONS     3
Gender and connoisseurship in rock music culture
Will Straw

2 MEN MAKING A SCENE     17
Rock music and the production of gender
Sara Cohen

3 WOMEN AND THE ELECTRIC GUITAR     37
Mavis Bayton

4 (R)EVOLUTION NOW?     50
Rock and the political potential of gender
Norma Coates

**Part II Masculinities and popular music**     65

5 LITTLE RED ROOSTER v. THE HONKY TONK WOMAN     67
Mick Jagger, sexuality, style and image
Sheila Whiteley

6 BRUCE SPRINGSTEEN AND MASCULINITY     100
Gareth Palmer

7 THE PET SHOP BOYS     118
Musicology, masculinity and banality
Stan Hawkins

**Part III  A time of growth and change:**
        **Femininities and popular music**       135

  8  CAN A FUJIYAMA MAMA BE THE FEMALE ELVIS?   137
     The wild, wild women of rockabilly
     *David Sanjek*

  9  FEMALE IDENTITY AND THE WOMAN SONGWRITER   168
     *Charlotte Greig*

 10  SINÉAD O'CONNOR – MUSICAL MOTHER   178
     *Keith Negus*

 11  MANNISH GIRL   191
     k.d. lang – from cowpunk to androgyny
     *Stella Bruzzi*

 12  THE MISSING LINKS   207
     Riot grrrl – feminism – lesbian culture
     *Mary Celeste Kearney*

 13  'REBEL GIRL, YOU ARE THE QUEEN OF MY WORLD'   230
     Feminism, 'subculture' and grrrl power
     *Marion Leonard*

**Part IV  Music, image and identity**   257
 14  SEDUCED BY THE SIGN   259
     An analysis of the textual links between sound and
     image in pop videos
     *Sheila Whiteley*

 15  FEELING AND FUN   277
     Romance, dance and the performing male body in
     the Take That videos
     *Paul McDonald*

 16  ROLLING AND TUMBLING   295
     Digital erotics and the culture of narcissism
     *Sean Cubitt*

# CONTENTS

**Part V  Annotated bibliography**                                317
17  SOURCES FOR FURTHER READING AND RESEARCH                       319

   *Index*                                                        336
   *Discography*                                                  351

# CONTRIBUTORS

**Mavis Bayton** teaches sociology, cultural studies, music and women's studies at Ruskin College, Oxford. She is author of 'How Women Become Rock Musicians', which appeared in Simon Frith and Andrew Goodwin (eds) *On Record: Rock, Pop and the Written Word* (1990) and of 'Out in the Margins: Feminism and the Study of Popular Music', in *Women: A Cultural Review* 3(1), Spring, 1992. She was a founder member of Oxford's first all-women band and has since performed in a number of contexts.

**Stella Bruzzi** teaches film at Royal Holloway, University of London. She is a regular contributor to *Sight and Sound*, and has published in *Screen* and other film and cultural studies journals. Her book *Undressing Cinema: Clothing and Identity in the Movies* is to be published by Routledge in 1997.

**Norma Coates** is a doctoral student in Communication Arts at the University of Wisconsin-Madison. Her research interests are in the area of feminist media studies, in particular feminist popular music studies. She has an article on women, rock and the Internet in the forthcoming Herman, Swiss and Sloop (eds) *Mapping the Beat: Popular Music and Contemporary Theory* (Blackwell).

**Sara Cohen** played in various bands before completing a PhD at Oxford University. She is a lecturer and Research Co-ordinator at the Institute of Popular Music, Liverpool University. Her publications include the books *Rock Culture in Liverpool* (Oxford University Press, 1991), and, with K. McManus, *Harmonious Relations* (National Galleries and Museums on Merseyside, 1991), as well as numerous articles in various edited books and academic journals. She is currently co-authoring a book on popular music, tourism and urban regeneration, and conducting a major research project on music policy, the music industry and local economic development.

**Sean Cubitt** is Reader in Video and Media Studies and route leader in Screen Studies at John Moores University, Liverpool. His publications

include '"Maybellene": Meaning and the Listening Subject', *Popular Music 4*, Cambridge University Press. He has published widely on contemporary arts and media. His most recent book is *Videography: Video Media as Art and Culture*.

**Charlotte Greig** is a freelance journalist and lecturer in popular music. Her book *Will You Still Love Me Tomorrow?* is recognised as a seminal text on girl groups. She is also a songwriter and performer with a number of bands and artists.

**Stan Hawkins** is Associate Professor of Musicology in the Department of Music and Theatre at Oslo University where he teaches and researches within the field of popular music studies. His publications include articles on commercial music of the 1980s and 1990s, the problems in the reception of popular music, and aspects of gender and identity within the area of postmodern critical studies. From 1991 to 1994 he was British chair of the International Association for the Study of Popular Music, and is currently co-editor of the journal *Popular Musicology*. As a musician, he has also pursued an international career as a composer and performer in the field of jazz and contemporary music.

**Mary Celeste Kearney** is a PhD candidate in the Film, Literature, and Culture Program, Division of Critical Studies, School of Cinema-TV at the University of Southern California. Her dissertation analyses the politics of gender, generation and representation in popular discourses of feminine adolescence and female youth cultures. She is currently editing a special issue on audiovisual media for *SPECTATOR*, the University of Southern California Journal of Film and Television Criticism.

**Marion Leonard** is a doctoral student and part-time lecturer at the Institute of Popular Music, Liverpool University. Her article on zines, 'Paper Planes: Travelling the New Grrrl Geographies' is collected in Tracey Skelton and Gill Valentine (eds) *Cool Places: Geographies of Youth Cultures* (Routledge, 1997).

**Paul McDonald** is a Senior Lecturer in Media Studies at South Bank University, London. He has written on aspects of television and film performance for *Critical Survey* and for an edited collection on *Approaches to Popular Film* (eds Joanne Hollows and Mark Jancovich). He is currently completing several publication commissions, writing for the film acting entry for the first volume of the *Oxford Guide to Film Studies* (eds John Hill and Pamela Church-Gibson) and completing an up-dated chapter on critical approaches to stardom for Richard Dyer's book *Stars*.

**Keith Negus** played in numerous bands before completing his PhD at South Bank University, London. His first book, *Producing Pop* (Edward

Arnold) was published in 1992. Since joining the Centre for Mass Communication Research at Leicester University he has completed further research in Europe, Japan and the United States and, as a result, has published in a number of academic journals. His most recent book, *Popular Music in Theory*, was published by Polity Press in 1996.

**Gareth Palmer** is a Senior Lecturer in Media Production at the University of Salford. His two research interests are representations of masculinity and documentary. His publications include articles on 'Yoof Television' (*Journal of Educational Television*), 'The Cosby Show' (*Critical Survey*), and 'Noel's House Party' (University of Bourgogne, *Interface*).

**David Sanjek** is the Director of Archives of Broadcast Music Inc. (BMI). He has taught Popular Music Studies at New York University and Hunter College. In 1996, *Pennies From Heaven: The American Popular Music Business in the Twentieth Century* (Da Capo Press), his update of his late father Russell's history of the music industry, was published. His own writings on popular music have appeared in *The Construction of Authorship* (Duke University Press, 1993), *Kaboom! Explosive Animation from America and Japan* (Sydney, 1994), *Mapping the Beat* (Blackwell, 1997) as well as such journals as *Trackings: Popular Music Studies, Popular Music and Society, NARAS Journal, Journal of Popular Culture, Ethnomusicology, American Music, Journal of American Folklore* and *South Atlantic Quarterly*. He is the US Chair of the International Association for the Study of Popular Music.

**Will Straw** is Associate Professor in the Graduate Program in Communications at McGill University in Montreal, and Director of the Centre for Research on Canadian Cultural Industries and Institutions. From 1984 to 1993, he taught in the Film Studies Program at Carleton University in Ottawa. He is an ex-chair of the Canadian branch of the International Association for the Study of Popular Music. He has published articles on popular music in *Cultural Studies, Popular Music* and *The Canadian Universities Music Review*. He is co-editor (with Jody Berland and Dave Thomas) of *Theory Rules: Art as Theory, Theory as Art* (1996).

**Sheila Whiteley** is a Senior Lecturer in Popular Music and an Associate Director of the Institute for Social Research at the University of Salford. Author of *The Space Between the Notes: Rock and the Counter-Culture* (Routledge, 1992), and an article on Hendrix in *The Jimi Hendrix Companion: Three Decades of Commentary* (Schirmer, 1996), her forthcoming publications include 'Repressive Representations: Patriarchy and Femininity in Rock Music of the Counterculture' in *Mapping the Beat* (Blackwell, 1997) and 'Progressive Rock and Psychedelic Coding in the Work of Jimi Hendrix', *Reading Pop* (Cambridge University Press).

# ACKNOWLEDGEMENTS

I should like to thank Kathleen Hanna of Bikini Kill, Huggy Bear and Earl Burrows for allowing us to quote their lyrics and for their good wishes; colleagues, friends and family for their helpful suggestions; the editorial team at Routledge – Rebecca Barden, Christopher Cudmore, Sophie Richmond and Katherine Hodkinson – for their encouragement and commitment; and Richard Earney for a perceptive and memorable cover design.

I should also like to thank Philip Keith (IMP), Sarah Smith (EMI) and Richard Williams (Zomba) for their hard work in obtaining copyright and to the following for permission to reproduce copyright material in the book:

*Johnny Get Angry* (David/Edwards). Used by permission of International Music Publications Ltd.

*Justify My Love* (Ciccone/Kravitz/Chavez). Used by permission of International Music Publications Ltd.

*Three Babies*. Words and Music by Sinéad O'Connor. © Copyright 1990, EMI Music Publishing (Holland) BV, UK. Reproduced by permission of EMI Music Publishing Ltd, London.

*Dancing with Mr. D*. Words and music by Mick Jagger and Keith Richards. © Copyright 1973, reproduced by permission of EMI Music Publishing Ltd, London.

*Domino Dancing*. Words and music by Neil Tennant and Christopher Lowe. © Copyright 1988, reproduced by permission of Cage Music Ltd/EMI 10 Music Ltd, London.

*Yesterday, When I Was Mad*. Words and music by Neil Tennant and Christopher Lowe. © Copyright 1993, reproduced by permission of Cage Music Ltd/EMI 10 Music Ltd, London.

Bruce Springsteen lyrics reproduced by permission of Zomba Music Publishers Ltd, London.

While every effort has been made to contact owners of copyright material, we have not always been successful. In the event of a copyright query, please contact the publishers.

# INTRODUCTION

## Sheila Whiteley

The collection of articles presented in this book provides a diverse range of perspectives, discussions and debates with one common mission in mind: to explore the ever-changing modes of expression within popular music and, in particular, its relationship to genders and sexualities. However, as the reader will discover, the analysis of popular music presents problems. It is not a well-defined academic discipline; there is no single methodological approach; there are no clearly demarcated areas of investigation. Rather, the genesis of popular music as a field of study has curious parallels with the emergence of rock itself. It is rebellious, contesting the established citadels of traditional musicology; it is eclectic, drawing on the conceptual and empirical methodologies of sociology, popular culture and film studies; it is sexy, in its focus on performers, teasing out the rituals of style and gendered identity. Most significantly, as a young discipline, it is vital and sentient as evidenced by the number of students enrolling on popular music courses, by its increasing literature, and its world-wide presence as an area of investigation on the Internet.

Sexing the Groove responds to an identified need to address the key debates surrounding gender, sexuality and musicology. It brings together a range of methodological approaches that highlight the interdisciplinary nature of a musical practice which has taken a long time to gain recognition as a legitimate area of scholarly work. The contributors thus hail from diverse theoretical backgrounds whilst retaining their identity as first- and second-generation academics in this new field of study. They are all actively involved in their own music scenes as performers, critics or fans. They have all delivered papers at major international conferences devoted to the study of popular music and culture. Most specifically, their research focuses attention on the musical text itself, so providing a forum for debate for researchers, musicians, students and other members of communities who share a concern for exploring the phenomenon of popular music within a range of social contexts. As such, the collection can be

characterised not only by its academic rigour, but equally by its sense of contemporaneity and a willingness to break new theoretical and empirical ground.

Traditionally, music has been analysed as an abstract form with limited reference to its function and role in society. For scholars of popular music, however, any grasp of musical understanding derives from identifying the specific localities in which the music is conceived and consumed. To theorise the significance of popular music, then, it is necessary to identify the interrelationships between musical sounds, lyrical texts and visual narratives (either in the form of live performance or music video) and how they produce and foreground different sensibilities. The act of listening to a song, for example, is distinct from watching either a live performance or a video. Musical meaning is thus located at variable points. Slick digital recording and sampling processes inherent in most 1990s commercial pop and dance music, for example, reveal their period of conception and say something important about the tastes and attitudes of consumers at this point in time. The qualities of sound production therefore embody distinct aesthetics associated with state-of-the-art and 'in' sounds. From a musicological perspective, the analysis and evaluation of recording technologies are important determinants in an understanding of both style and culture. As Richard Middleton argues, techniques employed in recordings have 'increased the variety of possible configurations, and the sense of specific physical space that can be created has enormous potential effects on the power and types of gestural resonance which listeners feel'.[1]

Simon Frith would agree. The choice of records can constitute a cultural expression for those whose access to other avenues of expression may be blocked.[2] Whilst Frith's observation relates to individual consumption and a personal mapping of experience, the playing of records in the house scene is equally significant. The bass resonance locks into the experience of the dancer, whilst the DJ assumes the identity of both composer and star performer. As such, the context of playing a record provides a particular trajectory into music, one where meaning is located at variable junctions and where gesture, production and the listener's experience intertwine.

It is arguably the case that live performance remains one of the principal constituents in notions of rock authenticity, as evidenced in the contemporary importance of Britpop. In particular, the significance of live performance lies in its focus on identity, in its expression of emotions which, for example, a listener may not be able to articulate because of personal repression or sexual taboos.[3] Thus popular music locates the pleasures that are available, the sites where desire and power are invested

and operationalised, and the possibilities for both determination and resistance. In turn, the power of the music relies on an investment by a particular social or cultural group; its strength lies in its ability to create a feeling of belonging.

Although popular musicologists would not disagree with Adorno that popular music works as 'social cement', that it must be studied in terms of its effect on the listener, his contention that the musical content is standardised and therefore lacking in meaning is clearly debatable.[4] Popular music has been relegated to the side-lines of academic debate for too long. As the editor of a recent sociological series observes, 'Normally, we do not think of rock music as a matter of serious sociological investigation',[5] to which the rider might be added, 'Why, then, do so many sociologists take it upon themselves to write about it?' and, 'Why has it taken so long for musicologists to intervene?' Whilst popular musicology has problems in common with popular culture in its fight to gain academic credibility, it is now evident that there is a growing acceptance that the music itself must be central to any meaningful analysis, not least in situating style and genre and their relationship to performance conventions. More specifically, an analysis of music provides a particular understanding of effect – the significance of a bass riff, the effectiveness of hi-hat in impelling movement, the melodic contouring of the vocal, the subtlety and nuance of harmonic change.

With lyric analysis representing a major route into problematising meaning within popular music, there has been a lack of significant interpretation of the primary level, the musical text. At the same time, the strength and power of musical expression rests on its ability to conceal its processes and to communicate nothing, or everything, directly. As such, the analysis of musical parameters such as melodic, harmonic, timbral and textural entities, are largely ignored in comparison to the more accessible and easier to describe 'beat', a fact bemoaned by many students of popular music. However, in concentrating on aspects of harmony and melody, musical analysis is often misleading, implying some rational control of the music and thus denying the ambiguities inherent in, for example, improvisatory forms. Popular music nevertheless employs fundamental organisational devices of repetition and variety, often rupture and restitution rather than a build-up of climax and resolution. This may be attributed to a dynamic function, the piling on of sounds, the barrages of chords, the sudden use of silence as catharsis. Equally it may depend on the singer's ability to hold a note with maximum emotional effect, or on a drummer's insistence on denying the backbeat through polyrhythmic excursions.

Notions of powerful and sweeping emotions are brought into play within countless genres of music. The violence often associated with the rock star as hero, or the imaginary fantasy of the performance itself, are examples of an implied discourse. Musical codes are inscribed within the sound event and enacted through performance where they interact with audience perception and experience. This includes, for example, the media hype surrounding musical artists (publicity, interviews, etc.) which contributes to how the consumer 'understands' a specific artist and their work and which, in turn, can construct an illusion of reality which resonates with the music itself.

What, then, are the approaches towards examining music as the central text and making sense of the musical structures themselves?

Popular musicologists acknowledge the need to situate the analysis of the musical text within the context of an active, interdisciplinary field for the purpose of achieving a more holistic enquiry into the musical sound. In particular, it is recognised that a flexible and adjustable critique can cater for the wide range of discourses and sets of references that are analogous to styles. In order to disentangle the stylistic signifying chains of popular music, musical structures need to be explored and identified within their relevant environmental contexts. What is crucial to any musicological investigation are not simple or, for that matter, complex transcriptions of the musical content of a song, nor mere isolated semiotic analyses, but rather fresh analytical explorations of the ways in which musical discourses work in tandem with lyrics, performance styles, gendered identities and consumer positions. The emphasis on self-invention implicit in the performing styles of artists such as Mick Jagger, the Pet Shop Boys and Madonna, for example, has opened up new critiques on sexuality in the 1980s and 1990s. Cross-dressing, in contrast to understated dressing on stage, has become 'a transcendent expression of human potentiality'. No longer signifying actuality, it has become a symbolic representation of the artificiality of theatrical convention; transvestism a 'sign' that 'socially-constructed gender roles may be reshuffled, and that no one with the divine spark need be relegated forever to single sex'.[6] Riot grrrl bands have challenged the automony of the male rocker and k.d. lang has demonstrated once and for all that lesbian identity is a source of musical inspiration.

## AN OVERVIEW OF THE BOOK

Sexing the Groove concerns itself with the debates surrounding popular music, style and representation. In particular it is concerned with the ways in

which the production of meaning is mediated by the social practice of popular music and how this informs gendered identity (the social construction of sexual difference). As a whole, the book describes and debates issues which are directly located within the discourses of femininities, masculinities, musicology and cultural studies. It offers a representative selection of methodological approaches which stress analytical strategies and a concern for arguments about popular music and meaning. As such, the collection cannot claim to cover the full range of popular genres.[7] Rather, contributors were chosen for their investigative approach, and the conceptual frameworks discussed provide different insights into textual analysis which researchers and students can apply to their own investigations into popular music and gendered identity.

Chapters have been grouped into four parts: 'Rock Music Culture', 'Masculinities and Popular Music', 'A Time of Growth and Change: Femininities and Popular Music' and 'Music, Image and Identity'. As the reader will observe, certain texts and debates emerge across the range of chapters presented in this book. This is not surprising. Current writing on sexualities and gendered identities draws on earlier theoretical models which provide a starting point for diverse kinds of text analysis. The ordering of chapters, and thus the contextualisation of the debates, rests with the editor but it is probable that students will be selective in their reading. For those with an interest in film theory, for example, an alternative grouping may emerge which draws together chapters by Keith Negus, Stella Bruzzi, Paul McDonald and Sean Cubitt, where Richard Dyer, Laura Mulvey and Judith Butler provide a significant theoretical underpinning. The final part of Sexing the Groove provides a bibliographic chapter which has been written with the aim of helping the student and novice researcher of popular music. In particular, it includes scholarly texts relevant to the range of theoretical positions inherent in the book by codifying the theoretical discourses under disciplinary headings.

Part I, 'Rock Music Culture', offers four perspectives on the cultural mapping of gendered identity and the ways in which popular music, as an ideological and cultural form, 'operates both as a form of sexual expression and as a form of sexual control'.[8]

Studies of rock music conventionally assume that the 'masculinism' of rock culture is most evident in the demonstrations of phallic power which run throughout that culture – in the physical prowess of the guitar player, or the arrogant, confrontational gestures associated with rock culture since the 1950s. This assumption has been used, for example, in claims that a non-masculinist rock music will foreground the voice, or that a feminist practice will employ acoustic instruments or other forms of expression or

performance in which physical, seemingly phallic force, is less conspicuous. In Chapter One, 'Sizing up Record Collections: Gender and Connoisseurship in Rock Music Culture', Will Straw argues, on the contrary, that the bonds which produce rock culture, and which have rendered it primarily 'homosocial' in nature, are organised around the sharing and circulating of knowledges. Record-collecting, historical contextualism and the connoisseurist creation and ongoing revision of a canon are activities central to rock music culture. They are also the activities in which that culture's masculinism is most clearly located.

Feminist critiques of connoisseurship in the visual arts, or of the collector impulse more generally, have pointed to the historical link between masculinity and the obsession with acquiring series of objects and mastering inventories of knowledges. In part, this represents an enterprise through which activities whose meaning is elusive, or seemingly irrational or bodily, may be reinserted within lists and catalogues which reduce them to items in a series, or moments in an unfolding history. In the case of popular music, the notorious difficulty of fixing the 'meaning' of popular musical texts may be set against the fetishistic urgency with which collectors note variations in pressings, catalogue lists of session players or establish lineages for performers, groups or styles.

Will Straw also looks at practices of collecting and connoisseurship in rock culture, including those which emerged around the so-called 'trash' culture of early to mid-1960s rock music. The endless documentation of this period serves in part to perpetuate the sense that it is 'bottomless', the sign of unending rediscoveries which guarantee that it will never be mastered and so keep alive the activity of documentation. At the same time, this period, within North American rock culture, functions as a privileged moment, knowledge of which is highly male-centred, which works to reinforce the gender boundaries characteristic of rock connoisseurship.

The relationship between experience, practice and the power structures inherent in rock culture is given a specific focus in Chapter Two, 'Men Making a Scene: Rock Music and the Production of Gender'. Sara Cohen examines the reproduction of rock cultures as male forms through a detailed ethnographic case study on a Liverpool (England) recording studio. Her discussion illustrates the ways in which the social construction of gender through music needs to be depicted in terms of social, economic and political relations that are geographically, historically and culturally specific. Drawing on in-depth interviews with local performing musicians, directors, producers, technicians and trainees, her study investigates the relationship between the collective identity of the recording studio and the day-to-day activities of its users. In particular, her research demonstrates

how social networks (including kinship and business relations), musical output, ambitions and dreams resonate with the gendered dimension inherent in the recording studio environment.

The case study itself is discussed in relation to the broader context of rock/pop culture – the gendered relations and ideologies bound up with particular musical styles and with the music industry itself. Cohen then moves to the specific environment of the studio and examines the social, cultural, economic and geographical factors which sustain and inform Liverpool's popular music scene and the way in which these relate to gender and musical creativity.

Cohen's discussion of the gendered construction of rock/pop by musicians and producers highlights the problems faced by women in challenging the systems of patriarchy inherent in the music industry. In particular, it shows how the interaction between individuals and the structure and processes of the music industry continue to marginalise women, whether as engineers, as producers or as musicians. In particular, it would appear that there is a negative correlation between the possibilities of 'changing the rules of the game' and the 'attachment of actors to them',[9] not least in the rock arena itself. As Mavis Bayton asks, 'Where are all the great female electric guitarists? Women are just as capable of becoming rock musicians as men are. Lead guitarists are made, not born. The reasons for women's absence are entirely social' (this volume, p. 39). Rock's function is to confer masculinity: to enter the domain of rock is a male rite of passage.

It is arguably the case that for any woman entering rock territory the omnipresent electric guitar remains the most significant of all instruments in establishing male autonomy. Not only are there problems in gaining access to a band as a guitarist, but equally women guitarists are confronted with the problem of conferring a female identity upon an arguably phallic instrument: how do you hold it? Chapter Three, 'Women and the Electric Guitar', is based on ethnographic fieldwork undertaken for Bayton's PhD during the 1980s and has been updated during the 1990s for her forthcoming book. Her research involved participant observation and nearly 100 in-depth structured interviews with women musicians. The broad sample included women who played a variety of instruments; a range of musical styles (pop, reggae, heavy metal, jazz, etc.); women at different stages of the musician career (amateur, semi-professional, professional); and women of various ages (16 years to 50 plus). The salutary lesson to be learnt from Bayton's research is that rock is unequivocally a male domain. Teenage women are not welcomed in male music-making cliques; they are excluded from the technical aspects of rock; ignored or

intimidated in guitar shops. At its most simple, a guitar-playing woman breaks the established codes of rock.

The relationship between individual needs, attitudes and ideologies, and the hierarchical relationships inherent in the music business, evidence the need to transform the gendered nature of rock if women are to achieve any real equality of opportunity. In Chapter Four, '(R)evolution Now? Rock and the Political Potential of Gender', Norma Coates examines rock as a performance of hegemonic tropes of masculinity and reflects on the problems surrounding 'women in rock'. In particular, Coates picks up on the debates surrounding the conceptualisation of rock as the 'technology of gender', and examines the way in which the 'performance of gender' is itself predicated upon the existence of a binary gender system based upon biological sex. '(R)evolution Now?' focuses on the underlying premise of 'women in rock' – the extent to which this phrase refers simply to musicians, or whether it equally includes fans, listeners, music business personnel. Her emphasis on questioning is important. At present there are no cut and dried answers. Rather, the feeling of alienation which accompanies the 'woman in rock' is evident both in the feminist celebration of, and the conservative backlash against, female-powered music; in the growing awareness that alienation might well be gender-based, not least in its intellectual and sociological modes of investigation.

It is thus evident that there is a continuing need to problematise the socially constructed and gendered nature of popular music in its widest context and to examine how structural questions of power impact upon the reception of the musical text. If rock music is essentially a male domain, does this imply that women simply avoid musical genres, structures, sounds and forms of expression that connote 'maleness'? Is the meaning of rock informed by the structures of the music industry machine, the marketing directors, the product managers, the A&R personnel, the music press and the studio environment? To what extent does ideological meaning depend upon the culture of its fans?

Parts II and III ('Masculinities and Popular Music', 'Femininities and Popular Music') provide particular insights into representations of masculinity and femininity, and the ways in which rock/pop provides an ideological framing of gendered identities. One of the strongest links between all the chapters concerns the notion of pleasure and empowerment within a popular music discourse and a recognition that the relationship between the performer and his/her audience depends ultimately on the meanings that are constructed by the fans themselves. In terms of gendered address, identification resides largely in the imaginary sense of wholeness, the pleasure that popular music affords in its

affirmation of sexuality – in heterosexual equals norm, in gayness equals norm, in androgyneity equals norm.

Part II, 'Masculinities and Popular Music', opens out the debates surrounding the performative male gendering of rock. Whilst it may be argued that the cultural ideals of masculinity as expressed in popular music do not necessarily conform to the actual personalities of the majority of men, it would appear that role models are significant, not least in providing a cultural expression of hegemonic masculinity. As Simon Frith succinctly writes, 'rock has become synonymous with a male-defined sexuality: "Under my thumb," sang the Stones, the archetypical rock group, "stupid girl."'[10]

Frith and McRobbie's article 'Rock and Sexuality' (1990; orig. 1978) was, in many ways, the starting point for Sheila Whiteley's chapter 'Little Red Rooster v. the Honky Tonk Woman: Mick Jagger, Sexuality, Style and Image'. In particular, their identification of Jagger as a 'cock rock performer' presented problems, not least in its implied construction of a heterosexual mode of address. A detailed investigation of the Rolling Stones, and in particular Mick Jagger, suggested a more problematic identity. His stage performances implied a sense of 'otherness' which challenged the traditional sense of masculine/feminine dualism; his 'ambivalent' sexuality opened up definitions of gender which were to dominate much of the early 1970s. As a musicologist, Whiteley's initial premise is based on the assumption that rock does not signify simply as sound and that the music has to be placed within the discourses through which it is mediated to its audiences. Jagger's role as singer thus provides an interface between sexual difference (his 'real' maleness, the androgynous performer) and the content of the song. At the same time, he assumes the form of a complex character in an unfolding drama which culminated in his identification with Lucifer and the unprecedented violence at Altamont.

If Jagger's performance style suggests an ambivalent sexuality, Bruce Springsteen provides a specific focus for the debates surrounding 'authentic' masculinity and, by extrapolation, the implied heterosexuality of working-class culture. Gareth Palmer's chapter, 'Bruce Springsteen and Masculinity', examines the cultural and historical norms which inform the 'blue-collar' connotations of the lyrics. Initially, Palmer investigates the ways in which Springsteen's 'heroes' provide an iconic and conservative trajectory into the signifying codes of father/son, male/female, employer/employee, within a framework which draws heavily on the 'lonesome cowboy' identity of Western US culture. To an extent his lyrics work because they appear ideologically transparent, obvious in their portrayal of

the fatigue and lethargy inherent in contemporary industrial labour; the pessimism generated by failed relationships whether within the family or with the omnipresent anonymous woman; the physical displays of maleness, the exaggerated claims of potency that mask failure and despair.

The downbeat, fatalistic feel of Springsteen's lyrics, the refusal to abandon what Palmer describes as the 'carefully drawn markers of masculinity which prevent escape into the world of feeling' appear, at one level, to deny the sense of rebellion, the challenge to authority inherent in rock culture. The power of the narratives, however, lies in the underlying resentment against the father's fatigue, the occasional moments of uncertainty which suggest a less secure male identity and which provide specific points of identity for two generations of fans. In particular it is Springsteen's constant presence on stage, celebrating work through the sweat of live performance, which situates him within the framework of rock authenticity. Palmer also examines the relationship of fans to Springsteen, the performer and the private man, the construction of 'ordinariness' that underscores his authenticity as masculine and which works to validate him as a genuine product of blue-collar culture, licensed to comment on that world.

As Grossberg has pointed out:

> for the fan, popular culture becomes a crucial ground on which he or she can construct mattering maps. Within these mattering maps, investments are enabled which empower individuals in a variety of ways. They may construct relatively stable moments of identity, or they may identify places which, because they matter, take on an authority (both for themselves and for others) through the mobilizations and organization of affective investments. By making certain things or practices matter, the fan 'authorizes' them to speak for him or her, not only as a spokesperson but also as surrogate voices. . . . The fan gives authority to that which he or she invests in letting the object of such investments speak for and as him or herself. Fans let them organize their emotional and narrative lives and identities.[11]

If Springsteen articulates the frustrations of the blue-collar hero, the disturbing inconsistencies between everyday feelings and public actions, the problems inherent in being stuck with a biologically determined personality, then the Pet Shop Boys challenge the apparently fixed and unified identity of the 'natural' man. Unlike Springsteen, whose narratives inhabit an often melodramatic framework, the Pet Shop Boys are the essence of

postmodernism – eclectic, camp and coolly ironic. Whereas Springsteen's heroes narrate the problems of the American male within a conservative frame of reference, the Pet Shop Boys problematise notions of 'difference' through an acute sense of British cynicism and witty eccentricity.

Stan Hawkins's investigation into 'The Pet Shop Boys: Musicology, Masculinity and Banality' provides an innovative framework of analysis which demonstrates how music can provide particular insights into gendered identity and everyday life. In particular, his musicological critique opens out the debates surrounding the politics of the image, and how expressions of sexual difference function through the codes of musical sound. Hawkins's analysis is situated within a discussion of the fragmented identity of the emerging 1980s male in Thatcherite Britain, the emphasis on narcissism and artifice, on style over content. His analysis of 'Yesterday, When I was Mad' shows how gratuitous repetition, easy harmonic progressions and simple melodic tunes suggest a retreat into a banality which masks a flirtation with closure and resolution, and where simplicity and bricolage 'taunt the rigidity of binary empowerment found in the oppressive modes of many patriarchal texts of pop culture', not least in the construction of normative sexuality itself. More specifically, the subtle and serious mode of address in the lyrics, the escapist Hi-NRG grooves and the innovative use of music technology establish a particular insight into how pop reconstructs authenticity. This also provides an interesting point of comparison with Palmer's analysis of authenticity in Bruce Springsteen. For the Pet Shop Boys, authenticity is situated in an acknowledgement of 'shameless' inauthenticity, where simulation challenges the autonomy of 'real' or live performance. The central aim of Hawkins's chapter, then, lies in the discussion of the musical text itself, and in the discovery of the links between new male identity and the Pet Shop Boys' irresistible grooves.

Although there is an evident distinction between the implied male address of rock and the celebration of 'otherness' in disco culture, it is important to note that neither constitutes a simple descriptive criteria or musical definition. Rather, the meaning of rock, of disco, necessitates an awareness of its cultural context and the ways in which music contributes to an understanding of sexual subjectivity which rejects any notion of 'naturalism'. It is equally important to be aware that histories of rock are also subject to historical specificity. Simon Frith and Angela McRobbie's discussion of 'Rock and Sexuality' (1990) reflects 'if homosexual, bisexual, and asexual men can now use their confusions (and zest) as a source of pop success, lesbianism remains a secret'.[12] In the 1990s this is no longer true. Lesbian identity has become a unique element of riot grrrl's

gender/sexual politics whilst demonstrating, once again, how easy it is for those in control of representational discourse to exploit and commodify marginalised cultures.

Part III, 'A Time of Growth and Change: Femininities and Popular Music', provides six approaches to the analysis of gendered identity. To an extent, the ordering of the chapters suggests an underlying chronology, framing the choices available to the woman musician from the 1950s to the 1990s, whilst raising questions as to the relationship between image and musical genre. At the same time, the writers all challenge the gendered history of rock/pop with its juxtaposition of the active male/passive female, whilst demonstrating that the stereotypical ideals of womanhood 'tramp, bitch and goddess, funky mama, sweetheart, the woman left lonely, the hapless victim of her man'[13] which have provided an ideological framing for gendered identity are themselves subject to reappropriation.

The continuing fascination with Elvis − 'prettier than most women'[14] − which not only crosses but confuses gender boundaries, prefaces David Sanjek's discussion of rockabilly. As he points out, the musical culture of the 1950s characterises the period as one of wild boys at play; the preponderance of white male rock historians themselves pause all too briefly and apologise all too little for the gender-based narratives they propose. 'Can a Fujiyama Mama be the Female Elvis? The Wild, Wild Women of Rockabilly' redresses the balance and examines some of the key female artists who contested this male-gendered musical domain. It is, without doubt, a timely interjection. For the researcher, Sanjek provides a tantalising history of a rebellion which has effectively been silenced by the disappearance of vast numbers of recordings from public circulation. As he suggests, there is a sad parallel with the blues queens of the 1920s whose names, at best, remain footnotes in the annals of history and whose collectivity often results in the reduction of the individual into a unitary black female subject.

Tracing the influence of honky tonk upon female rockabilly artists, Sanjek cites such legendary figures as Texas Ruby, Jean Shepard, Kitty Wells and Charlene Arthur who 'fought to become country's first truly aggressive independent female of the postwar era'.[15] Arthur's failure to achieve recognition can be seen as a salutary legacy to the up-and-coming female rock and roll singers of the 1950s. Success in a man's world depends largely upon compromise, a willingness to be transformed into a 'bit of exotica'. Initially this is evidenced by the 'nymphettes', the prepubescent girls whose projection of sexually potent songs became an effective marketing strategy for the major record companies. The

promotion of 'little girls with grown-up reactions' is but one example of the arguably misogynistic attitudes of the major record companies. Barbara Pittman, one of the few women to record for Sam Phillips's Sun Records, does not merit even a footnote in the standard history of the label. Janis Martin's initial success as 'the female Elvis' ended abruptly when she gave birth at the age of 18. Marriage and motherhood were considered incompatible to the image of a 'rockin' country girl'. Wanda Jackson, arguably one of the most successful singers of the period, eventually turned to religion and gospel as her career in country and rockabilly foundered. Children and a broken marriage had again amounted to a demonstrable fall from grace.

Sanjek's discussion of 'the wild women of rockabilly' highlights many of the problems surrounding popular music. The fact that performance and/or recordings are essential primary source material means that historical evidence is shrouded in selectivity. The exclusion of so many black women from the history of blues resulted, as Sanjek points out, first from the false bifurcation between 'traditional standard' and 'nightclub' blues forms; second, the inference that since most of these women's songs were written by men, they must remain mere vessels of other individual's sentiments; and third, the limited period of time during which these artists recorded and consequently the small number of available tracks they completed are employed as a means of belittling their contribution to musical history. For researchers interested in female rockabilly artists there are similar problems. Documentation and recordings are again negligible and as a result little is known, either empirically or otherwise, of the contributions made by these women to American popular music. Without evidence, they remain marginalised.

Sanjek's discussion opens out many of the points raised in Part I, most specifically that the bonds which produce particular cultures (whether rock or rockabilly) are primarily homosocial, and that knowledge is highly male-centred and serves to reinforce gender boundaries. It is equally evident that success, for the woman musician, is compromised by hard facts – the collisions with commercially driven and headstrong A&R men; the requirement to 'fit' into a music business which remains a male domain; the emphasis on image over musicianship; the problems surrounding the maturing of young performers; the choice between career and family.

The last point is taken on board by Charlotte Greig whose chapter, 'Female Identity and the Woman Songwriter', focuses on the emotional response to childbearing and motherhood. It is, she suggests, no coincidence that the majority of pop songs are about romantic love and that the

female protagonists remain free and unattached. They don't get pregnant, they don't get married or divorced, they don't have family problems of any kind. It is not, then, too surprising that the record industry has demanded a similar attitude from its women musicians. However, as Greig points out, the accepted ideal of womanhood has finally ceased to have universal appeal and women songwriters today are responding by bringing their experiences of, and attitudes towards, childbearing and motherhood into their work.

Greig's discussion of what she calls the 'domestic drama' traces the origins of songs about motherhood to Anne Briggs's revival of the folk song 'Gathering Rushes in the Month of May'. The probable 'collective' authorship of the song, its expression of blunt honesty, provides a specific insight into the importance of such songs to the 1960s, not least in its practical exposition of the facts surrounding conception and birth. The dignity and courage of the young woman in 'Gathering Rushes' derives, Greig suggests, from the telling of the tale and, as such, there are strong parallels with grassroots feminism where frank discussion of the debates surrounding power relations in personal life, in reproduction, sexual relationships and the implications of motherhood was of particular significance.

Unwanted pregnancies, 'nine-month blues', marriage, motherhood, and ageing are brought into focus through a discussion of country, folk, and such singer-songwriters as Joni Mitchell and Laura Nyro. Greig ends with a brief analysis of Sinéad O'Connor's 'three babies' which she cites as a song about independence and rebellion against the social order. It is significant that the same song should become the focus of the following chapter 'Sinéad O'Connor – Musical Mother', as its importance lies not only in the subject matter of the song but also in O'Connor's personal experience of pregnancy and the realities of sexism within the music industry.

However, as Keith Negus points out, his chapter is primarily intended to show how the identity of a contemporary recording artist is produced, performed and communicated across a range of media texts. In particular, he discusses the ways in which a performer participates in self-authorship, drawing on Dyer's model of the 'total star text'. His analysis of the ambiguities of the meaning of 'three babies' explores the tensions inherent in the contrast between the confessional and the assertive, and the ways in which this contributes to the articulation of O'Connor's identity and performance style. This, in turn, is opened out by a discussion of image which is given a specific focus in his deconstruction of the multiple connotations surrounding O'Connor's shaved head. His analysis provides an exemplary model for students interested in the sexual politics of pop, the

controversial issues surrounding the 'appropriate' female image, the qualities that are directly or indirectly coded as 'feminine' and their relationship to genre. Finally Negus turns to issues surrounding cultural identity and social injustice. His discussion of the connections between the colonial oppression of the Irish and black people by the English state usefully extends current debates surrounding the appropriation of musical signifiers (not least in world musics). In particular his identification of styles, techniques and instruments which connote particular relationships to Irishness and Blackness demonstrates the ways in which musical sounds contextualise national identity and cultural knowledge to effect 'a transatlantic hybrid synthesis, an imaginary musical space' which suggests solidarity between different cultures.

The contextualisation of identity through musical sound also informs Stella Bruzzi's chapter, 'Mannish Girl: k.d. lang – from Cowpunk to Androgyny'. In particular the significance of lang – a short-haired vegetarian lesbian – within the Nashville scene, performing *Shadowlands* with such grand ladies of Country as Kitty Wells, Loretta Lynn and Brenda Lee, points to the apparent incongruity of the difference between herself and her Country 'persona'. As Bruzzi asks, does this mean she was treating Country ironically, distancing herself from it despite the fact that the reappropriation of such heterosexual songs as 'I Will Survive' has become an established part of Country? What does being 'out' mean to lang – apart from proclaiming her sexuality?

'Mannish Girl' charts k.d. lang's journey from difference to androgyny, from a self-identity tied to gender to an identity tied to sexuality. Framed by a discussion of lang's performing persona, Bruzzi suggests that notions of 'progression' are informed by a political awareness of sexuality which adheres to the defiance of recent queer politics, a stance that seeks to collapse the gender boundaries between gays and lesbians, and which suggests the necessary identity of the gay/lesbian self through sexuality rather than biological sex. It is at this transition point (largely coinciding with the release of *Ingénue*) that k.d. lang's image achieves a naturalness or wholeness lacking in the earlier 'personae' she created for herself and coincides with lang coming out to *The Advocate* (1992).

Notions of finite gender divisions and binary oppositions inform many of the current debates surrounding gender and sexuality. In particular, psychoanalytic theory has been reinterpreted in an attempt 'to use it to describe and explain the ways in which males and females acquire their socially ordained sexual roles and their correlative psychical attitudes and structures'.[16] Feminists, generally, have had an ambivalent and problematic relationship to Freud's preoccupation with biological or anatomical

difference as leading inevitably to psychological and sexual difference. However, whilst many have cited it as misogynist, acultural and ahistorical, radical feminists have accepted psychoanalytic theory as a necessary part of the feminist account of the relations between the sexes. Most recently, attention has been focused on the divergence between Freud's explanation of the operations of the physical unconscious and gendered sexuality and the queer concept of sexuality *preceding* gender. Derrida's writing on 'différance' (simultaneously to differ and to defer) and the writings of French feminists such as Hélène Cixous and Luce Irigaray, for example, have been bound up in the need (imposed by positive theories of difference) to identify identity not by what it is in its own terms, but by what it is not.

One clear response to the negative conditions and conditioning of 'différa/ence' is to manipulate, control and subvert notions of gender and gender roles. This is evidenced by the first part of lang's career, the turning point being the *So in Love* video for the *Red Hot and Blue* compilation, the feature *Salmonberries* (1991) and the album *Ingénue* (released April 1992). Lang's creation of certain multiple personae that play around with notions of the feminine suggest an identity that is gendered and only ambiguously sexed. As such, Bruzzi suggests that early lang is about superimposed identities that question and laugh at views of gender and sexuality, not least in the stage renditions of 'Johnny Get Angry'.

The use of self-shifting images, the 'attempt to redraw and mix up the lines of difference in a new, energising way'[17] can be interpreted as a form of feminist strategy which reclaims identity from a history of multiple associations. At one level this appears common sense: women are not men, lesbians are not straight; and whether heterosexual, homosexual or lesbian, we present/display different aspects of our gendered identity to parents, employers, lovers and, in the case of the performer, to the media and fans. However, as Bruzzi points out, lang's performance has become a denial of difference – she denies rather than reaffirms gender difference by not signposting the 'real' and 'pretend' genders of the androgyne. As such, the boundaries become insignificant rather than more pronounced. Indeed, since coming out in 1992, lang has dropped the multiple, problematic personae of her earlier work, the fascination with 'the space between the notes' that both reveals and conceals her lesbian sexual identity. Her performance has become far more homogeneous, her style more mellifluous, combining the traditions of torch songs and ballads.

To an extent, Bruzzi's chapter can be read as mourning the loss of the dangerous, ambivalent and cheeky lang, particularly since she now insists on remaining coyly cagey (as far as her lyrics go) about her lesbianism.

Being 'out' she no longer has to name or make visible her identity and she
has left the queer dynamism of her earlier work behind. As Bruzzi argues,
k.d. lang's androgyny (the denial of gender difference), her lesbianism
(sexuality) and being out (politicisation) have merged to form her iden-
tity and it is this broadening of the parameters that normalise her
androgyny. Today she is less radical than she was when in the closet, and
perhaps less radical than she would like to be.

Queer politics is not only the reappropriation of negative attitudes
towards gay sex and sexuality, making 'deviance' into something positive,
but clearly this is a fundamental issue. The political-sexual impulse behind
establishing a queer identity through the reappropriation of such deroga-
tory terms as 'fag', 'dyke' and 'queer' remains important, but a strictly
feminine conversion of negative connotations into a positive image is still
bound up in issues of gender, binary opposites, of accepting, rather than
thwarting, difference itself. Queer politics, then, is contradictory. It is a
way of defining the self so that homosexuality is no longer transgressive
and, as such, marginal to normal, dominant, stable heterosexuality. At the
same time, it is: 'a form of resistance. . . . It is defined more by what it
is against than what it is for. Its slogan is not "get out of my face" (let
alone "gay is good"), but rather "in your face".'[18] It is this sense of 'in
your face' that is one of the defining features of riot grrrl politics.

It is no coincidence that the last two chapters in this section are both on
riot grrrls, arguably the most significant revolutionary counter-culture to
emerge over the last twenty years. However, as Mary Celeste Kearney
points out, their contextualisation by the media currently reflects an
attempt to incorporate them within popular frameworks for understand-
ing youth cultures. Such representations more significantly reveal the
desire to not speak about riot grrrl as a radical political community. In par-
ticular, the media's reductive construction of 'riot grrrl as punk' makes it
easier to contain the feminist rage of this radical community by com-
modifying it.

'The Missing Links: Riot Grrrl – Feminism – Lesbian Culture' moves the
discussion of riot grrrl beyond the semiotic approaches which typically
dwell on only the most visible (and audible) forms of cultural significa-
tion; it demonstrates the various elisions which occur when the mainsteam
media rely on certain frameworks to understand (female) youth cultures,
predominantly the frame of music. Deconstructing this frame as one
which helps in the ideological recuperation and commercial commodifi-
cation of youth cultures, Kearney brings to the surface riot grrrl's
connnections with politicised movements such as feminism and lesbian
separatism. Her approach is not meant to merely rewrite riot grrrl's place

within feminist history (and womyn's music within musical history) but rather to re-inflect analyses of youth cultures within a study of their broader ideological, economic and, most importantly, *political* significance. In particular, her analysis inflects feminist theory with the dimensions of age and generation, an approach which has been seriously neglected in analyses of feminist and queer cultures and politics.

Kearney's discussion explores the interconnectedness of youth cultures and the mainstream media. Riot grrrl's challenge to popular notions of adolescence, femininity, youth cultures, political identity and the processes of ideological and commercial recuperation are examined through press representations over the initial years of its emergence and formation. It is, as she points out, a history of misrepresentation, co-option and containment, and despite the coterminous emergence in the United States of riot grrrl and queercore bands such as Tribe 8, Random Violet, Team Dresch and the Mudwimmin, relatively few links have been made between lesbianism, queercore and riot grrrl. Kearney redresses the balance, and examines the ways in which riot grrrl and queercore bands are indicative of a new phase of feminist politics and ideology. Her discussion returns the reader to the debates surrounding queer politics and theory, in this case focused by a discussion of Tribe 8's punk confrontation of feminist music-making at the Michigan Womyn's Music Festival.

Considering the influence music has had on the formation and popular understanding of both riot grrrl and lesbian separatist communities, it is surprising that this has been largely overlooked. In particular, the DIY ethos of feminist music is resonant of early radical feminism, not least in its creation of alternative institutions, relations and forms of cultural expression. This view is evidenced equally in Marion Leonard's British view of riot grrrl and her discussion of zine culture: '"Rebel Girl, You Are the Queen of My World" – Feminism, "sub-culture" and grrrl power'. To an extent the two chapters provide a discursive frame of reference in that Leonard situates part of her discussion within the context of 'women in rock', and the punk tradition. In a way, this is symptomatic of the larger problems occurring in contextualising innovative youth cultures. At the same time, both writers draw attention to the problems surrounding the construction of riot grrrls by mainstream media. In particular, Leonard discusses the construction of riot grrrls as cultural curiosity and the strategies adopted by such groups as Bikini Kills to control and manage both media and academic misrepresentation. This point is given a specific focus in her discussion of zines, the grrrl lines of communication which offer both an individual response to riot grrrl and, significantly, identify with a common goal of empowering girls and women. Whilst zines include traditional

fanzine staples such as record and concert reviews, they equally act as spaces in which grrrls can share information and voice opinions on such issues as date rape, abortion rights and a discussion of the problems of walking home alone at night.

The importance of zines, then, lies in their facilitation of frank dialogue, as a way of seeing, of overcoming alienation and isolation. As such, it is arguably part of a larger democratisation of music and culture, the emergence of networked composition, the virtual studio, where musical ideas are both initiated and developed on a global scale, significantly distanced from the oppressive patriarchal structures of mainstream music discussed in Part I of this book. Kearney and Leonard's discussions of riot grrrls also provide an interesting comparison with Sanjek's discussion of rockabilly nymphettes. As Natasha Stovall observes in her article 'Adult Crash':

> Their life experiences have long since outstripped the boundaries of childhood, but (they) continue to be avatars of teen rebellion, teen anger, girl anger. Their investigations of childhood's underbelly – incest, abuse, selfabuse – suggest that they have already grown up – way too early. But there is a difference between being yanked into adulthood and sincerely embracing your womanhood. . . . They have to move forward or else get sucked into a vortex of itty-bitty barette self-parody.[19]

Recent communication with Kathleen Hanna of Bikini Kills suggests this has already happened. She writes:

> I am presently working with a group in the States called REFUSE AND RESIST. I am doing stuff about police brutality, immigrants' rights etc. . . as I see this as all being connected with feminism and what really makes me sad and hopeless but also know I have to stop the cops from killing Black people and beating up my friends.

She adds, 'I like yer paper. I'm just glad the thing is being documented by people who seem to care.'

The struggle by women to gain equal access to the world of professional popular music is clearly one of the key themes to emerge so far. 'The ascendancy of music video as a promotion vehicle, and final stage in the song production process'[20] is equally problematic in that it conflates two potentially sexist modes of objectification, popular music and visual representation. Part IV, 'Music, Image and Identity' moves to a consideration

of pop promos and offers three approaches to the reading of music videos. In 'Seduced by the Sign', Sheila Whiteley discusses the textual links between sound and image in Madonna's 'Justify my Love'; Paul McDonald investigates 'Romance, Dance and the Performing Male Body in the Take That Videos' and Sean Cubitt looks at 'Digital Erotics and the Culture of Narcissism'.

The debates surrounding music as inner expression and music as saleable commodity have been one of the defining features of the twentieth-century pop experience, not least within the field of music videos. Emerging out of a complex relationship between television presentation of popular music and an established genre of rock music and youth films, pop videos are now the most powerful promotional tool for both pop groups and individual performers. As such, it is hardly surprising that they depend upon a sensuous approach to marketing, combining inputs from fashion, advertising and the avant garde to lure the viewer into a perpetual state of unfulfilled expectations. Visually innovative, momentarily diverting, they play on the rhetoric of desire, providing fans with sounds, images and experiences where they can locate their own sense of identity. But this sense of communitas, as mediated by videos, is illusory and has to be constantly renegotiated. 'Only the viewer's continued consumption of videos and video programs will ensure the extension of that feeling of belonging'.[21]

The distinction between live performance and visual presentation would appear to be the axis around which many of the debates about the stylisation of pop promos appear to revolve. Sensational imagery, violent imagery and a glossy presentation that is often unrelated to the musical text suggest that visual devices are there not simply to draw the viewer in. Rather they are competing with the sounds in structuring the experience of the audience and shaping its response to the meaning of the musical content. Clearly, any meaning assigned to music does not have to depend upon the existence of external referents. As Shepherd points out, 'music is not an informationally closed mode of symbolism relevant only to "emotive, vital, sentient experiences", or "inherent psychological laws of rightness"',[22] and whilst lyrics and song titles suggest a preferred reading, music's abstract character allows for a mapping of individual experience and meaning that provides a sense of identity and a fluidity of engagement.

Whilst Shepherd's analysis of 'meaning in music' relates primarily to the ways in which meanings in society are encoded and creatively articulated in music, the notion that the reality of an analysis resides in the meanings and realisations that a 'reader' is able to construct for him/herself has a

particular relevance to the debates surrounding music videos. In particular it highlights the point that music videos, by imposing a visual interpretation of the song, can diminish the interpretative liberty of the individual music listener,[23] and that the experience of music video is largely weighted in favour of the 'image'. If this is so, then it could be assumed that music videos have somehow impoverished individual interpretation and experience and that any meaning assigned is predicated upon a specific mediation of the musical text. Clearly this has strong implications for any consideration of gendered identity.

Experience of teaching both media and music students suggests that there is a marked distinction in their interpretation of 'meaning' in rock videos. For the media student, the visual images are the prime markers in the analysis of meaning; for the music student, meaning centres around the experience and primacy of sound. Whiteley's paper, 'Seduced by the Sign: An Analysis of the Textual Links between Sound and Image in Pop Videos' proposes an analytical methodology based on Barthes's codes of narratology[24] and exemplifies this through an analysis of Madonna's video 'Justify my Love'. In particular, her concern is to discover the extent to which the projected images restructure or confirm the meaning(s) of the musical connotations inherent in the single.

Whiteley's discussion of femininity at play and the complex range of identification and desire for Madonna as opposite sex/same sex extends many of the debates raised by Bruzzi, Kearney and Leonard whilst returning the reader to the importance of theorising popular music through the interrelatedness of musical structures, lyrical texts and visual narratives. In particular her application of Barthes's codes of narratology exemplifies the importance of situating the musical text within the context of an interdisciplinary field and investigating conceptual models which have the potential to provide new insights into gender and sound.

The emphasis on *potential* is important. Over the last ten years the importance of theorising popular music has increasingly involved the 'borrowing' of analytical approaches from sociology, semiotics, cultural studies and film studies. Whilst this has demonstrated that generalisations across the field of popular music are no longer tenable, that students of popular music should employ a range of conceptual tools to unpack the meaning of music, it is equally evident that certain approaches have worked more as a straitjacket, confining and restraining the range of meanings through preferred readings of arguably polysemic texts. This point is highlighted in Paul McDonald's chapter, 'Feeling and Fun: Romance, Dance and the Performing Male Body in the Take That Videos', where his analysis of 'boy gang' videos takes issue with the legacy of

screen theory, which has constructed lines of inquiry which disavow masculinity as spectacle. Drawing on Foucault, Bourdieu and Butler, his chapter investigates the action of body and voice in constructing gendered display, and the ways in which videos construct imaginary worlds/scenes which are further embodied in the actions of the performers.

McDonald's analysis situates videos as performance discourses which constitute 'ways of being'. These, in turn, acquire meaning through their interaction with a framework of discourses that identify contemporary masculinity. As he points out, these readings are themselves historically formed and, as such, it is important to dismantle the conventional categories, the potential conditions of intelligibility, which make such readings possible. As Cornwall and Lindisfarne suggest, 'the difficulties of translating particular meanings of masculinity from one social setting to another . . . challenge(s) the existence of any apparently straightforward category'[25] and McDonald's discussion of performance signs and codes of masculinity demonstrates that 'notions of masculinity, like the notion of gender itself, are fluid and situational' and that gender labels conceal a diversity of meanings which 'change before different audiences in different settings'.[26]

The examination of gendered identity, the ways in which notions of masculinity and femininity are created and presented in pop videos, also informs Sean Cubitt's chapter 'Rolling and Tumbling: Digital Erotics and the Culture of Narcissism'. As he points out 'there is the possibility for a profound remaking of the ways we represent sex, eroticism, gender, sexuality. But there is also the strong likelihood that these new techniques will be recruited for a remaking of old ways.' Cubitt also discusses the problems inherent in applying classical film theory to pop videos. Focusing on the voyeuristic and fetishistic gazes inherent in patriarchal structures of looking, he provides a challenging and persuasive analysis of Madonna's video for 'Vogue' – as enacting a sense of the essence of femininity at play – through an evaluation of Mary Anne Doane's essay 'Film and Masquerade: Theorising the Female Spectator'.[27] For any student of film studies this is a seminal text, and Cubitt's discussion provides particular insights into notions of gendered identity, but he returns the reader to Freud, arguing that psychoanalysis offers a richer ground for understanding the variety of sexualities and sexual identifications. In particular he identifies 'primary narcissism' as providing an important insight into digital imaging, not least in the construction of female spectatorship.

'Digital Erotics' is an important chapter to end on in that it furthers important debates surrounding narcissism and eroticism whilst returning the reader to the premise that informs the range of discussions presented

in *Sexing the Groove*. There is nothing natural, permanent or immovable about the regime of sexual difference that governs society and culture. Femininity is a construct; masculinity is a construct; and, as Cubitt argues, both are fragile. Sexual difference is not only a method of governance. In the 1990s it no longer has charms for us as a culture. That is why it is so necessary for the dominant culture to repeat over and over again the naturalness of heterosexism.

# NOTES

1 Middleton, R. (1993) 'Popular Music and Musicology: Bridging The Gap', *Popular Music* 12(2): 177–90.
2 Frith, S. (1987) 'Why Do Songs Have Words?', *Sociological Review Monograph* 34: 77–106.
3 Adorno, T. (1976) *Introduction to the Sociology of Music*, New York: Seabury Press.
4 Adorno, T. (1941) 'On Popular Music' reprinted in S. Frith and A. Goodwin (1990) *On Record: Rock, Pop and the Written Word*, London: Routledge, pp. 301–14.
5 Cookson, P.W., Jr (1994) 'Preface' to J.S. Epstein, *Adolescents and their Music: If it's Too Loud, You're Too Old*, New Directions in Sociology, Vol. 1, New York: Garland Publishing Inc., p. x.
6 Showalter, E. (1991) *Sexual Anarchy: Gender and Culture at the Fin de Siècle*, London: Bloomsbury, p. 166.
7 There are, for example, no discussions of reggae, rap, Britpop or, indeed, the arguably egalitarian culture of rave. Whilst these are regrettable omissions, *Sexing the Groove* does not claim to cover a representative selection of rock and pop genres. Rather the contributions were chosen for their analytical content and it is hoped that readers will apply the methodological approaches to their own studies of style, genre, sexualities and gender.
8 Frith, S. and McRobbie, A. (1990) 'Rock and Sexuality', in S. Frith and A. Goodwin, *On Record*, p. 373.
9 Cockburn, C. (1990) 'Men's Power in Organizations: "Equal Opportunities" Intervene', p. 87 in J. Hearn and D. Morgan, *Men, Masculinities and Social Theory*, London: Routledge.
10 Frith and McRobbie, op. cit., p. 372.
11 Grossberg, L. (1992) 'Is There a Fan in the House? The Affective Sensibility of Fandom', in L.A. Lewis, *Adoring Audience: Fan Culture and Popular Media*, London: Routledge, p. 59.
12 Frith and McRobbie, op. cit., p. 420.
13 Pavletich, A. (1980) *Sirens of Song: The Popular Female Vocalist in America*, New York: Da Capo, p. 76.
14 Clarence Worly (Christian Slater) in *Jailhouse Rock* (1957).
15 Blackwell, R.B. and Marascalco, J. (1956) 'Rip It Up', ATV Music, p. 173.
16 Rowley, H. and Grosz, E. (1990) 'Psychoanalysis and Feminism', in S. Gunew (ed.) *Feminist Knowledge, Critique and Construct*, London: Routledge, p. 175.
17 Suleiman, S., quoted in Weil, K. (1992) *Androgyny and the Denial of Difference*, Charlottesville and London: University Press of Virginia, p. 144.
18 McIntosh, M. (1993) 'Queer Theory and the Law of the Sexes', in J. Bristow and A. Wilson (eds) *Activating Theory, Lesbian, Gay and Bisexual Politics*, London: Lawrence & Wishart, p. 31.
19 Stovall, N. (1996) 'Adult Crash', *Village Voice* 30 April: 69.
20 Lewis, L.A. (1993) 'Being Discovered: The Emergence of Female Address on MTV', in S. Frith, A. Goodwin and L. Grossberg, *Sound and Vision: The Music Video Reader*, London: Routledge, p. 131.

21  Marion, J. and McClarty, L. (1984) 'Rock Video's Message', *Canadian Forum* July, quoted by J. Berland, 'Sound, Image and Social Space: Music Video and Media Reconstruction', in Frith *et al.* (eds) *Sound and Vision*, p. 35.

22  Shepherd, J. (1991) *Music as Social Text*, Cambridge: Polity Press, p. 83.

23  Straw, W. (1993) 'Popular Music and Post-Modernism', in Frith *et al.* (eds) *Sound and Vision*, p. 3.

24  Barthes, R. (1987) *S/Z*, trans. S. Heath, London: Fontana.

25  Cornwall, A. and Lindisfarne, N. (1994) *Dislocating Masculinity: Comparative Ethnographies*, London: Routledge, p. 2.

26  Ibid., p. 3.

27  Doane, M.A. (1982) 'Film and the Masquerade: Theorising the Female Spectator', *Screen* 23 (3/4); reprinted in Doane, M.A. (1991) *Femmes Fatales: Feminism, Film Theory, Psychoanalysis*, London: Routledge.

# Part I

# ROCK MUSIC CULTURE

# 1

# SIZING UP RECORD COLLECTIONS

## Gender and connoisseurship in rock music culture

*Will Straw*

For example, suppose we required a dense texture of classical allusion in all works that we called excellent. Then, the restriction of a formal classical education to men would have the effect of restricting authorship of excellent literature to men. Women would not have written excellent literature because social conditions hindered them. The reason, though gender-connected, would not be gender per se.

(Baym, 1985: 64–5)

I wish Riot Grrrl had inspired girls to be more curious about the great female musicians of yesteryear. Boys bond around discussing used records and obscure bands. With girls it's like every generation has to exhaust itself reinventing the wheel. So we end up with bands that are good but less original than they think they are.

(Vincentelli, 1994: 24)

You don't have to be a German genius to figure out that any pop combo is only as good as their record collection . . .

(Moore, 1993)

## INTRODUCTION

When I had almost finished writing this article, I was interviewed by the director of *Vinyl*, a documentary film-in-progress whose subject is record collecting. By the time shooting of the film is completed, its director told me, he will have interviewed almost 100 record collectors. Only five of these, he admitted, were women. He had tried (he claimed, convincingly) to find more female collectors, following up on every lead and making certain that his search was well publicised, but had met with no success. (In response to my own concern that my collection might not be spectacular enough, the director reassured me that some interview subjects had collections of only a few hundred records.) With the director of this film, as with everyone who has discussed the subject with me, there was easy and intuitive acceptance of the idea that record collecting, within Anglo-American cultures at least, is among the more predictably male-dominated of music-related practices.

The challenge, however, is to determine what might be said next. When people are pressed to account for the gendered, masculinist character of record collecting, the certainty that it is so gives way to hesitant and often contradictory explanations as to why. As I shall argue, this uncertainty is rooted in competing images of the collection as cultural monument and private haven. Record collections are seen as both public displays of power/knowledge and private refuges from the sexual or social world; as either structures of control or the by-products of irrational and fetishistic obsession; as material evidence of the homosocial information-mongering which is one underpinning of male power and compensatory undertakings by those unable to wield that power. Indeed, the confusion underlying these characterisations is such that, were one presented with statistical evidence that the typical record collector was female, one could easily invoke a set of stereotypically feminine attributes to explain why this was the case. One might note, for example, that collecting is about the elaboration of a domestic context for consumer goods; that, within collecting, the values of consumption come to assume priority over those of production; and that, in the collection, an immediate, affective relationship to the object takes precedence over collective, spectacular forms of cultural involvement (for a discussion which explores some of these claims, see Belk and Wallendorf, 1994).

## TAXONOMIES OF MALE IDENTITY

At the very least, we may say of record collecting, as of most practices of connoisseurship and systematic consumption, that it stands in an uncertain relationship to masculinity. As part of the material culture of music, records themselves participate in the gendering of cultural habits at a number of levels. From one perspective, records are merely the physical residues of processes of commodity turnover and stylistic change, and, as such, are part of the ongoing, unofficial relocation of objects from the public, commercial realm into the domestic environment. In this, they contribute to the differentiation of domestic spaces, and it is as an effect of the male collector's salvaging of popular cultural artefacts from the world outside that many of the distinctive or stereotypically resonant aspects of men's domestic space take shape. (The slovenly bachelor, his apartment collapsing into disorder amidst the chaos of clutter, is one such stereotype; the apartment which is little more than a compulsively ordered archive is another.) It is often in his relationship to his collections that a male's ideas about domestic stability or the organisation of a domestic environment find their fullest or most easily decipherable elaboration. (Writing of the 1950s, Keir Keightley (1966) has discussed the role of hi-fi equipment in nourishing a masculine ideal of the listening room as refuge from the noise and interruptions which come with married or family life.)

Were record collections merely graveyards for exhausted commodities, however, their connection to what Medovoi has called the 'masculinist politics' which surround so much popular music might not be apparent (Medovoi, 1984). As accumulations of material artefacts, record collections are carriers of the information whose arrangement and interpretation is part of the broader discourse about popular music. In a circular process, record collections, like sports statistics, provide the raw materials around which the rituals of homosocial interaction take shape. Just as ongoing conversation between men shapes the composition and extension of each man's collection, so each man finds, in the similarity of his points of reference to those of his peers, confirmation of a shared universe of critical judgement.

In the psychological literature on collecting, it is sometimes noted that males and females tend to accumulate objects with equal intensity. If men's accumulations of objects tend, more frequently, to be considered 'collections', one explanation is that this simply signals the higher prestige which has accrued, historically, to the sorts of objects amassed by men. Baekeland has suggested that this argument is not sufficient, and that, in

5

fact, male practices of accumulation take shape in an ongoing relationship between the personal space of the collection and public, discursive systems of ordering or value. These public systems are no less arbitrary, of course, in their choice of objects or criteria of value, but they tie each male's collection to an ongoing, collective enterprise of cultural archaeology. Baekeland cautions that:

> we should not forget that many women privately amass personal possessions far in excess of any practical need, without any thought of public exhibition other than adornment: we rarely think of accumulations of dress, shoes, perfumes, china and the like as collections. They consist of relatively intimate and transient objects intended directly to enhance their owners' self-images, to be used until they are worn out or broken, and then to be discarded. Men's collections, however, be they of stamps, cars, guns or art, tend to have clear-cut thematic emphases and standard, external reference points in public or private collections. Thus, women's collections tend to be personal and ahistorical, men's impersonal and historical, just as, traditionally, women have tended to have a relatively greater emotional investment in people than in ideas and men to some extent the reverse.
>
> (Baekeland, 1994: 207)

This opposition of 'people' to 'ideas', however, misses the extent to which it is an ideal of systematicity itself which typically grounds the masculinist inclination to collect. Images of the stamp collector as armchair traveller or the phonecard collector as folklorist miss, in their emphasis on the object itself, the degree to which any corpus which may be differentiated in consensual ways will become the focus of collective collecting. Indeed, the most satisfying (albeit under-theorised) explanation of the masculine collector's urge is that it lays a template of symbolic differentiation over a potentially infinite range of object domains. (In this, railroad systems offer the most perfect image of the collector's object, both in the flat, geometric structure of such systems themselves, and in the fact that all there is to be collected, ultimately, are the numbers through which trains are differentiated.)

This vision of collecting leaves unanswered the reasons as to why it might be so. One explanation is that collecting works to displace the affective or corporeal aspects of particular practices (sports, music-listening) onto series and historical genealogies, in what might be seen as a fetishistic act of disavowal. Another might tie the compulsion to contextualise to

a broader male preoccupation with the subject's place within symbolic configurations of identity, a preoccupation whose links to Oedipal anxiety should be apparent. 'What motivates the purchase', Baudrillard writes of the collector, 'is the pure imperative of association' (1994: 23). These are both, it must be acknowledged, pop-psychoanalytic accounts of collecting and the compulsion to contextualise, and each is convincing only to the extent that it sheds light on the social dimensions of collecting – its role in structuring and excusing relations between men.

## WEARING KNOWLEDGES

Several years ago, film studies scholars noted that skills and knowledge have a problematic place within dominant representations of an ideal masculinity, and that there is ongoing anxiety over whether the most valorised forms of masculine mastery are social or asocial. (See, for a summary and development, Neale, 1983.) Forms of expertise acquired through deliberate labour of a bookish or achival variety are typically so dependent upon bureaucratised institutions of knowledge that they are poor supports for ideals of masculinity as transcendent strength. In Neale's words, this subservience to the terms of a symbolic order will 'threaten any image of the self as totally enclosed, self-sufficient, omnipotent' (Neale, 1983: 7). A disavowal of the social, discursive origin of such knowledges is necessary if skill is to be seen to be instinctual, the sign of 'power, omnipotence, mastery and control' (1983: 5).

The variable relations between knowledge and mastery help to generate the range of masculine identity formations which circulate within popular culture and nourish our everyday classifications. In any discussion of this range, we would do well to recall Eve Kosofsky Sedgwick's insight that positions in what she calls the 'male homosocial spectrum' have long been marked by the variable susceptibility of each to accusations of homosexuality (Sedgwick, 1990: 185). Within the peer cultures of adolescent males – groups which typically show a high involvement in popular music – the contours of public postures will be shaped to significant degrees by the possibility of such accusations. Positions in this spectrum are individuated through the ways in which the possession of knowledges is signalled in self-presentation, in 'the most automatic gesture or the apparently most insignificant techniques of the body – ways of walking or blowing one's nose, ways of eating or talking' (Bourdieu, 1984: 466). Males police themselves, not only in terms of the looseness or control which mark bodily gesture, but in the ways they 'wear' and release the knowledges they have cultivated. While the dandy, for example, manifests

a mastery of the most social of codes, the sense that his persona is frivolous or depthless, reducible to the surface on which this mastery is displayed, is the frequent basis of his denigration. Inversely, the nerd is noted for a mastery of knowledges whose common trait is that they are of little use in nagivating the terrains of social intercourse. (Indeed, nerdish dispositions are marked by their ability to turn virtually any domain of expertise into a series of numbers on a checklist.) Both the dandy and the nerd are characterised by a relationship to knowledge which is semiotically rich and easy material for parody. For the dandy, this is the result of a labour which transforms cultivated knowledges into the basis of an ongoing public performance. For the nerd, knowledge (or, more precisely, the distraction which is its by-product) stands as the easily diagnosed cause of performative social failure, blatantly indexed in the nerd's chaotic and unmonitored self-presentation.

We might add to this taxonomy (if only as the marker of an extreme position) the figure of the brute, the male persona characterised by a pure and uncultivated instinctuality. The brute shares with the nerd an obliviousness to the rules of social comportment, and, as with the dandy, there is a sense of explicitness, of little depth beyond the immediately visible. What the brute most famously suggests, however, is a strength and mastery independent of knowledges which originate and find value within the social and the symbolic. In Western popular culture of the postwar period, for the most part, the brute has not been a principal source of heroic or appealing imageries of the male. (As Sharon Willis (1993/4) has noted, with respect to the films of Quentin Tarantino, even the racist positing of certain African-American cultural figures as purely instinctual has seemed to require the interpretive gaze of a cultivated white man who is able to recontextualise such figures within popular cultural traditions.)

In popular music, ostensibly dependent upon the expression of raw, erotic energy, we might expect the figure of the brute to be prominent, but this has been the case only in isolated instances. Throughout most of the recent history of that music, the privileged masculine stances have been those which move between the immediacy of unfettered expression and the acknowledgement that a tradition or genealogy is being reworked or updated. (The postures of recent Britpop stars, marked by both libidinous laddishness and knowing references to Burt Bacharach or Ray Davies, are almost perfect examples of this ambiguity.) Indeed, an image of instinctual strength which is not informed by an awareness of progenitors or not anchored in the solidity of a canon and tradition risks appearing naive (as has often been the case with Heavy Metal performers). It is from the raw material of instinctuality, nevertheless, that the most appealing

images of a cool, hip masculinity within popular musical culture have been formed (e.g. Chris Isaac or Damon Albarn). Hipness almost always requires a knowledge which is more or less cultivated, but must repress any evidence that this knowledge is easily acquired in the mastery of lists or bookish sources. In this respect, as Andrew Ross suggests, hipness is one point in an economy which threatens to flounder on the opposed alternatives of being over- or under-informed (Ross, 1990: 83). What counts, however, is not simply the degree of knowledge but the amount of restraint with which it is deployed or guarded. The jazz musician quizzed at length about his influences by the eager fan will almost always insist that music is a question of an elusive 'feel,' even when, like Kirk Douglas in the film *Young Man With a Horn*, he carries his record collection with him from town to town. Similarly, it has long been common in the hipper circles of science fiction fandom to belittle as nerdish those who see that fandom as a cultural space in which to discuss science fiction. To actually introduce science fiction into conversation − to take the pretext for fannish intercourse as its ongoing focus − is to risk being denounced as 'sercon' (*serious* and *conservative*), someone unable to sustain effortless and generalised sociality. A familiarity with the symbolic universe of science fiction is a long-term necessity for a subcultural career within fandom, but this familiarity must be signalled in ways which do not show the marks of contrived effort.

Hipness and nerdishness both begin with the mastery of a symbolic field; what the latter lacks is a controlled economy of revelation, a sense of when and how things are to be spoken of. Hipness maintains boundaries to entry by requiring that the possession of knowledge be made to seem less significant than the tactical sense of how and when it is made public. Cultivation of a corpus (of works, of facts) assumes the air of instinctuality only when it is transformed into a set of gestures enacted across time. The stances of hip require that knowledge and judgement be incorporated into bodily self-presentation, where they settle into the postures of an elusive and enigmatic instinctuality and may therefore be suggested even when they are not made blatantly manifest.

It is within social constructions of hipness that values we might call masculinist and strategies whose effect is to reproduce social stratification interweave in interesting ways. The male club disc jockey who refrains from discussing labels and producers with a fan avoids the dissipation of his power within meshes of trivial knowledge and is thus part of a line of descent that includes the silent but effective hero of western films. However, he is also, by insisting on the instinctual and uncultivated nature of his choices, limiting access to the set of practices which are his

9

own ticket to social mobility. If the worlds of club disc jockeys or rock criticism seem characterised by shared knowledges which exclude the would-be entrant, this functions not only to preserve the homosocial character of such worlds, but to block females from the social and economic advancement which they may offer.

In general terms, it might be said that most forms of collecting are devalorised within male peer groups. They are viewed as the sign of a retreat from those realms in which patriarchal power is most obviously deployed and enjoyed. At worst, collections are taken as evidence that blocked or thwarted sexual impulses have been sublimated into lifeless series of facts or objects. At best, the distraction which characterises the collector is seen as causing an obliviousness to the implicit rules of public presentation which govern dress, gesture and bodily comportment. Collecting is an important constituent of those male character formations, such as nerdism, which, while offering an alternative to a blatantly patriarchal masculinity, are rarely embraced as subversive challenges to it.

Record collecting, nevertheless, is almost never irredeemably nerdish. While canonical forms of nerdishness take shape around domains of knowledge (such as computer science) which may only in special circumstances emerge as heroic or eroticised, there are lines of flight which easily connect record collecting to a variety of stances which are more easily recuperable. These stances include hipness which, as discussed above, may draw sustenance from those skills which the cultivation of a collection may provide. Other such stances include the connoisseurship which furnishes historical depth to musical practice itself, and through which canons and terms of judgement take shape. Record collecting also converges with those anti-consumerist ethics which tie the collector's investment in the obscure to the bohemian's refusal of the blatantly commercial. Finally, with growing frequency, images of the collector circulate which cast him as adventurous hunter, seeking out examples of the forgotten or the illicit.

## ACQUISITION AND OBSESSION

In three recent novels, men whose lives and relationships to women are in crisis take refuge within intense (even obsessive) relationships to works of popular culture. In the most well-known of the three, Nick Hornby's *High Fidelity*, the protagonist's successful passage into middle age is marked by his renouncing the secure refuge of his record shop and the system of values and homosocial relations which has taken form around it (Hornby, 1995). In Tim Lucas's novel *Throat Sprockets*, the protagonist is driven

obsessively to see, over and over again, a low-budget porn film (itself enti-
tled *Throat Sprockets*) and to seek out its makers (Lucas, 1994). In *Glimpses*,
by Lewis Shiner, a troubled man on the verge of middle age imagines that
he travels back in time to participate in the final completion of such leg-
endary unfinished albums as the Beach Boys' *Smile* and Jimi Hendrix's
*Church of the New Rising Sun* (Shiner, 1995).

At the conclusion of *High Fidelity*, the male protagonist learns that he is
now able to visit middle-aged professionals with horribly middle-brow
record collections (Peter Gabriel, Simply Red) and still finds reasons to
value their friendship. He comes, as well, by novel's end, to organise club
nights on which cover bands and disc jockeys play oldies for an ageing
audience hopelessly out of touch with contemporary music. Both these
transformations are meant to signal a (belated) coming of age, and the
signs of this new maturity are a declining interest in policing other's tastes
and the withering of the main character's commitment to anti-commercial,
connoisseurist musical tastes. As it moves towards its conclusion, the
novel becomes increasingly ironic. Changes described to us (in the pro-
tagonist's own voice) as logical adaptations to changing material or
romantic circumstances are clearly, from our vantage-point as readers, an
ageing male's strategies for survival in a cultural realm in which his place
is no longer certain.

That these changes are both conservative (a capitulation to mass, unin-
formed taste) and liberating (a release from structures of judgement which
limit social and sexual opportunity) takes us to the heart of the male
record collector's increasingly problematic political status. On the one
hand, as Eric Weisbard suggests, the record collector's obscurantist inter-
est in the marginal may be seen to be fully continuous with rock culture's
myths of oppositionality (Weisbard, 1994b: 19). To collect the obscure is
to refuse the mainstream, and, therefore, to participate in an ongoing fash-
ion in what Lawrence Grossberg has called rock culture's processes of
'excorporation', 'operating at and reproducing the boundary between
youth culture and the dominant culture' (Grossberg, 1984: 231). This
sense of rock music culture as marked by a permanent division has always
given the investment in the obscure and the margin a heroic edge, and
made of it the very foundation of rock politics.

What *High Fidelity* suggests, however, is that the only real choice is
between entry into an world of adult sexuality and responsibility and
remaining within the immature, homosocial world of the record store
where obscurantist tastes continue to appear political. Elsewhere, Eric
Weisbard notes that the wave of female alternative rockers who emerged
in the early 1990s offered 'the first version of punk we've had in ages that

11

doesn't require owning a big record collection' (1994a: 24). One effect of new movements in rock music (initiated by women and queers), he suggests, is to reveal a 'consumption-based ethic of oppositionality' as not much more than the only readily accessible political stance for the white rock musician or fan (Weisbard, 1994b: 19). Elsewhere, writing of moves to render dance music 'militant', I suggested that when the militant credibility of a cultural group can no longer be grounded in a sense of itself as political agency, it will be installed as a set of constraints or expulsions set in place against the lure of vulgarity (Straw, 1995: 252). For some time, now, the status of collecting has been caught within the dilemma discussed here and thematised within *High Fidelity*. To collect is to valorise the obscure, and yet such valorisation increasingly stands revealed as dependent on the homosocial world of young men, a world in which boundaries between the acceptably collectable and the vulgar or commercial are strengthened and perpetuated as the only available and heroic basis for political claims.

Tim Lucas's novel *Throat Sprockets* is not about records, but in its emphasis on a degraded, obscure work of popular culture which becomes the focus of a intensely private obsession, it leads us to consider the libidinal dynamic of boy-dominated trash fandoms. These fan formations have been a persistent part of Anglo-American popular musical culture for some two decades, fixing their attention on the marginal spaces of garage psychedelia, surf music and, more recently, what has come to be called Space Age Bachelor Pad Music or loungecore. At one level, the impulses behind these fandoms are directed at activities of documentation and vernacular scholarship, producing ongoing series of compilation albums, discographies and fanzine reconstructions of performer careers and historical moments. At the same time, however, the dispositions of trash fandoms depart from those of an indie rock obscurantism in that, while both privilege a notion of the culturally marginal, the former often ties this to an idea of the illicit. In the spaces of trash culture, the implicit claim runs, one finds the purest glimpses of a sexual energy or a transgressive anti-conventionalism.

In their privileging of illicit, even abject texts (such as strip-club music) trash fandoms run the risk, as Bryan Bruce has noted, of an amorality which valorises transgression irrespective of its content or purpose (Bruce, 1990). Indeed, in the current easy listening revival, the most prominent dynamics are those which diverge from the more respectable and populist anti-rockism which was one of this revival's original impulses. In place of that impulse, one finds an ongoing move to rehabilitate ever more scandalous musical currents, from the soundtracks to German porn films

12

through baroque orchestral versions of late Beatles songs. Here, as in trash fandoms more generally, collecting is refigured as anthropology, an expedition into the natural wilderness of discarded styles and eccentric musical deformations. Indeed, within the easy listening revival, the civilised sound of tinkling Martini glasses is counterbalanced by the image of intrepid explorers marching from one thrift store to another. As the editors of *Incredibly Strange Music II* note, admittedly with some irony:

> In search of amazing endangered records as well as insights as to their genesis, we interviewed not just original musical innovators (who once experienced fame), but trail blazing collectors who, without benefit of discography or reference guide, went out into backwater flea markets and thrift stores to search through that which society has discarded. Experiencing the thrill and adventure of the hunt, they made their selections and then listened for hours to ferret out exceptional recordings.
>
> (Juno and Vale, 1993: 3)

This evocative account may be seen as part of a broader history of moves which cast the spaces of popular music consumption as primitive and adventurous. Michael S. Kimmel has written about those transformations in American popular fiction which, after the turn of the century, presented the city as 'wilderness' or 'jungle' and the male inhabitant of such settings as manly adventurer (Kimmel, 1994). In the 1950s, a prominent television genre joined private investigators and the world of the jazz club (for example, *77 Sunset Strip*) , turning urbanised spaces of musical consumption into natural spaces of danger or illicit promise. Trash fandoms themselves perpetuate the sense that particular moments or spaces of popular culture (the mid-1960s, for example) will remain chaotic or unpacified, forever yielding up hitherto unimagined and possibly scandalous artefacts for the adventurer/collector. In this they depart from those fan/collector formations (such as those centring on jazz) which seek explicitly to bring order to a corpus and history of formidable scope.

In Lewis Shiner's *Glimpses*, the narrator's personal collection functions in a minor way as refuge, of the sort seen in *High Fidelity*, but the novel's more central concern is the canon, the virtual collection of unfinished albums by such masters as the Beach Boys, the Doors, Jimi Hendrix and the Beatles. Here, the narrator seeks release, not in the comfort of domestic accumulation, nor in the lure of the illicitly obscure text, but in a reassuring experience of rock history as a series of recognisable and, finally, completed monuments. Indeed, the central concern here is not

simply the composition of this canon, but the sense that rock music is principally about that canon, about completing the unfinished history of the 1960s.

The gendering of musical consumption has, as one of its most sharply-drawn axes, the relationship of record collection to canon. Elizabeth Vincentelli's claim (quoted at the beginning of this article), that new female bands are not sufficiently aware of their predecessors, signals the problematic relationship, within rock music's history, between the idea of cyclical rupture and the critical investment in the idea of a stable canon. Histories of punk which foreground its origins in socio-cultural conditions (working-class anger or art world interventionism) on either side of the Atlantic have steadily lost ground to arguments which assert the continuity of a dissident tradition beginning in the USA and running through the New York Dolls and the Ramones. In part, such arguments are about empirically verifiable patterns of imitation and communication, but they centre, as well, on the manner in which punk was to be heard.

One way to hear punk, of course, was as the centre of new relationships between the cultural spaces of art, fashion and music, and to pursue these threads of dissemination and influence outwards to their respective destinations. As a means of building a context for punk, this road was highly likely to encounter female figures or feminist practices, and offer a diminished view of the importance of specifically musical ancestors. The other way meant being sent back to investigate a whole series of progenitors of punk, buying Velvet Underground or New York Dolls' albums and building a collection which embodied the transformed rock canon inaugurated in the late 1970s. This was the road mapped out, in the late 1970s, in such publications as *New York Rocker*. In a debate long posed as one between those who held to a theory of spontaneous working class uprising and others who held to the idea of a steady, imperceptible weaving of trans-Atlantic influences, the latter position would always seem more historiographically comfortable. Over time, nonetheless, the debate over the sources of punk has become a debate about influences (British pub rock versus downtown New York punk) rather than the status of specifically musical influences, each side offering its canon of forebears to be added to a representative record collection.

## CONCLUSION

Just as I began writing this article, I was interviewed by the maker of a National Film Board of Canada documentary on 'nerds'. (I was chosen, the director assured me, as an 'expert' and not as a case study.) The film was

inspired, in part, by the sentiment that the nerds of youth are the Bill Gates of adulthood, and that, in the interests of long-term economic stability, the social pressures exercised upon the young should nourish nerdish sentiments rather than work to repress them. From a perspective which locates the most harmful forms of masculinist power in blatant displays of physical or technical prowess, the nerd may well seem an enlightened frog awaiting the kiss which will turn him into a cool and suave prince of the post-industrial economy.

And yet, it might be argued, the nerdish homosociality of those who collect popular music artefacts is as fundamental to the masculinism of popular music as the general valorisation of technical prowess and performative intensity more typically seen to be at its core. Eric Weisbard has noted, in connection with the rise of alternative rock after 1991, that '[r]ock stars no longer make a pageant of their power, as modesty and constant allusions to unknown underground bands become required decorum' (Weisbard, 1994b: 17). At one level, this suggests a historical change, as semiotic competence in reading the state of the musical field comes to assume greater importance, within musical culture, than the public display of technical mastery. At a more conspiratorial level, this account might be taken as describing the successful adaptation of rock music's masculinist impulses to an era of sampling or niche market obscurantism. Interviews with contemporary female rock musicians frequently describe how, having learned to play guitars and play them loud, women find that the lines of exclusion are now elsewhere. They emerge when the music is over, and the boys in the band go back to discussing their record collections.

## ACKNOWLEDGEMENT

As always, I owe an enormous debt to Keir Keightley, for incisive ideas, ongoing and productive debate and tips as to sources. Conversations with David Galbraith and Graciela Martinez-Zalce, as we drove from one record store to another during their visits to Montreal, helped me develop many of the ideas here. The ongoing research out of which this article grows has been financed in part by grants from the Fonds pour la Formation de Chercheurs et l'Aide à la Recherche (Quebec) and the Social Sciences and Humanities Research Council of Canada. Small portions of this article have appeared in Straw (1995).

15

# REFERENCES

Baekeland, Frederick (1994) 'Psychological Aspects of Art Collecting', in Susan M. Pearce (ed.) *Interpreting Objects and Collections*, London: Routledge, pp. 205–19.

Baudrillard, Jean (1994) 'The System of Collecting', in John Elsner and Roger Cardinal (eds) The *Cultures of Collecting*, Cambridge, MA: Harvard University Press, pp. 7–24.

Baym, Nina (1985) 'Melodramas of Beset Manhood: How Theories of American Fiction Exclude Women Authors', in Elaine Showalter (ed) *The New Feminist Criticism: Essays on Women, Literature, Theory*, New York: Pantheon Books.

Belk, Rusell W. and Wallendorf, Melanie (1994) 'Of Mice and Men: Gender Identity in Collecting', in Susan M. Pearce (ed.) *Interpreting Objects and Collections*, London: Routledge, pp. 240–53.

Bourdieu, Pierre (1984) *Distinction: A Social Critique of Judgement*, trans. Richard Nice, Cambridge MA: Harvard University Press.

Bruce, Bryan (1990) 'Right Wing Chic: Adam Parfrey and R. Kern Fingered!!' *CineAction* 19/20 (May): 3–10.

Grossberg, Lawrence (1984) 'Another Boring Day in Paradise: Rock and Roll and the Empowerment of Everyday Life', *Popular Music* 4: 225–58.

Hornby, Nick (1995) *High Fidelity*, New York: Riverhead Books.

Juno, Andrea and Vale, V. (1993) 'Introduction', *Incredibly Strange Music* (San Francisco: Re/Search Publications) 1: 2–5.

Keightley, Keir (1996) '"Turn it Down!" She Shrieked: Gender, Domestic Space, and High Fidelity, 1948–1959', *Popular Music* 15(2): 1–28.

Kimmel, Michael S. (1994) 'Consuming Manhood: The Feminization of American Culture and the Recreation of the Male Body, 1832–1920', *Michigan Quarterly Review* 33(1) (Winter): 7–36.

Lucas, Tim (1994) *Throat Sprockets*, New York: Delta.

Medovoi, Leerom (1992) 'Mapping the Rebel Image: Postmodernism and the Masculinist Politics of Rock in the U.S.A.', *Cultural Critique* 20 (Winter): 153–88.

Moore, Rob (1993) Liner notes to the CD album *Here's to the Lovers*, by the group Love Jones, Toronto: BMG Music.

Neale, Steve (1983) 'Masculinity as Spectacle', *Screen* 24(6) (November–December): 2–16.

Ross, Andrew (1990) *No Respect: Intellectuals and Popular Culture*, London: Routledge.

Sedgwick, Eve Kosofsky (1990) *Epistemology of the Closet*, Berkeley and Los Angeles: University of California Press.

Shiner, Lewis (1995) *Glimpses*, New York: Avon Books.

Straw, Will (1995) 'The Booth, the Floor and the Wall: Dance Music and the Fear of Falling', in Will Straw, Stacey Johnson, Rebecca Sullivan and Paul Friedlander (eds) *Popular Music: Style and Identity*, Montreal: The Centre for Research on Canadian Cultural Industries and Institutions/International Association for the Study of Popular Music, pp. 249–54.

Vincentelli, Elisabeth (1994) Letter excerpted in 'Year of the Woman' Music Supplement, *Village Voice* 8 (1 March): 24.

Weisbard, Eric (1994a) Letter excerpted in 'Year of the Woman' Music Supplement, *Village Voice* 8 (1 March): 24.

Weisbard, Eric (1994b) 'Over & Out: Indie Rock Values in the Age of Alternative Million Sellers', *The Village Voice Rock & Roll Quarterly* Summer: 15–19.

Willis, Sharon (1993/94) 'The Fathers Watch the Boy's Room', *Camera Obscura* 32 (September–January): 42–73.

# 2

# MEN MAKING A SCENE

## Rock music and the production of gender

### Sara Cohen

## INTRODUCTION

In 1996 two Liverpool bands, the Lightning Seeds and Cast, were nominated for 'best band' and 'best new band' categories in the annual Brit Awards. Each year the bands nominated for these categories are predominantly male. This situation is not particularly surprising and is usually taken for granted. Within Euro-American cultures there tends to be a general assumption that rock music is male culture comprising male activities and styles. Women, meanwhile, tend to be associated with a marginal, decorative or less creative role, hence the common stereotypes of glamorous women who act as backing singers for male groups or feature on their videos and other merchandise, and girls as adoring fans who scream at male performers.

This chapter dismisses the idea that rock is naturally male, or that it reflects or expresses a pre-existing male culture. Rather, it seeks to understand and explain how and why rock is actively 'produced' as male. It does so by situating bands like Cast and the Lightning Seeds in relation to the local music 'scene' in which they are located, a scene based around guitar-oriented bands performing so-called 'indie' style rock music.[1] The term 'scene' has been adopted because it is commonly used by music-makers and audiences in Liverpool and elsewhere, and because I particularly want to highlight the spatial, 'scenic' aspects of rock music in Liverpool, and to draw upon the dramatic sense of scene as public performance. I have tried to outline general characteristics of the scene whilst also raising examples of specific groups and situations. The chapter will suggest that rock is produced as male through the everyday activities that comprise the scene; through the sensual, emotional aspects of the scene; and through the systems of ideas that inform the scene, including the contested concept of

17

'scene' itself. It emphasises the contradictions and complexities of this process, and the way in which it is shaped and constrained by specific relationships and institutions, situations and circumstances.

## SCENE ACTION

The 'indie' rock scene in Liverpool is dominated by men. The vast majority of musicians are men and most of the several hundred or so bands are all-male. Of the minority of women musicians involved, most are singers and there are perhaps one or two all-women bands. Liverpool 'indie' rock bands usually comprise four or five musicians on drums, bass guitar, lead guitar and sometimes keyboards, most of whom are white, working-class men in their 20s and 30s. Many began performing in bands before they were in their teens, and older musicians have spent much of their lives in or in between bands. Hence for most, being in a band is a way of life. At the time of writing (May, 1996) the Liverpool bands attracting the most commercial success are Cast, Space and the Lightning Seeds. All three have recently been in the Top 20 of the UK charts. Besides one female session musician who plays keyboards with the Lightning Seeds, all the musicians involved are men. Within the local scene audiences for indie rock bands are also predominantly male. Audiences for lesser-known bands tend to be disappointingly small, largely comprising friends and relatives of the bands' members and other local musicians. The number of women varies according to the venue or the style and notoriety of the band performing.[2] ln 1995, for example, Space performed at a Liverpool venue called the Lomax to a small, largely male audience. A year later, after some chart success, they performed in a larger local venue to an audience about ten times the size which was over one-third female and had a large student component.

Besides musicians and audiences Liverpool's rock scene consists of a diverse set of small businesses and organisations that are often just one or two-person operations. Many are involved with band management and some with live music performance, although there are no really large venues or arenas aimed at rock and pop music, but there are a few medium-sized and smaller ones (e.g. the Lomax which has a 200–300 capacity), and some clubs, pubs or bars that occasionally put on local rock bands. Others are concerned with music as a recorded medium, although the recording industry is overwhelmingly concentrated in London where the major record, publishing, manufacturing and distribution companies are based; with music retail, selling instruments, recorded products or other music-related merchandise; and with music education and training,

advice and information. There are also a few disc-jockeys and journalists who broadcast music by local bands or write about them for local publications. Cast, Space and the Lightning Seeds are all signed to London-based record companies, but the management companies of Cast and Space are based in Liverpool, and the Lightning Seeds have their own studio in Liverpool which is situated in the same building as the management of Space. Other music-related businesses also rent rooms in this building which is run by a company called Liverpool Music House, a company that is involved with music management and production and runs a second studio in the building (recently recorded in by Space). However, the local music industry is not particularly large or profitable and its businesses tend to be unstable and short-lived. Again, the vast majority of those running local music businesses are working-class men of varying ages, most from a background of performing in bands. In 1989, 289 people working within this local industry were surveyed and only thirteen of them were women, six of whom worked in music journalism (Cohen, 1991b, 1991c).

The people involved with the scene are engaged in many different kinds of musical activity, all of which involve established conventions of male and female behaviour. With regard to learning, for example, many local rock musicians, including those based at Liverpool Music House, learned to play their instruments at home under the influence of male relatives, with few learning in school where younger musically active pupils are usually girls (Finnegan, 1989: 203). Some are engaged in such activities most of the time. Others participate in the scene on a more occasional or temporary basis, and many participate in other local scenes, blurring the boundaries between them. Motivation for participation in the scene varies but usually combines social, artistic and economic factors, with music offering a particular lifestyle and social network, but also a promise of artistic and financial success. For most musicians and managers their overwhelming ambition is to 'make it' with their band, signing a contract with a major record company in order to reach wider audiences and achieve success. Much time and effort is spent chasing 'the deal' and establishing and maintaining relations with 'A&R men' who work in the Artist and Repertoire departments of London-based companies.

Elsewhere (Cohen, 1991a) I have described the struggles and tensions involved in this quest for success. Close relationships develop within and between bands, for example, with many describing their band as a 'family', yet the strength of such relationships is also accompanied by marked rivalries between bands and internal divisions that frequently cause bands to break or split up. The scene as a whole is often described as fragmented, yet it also involves considerable collaboration. It comprises,

for example, an informal economy involving reciprocal relations within networks of businesses, musicians and fans. Through such relationships knowledge about music and the music scene is generated. Shank (1994: 120) points out that simply knowing about a particular venue, group or event marks the boundary between being inside or outside the scene. For some in the scene the accumulation of such knowledge is a major pre-occupation, and Straw (1990) has referred to 'the cultivation of connoisseurship in rock culture — tracking down old albums, learning genealogical links between bands and so on', describing this obsessive accumulation of facts as a male concern, 'one of the specific mechanisms through which women have been excluded from rock culture over the last decade . . . one rite of passage through which the masculinism of rock-music culture has been perpetuated' (see also Hornby, 1995).

The scene thus comprises predominantly male groups, cliques or net-works engaged in activities shaped by social norms and conventions, through which they establish and maintain relationships with other men. Liverpool Music House, like many institutions within the local music industry, is largely frequented by men who refer to each other by nick-names, use technical and in-house jargon and share the jokes and jibes, the myths, hype and bravado surrounding bands and band-related activity. In addition they regularly circulate and exchange information, advice and gossip; instruments, technical support and additional services; music recordings, music journals and other products.[3] Social networks such as these extend out of the local scene to national and international scenes and industries, maintained through face-to-face interaction and communication technologies.

The simple fact that the relationships, networks and activities that com-prise Liverpool rock culture are predominantly male works to exclude women from music creativity and collaboration. In addition, the scene is concentrated around the city centre and many of its venues (including Liverpool Music House and the Lomax) are situated in narrow back streets around and behind the main city centre thoroughfares. These are areas that many, particularly women, might feel uncomfortable venturing into at night, and large areas of the city centre tend to be quite deserted on most nights of the week, despite recent efforts to animate the centre and attract people in. City centres are commonly associated with male crime and vio-lence, and many have pointed out women's exclusion from them despite attempts to 'reclaim' them. Some women may also be deterred by the scene's daily and weekly rhythms. Visit Liverpool Music House early one evening and the hallway may be stacked with equipment waiting to be loaded into the Lightning Seeds' van for their next performance on a brief

UK tour. In the studio upstairs another band might be getting ready for an all-night recording session, while a couple of engineers or tape-operators are taking a tea break in the kitchen. Elsewhere in the building people might be dropping in and out of various offices, although the manager of Space will probably be ringing into his office on his mobile phone en route to or from London, whilst others are out at meetings elsewhere in the city. Some will finish work early, but most will work late before going for a drink or meeting up later on at the Lomax. Such regular routes and routines tend to be structured by and for men, and for those (particularly women) with childcare responsibilities, the touring, travelling and late-night activities involved can pose problems.

Liverpool rock music is thus created apart from women, although relationships between men in the scene are strongly influenced by their relationships with women. For some men involvement in the scene might offer close and intense social interaction and male companionship free from the pressures of relating to women; for others music promises status, identity, success and the possibility of attracting women; for many music represents an escape or retreat from women and a way out of domestic obligations, and many come from backgrounds where the division of labour between men and women is marked and single-sex leisure activity commonplace. Women are thus very much present in the scene despite their absence.

Focus on the domestic and kinship networks of these musicians rather than on those between the musicians themselves, and women's importance to the scene and to the production of local rock music is further highlighted. Involvement of men with the scene's bands and businesses frequently depends upon financial and other support received from friends, relatives and partners, many of whom are women. Without such support a business like Liverpool Music House would not survive, but even a successful musician like the singer of the Lightning Seeds relies on his wife to help take care of the band's financial accounts. Women's role in supporting, encouraging and facilitating music activity has been noted by Wilmer (1977) in relation to jazz, and by Finnegan (1989: 315) who emphasised the co-operation of both men and women within most music genres, 'Despite the imbalance of male and female in many groups and the gender constraints on certain activities'.

Shift focus again, however, to consider the activities and relationships of the women themselves, and women appear more active than supportive. Folk and media images commonly portray Liverpool women as outspoken and sharp-tongued, as coping while their husbands are away at sea, and taking charge of family and home (the latter commonly referred to as 'me

mum's'). Certainly many Liverpool women have different priorities and responsibilities than men that restrict their participation in rock music scenes (domestic duties for example – see Bayton, 1990), but they also tend to have different social and leisure interests, suggesting that they are not just discouraged from involvement with rock culture, but that they might not even need or want it. Meanwhile, women musicians and audiences who do participate in the scene play a creative and visible role in producing it. Feminist writers on music have focused on the activities of such women who have been ignored, marginalised or excluded in previous accounts of rock and pop. They have pointed to musical strategies specific to women, questioned assumptions about rock as male culture, and critiqued existing popular music theory, highlighting masculine conventions that were previously taken for granted or treated as the norm, and revising previous rock histories, accounts and theories in order to bring issues of gender and sexuality to the fore (see, for example, Bayton, 1992; McClary, 1991; Garratt, 1990; Lewis, 1990; Wise, 1990).

Nevertheless women are in many ways actively excluded from Liverpool's indie rock scene. The conversation within the scene's male networks, for example, is frequently 'insider-ish', involving nicknames, in-jokes and jargon that discourage women newcomers from joining in, and it is often sexist. In the everyday conversation of male band members women are often treated as objects of sexual desire, conquest or derision, or linked with the domestic sphere of family and home. Some men at Liverpool Music House describe problems they have had with women temporarily based there on work experience placements. They suggest that the women differ from male employees in terms of their priorities, interests and ambitions, but they and the women also mention problems concerning the attitudes of male staff and customers, their sexist banter, and the one or two men who continually make sexual advances towards the women.[4] In addition, women are often perceived by male musicians within the scene as a threat to their relationships with other men in the scene and to their creativity. Female partners of male band members, for example, may be seen as a threat because they are likely to make demands that direct a musician away from the band, because their presence disrupts the pattern of interaction established between the men, and because they are associated with the home, domesticity, conventionality and the responsibilities of life outside rock culture (Cohen, 1991a). Meanwhile women musicians in Liverpool complain about derogatory attitudes towards them expressed by the scene's men, and the fact that they are generally not taken as seriously as men musicians (see Cohen, 1991a).

Gender relations within Liverpool's rock scene are thus shaped by

various local and national institutions and organisations. There are the scene's own music institutions where a male culture and atmosphere usually predominate. This includes recording and rehearsal studios (see Cohen, 1991a), and music instrument and record shops which are largely staffed and frequented by men.[5] Independent record shops, for example, play a unique and important role in Liverpool's rock and dance scene, and within them it is men who tend to serve behind the counter or crowd around it discussing and exchanging recordings and releases, who browse around the shop looking at records and clothes (many sold in men's sizes only), and who breeze in and out with fliers, posters, etc. (Meanwhile, large national retailers like HMV and Virgin are more mixed in terms of male and female staff and customers, whilst according to the Goldring Report on the music industry (BBC2, 1995), the industry associates the record divisions of Woolworths and W.H. Smith's with women shoppers.) In addition, access to the music venues of these scenes is usually determined by male 'bouncers', and within these venues further spatial and gender divisions emerge. Fonarow (1995), for example, describes how men and women typically situate themselves in different parts of a venue at live performances of British indie bands, whilst Leonard (Chapter Thirteen this volume) highlights efforts made within the riot grrrl movement to confront and reverse this order.

Gender relations within the scene are also shaped by other important institutions such as those of the family, community and school (see Green, forthcoming, on the latter). Most of those within the scene are from working-class families and cultures where male and female roles and images are clearly defined and intolerance often expressed towards those who transgress the boundaries. It is not just the performers like Pete Burns from Dead or Alive and Holly Johnson from Frankie Goes to Hollywood who have described the hostility they encountered in Liverpool for their flamboyant appearance and sexuality. Other male musicians who have adopted a slightly hippy or punk style of dress have also told of being thrown out of Liverpool clubs and pubs or attacked verbally and physically in the streets. The behaviour of men and women in Liverpool, and the sexual division of labour between them, has been considerably shaped by the city's position as a port. The port was a major employer within the city, recruiting a largely (though not totally) male, casual and unskilled labour force. Port activity has declined over recent decades and the rate of local unemployment is high, but the port promoted male and female activities and images that still have considerable influence on the city's social and cultural life (the city's masculine image, for example, associated with its sailors and dockers – see Lane, 1987). Music-making was popular with

many men away at sea or at home in between jobs as a way of passing the time or earning extra income. Many women, meanwhile, took primary responsibility for the day-to-day running of family and home, or were engaged in more secure factory employment.

Gender relations within the scene are at the same time influenced and shaped by local and national government policies, some of which may be aimed at men (e.g. some criminal and funding policies), and some at women (e.g. those designed to encourage community access to the scene); by the national and international music industry with its strong sexual division of labour (see Negus, 1992; Frith and McRobbie, 1990; Garratt and Steward, 1984); and by the wider national and international rock 'world' with its own unique set of practices, conventions and institutions (see Finnegan, 1989). Rock music journals, for example, may be aimed at predominantly male or female readers, with trade magazines and journals such as the NME discussing the music and the technicalities of its production for a predominantly male readership, and magazines aimed primarily at young girls paying more attention to the personalities and appearance of rock 'stars' (see Frith and McRobbie, 1990; Théberge, 1991).

So far I have presented a broad sketch of the people, institutions and activities that comprise and influence Liverpool's rock scene. Through relationships between men, women and men, and women the scene has been shown to be socially and actively produced as male, a process shaped by local and national conventions and institutions. The scene is also, however, a sensual experience, and the following section of the chapter will consider some of the sounds, images and feelings created within it, discussing later on in the chapter how they are associated with ideas and meanings concerning gender.

## SENSUAL SCENES

Liverpool's rock scene has its own particular sounds and even soundscape that distinguish it from other music scenes within the city. These include the repetitive beats of instruments being miked up and mixed at the start of a sound recording session; the noise of the soundcheck before a live public performance; the public address system set to produce a bassy reverberation with a heavily amplified drum kit; the background hum of audience members around the bar, their shouting and heckling during the performances, and the half-hearted clapping in between songs or the shouts for more at the end of the performance. That such sounds are usually produced by men has already been established.

Meanwhile the scene's musical sounds reveal a broad and diverse range

of influences drawn from national trends and from music of other places and times, but they also reflect to a certain extent the social and economic characteristics of the scene and of Liverpool, resulting in familiar sounds and styles that might be described as guitar and sometimes keyboard based; of medium/slow tempo; featuring a strong emphasis on song and melody rather than rhythm and dischord, and a relatively high-pitched male vocal characterised by thin, reedy or nasal tones, the distinctiveness of which may be partly attributed to the Liverpool accent and vernacular with its recognisable styles of intonation, pronunciation and phrasing. This so-called 'Liverpool Sound' has been associated with various local bands, particularly the Beatles, Gerry and the Pacemakers and other Merseybeat bands of the 1960s, China Crisis and Echo and the Bunnymen of the 1980s, and the Lightning Seeds and Cast of the 1990s. It also, as will be discussed later, signifies particular types of masculinity. Yet there are, of course, numerous distinctions within, and deviations from, this general category. For example, the simple guitar melodies favoured by most of the aforementioned bands contrast with the quirky or rhythmic sounds of more theatrical Liverpool bands, such as the flamboyant and camp Frankie Goes to Hollywood and Dead or Alive, the comic and eccentric Mel-O-Tones, or Space, whose press reviews use terms such as 'mad', 'zany', 'weird', 'bizarre' and 'freakish' to describe band, music and lyrics.[6] The reviews stress that although Space may look like a lot of other contemporary bands their music is very different, involving use of samples, keyboards, dance rhythms and rap as well as melodic pop, and Space are of course themselves keen to distinguish their music from that of their Liverpool contemporaries.

The scene also has its own look or visual 'scenescape'. Buildings associated with it are often old and in a state of disrepair. Such buildings are a familiar sight in Liverpool but, as those involved with the scene continually point out, venues for live rock performance are particularly dark, dingy and generally inadequate. This doesn't help to attract audiences and many men, and perhaps particularly women, prefer instead to frequent the city's dance clubs which feature balconies and central dance areas and are designed for looking, being seen and for displaying sexuality. The rock venues, on the other hand, are largely designed for looking at the band lit up on stage, although most have a separate bar area where audiences congregate before and after the performance. Many local musicians regularly frequent these bars in order to mingle with others involved with the scene and in order to be seen to be part of the scene. In the Lomax the walls around the bar are covered with photographs of bands that have performed there – particularly local bands, creating an impressive black

and white display of men. The other walls, like many of the scene's interiors and exteriors, are decorated with posters advertising band performances.

To some extent the scene also has its own visual style, but again it is difficult to generalise, with local styles of dress, body adornment and display heavily influenced by national and international trends. For over a decade, however, many musicians and audiences involved with Liverpool indie rock bands have adopted a casual, 'scally'[7] style of dress, a style associated with the so-called 'Britpop' scene of the mid-1990s involving training shoes, baggy trousers, football shirts, long floppy fringes, and jackets in a sports style or a 1970s style of suede or leather. Members of Cast, Space and the Lightning Seeds dress in this style which conveys an image of spontaneous, heterosexual lads-off-the-street and the male camaraderie of the football crowd. There are, however, subtle stylistic variations. The lead singer of Cast, for example, holds his guitar tight up to his chest rather than slung lower around the stomach or pelvis, in a manner that conveys a youthful fragility and earnestness which is enhanced by the clarity of his voice and by the way he stretches his neck up to the microphone. It is very different from the dark glasses and fairly motionless, moodier pose of the Lightning Seeds' singer, and from the more boisterous jocularity conveyed by Space. These sounds and images have been created and shaped through interactions within the bands and through their relationships with family and friends, managers, producers and record companies (with the ideas and priorities of the latter often taking precedence).

Meanwhile the lyrics and visual graphics of bands within the scene also vary considerably. The graphics for the Lightning Seeds' recorded products and live performances are colourful and comic-book or fairytale in style. The album *Sense* features an impression of outer space with spaceship motifs, whilst *Jollification* features large red strawberries floating in a blue cloudy sky, with singles from the album featuring variations on this theme. The main lyrical themes of these albums include deceit, lack of control, uncertainty, loss and a wistful dreaminess involving numerous references to sky and space, and a sense of blocking out or escaping from the world. At the time of writing, however, the band is at Number 1 in the national charts with a song written for the Euro '96 football championships. The singer's love of football has been well documented in the press, and the video that accompanies the song features him and his co-performers as football 'lads' drinking in the pub, watching football on the television and playing football in the park.

The video that accompanies the latest single from Space, entitled 'Female of the Species', features beautiful and gigantic women dancing in a

seductive manner on a screen behind or to one side of the band. Black and white backdrops are used to mark the divide between the women and the band, and stylistically the video evokes the title sequences of James Bond films and television's *Tales of the Unexpected*. The song repeats the lines: 'The female of the species is more deadly than the male', and other lines elaborate upon the threat of the female, linking her with witchcraft and domination.[8] The artwork used to market and publicise this song features the members of the band bound together by thick rope, whilst circling them are the faces of beautiful women. The image bears some similarity to illustrations for the band's previous singles, both of which feature the band trapped in a confined space and under threat. One shows the band standing inside a glass honey jar staring at some bees circling around them. The empty jar is featured on the reverse of the sleeve with both honey and band gone. Another shows the band members huddled together gazing up at the camera and surrounded by a circle of front doors, behind which the shadowy forms of the occupants loom ominously. Meanwhile Cast's lyrics have a rather a grandiose feel. Their first album is entitled *All Change* and the lyrics address 'history' and the 'future' in relation to 'mankind' and 'the world', and religious terms and references frequently appear. Many songs suggest a struggle to escape and 'break free', to achieve control and attain a better future, and again there is a strong sense of being trapped, confused, helpless, betrayed and deserted.

The scene is also a physical and emotional experience. Liverpool's famous Cavern Club of the 1960s was demolished, but at the Beatles museum in Liverpool they have tried to recreate it and evoke its sweaty atmosphere and heaving crowd. Fonarow (1995), Laing and Taylor (1979) have highlighted the intimate physical contact, particularly male–male body contact, of live rock gigs, and Shank (1994: 125) emphasises the kinetic qualities of the scene as a whole. The '"physical expression of having a good time"', he writes, 'is an integral component of experience in the rock 'n' roll scene.' 'The necessary conditions for the development of a scene', he suggests, are 'a situated swirling mass of transformative signs and sweating bodies' (1994: 128). Certainly live performances play an important emotional and physical role in Liverpool's rock scene, and within the scene concepts such as 'buzz', 'vibe' and 'high' are used to try to convey the intensity of the experiences invoked. Live performance is thus central to concepts of the scene, and it is at live performances that the scene is literally embodied and made more visible and real.

The quality of the sensual experiences produced at such performances is dependent, however, upon a variety of factors, including not just the

musical performance, but the interaction between musicians and audiences, and the layout, acoustics and facilities of the venue. Consequently, performances are often disappointing experiences (see Cohen, 1991a). There are too few people, or people stand too close and intrusively, placing mouths against ears to shout loudly and inaudibly, or clumsily bump against each other spilling beer that is slippery underfoot and smells too strongly. 'Today', says the singer of the Lightning Seeds, 'gigs have become places where it's crap to be [with] . . . crap drinks and warm beer' (personal communication). At some gigs, however, there can be quite a crowd with good music, a smokey and relaxed atmosphere, and band and audience in good voice and humour. Such occasions can raise the spirits of the participants, producing within them excitement or a warm sense of well-being and sociability. Occasionally people even dance, but usually it is women who initiate the dancing and dance with other women, although one or two local bands have male fans that cluster together in front of the stage and engage in more boisterous movements. Very rarely do women and men dance together as couples or in groups. The scene's sounds, images and experiences are thus produced through activities and relationships that involve established conventions of male and female behaviour, and in the next section I want to discuss some of the ways in which they, along with the scene itself, are linked with ideas, meanings and values concerning men and women, male and female, masculine and feminine.

## SCENE IDEOLOGY

Within particular social and cultural groups music signifies collective ideas, images and meanings, some of which concern gender. Particular instruments, sounds, structures and styles may, for example, connote male or female stereotypes (see, for example, Bayton, 1990; Tagg, 1990; Shepherd, 1987; Green, 1997), and in Euro-American cultures rock music has commonly symbolised masculinity.

According to Frith and McRobbie (1990: 372): 'Some feminists have argued that rock is now essentially a male form of expression, that for women to make non-sexist music it is necessary to use sounds, structures, and styles that cannot be heard as rock.' Walser (1993) has shown how heavy metal musicians 'forge' masculinity through their use of particular instruments, sounds, lyrics and visual performance styles, such as the electric guitar, use of feedback, black leather or denim stage clothes, and a rasping, throaty singing voice, all of which can be recognisable symbols of male power. Heavy metal doesn't necessarily reflect any real power on the part of the men involved in making or listening to the music. Rather,

it presents a spectacle of male power and offers a musical means through which men can demonstrate their manhood. Walser highlights the existence of several masculine types within heavy metal, all of which express different types of control over women. Musicians involved with Liverpool's indie rock scene tap into these and other symbols of male power, but indie rock is generally characterised by an alternative range of masculinities.

The sounds produced by bands like Cast, Space and the Lightning Seeds suggest a masculinity that is rather soft, vulnerable and less macho, aggressive and assertive, less threatening or explicit than that promoted by many styles of heavy rock and metal, rap or funk. The lyrics convey a similar impression, covering a broad range of themes and issues but suggesting a fragile masculinity – men who are lost, confused and betrayed. Such lyrical and musical themes are common to many styles of rock music and the image of vulnerable men threatened by seductive women is a familiar one, although vulnerability is expressed here not only in relation to women. The lyrics relate to the musical sounds and structures in interesting and important ways. The lead vocals, for example, give the lyrical themes a particular slant, whether through the up-beat singing style of Space which can suggest cheekiness or irony; the slightly extended and distorted vowels of Cast that tend to convey a yearning rather than an arrogant sneer; or the rather frail vocal tones of the Lightning Seeds that emphasise a sense of wistfulness and isolation in the lyrics.

Yet such musical meanings are not fixed but open to interpretation. According to Walser (1993: 130), for example, male fans of 'harder' styles of heavy metal have often denounced glam metal with its fusion of male and female images and its suggestions of homosexuality, pointing out that 'real men don't wear make-up'. Meanwhile other fans, particularly women, have defended glam performers by praising their musical abilities, emphasising the intensity of the experience they provide, or by simply admiring their 'guts'. However, whilst it may be possible to identify typical male or female interpretations of music due to a sharing of conventions and experiences within certain male or female groups, interpretations are at the same time influenced by the life histories of individual listeners, by the media and other social institutions, as well as by specific performance or listening events, situations and circumstances. The music media play a particularly important role in guiding consumers towards particular meanings, describing and assessing music and musicians in ways that commonly involve reference to well-established gender stereotypes or assumptions, and that reinforce inequalities between men and women within local music scenes. One review of Space, for example, stated that the band they were performing with could be 'easily dismissed

as another girl-fronted indie group' (*Vision* 15 May 1996) as if there were already too many such bands, or as if having a 'girl' singer was a well-worn gimmick, thus illustrating how different ideas and values may be attached to the music according to whether it is created by men or women.

All of this indicates that ideas about gender are not fixed or universal but fluid and situational, and the different meanings attached to terms such as 'man' and 'woman', 'masculine' and 'feminine', 'male' and 'female' emphasise the fact that these are not biological but social categories, one of the many ways in which people and their bodies and behaviour are classified. The music of Liverpool's indie rock scene is thus not naturally or essentially male as if its musicians were born to create music in a par-ticularly male way, or as if musical sounds and lyrics directly reflected biological male characteristics, despite popular beliefs to the contrary (hence notions of women's or men's music). The music does, however, contribute to the continual process through which categories of men, male and masculine are produced, contested and redefined, and rock and pop have typically involved exploration of both behaviour and ideas concern-ing gender and sexuality. The Liverpool scene reflects and reinforces conventional gender relations and masculinities, but it also offers, within certain constraints, the possibility to explore alternative male behaviour and identities that challenge or subvert existing conventions.

In a number of ways the Liverpool indie rock scene involves a produc-tion of contradictory masculinities. The vulnerability that musicians express through their musical stage performance, for example, contrasts with a more assertive celebration of masculinity within the scene. The scene is attributed by many, for example, with masculine characteristics linked to male rivalry and competitiveness, fragile male egos, male aggression and ambition. Its history is constructed around a male lineage, canon and legacy,[9] and the myths, tales and narratives that play such a central role in constituting it are full of male bravado and help reinforce male comrade-ship and collectivity. The masculinity of the scene is influenced by a more general rock ideology. Within that ideology, for example, rock is commonly associated with 'the street' and opposed to the bedroom. The street, like 'the road', is associated with live performance, male activity and rebellion, and with public spaces that women are not supposed to fre-quent, whilst the bedroom is associated with the consumption of recorded pop music and with women, passivity and private domestic spaces. The familiar pop/rock opposition and the common tendency to associate women with the former and with mass commercial entertainment, and men with the latter and with the alternative and authentic, has been

highlighted and critiqued by several writers (see, for example, McClary, 1991; Thornton, 1995; Bradby, 1992). This ideology informs the way in which spaces within Liverpool's rock scene are imbued with meaning and attributed moral value involving ideas about how men and women ought to behave. Women who 'hang out' in Liverpool rehearsal or recording studios, for example, are likely to attract attention and jokes about 'groupies', the assumption being that they are there primarily for sexual reasons. (The studies of women musicians and audiences mentioned earlier challenge such associations by emphasising women's visible, active and influential role in rock and pop, and female rebellion and empowerment in rock and pop.)

## POWER AND PERFORMANCE

Liverpool's indie rock scene is thus about male freedom and domination, but also about powerlessness and constraint. For many men rock music and the local rock scene might seem a potential source of power that as a group they might want to control. The scene is, for example, an important social and and cultural resource. It may seem a cliché, but in Liverpool involvement with rock bands is an attractive option for men, and an alternative to unemployment or monotonous, unfulfilling jobs in a city surrounded by a discourse of failure. The scene offers a social life, a sense of purpose, and dreams and aspirations outside any restrictions or responsibilities of work, family or home. It becomes an important source of individual and collective identity, and a means through which men can explore relationships with other men or relationships with women within the security of male groups. Rock music is also a source of status and prestige, involving instruments, images, poses, etc. that have come to symbolise male sexuality and power, and it is a powerful emotional resource in that through rock music men can express ideas and sentiments in a manner that is discouraged in other public settings. In addition, the music is a potential economic resource. Live performance can occasionally be a means of earning extra income, but the recording industry is also one of the UK's most valuable export industries and its star performers amongst the richest men in Britain.

Liverpool rock music is also, however, about male powerlessness and insecurity. Being on stage in public is in some ways a vulnerable and exposed position that often involves performance of music and lyrics of a private and personal nature. In fact many local musicians state that when they were younger they were described as 'cissy' by their male peers if they indulged in any kind of music activity in or out of school (see also

Finnegan, 1989: 315; and Green, 1997), and McClary (1991: 151–2) has suggested that through its links with the emotions and with the body rather than the mind, music has come to be associated with femininity, which makes men even more keen to exclude women from music-making in order to distance themselves from such associations as far as possible.

In addition, the UK recording industry could be characterised by competition, instability and inequality, and it is overwhelmingly concentrated in London which can make it difficult promote bands and music businesses successfully within the regions. At the time of writing both the Lightning Seeds and the management company of Cast are about to leave Liverpool and/or set up an alternative London base, although in 1992 the singer of the former stated that he was concerned to 'try to get things going in Liverpool rather than having to go to London all the time' (personal communication). Many of those remaining in Liverpool bemoan the role that London plays in luring such musicians away. Within the music industry the imbalance of earnings is striking, audience tastes in music and thus commercial success are notoriously unpredictable, and the quest for success is frustrating and elusive, with only a tiny percentage of bands ever 'making it' (Cohen, 1991a). Meanwhile, the local music industry, particularly in an economically depressed city like Liverpool, largely comprises small unstable businesses, and for most musicians being in a band involves a day-to-day effort to raise funds in order to hire or purchase instruments, find audiences and opportunities to perform, come up with commercially viable songs, and attract the attention of London-based record companies. All of these factors intensify a preoccupation with success and failure, a sense of rivalry between bands, and a struggle over music as a resource, placing considerable pressure on the relationships involved. Such preoccupations and struggles influence the whole notion of 'scene'.

So far, the term 'scene' has been used uncritically, as if there actually was such a thing and everyone knew about it and could agree on what it consisted of. However, whilst those involved with Liverpool rock bands are familiar with the term, they define it in different ways, with many, even though they use the term, questioning the existence of a so-called 'scene'. As one local promoter put it: 'There is and there isn't a scene, it depends how you want to look at it' (The Big Issue 1 August 1995). The scene is thus a contested concept. The scene is described as particular kinds of activity (some complain, for example, that there isn't a scene because 'nothing much has happened', meaning by this that few bands have been signed up to record companies); as a creative entity or live organism that needs a good performance venue to act as its 'heart' or 'core'; or as a particular sound or style ('There's no scene . . . every band is totally different' –

member of Space quoted in the *NME* 18 November 1995). It is also occasionally described as close-knit but usually as factionalised. Definitions and meanings bound up with the scene are strongly influenced by the media, with local and national music publications (such as the Liverpool journal *L-Scene*) playing a particular role in defining a scene so that people recognise it, use it to construct identities and a sense of community, and thus contribute to its development.

The identity of a scene is shaped by distinctions drawn between local scenes. In the comparisons frequently made within Liverpool between the rock scenes of Liverpool and Manchester the Liverpool scene is commonly associated with notions of authenticity and linked with expressions of local identity and pride. The concept of a local scene thus combines both music and place, two highly potent symbols of belonging and allegiance. The music press emphasises rivalries between local scenes, and a scene is generally considered 'healthy' when it gains a lot of media coverage, as well as when its bands are being 'signed up'. Yet media accounts are frequently contested. When the music press reported that there was no longer a scene in Liverpool, for example, a manager based at Liverpool Music House objected, pointing out that this was just a perception 'from London' that didn't reflect what was actually going on in the city. The singer of the Lightning Seeds criticises the press for 'inventing' a scene 'at the expense of the music . . . killing it before it's even started to grow at its own pace' (personal communication). A scene is thus conceptualised as a rather fragile, unstable or precarious entity that needs nurturing and protecting, threatened by a variety of factors, and Shank's (1994) analysis of a scene emphasises its temporary nature and its dynamics: the rise and fall of scenes, their continual flux and flow, geographical movement and dispersal.

Whilst the precarious position of male rock music-makers in Liverpool may make their efforts to dominate the scene and exclude women from it more urgent and necessary in order to achieve status, solidarity and control, within the safety of that position and male security music enables these men to nevertheless express feelings of powerlessness and frustration. Images and ideas about men promoted 'on-stage' are thus legitimated by the production of a very different type of masculinity off-stage and underscored by the heightened sensual dimension of the performance. All of this indicates how complex the production of rock as male can be, involving multiple, diverse and contradictory masculinities, and male power that is ambiguous and precarious. In some ways it may be useful to make use of the dramatic connotations implied by the term 'scene' to describe the scene as performance of gender (Butler, 1990), and through the way they

stand, move, dress, etc. men within the scene do not just act out but phys-
ically embody ideas about masculinity. Liverpool's indie rock scene
involves the performance of rather traditional gender roles and ideology,
with men dominating the scene and excluding women through their
activities, relationships and conversation, yet it also involves the perfor-
mance of alternative or contradictory masculinities. Through musical
performance within the scene, for example, ideas and emotions are com-
municated or expressed in a manner that is discouraged in other public
events and settings or through everyday conversation, with male musicians
expressing, even confessing, rather private views on life and relationships
and suggesting a position of vulnerability. The use of the performance
metaphor to explain social behaviour is of course familiar within the
social sciences, but it does re-emphasise the point that there isn't any 'nat-
ural' masculinity that rock culture reflects, or that rock music performance
offers a release from. Rather, through rock music performers and audiences
can adopt, create and recreate masculine roles and identities. Gender thus
appears as part of the many different roles that we enact in social life, per-
formances that take on different forms according to the audiences and
situations involved.

## CONCLUSION

This chapter has attempted to describe and explain the production of rock
as male by focusing upon one local rock music scene, drawing upon dif-
ferent connotations of the term 'scene' in order to explore music as
drama and spectacle located in particular social, spatial and geographical
settings. Liverpool's rock scene is not naturally male or a reflection of pre-
existing gender roles and ideologies and a pre-existing male culture.
Rather, it is actively produced as male through social practice and ideol-
ogy, contributing to the process through which patterns of male and
female behaviour, and the ways in which we think about men and women
and how they should or shouldn't behave, are established. This production
and performance of masculinity is a complex and contradictory process
that takes on a particular form and meaning in accordance with the rela-
tionships and circumstances involved. It is shaped or constrained by
conventions of behaviour and thought within the general rock 'world', but
also by local conventions, resulting in a local rock scene dominated by
men and by certain types of masculinity.

## NOTES

1 The term 'indie' usually refers to music that is associated with independent record labels and is 'alternative' rather than 'mainstream', and neither 'pop' nor 'heavy rock', although much of the music is now mainstream in that it features strongly in the national charts, and most independent record labels are now linked to major labels. The scene will be referred to throughout the chapter as simply the 'rock scene'.
2 Also, the more women in the band, the more women the band attracts to its performances.
3 Including pornographic videos.
4 During 1996 Space were employed as support band on a major UK tour, but were thrown off the tour after a member of the band sexually harassed the female singer of the headlining band.
5 See Hornby (1995) for a fictional account of the male culture of a London-based record shop.
6 'Scally pop-weirdos' (The Face, April 1996), 'Liverpool weirdo scallydelics' (Melody Maker 20 April 1996).
7 The term arose in the early 1980s and is derived from 'scallywag'. It implies a roguish laddishness, referring to young working-class men (those from Liverpool in particular) with a certain style of slang and dress.
8 One article (The Face April 1996) quotes Jamie, the guitarist, explaining that the song is 'about being in love with a witch', whereupon a fellow band member retorts that Jamie's girlfriend really is a witch, and proceeds to describe her in rather uncomplimentary terms. In a previous study I wrote about two other Liverpool rock bands whose main lyrical themes included that of betrayal in which women were again featured or implicated as deceitful or as a threat (Cohen, 1991a).
9 See Straw (1991: 378) on how this works for national and international rock music scenes.

## REFERENCES

Bayton, M. (1990) 'How Women Become Musicians', in S. Frith and A. Goodwin (eds) On Record, New York: Pantheon.
Bayton, M. (1992) 'Feminist Musical Practice: Problems and Contradictions', in T. Bennett et al. (eds) Rock and Popular Music: Politics, Policies, Institutions, London: Routledge.
Butler, J. (1990) Gender Trouble: Feminism and the Subversion of Identity, London: Routledge.
Bradby, B. (1993) 'Sampling Sexuality: Gender, Technology and the Body in Dance Music', Popular Music 12(2): 155–76.
Cohen, S. (1991a) Rock Culture in Liverpool: Popular Music in the Making, Oxford: Oxford University Press.
Cohen, S. (1991b) 'Popular Music and Urban Regeneration: The Music Industries of Merseyside', Cultural Studies 5(3): 332–46.
Cohen, S. (1991c) 'Survey of the Music Industries on Merseyside', Music City Report, Liverpool: Ark Consultants.
Finnegan, R. (1989) The Hidden Musicians: Music-Making in an English Town, Cambridge: Cambridge University Press.
Fonarow, W. (1995) 'Participatory Alignment and Spatial Distribution at British Indie Gigs', paper presented at the seventh international conference of the International Association for the study of Popular Music held in Glasgow.

Frith, S. (1990) 'Afterthoughts', in S. Frith and A. Goodwin (eds) On Record, New York: Pantheon.

Frith, S. and McRobbie, A. (1990) 'Rock and Sexuality', in S. Frith and A. Goodwin (eds) On Record, New York: Pantheon. (Orig. 1978.)

Garratt, S. (1990) 'Teenage Dreams', in S. Frith and A. Goodwin (eds) On Record, New York: Pantheon.

Garratt, S. and Steward, S. (1984) Signed, Sealed and Delivered: True Life Stories of Women in Pop, London: Pluto Press.

Green, L. (1997) The Sexual Politics of Music: Discourse, Musical Meaning and Education, Cambridge: Cambridge University Press.

Hornby, N. (1995) High Fidelity, London: Indigo.

Laing, D. and Taylor, J. (1979) 'Disco-Pleasure-Discourse: On Rock and Sexuality', Screen Education 31.

Lane, T. (1987) Liverpool: Gateway of Empire, London: Lawrence & Wishart.

Lewis, L. (1990) Gender Politics and MTV: Voicing the Difference, Philadelphia: Temple University Press.

McClary, S. (1991) Feminine Endings: Music, Gender and Sexuality, Minneapolis: University of Minnesota Press.

Negus, K. (1992) Producing Pop: Culture and Conflict in the Popular Music Industry, London: Edward Arnold.

Negus, K. (1996) Popular Music in Theory, Cambridge: Polity Press.

Shank, B. (1994) Dissonant Identities: The Rock 'n' Roll Scene in Austin, Texas, Hanover, NH: Wesleyan University Press.

Shepherd, J. (1987) 'Music and Male Hegemony', in Music as Social Text, Cambridge: Polity Press. pp. 151–72.

Straw, W. (1990) 'Characterising Rock Music Culture: The Case of Heavy Metal', in S. Frith and A. Goodwin (eds) On Record, New York: Pantheon.

Straw, W. (1991) 'Systems of Articulation, Logics of Change: Communities and Scenes in Popular Music', Cultural Studies 5(3): 368–88.

Tagg, P. (1990) 'An Anthropology of Stereotypes in TV Music?' Svensk Tidskraft fur Musikforshning: 19–42.

Théberge, P. (1991) 'Musicians' Magazines in the 1980s: The Creation of a Community and a Consumer Market', Cultural Studies 5(3): 270–94.

Thornton, S. (1995) Club Culture: Music, Media and Subcultural Capital, Cambridge: Polity Press.

Walser, R. (1993) Running with the Devil: Power, Gender and Madness in Heavy Metal Music, Hanover NH: Wesleyan University Press.

Wilmer, V. (1977) As Serious as Your Life, London: Quartet Books.

Wise, S. (1990) 'Sexing Elvis', in S. Frith and A. Goodwin (eds) On Record, New York: Pantheon.

# 3

# WOMEN AND THE ELECTRIC GUITAR

## Mavis Bayton

Where are all the great female electric guitarists? Why haven't we had an Erica Clapton, Pat Townsend or Jenny Hendrix? Ask the average person to think of some famous women guitarists and they will be hard pushed to come up with a single name. In June 1996 *Mojo* Magazine (Issue 31) celebrated 'The 100 Greatest Guitarists of All Time'. Only three of them were women: Sister Rosetta Tharpe, Joni Mitchell and Bonnie Raitt. The lack of women guitarists in rock's hall of fame is partly a result of the way in which women get written out of history and their contribution undervalued, but mainly a reflection of the fact that so very few women get a foot on even the bottom rung of the rock career ladder. So the key question is: why do so few women set out on the career of electric guitarist?

Looking at popular music as a whole, women have been music consumers rather than music producers: the main role for women is that of fan. Women performers have been more prominent in commercial 'pop' and 'folk' than in 'rock', but their place in all these worlds has been predominantly that of vocalist rather than instrumentalist. Where women have been instrumentalists they have tended to be keyboard-players. Whilst women folk singer-songwriters have played the acoustic guitar, the electric guitar (surely the instrument which most epitomises 'rock') has been left in the hands of the boys.

There have always been women vocalists. So, for example, in the early 1960s there were, in America, a large number of all-female singing groups. The 'British Invasion' of beat music, however, signalled the end for these vocal groups. It is hard to think of any women's beat groups. This female absence is all the more surprising in that many of these beat groups, and most notably the Beatles themselves, performed quite a lot of covers of American all-girl singing groups. Why were young women not themselves performing this eminently suitable material in the new beat group format? The answer, I believe, is simple: all-girl vocal groups suddenly looked passé. The Beatles had changed the mould: it was no longer

enough just to sing, you had to play your own instruments too and, above all, that meant the electric guitar. At that time, although many girls took up the acoustic guitar (in the footsteps of Joan Baez and Joni Mitchell), the idea of playing the electric guitar was alien to them. The arrival of the electric guitar, then, led to the exclusion of women from groups for some considerable time.

In the decades since, there have been more women playing electric instruments and, indeed, all-women rock bands, but it is still the case that men are the norm and women the exception. A head-count of UK musicians in local and national bands will highlight the continuing gender imbalance. In a typical small city or large town in the UK, there will be hundreds of men playing electric guitars in local bands and hundreds more playing by themselves at home. In contrast, you will find around a dozen women playing electric guitars in bands. I have recently carried out a head-count in Oxford and I estimate the proportion of women instrumentalists in local bands to be somewhere between 2 and 4 per cent. The trade magazines reflect this relative absence. They also reinforce it, for any novice or would-be female guitarist is still confronted with a solidly masculinist world.

In 1988, 1992 and 1996, as part of my ongoing research into women's popular music-making, I analysed the trade magazines for guitarists. In each year, the overwhelming majority of the photos, features and news were of male guitarists: women's presence has been absolutely minimal. Here I shall just discuss the summer of 1996. Taking the August issue of *Guitar*, there were eighty pictures of male guitarists. In contrast, there were only two of women playing guitars and one of these seemed to be stereotyping female insecurity, by showing a scantily-clad and worried looking female under the sentence 'Don't Drop That Guitar' (an advert for guitar security straps)! The back cover of the August issue of *Guitar School* magazine shows musical equipment and a sexy woman clearly positioned for the male guitarist to have sex with. In *Total Guitar* there was a handful of pictures of women but they were without exception holding acoustic instruments. The only sizeable picture of a woman was located over the advertising line 'The best players play the best pickups': the scantily dressed woman is not positioned as musician but as groupie. On the other hand, compared to 1988, I did notice that there is an absence of blatantly phallic and naively macho 'cock rock' advertisements, such as 'Make it Big with an Aphex Aural Exciter' or 'Mega-Muscle', although there were still plenty of naked hairy chests and medallions in evidence!

In terms of text, all but one magazine in the batch I purchased had no main feature articles on female musicians. The exception was *Guitar School*

magazine, which had one feature article on Sinéad Lohan, whilst the other six articles were on men. This article was, however, somewhat questioning her playing abilities. The title was 'I Can Play, Really' and asks, 'Who says a woman's place is in the kitchen?' The (male) author later comments, 'As a "girl with a guitar", one might expect Sinéad to opt for a dainty acoustic, but no, her current instrument is a black Godin Acousticaster.' Has he not heard of Chrissie Hynde, Bonnie Raitt or L7?

Last, these magazines typically contained transcriptions of pieces for purchasers to learn to play. These were all written by men. Likewise, all the technical advice pages and playing advice were by men. All the covers depicted male guitarists. Two magazines came with free CDs, predictably, of male players.

How can one explain the lack of female electric guitarists? At the turn of the 1980s, when I was playing guitar in an all-women band, the question intrigued me to the extent that I embarked on a sociological research project. This research involved participant and non-participant observation and in-depth interviewing of a cross-section of female rock musicians in the mid-1980s. In 1995–6 I updated my research. In total, I have interviewed around a hundred women musicians. The points I make here are based on that research.[1]

I start from the supposition that there are no physical reasons for the lack of female guitarists. Women are just as musical as men, and at any age they can acquire the strength and skills required to play any instrument in any style of popular music. Women are just as capable of becoming rock musicians as men are. Lead guitarists are made, not born. The reasons for women's absence are entirely social.

As girls grow up, they learn (from family, school, books, magazines and, above all, their friends) how to be 'feminine' and not to engage in 'masculine' activities. Playing the flute, violin and piano is traditionally 'feminine', playing electric guitar is 'masculine'.[2] On TV and in magazines, young women are presented with repeated images of men playing electric guitar; there are few female role models to inspire them. Thus most young women do not wish to become rock guitarists, and, even if they did, would not believe it to be possible. The very first steps in learning the electric guitar force a young woman to break with one of the norms of traditional 'femininity'; long, manicured, polished fingernails must be cut down.

> Yolande (bassist with Marcella Detroit): I have taught a little bit in youth clubs. . . . I have had girls saying 'I don't want to cut my nails'. I've had other women saying they don't like the idea of getting muscles.

It is difficult to stay 'feminine' in a rock band precisely because 'femininity' is an artifice: it is assumed that women do not sweat, that their noses do not go red and shiny, and that their hair stays in place. Or, in the words of Judith Butler (1990): 'gender is an identity tenuously constituted in time, instituted in an exterior space through a stylised repetition of acts'. Those 'acts' involve 'work' which is antithetical to the 'work' involved in playing electric guitar in a band. Moreover, if gender is 'tenuously constituted', then playing electric guitar jeopardises its maintenance.

> Terri (guitarist in 1980s jazz rock band: You find you have to keep up your feminine 'girly' thing and that doesn't particularly go with being in a hard, sloggy job, which is what music's all about.

In contrast, for young men playing guitar in a band directly enhances their masculinity. (I have known more than one male guitarist who proudly preserved the bloodstains on his fretboard.)

That minority of girls who are not discouraged from playing the electric guitar by its traditionally masculine connotations face a series of further obstacles. Compared to boys, teenage women lack money, time, space, transport and access to equipment. They are pressurised (by commercial teen culture and their schoolfriends) to get a boyfriend. The search for romance can devour their time, better preparing them for the role of fan than for that of musician and, even in this role, young women behave differently from young men. Male fans identify with their guitar-heroes and seek to emulate them by learning to play themselves. In contrast, female fans fantasise about sex, love, marriage and babies with their idols (Vermorel and Vermorel, 1985). Male fans buy a guitar; female fans buy a poster.

If, against the odds, the desire to play electric guitar persists, a girl has to contend with another major obstacle: boys. Unlike classical guitar, there are few formal settings in which to learn to play rock. Thus the informal friendship groups within which rock music-making occurs are of crucial importance as learning environments. However, teenage women are not often welcomed in male music-making cliques and thus do not generally get the insider information and tips which are routinely traded within them. Male musicians tend to be possessive about such technical information.

The vast majority of bands are male and many actively exclude women. A major preoccupation of young men is establishing their 'masculinity'. Thus, so-called masculine traits are exaggerated. It is in their younger teens

that most male rock guitarists start playing in bands. To have, say, a girl on lead guitar would undermine rock's latent function of conferring 'masculine' identity on its male participants. Its 'masculinity' is only preserved by the exclusion of girls. I think that if it were traditional for girls to play electric guitar, then boys would avoid it just as much as they currently avoid embroidery. Girls fulfil the role of 'outsiders'/'negative reference group'/'the Other'. So, from the boys' point of view, girls must be kept out of rock bands just as they are kept out of cricket and football. A number of the women I interviewed told me of their early experiences. Enid, for instance, who was a heavy metal guitarist during the early 1980s:

> Enid: At that time, the guys we knew who could play didn't want to know at all about us. Females playing in a band, at that time, was totally unheard of. They thought, 'Oh, girls! They won't be serious and they won't carry on. And they wouldn't be any good anyway.'

Guitar shops are also 'male' terrain: they rarely employ women as assistants, and the customers are overwhelmingly male. Thus boys tend to feel at home there. In any of these shops you can observe the assertive way in which young men try out the equipment, playing the beginning of a few well-know songs time and again, loudly and confidently, even though those few bars may encompass the sum total of their musical knowledge. In contrast, nearly every one of my interviewees said that guitar shops felt like alien territory. For instance:

> Amy (16-year-old guitarist in 1990s Oxfordshire band, Frances Belle): At Russell Acott I feel very intimidated. Especially going to ask − they're all stood behind the counter, these massive metal blokes. Well, that's what they look like, judging by their image. I go up and go, 'Can I have a top E string?' because I don't know the proper names or anything, so it's even worse. And they go, 'What gauge? What sort?' And I'm like, 'I don't know'. So I don't like going in and looking at guitars or anything in music shops. . . . When you're trying, they're just staring at you. If you don't know much as well − and then they pick it up and go (imitates complicated guitar playing) and you're going, 'Oh no, I'll just take that!'

Novice guitarists, like Amy, reported that trying out the equipment was akin to being on trial; they were scared of showing themselves up and

being 'put down' by the assistants or laughed at, whilst experienced players relayed tales of condescension or of simply being ignored. If a woman guitarist goes into a shop with a man, the assistants tend to talk to the man not the woman, even if the man is not actually a guitarist.

> Fran (bass guitarist in various 1990s Nottingham bands including Sub Rosa, Mothers of the Future and The Very Good Rock and Roll Band): You go in and all the blokes are sitting in one corner talking about some riff that they came up with last night, totally ignoring you. They are very patronising. They see that you're a woman and they think, 'How did you dare come in our music shop?'

Rock is associated with technology, which is itself strongly categorised as 'masculine'. 'Femininity' involves a socially manufactured physical, mechanical and technical helplessness, whilst 'masculinity' involves a display of technical competence. In marked contrast to girls, boys get given technical toys and become confident about technical things. Women are often alienated from the essential technical aspects of rock. If they become singers, or play the sax, they may manage to avoid full immersion in this sea of technicality, but not if they play the guitar. Thus young women may be drawn towards the electric guitar but are put off by the multitude of electronic and electrical components, which are a basic requirement for a rock performance: leads, plugs, amplifiers, plug-boards, etc. They lack confidence. Some women who had been playing in rock bands for years said that they still had not completely overcome this problem of 'techno-phobia'. For instance:

> Vi Subversa (guitarist in 1980s punk band, Poison Girls): I think there is a tendency for us still to be scared of equipment: the 'black-box-with-chrome-knobs' syndrome. . . . I've obviously become very familiar with what I do but I still don't feel physically as at one with my equipment as I think most men do. . . . It took me a year before I turned my volume up. Roger would see that my amp was turned up even if I turned it down, because I was still scared of it . . . of making a noise to that extent. I turned the knobs down on my guitar for a whole year. And then, suddenly, I thought, 'Fuck it! I'm not going to do that anymore'.

Moreover, technical language is often used as a power strategy in a mystifying way in order to exclude women. This can happen informally

amongst groups of male musicians, by sound crews at gigs, by technicians in recording studios and so on. So it is not only that women lack confidence, they are also deliberately excluded from this technical world.

There are, then, a number of factors which can help to explain why so few women play the electric guitar, but I believe the major reason is that the electric guitar, unlike the acoustic guitar, is seen as 'male'. The skills involved in playing the instrument are perceived as 'male' skills, inappropriate for women. A woman playing a rock instrument is breaking the gender code.[3] She faces a set of low expectations concerning her competence (woman with guitar = fish with bicycle). For a man, a good performance on the electric guitar is simultaneously a good 'performance' of 'masculinity'. The 'heavier' the rock the more true that is. When you go to a metal concert, it's the men in the audience who play 'air guitar', not the women. In doing so, they are affirming the male bond between themselves and the musicians up on the stage. The electric guitar, as situated within the masculinist discourse of rock, is virtually seen as an extension of the male body. This is always implicit and sometimes explicit, as when men mime masturbating their 'axes'. Heavy metal guitarists unashamedly hold their guitars like a penis. Prince even has a substance being 'ejaculated' from his guitar! (Male) musical skills become synonymous with (male) sexual skills. With legs firmly planted akimbo, the guitarist is able to lean back in a parody of sexual ecstasy. Metal fans may argue that this whole bodily stance is knowing, ironic and fun. That may be so. The fact remains, however, that it is an exclusively 'masculine' idiom.

It is not only the shape which is symbolic, but also the sheer volume and attack of the instrument which connotes phallic power. 'Power, the essential inherent and delineated meaning of heavy metal, is culturally coded as a masculine trait' (Weinstein, 1991). Advertisers in guitar magazines choose words with care to endow their gadgets with masculinity: 'strong', 'overpowering', 'punch', 'tough', 'cut-throat' and so on. And in both language and image, sexual innuendo abounds.

All of this causes problems for the woman guitarist, in terms of how she holds and plays her instrument. Rock guitarists (unlike classical and jazz players) typically hold their instrument low down in front of their genitals, radically adapting their fingering style to suit. Yet most players actually find it easier to hold their guitar on their chest or at their waist. The main reason given, by men and women, for playing the guitar at pelvic level (or lower) is that it 'just looks right'. I would argue that the only reason for this is the silent encoded phallocentric message. If you play it higher up it is seen as less 'masculine'. A woman with an electric guitar

looks 'wrong' anyway and if she then plays it at chest height she looks even more 'wrong'. Thus, if a woman wants to look 'good' she has to play in a 'masculine' way. For instance:

> *Sara* (guitarist in 1990s Sheffield rock band Treacle): When I record I have it really short, up here. Because it's easier to play. But when I'm on stage, obviously, I have it – not really low down like a big heavy rocker – but in the middle, so it doesn't look stupid up round my boobs.

Feminists have had particular objections to the traditional mode of playing. For example,

> *Alison* (bass guitarist in 1980s jazz rock band): Women don't often seem to play guitars and basses so low down. . . . I don't think it's true that women can't do it. I think there are very few women who would choose to do it, feminist or not, actually. . . . I think a lot of women find using your guitar like that very obnoxious or objectionable, and if you're feminist it's that much worse, because you can see that much more in it.

Heavenly is a band not noted for its worries about being 'girly' and so it was particularly ironic that Amelia told me she was worried about playing the guitar too high:

> *Amelia* (guitarist in 1990s indie band Heavenly): I would say that if I had been a better feminist I would have been more determined to hold it correctly. I don't hold it well . . . I used to play quite high and it was considered very sissy. So I now wear it probably lower than I should do! It is an issue, definitely! Pete's always trying to get me to wear it higher, because he says I play it better when it's higher. But I refuse to do it 'cause I look too silly!

Most female guitarists I spoke to (whether in the 1980s or the 1990s) had considered these problems if not actually agonised over them.

> *Claire* (guitarist in 1990s indie band Sidi Bou Said): If you wear your guitar too low you are incapable of moving anywhere and because I play lots of bar chord and stuff up the neck it's easier to have the guitar higher. But I feel a bit 'poncey' with the guitar too

high. . . . I do like the idea of women playing guitars slung like men. . . . I've always thought guitars are really sexy and really strong things and I like the fact they're slung where they are. I couldn't play it up here; it wouldn't feel right. It's all about sex, really.

Debbie even risked her health by playing her guitar very low:

Debbie [from 1990s pop band Echobelly]: I started getting RSI [repetitive strain injury]. It's really bad. So my guitar started getting higher and higher. But it's really bad. I get a huge swelling up here from fretting.

The problem is partly one of a lack of female role models. Although a musician might not be consciously copying anyone, there is no doubt that she is unconsciously influenced by other (male) guitarists and absorbs masculinist performance norms. The middle-aged punk performer Vi Subversa developed an ironic solution to this problem, subverting the meaning of stereotypical macho guitar hero movements:

Vi Subversa: I know when I go in for some big chords that this is what men do. And my feeling when I do it is irony, because I know that you don't have to strut around to make a good sound. I know that you can do it anyway. For boys to see a woman doing it is feeding them an image they haven't had before.

And in Vi Subversa's case not only are the boys seeing a woman playing 'power-chords' but an older woman at that.

If playing styles raise issues concerning the female body, so does the instrument itself. Technical objects are political in their design. The electric guitar was designed for men, by men, and it has thereby functioned to exclude women. These days, guitars can be made in various shapes. Why, then, does the standard rock guitar remain decidedly phallic? I believe that if it was mainly women who played electric guitar the shape of the instrument would have changed by now; not only for symbolic reasons but also because of the female body. Perhaps guitars would typically be held above the waist and their design make allowances for the fact that women have breasts. If you hold your guitar at chest level you risk crushing them and this is particularly painful if you are pre-menstrual. Both Juliet and Kate from Oxford's 1990s band, Twist, for instance, mentioned this problem. Kate used to play a Gibson 5, which is a big-bodied guitar,

and her breasts hung over the top in a manner which sometimes embarrassed her. I used to play a Gibson Les Paul and, whilst my left breast used to get squashed, my right breast used to fit snugly into the top curve in the guitar's waisted middle. I was not the only one to attempt this partial solution. For instance,

> *Anna* (guitarist in Sub Rosa): They've got that kind of slot at the top which you can hook your tit over the top of. You can either squash it against your stomach, which is going to hurt, or you can hook it over the appropriate bit. . . . I'm going to work on a funk rhythm guitar with a concave back that you fit your tits into!

Despite all the physical and symbolic obstacles strewn in the path of would-be female electric guitarists, a small minority do set out on a musical career.[4] My research shows that they then face further problems which men do not; the entrenched sexism of the rock world. They encounter hostile male musicians, prejudiced promoters, patronising disc jockeys, obstructive technicians who sneer and make sexist jokes at their expense, inhospitable masculinist working conditions, unimaginative marketing by record companies, and sexploitative media coverage. They also face harassment and put-downs because they are women.

The most common form of harassment is verbal abuse of the 'show us yer tits' variety. This sort of abuse reflects the fact that women's place on stage is only legitimate if they take their clothes off. At gigs in the 1970s you could sense some men's incredulity: if you were not going to expose your breasts, then what were you doing up on stage? A woman is as likely to be evaluated on the size of her breasts as on her guitar playing. Moreover, such comments are meant to be heard by the performers. It can be startling and off-putting for the novice guitarist to have to deal with demands that she strip.

This kind of harassment is still as common in the 1990s as it was in the 1970s. To many of my interviewees, such abuse was so routine and taken for granted that it barely required a comment. Practically every woman musician that I interviewed had experienced it.

> *Terri* (of 1980s jazz rock band): There's always either a comment or some uneasy atmosphere or something. Every gig there'll be some little something that has to be dealt with. [But] a lot of women just have that experience happen to them so much of the time that they block it out. And it's the victim syndrome. It's like almost that you draw that kind of attention to yourself, that

somehow women are responsible for those things. Or, 'Oh, it's not serious, dear. It doesn't matter.' We're so used to being harassed.

But younger women today have been strongly retaliating. Actively drawing the audience's attention to the perpetrator and confronting him usually works. My interviewees supplied me with a number of amusing and effective one-line retorts which they had used. Male hostility also often makes women musicians determined to show how good they are, although there is usually an accompanying resentment.

Sometimes harassment goes further than verbal insults, to become physically threatening. My interviewees recounted particularly scary stories of gigs abroad. For instance:

> Shareen (guitarist in Ms45): I remember once when I was 18. I was doing a gig in Colorado. Some guy actually came up to the stage and picked me up and started to carry me off . . . it was scary! I hit him on the head with my guitar and a big fight started.

> Emma (of Lush): We just did a tour of America and we walked off the stage at one gig. Because there are these weird radio festivals and people are just moshing and punching each other senseless. And people were just throwing things at us. Not like 'Get off the stage'; it was just a sport for them at these festivals. . . . It was a really violent atmosphere. . . . I was afraid when this massive shoe came hurtling towards my head. That's when I walked off.

So sexist prejudice and active harassment act as a handicap for the female guitarist. But the most general problem is simply not being taken seriously. The status 'woman' seems to obscure that of 'musician'. Female guitarists are expected to be sexy and incompetent and these expectations form a hurdle which must be coped with or combated in some way. Guitarists told me about men at gigs who, after admiring their instrument, played very fast up and down the neck to show how good they were and to put the woman down. Even when a woman's performance is appreciated it is not always her instrumental skills that she is complimented on:

> Sara (of Treacle): After the gig, people come up to you and, instead of saying, 'I really liked what you did', they'll say, 'I like your hair.' Like, when has a male musician ever got 'You've got

nice eyes' instead of . . . . They'd never say that to a male person!

Furthermore, even when the comments seem to be about a woman's musicianship they may mean something different:

*Anna* (of Sub Rosa): The times I've gone on stage and been wearing miniskirts or looking fairly girly, I've got more compliments on my playing than if I had been wearing jeans and a T-shirt. I've got a friend who says, 'Them right dead-legs who come up to you after gigs and go, "I thought your playing was really good", what they actually mean is, "I fancy you in a skirt".'

Finally, there is another very basic reason why female guitarists do not reach the celestial heights. Unlike men, women have to carefully juggle the demands of family and career, personal and public life. Women are typically unable to commit themselves to rock careers in the wholehearted way in which men do precisely because of these commitments elsewhere. The centrality of family and love relationships make it difficult for girls to make long-term plans. In a sense, all career plans are provisional. In contrast, for a boy having a girlfriend is not the be-all-and-end-all of his life and marriage does not interrupt his career. For a man, paid work is the central plank of his life. Apart from the minority of highly successful musicians, most women still have to choose between a rock career and motherhood. Male guitarists typically have their career serviced by the hidden labour of girlfriends and wives. Female guitarists are far less likely to get such support. Where were Erica Clapton and Pat Townsend? Washing the dishes and feeding the baby, probably.

I look forward to the day when there will be as many women playing electric guitar in bands as men. I look forward to this not merely because I want to see an end to sexist constraints on women, but also because of the effects this would have on musical performance itself. In playing styles, men would no longer be the yardstick against which women are measured. If as many women played guitar as men, particularly lead guitar, then the instrument would no longer be seen as a phallic symbol and this would also be reflected in its design. Playing rock would no longer denote masculinity. In a non-sexist world half of all electric guitarists would be women and gender would be no more relevant to playing than eye colour or height is today. I choose to end with a quote from the inveterate middle-aged guitarist Vi Subversa:

All of technology is dominated by men . . . but I'm fucked if I'm going to say it belongs to them. It's ours! Right? Every single wire that's been put together was made by a man who was fed, nurtured, supported by women somewhere. I think we've got to reclaim the lot.

## NOTES

1 The 1980s research led to an unpublished doctoral thesis: Mavis Bayton (1989) 'How Women Become Rock Musicians', Warwick University. The updated research has been for a book being published in the near future by Oxford University Press.
2 In many parts of the world musical instruments are sexually classified and in some tribal societies the consequences of breaking a musical taboo can be serious. But exactly which instrument each sex is allowed to play varies cross-culturally.
3 I do not have space in this article to discuss clothes, but women in feminine 'drag' (satin slips, nighties, wedding dresses) 'kicking shit' out of their guitars, women like Courtney Love and Babes in Toyland, and indie women with the ironic and contradictory ballgowns-plus-Doc Martens approach, are creating exactly the sort of 'gender trouble' which Judith Butler (1990) proposes as subversive political action, upsetting the notion of a fixed, true or real gender and revealing gender to be, in itself, a fabricated performance.
4 The women who do play electric guitar are exceptional in that they have overcome the obstacles which I have been discussing. Two main routes into playing have been feminism and punk. Both of these opened up a playing space for women. It is no accident that there was an increase in women musicians in the late 1970s and early 1980s.

## REFERENCES

Butler, J. (1990) *Gender Trouble: Feminism and the Subversion of Identity*, London: Routledge.
Vermorel, F and Vermorel, J. (1985) *Stardust: The Secret Life of Fans*, London: Comet.
Weinstein, D. (1991) *Heavy Metal*, New York: Lexington.

# 4

# (R)EVOLUTION NOW?

## Rock and the political potential of gender

### Norma Coates

When maturity beckoned, she lost her nerve. The warrior retreated.
(Lucy O'Brien, 1995: 117, writing about Patti Smith)

before there was BONO
before there was MICHAEL STIPE
before there was KURT COBAIN
ONE VOICE MESMERIZED EVERYONE.
(promotional material from *Gone Again*,
Patti Smith, June 1996)

The Rolling Stones trouble me. As much as I love their music, it periodically grates against my sensibilities and produces spasms of feminist guilt. 'What am I doing', my inner voice inquires, 'dancing around and getting crazy to such blatant misogyny?' I have encountered other women who share my passion for listening to, collecting, accumulating knowledge of and talking about popular music, and more than a few of these women hate the Stones and won't listen to them because of the misogyny problem. Conversely, and curiously, some respondents, when asked why they like the Stones, reply 'because they're sexy'. In this case, 'they're' does not necessarily refer to the manly beauty of Mick, Keith or even Bill or Charlie. It refers, rather, to the sound of the Stones, the totality of the mix and the beat, the way the music hits the body and the hormones instantaneously. Herein lies the problem which troubles me. This sound, perhaps some of the most definitional sound of ultimately undefinable rock, is coded as unmistakably phallic, and masculine.

Attali sees music as a tool for the creation of a community, a link from a power centre to its subjects (1989: 6). If this is true, then a feminist fan of the Stones and rock like myself is faced with an immediate conundrum: if indeed it is the phallic power of the sound that draws me to it, then I

am complicit in my own submission to that power. I accept that power and at the same time reinforce it. Some might say that when I describe the Stones' sound as sexy, I am operating under 'false consciousness', simply accepting and reinforcing hegemonic tropes of male and female sexuality. This is an unsatisfactory explanation.

What Grossberg (1992) identifies as the current rock formation, a particular conjunction of post-war ideological and cultural forces, is especially resistant to incursions from those outside or on the margins of it. In this rock formation, women's space in rock has been in the bedroom, either as groupies to male rock lovegods, or relegated there to swoon over pin-ups of teenybop idols by cultural critics. Women have been critically and analytically allowed on the dancefloor as well (Frith and McRobbie, 1990) – another space coded as 'feminine'. McRobbie and Garver's (1976) characterisation of women's position vis-à-vis rock as secondary and passive, tendered over twenty years ago, still rings true today.

Now, given the recent influx of 'women and rock', it would seem that this assertion is unfounded. However, although women are no longer locked behind their bedroom doors or exiled to the dancefloor rather than Main Street, women are still marginal and unrepresented, even unrepresentable, in rock. The epigrams with which I opened this piece illustrate this point. The first is taken from *She Bop: The Definitive History of Women in Rock* (1995) by British rock critic Lucy O'Brien. In this brief snippet and in the larger context from which I took it, O'Brien falls back upon a masculinist discursive tendency of rock criticism to erase women as anything other than sex objects for men or as imitation males ('tomboys'). O'Brien, here, is specifically discussing Smith's 'hiatus' from rock to pursue other interests, which included but were not limited to marriage and motherhood. The second is from the promotional material for Patti Smith's 1996 'comeback' album *Gone Again*. Given that the three years preceding 1996 were all dubbed 'the year of the woman', and that during that period hard and tough rock music by female artists topped critical and popular charts, it is curious and telling that Arista's promotional staff still found it necessary to use male rock superstars to 'sell' Smith.

Granted, the exigencies of the market drive Arista's promotional efforts, and O'Brien has a rather limited discursive tradition to draw upon.[1] However, marketing managers and journalistic rock criticism are not solely responsible for who and what is central to the rock formation. Rock's mechanisms of inclusion and exclusion are more finely developed, subtle and disguised than strategies outlined overtly in marketing plans and covertly in stylebooks. A more plausible explanation for why the Stones' music is coded and accepted as phallic, and why Patti Smith can only be

described in terms of her relation to and influence upon male stars, is to consider rock's role as a technology of gender, one which constructs 'masculinity' in and by the rock formation.

De Lauretis (1987) suggests that gender is the product of various social technologies, including forms of so-called popular culture, and of institutionalised discourses, critical practices and practices of daily life. Gender is at the same time constructed and always under construction. De Lauretis appropriates the Foucauldian term 'technology', describing the way that power works productively to replicate and multiply itself, in order to explain how gendered social and cultural relations are reiterated and reinforced.

Gender, moreover, is performative (Butler, 1990: 136). The practices cited by De Lauretis which work to construct, mark and sediment a cultural form as associated with a particular gender are at the same time citing and reinforcing acts, gestures, enactments and other signifiers which express that gender. Furthermore, as Butler observes, the essences and identities expressed 'are *fabrications* manufactured and sustained through corporeal signs and other discursive means. That the gendered body is performative suggests that it has no ontological status apart from the various acts which constitute its reality' (1990: 136). Since gender is a sedimented amalgam of various signifiers, gestures, enactments and so forth, it would appear that an element of choice solidifies signifiers into a particular way of performing an ultimately fictive 'masculinity'.

Rock is indeed a technology of gender in that 'masculinity' is reinforced and multiplied in its many discursive spaces. However, what is reiterated in and by rock is a particular type of masculinity, one which was 'fixed' in the early days of rock and roll.[2] Rock masculinity, at least the stereotype which, I assert, is still very much in play discursively and psychically, is one in which any trace of the 'feminine' is expunged, incorporated or appropriated.[3]

Moreover, performative rock masculinity is inscribed by far more subtle and even insidious ways than egregiously sexist lyrical content or 'over-the-top' visual displays of masculinity associated with some rock performances.

Consider, for example, the discursive and stylistic segregation of 'rock' and 'pop'. In this schema, rock is metonymic with 'authenticity' while 'pop' is metonymic with 'artifice'. Sliding even further down the metonymic slope, 'authentic' becomes 'masculine' while 'artificial' becomes 'feminine'. Rock, therefore, is 'masculine', pop is 'feminine', and the two are set in a binary relation to each other, with the masculine, of course, on top. The common-sense meaning of rock becomes 'male', while 'pop' is naturalised as 'female'. Real men aren't pop, and women,

real or otherwise, don't rock. Further, according to this schema, authenticity in rock is something which, like pornography, one is supposed to know when one sees it. 'Rock' is not so much a sound or a particular style of playing music, but represents a degree of emotional honesty, liveness, musical straightforwardness, and other less tangible, largely subjective aspects. 'Pop' music is allegedly slick, prefabricated, and used for dancing, mooning over teen idols, and other 'feminine' or 'feminised' recreations. The onset of new musical trends such as techno, digital sampling, and the increased reliance upon studio technologies to enhance and stimulate musical production has provoked a rethinking of the concept of authenticity. For example, Thornton argues persuasively that authenticity be rethought away from the valuation of 'liveness' and other intangibles, and to the point where 'a musical form is authentic when it is rendered essential to subculture or integral to community' (1996: 29). Nevertheless, the metonymic equivalencies described above between rock, masculinity and authenticity remain discursively hegemonic.

On a more mundane level, the increased visibility and importance of female rock performers should make the distinction questionable, but in reality, it has not. In the place of automatically labelling female musicians 'pop', or ignoring their output, or attributing their success to their 'tomboy' characteristics, women are now 'called out' by the discursive structures of the rock formation by being labelled 'Angry Young Women' or by foregrounding their femaleness in ways that maleness has never been foregrounded – it is apparently *assumed* that rock musicians are angry young men. This is a strategy of containment, necessary to stabilise and cohere 'masculinity' as constantly reiterated and reinscribed in the rock formation. Women who play rock which follows all of the rules of 'authenticity' – lack of artifice, standard even stripped-down instrumentation and frank, often sexually explicit lyrics – throw the category of 'rock' in flux by transgressing and threatening to expose the artificial gender boundaries erected by the technologised machinations of power. Such violations of the invisible yet potent rules of power in rock result in the mobilisation of tropes of 'traditional' femininity to keep women firmly in their marginal place in rock. For example, upon the release of *Exile in Guyville*, Liz Phair's iconoclastic report from the sex/gender/rock front, in 1993, Phair was featured on the cover of *Rolling Stone* magazine, clad only in a slinky blue slip. The photograph's soft lighting provided a rather pornographic come-on to potential buyers. Phair was complicit in the staging of the shot, but had no control over the ultimate reception and uses of the cover which established – and diminished – Phair as Alternative Rock's salacious pin-up girl for 1993. The same article (written by a

female critic obviously steeped in the gendered discursive style of main-stream rock criticism) went on to describe Phair's appearance in great detail, as well as to write a male Svengali into the story of Phair's rock success – a story which was greatly exaggerated by the writer, according to the designated Svengali.[4]

Although *Rolling Stone* appears to go out of its way to reinforce the marginal position of women in the rock formation even while featuring female artists on its cover with greater frequency, other rock magazines are beginning to accept 'women in rock' as a permanent part of the rock landscape – to an extent. Women have captured the top position in the prestigious *Village Voice* 'Pazz and Jop' poll for three years in a row as of this writing (1993, 1994 and 1995). However, comments from individual critics peppered throughout the annual Pazz and Jop supplement indicate that the gendered nature of rock, at least as expressed through rock criticism, rock's primary journalistic and taste-making device, will not change quickly or quietly, as this snipe from a male critic writing in 1993 indicates:

> Reasons why the Breeders aren't the most important band of '93:
> Unlike the riot grrrls, they just shut up and rock; unlike PJ Harvey
> and Liz Phair, they're not explicity female-centric and therefore
> men relate to them; unlike so many alternative bands, they're
> optimistic and straightforward. Reasons why the Breeders are the
> most important band of '93: They're exactly like the riot grrrls
> except they've got a great poker face; they're totally female-cen-
> tric, yet leave men more bewildered than threatened; Kim Deal is
> the most pessimistic, ironic songwriter in the Top 40; plus, oh
> yeah, they rock like a hurricane, named after a woman, of
> course. – Charles Aaron, Brooklyn.
>
> (Aaron, 1994)

Aaron's rant is a wonderful example of the technology which reinforces and reinscribes the male gender in rock at work. In a few short phrases, he undermines the riot grrrl subculture/movement of women in rock, the frank body and sexual politics of rock musicians like Liz Phair and PJ Harvey (1995's Pazz and Jop Poll winner), the pessimistic and problematic politics of alternative rock, the genre in which most of the 'new' female artists apparently fall, and reinscribes rock's patrimony by invoking lyrics from a well-known song by Neil Young. The Breeders, according to Aaron, are great because 'they rock'. That is, they play like 'guys' – none of this sissy political stuff thrown in, just straight ahead, masculine rock

and roll. Aaron, like many other journalistic and academic writers on rock, as well as the legions of fans talking about rock in real-time and Internet discussions, can only relate to women in rock as 'men in rock' plus and minus a few crucial anatomical parts. Moreover, although Aaron's opinion may be read as celebratory, note that he ultimately falls back upon discursive techniques that succeed in positioning women as Other to the rock formation. Why is it, for example, that in his formulation it is better for men to be 'bewildered' than 'threatened' by female musicians?

Riot grrrls draw Aaron's (and others') particular ire, possibly because they can be interpreted as bringing some of feminism's traditional (and mythical) humourlessness and pendantry to the fun-loving precincts of the rock formation. As Gottlieb and Wald (1994) point out, the riot grrrls movement, particularly those aspects represented in performance, recordings and fanzine networks, creates a 'feminist praxis' interrogating issues of gender, sexuality and patriarchal violence using some of the (literal) instruments of the rock formation (1994: 269). However, Gottlieb and Wald also discuss riot grrrl's 'vexed' relation to the mainstream rock and other media, a relationship which leaves the movement willingly and wilfully subcultural (1994: 269). Although in doing so riot grrrls themselves retain some control over self-definition of the movement, this strategy ultimately results in a loss of control over representation of the movement in exactly those mainstream publications that they avoid. By losing control over their own representation, they thus reinforce their, and by association, other women's position on the gendered margins of rock.

Indeed, the wilful subculturation of the riot grrrl movement by its followers points to a problem identified by De Lauretis (1987: 3) in her definition of technologies of gender:

> Paradoxically, therefore, the construction of gender is also effected by its deconstruction; that is to say, by any discourse, feminist or otherwise, that would discard it as ideological misrepresentation. For gender, like the real, is not only the effect of representation but also its excess, what remains outside discourse as a potential trauma which can rupture or destabilize, if not contained, any representation.

Therefore, despite the large female audience, and the current trendy position of women, angry or otherwise, and a strong subculture of women working with rock tropes, the answer to the question, 'Are women still excluded from rock?' is 'yes'. How, then, can we theorise woman or women in relation to rock? What would happen to 'rock' as we know it?

Would it continue to exist in the form in which we currently conceive of it, or would something new be created from the broken pieces that such theorising will scatter about? Would this ultimately be a political move, or even make rock into a force in some political field? What could all this mean for the analysis of this thing called 'rock'.

As discussed earlier, masculinity, as performed in and by the rock formation, is constructed on a false foundation. In addition 'rock masculinity' depends upon the development and reiteration of tropes and signifiers which have become tightly associated with both rock and masculinity.[5] Because masculinity in rock is based on a fictive foundation, and in addition, because it is a particular style of masculinity which is being performed, it is crucial to expel and incorporate any threat to its (however tentative) stability. Otherwise masculinity in rock, and therefore rock itself, becomes incoherent. To maintain coherence, any excess must be contained. For the purpose of this essay, femininity is the marker of excess in rock.[6] Male rockers who literally appropriate 'feminine markers' do so in order to assert power over them, and over the 'feminine' or the female. It is no surprise, then, that heavy metal rockers, those with the biggest hair and the tightest clothes (including Spandex, outside of its usual use as female exercise wear), are often held up as the prime representations of excessive masculinity in rock.[7]

Butler terms that which is expelled from a body, or a discourse, or some other gendered form, the abject (1993:3). The abject is always contained in that which is excluding or expelling it. The 'return of the abject' radically destabilises that from which it was expelled, opening the site to reconfiguration and resignification. The return of the abject to a gendered formation or discourse is a way to question and open up terms, fields and formations. Further, it may be productive to see the ultimate goal of such work as *disrupting* the reiterative cycle which produces masculinity as the common-sense of rock.

The first move toward such disruption is to open up the gendered meaning of rock by returning 'woman' to it. At the same time, the term 'woman' must be opened up, or at least made permeable. It is necessary to use 'woman' in this sort of analysis as a contingent category. But the definition of women must, as Butler reminds us, be constantly scrutinised, as the articulation of specificity 'invariably produces factionalizations and exclusions' (1993: 15). Concomitantly, 'women' cannot be deployed in the manner naturalised by the discursive conventions and frame of the rock formation (e.g. the unreflective use of the term 'women in rock'). To do so would further sediment the gendered meanings of both women and men in rock.

Moreover, the term 'male' and the deployment of 'masculinity' within rock discourse and the rock formation must not only be opened up and rendered contingent, but also historicised and specified. Why, for example, has it been so important to maintain this particular performance of masculinity in rock? What cultural and ideological purpose has this served? What is at stake if rock is no longer conceived as a purveyor of dominant, hegemonic meanings and ideological control? In the remainder of this chapter, I offer some contingent and tentative approaches to these questions, in the hope of encouraging further discussion and critical inquiry.

The performance of masculinity in and by rock has served important cultural and ideological purposes, especially given the time of rock's emergence from US 'race' music in the 1950s. Grossberg's (1992) depiction of the rock formation as articulated to the ideological needs of the US post-war liberal state locates the moment when rock (more accurately, rock's predecessor, rock and roll) took on the ultimately conservative ideological, gendered and racial meanings that continue to be inscribed and reiterated in rock. What is foreclosed by this articulation of rock and post-war 1950s ideology are other ways to inscribe rock with meaning, to theorise beyond a point of fixity located in the 1950s. The tenacity with which gendered meanings have 'stuck' to rock, even as its cultural milieu has changed in space and time, indicates that more than ideology is at play.

To this end, we might consider rock to be an example of what Stallybrass and White call a 'bourgeois bohemia', a space of respite from everyday life in the 'real' world in which the rock formation is imbricated. Rock has long been represented as a site of opposition to dominant cultural formations; the truly oppositional potential of rock is questionable, but cultural meanings and resonance which became attached to it in its early days have stuck and increased in strength even as a few huge transnational media conglomerates take over the production and distribution of rock music, or as significant rock songs are used to sell sneakers.[8] However co-opted it may be, rock still stands as a space of the residual carnivalesque of modern society, a space at the same time implicated in and removed from mainstream culture. Stallybrass and White, near the conclusion of The Politics and Poetics of Transgression, assert that in the late nineteenth century, 'bourgeois culture produced a compensatory range of peripheral "bohemias" which afforded "liminoid" symbolic repertoires of a kind approximating those of earlier carnival forms' (1986: 189). These 'bourgeois bohemias'[9] 'took over in displaced form much of the inversion, grotesque body symbolism, festive ambivalence and transgression which had once been the provenance of carnival' (1986: 189). Rock, then, may be viewed as a fin-of-this-siècle bourgeois bohemia, in that it provides

opportunities to figuratively 'step outside' bourgeois life. The meanings associated with rock include hypersexuality, noise, unruliness and 'outsiderness' among others, all of which invoke the spirit of the carnivalesque.

However, Stallybrass and White also note the gender dynamics of bourgeois bohemias, observing that '[s]ince "respectable" women were defined precisely by their self-distancing from such indecent domains they were the social group most remote from any access to available symbolic articulations of the lower body' (1986: 189). Sexuality in rock has, until recently, been conflated with male sexuality, therefore erasing any expression of the lower body of the female, and female sexuality, except in relation to male sexuality. The recent influx of 'women in rock', particularly younger women like Courtney Love, who play guitar, scream and sing from the point of view of female experience and sexuality, trouble the performance of masculinity as enacted in and by the rock formation. Moreover, male sexuality in rock has been mythicised sexuality; that is, sex in rock did not have consequences, such as children or parenting. Mothers, for example, undermine some of the bedrock beliefs of the rock formation.

One of the 'threats' of the representation of 'female sexuality' in rock is that it opens the Pandora's box of 'sexualities'. Rock, as I have been arguing, has depended upon the reiteration of a stable representation of heterosexual, usually white masculinity to cohere its meaning and, therefore, its cultural and discursive resonance. Rock has played an important role as a fantasy site of unbridled male sexuality, undisturbed by the spectres of pregnancy, AIDS or any other consequences. In this way, rock becomes a redoubt of mythical white male power, regardless of social or economic circumstance. Even the whiny 'math boys'[10] of American alternative rock claim this power by appropriating victimhood and inscribing it with a sexual power unavailable to those who are usually discursively burdened with the 'victim' mantle. However, the introduction of 'sexualities' threatens to tear the wraps off the implicit homoeroticism of much rock, generally denied or rendered invisible by rock fans, critics and performers. It is beyond the scope of this chapter to posit a queer reading of rock. The intention is, rather, to open up the field of male sexuality, a move which I hope would lead to a political rethinking of rock and sexuality and ultimately, masculinity.

For example, in 'Sexual Mobilities in Bruce Springsteen: Performance as Commentary', Martha Nell Smith (1992) discusses the homoerotic aspect that is threaded throughout Springsteen's work – the very visible sight that Springsteen's avid (male) fans and critical champions do not wish to see.

By focusing her analysis on an icon of American male masculinity, and by extrapolation, heterosexuality, Smith takes a step toward problematising the feminine and/or homoerotic tropes prevalent throughout much of rock, particularly rock performance.

As the residual carnivalesque of late twentieth-century culture, rock does indeed serve a co-opted purpose of ideological 'crowd control' on a mega-stage. 'Women in rock' reinforce hegemonic dominance by providing site for reinscribing 'traditional' representations of femininity in a sleight of hand that hides its very operation. I point to the example of the popular demonisation of Courtney Love as evidence of the operation of, to play fast and loose with a term from Stallybrass and White, 'low-Othering'. According to Stallybrass and White, the low-Other is a recurrent trope throughout the history of popular culture. Bourgeois society, they assert, attempts to eliminate the 'bottom', only to discover that they depend upon it. Symbolically, the low-Other becomes the 'primary eroticized constituent of its own fantasy life' (1986: 5).

Rock has provided fertile ground in which to propagate low-Others to mainstream culture. The trappings of rock, its metonymic identification with youth culture, and its frequent representation as somehow threatening to 'family values', construct certain alliances and eruptions within the rock formation as low-Other to bourgeois society. Women in rock are already placed in a position of low-Other to mainstream culture just by merit of being part of the rock formation. The threat to mainstream culture, therefore, is no longer: 'Would you want your daughter to marry a Rolling Stone?' The new threat is: 'Would you want your daughter to be a Rolling Stone?'

Curiously, the discursive mechanisms of the rock formation itself reinforce these 'mainstream' conventions and fears. For example, there has been a long-standing, widely held view in both academic and popular rock criticism that women have traditionally been relegated to the role of singer in rock bands, and that this position is denigrated and of lower status than the other (male) band members. Mary Anne Clawson (1993), for example, adopts the 'standard' academic bifurcations of rock and pop, and male and female, in an examination of how two female lead singers negotiated their devalued statuses as singers in otherwise male bands. Clawson makes the oft-repeated assertion that female singers in bands are regarded as less highly skilled than instrumentalists, that singing is overdetermined as 'natural' (invoking the nature/culture split along gender lines), and that singers are marginalised by the valorisation of instrumentalists.

Clawson's argument is not without value, and may have been true during certain periods of rock history. However, it is time to attempt to

answer the questions which are foreclosed by such hegemonic lines of rea-
soning, for example: Why is the male lead singer valorised while the
female lead singer is not? Is the fact that this question is not considered by
academics writing about rock a symptom of the hold of gender hegemony
on all aspects of the rock complex? Was the female lead singer once deval-
ued? Is this still the case? What would happen to theorising about rock if
the singer was accorded equal status, despite gender? Might this now be
happening?

The treatment of women in rock history and discourse exemplifies
what Stallybrass and White call 'displaced abjection'. This is 'the process
whereby "low" social groups turn their figurative and actual power not
against those in authority, but against those who are even "lower"
(women, Jews, animals, particularly cats and pigs)' (1986: 533). Granted,
it is a stretch to nominate a popular form which is so imbricated with and
integral to international media capital as 'low', but rock's celebration of its
mythical Otherness to mainstream culture is an important part of its cul-
tural and masculinised power. Women in rock threaten this perceived
power. Analysing the abjecting mechanisms in rock this way starts to
answer questions about the valorisation of male singers, and the erasure of
denigration of women and their various roles in rock throughout the
decades.

However, this way of perceiving the abjecting operations of rock also
provides us with the tools to start dissecting them and, further, destroy-
ing them. Many questions beg to be asked once the abject, in the form of
a contingent and permeable definition of 'woman', is returned to rock.
This questioning must be undertaken using critical and discursive practices
that do not reproduce the 'common sense' of rock. Such critical work has
begun, as seen in the recent proliferation of 'herstories of rock', edited
compilations of women's writing on rock, and revisionist looks at previ-
ously denigrated phenomena such as women's contributions to the Brill
Building songcraft of the early 1960s (see Rohlfing, 1996). Accordingly,
the rock/pop distinction, which ghettoises women in popular music,
must be rethought or done away with, along with its corollary, the dis-
tinction between musical authenticity and artifice, increasingly meaningless
as an aesthetic distinction.

Moreover, other techniques of categorisation which, intentionally or
not, continue to signify women as marginal in and to rock must be scru-
tinised. Categorisation is often necessary to make ideas and formations
intelligible, but categorisation is, after Foucault, a disciplinary operation of
power. It is easy for the critic to lump 'women in rock' into categories,
such as 'groupies' or 'tomboys' or 'Angry Young Women' to make or

clarify a point. However, this categorisation is usually done in relation to a reference point, and in the case of rock, that reference point is discursively constructed as masculine. Categorisation, if done at all, must be done carefully and self-consciously.

For example, popular rock discourse appears to be deeply conflicted about the rise of 'women in rock' and the fact that, at long last, it appears that 'women in rock' may become a permanent category and force in the future of the form. On the one hand, the rock press, like rock music itself, needs 'the next big thing' to sustain it. The rock press must have new fads to start, new bands to discuss, new topics to explore, in order to keep it fresh to its audience, and to reach new audiences as old ones age or otherwise move away from their active involvement with rock music. Granted, rock criticism does play a role in positioning rock as a 'serious' medium, but it also plays gatekeeping and taste-making roles. These roles provide the economic justification for the mainstream rock press. 'Women in rock', then, is the new hot thing that sells rock magazines. 'Women in rock', or today's trend, 'Angry Young Women', could actually turn out to be extremely important to the economic viability of the music industry as a whole. However, 'women in rock' threatens the monolithic male gender structure of the rock complex. Therefore, even while promoting 'women in rock' and devoting a great deal of press ink to it, the rock press attempts to contain it.

Perhaps the most egregious example of this 'othering' is the moniker 'women in rock'. The designator itself delineates hegemonic space. 'Rock' is separate from 'women'. 'Women' are only related to 'rock' by being allowed 'in'. The 'in' of 'women in rock' has a contingent feel about it, an aura of something that will never be complete, never fully integrated with the whole. As a result, female performers and groups who are pegged by that name tend to refuse it, or to refuse the subtextual meaning of the term – 'women in rock' as being code for 'feminists', a contested term itself.

However, 'women in rock' may be a politically useful term right now, as a way to designate rock as contested ground. At the conclusion of *Bodies that Matter*, Butler (1993) examines the current pragmatic use of the term 'queer' in gay activist politics. According to Butler, although the term 'queer' worked, for a time, to unite homophobic communities, the reappropriation, or 'refunctioning' of the term by gay activists signified a new and affirmative set of meanings. Therefore, reappropriations and subsequent refunctionings of terms by the groups which they denigrate disrupts the reiterative power of abjecting repetitions.

Applying Butler's insight to rock, latching on to the term 'women in

rock' as a contingent move of identity politics can enable women involved with rock to problematise the very practices and conditions which necessitate the use of that term within popular rock discourse. Repeated use of 'women in rock' begs numerous questions: Why is it important to segregate 'women in rock' in this manner? Why don't we speak of 'men in rock'? Haven't women always been in rock? What does 'in' mean? Does 'women in rock' refer only to musicians, or does it refer to any women involved in rock in any way (fans, listeners, music business personnel, and so on)? What does 'woman' mean in the context of rock? What does 'woman' mean? Returning the abject in the form of 'women' to rock, or in any other form, relies upon a refusal to fix and to categorise. Instead, it relies upon the ability to think beyond visible and invisible limits. Most importantly, it means to be willing to recognise that such questioning ultimately destabilises the technologised gendering of rock.

'Women in rock', then, at this historical and specific moment, should embrace the use of the term by which the rock press and music business at the same time includes them in *and* abjects them from the rock complex. Refusing the title 'women in rock' only reinforces the naturalisation of the unspoken 'men in rock'. At worst, the term attempts to contain the semiotic excess that 'women in rock' represents to the rock complex. But at the same time, 'women in rock', as artists and as the 50 per cent of the rock audience which is female, as well as analysts and theorists thinking and writing about rock, can use this term to truly put women into rock.

In the meantime, and in conclusion, a most transformative move may be to appropriate, and thereby undermine, the performative aspects of rock's male gendering. This quotation, which I pulled from alt.fan.courtney-love, although somewhat crude and perhaps out of place in an academic essay, expresses what I mean quite clearly:

> I've never heard this issue taken seriously before, I just seen the situation kinda laughed at, referred to as part of the lifestyle, i.e. rock is meant to be all about powerful sexy men and powerless girls on their knees sucking off the stagehand for a glimpse at God. Are there any guys out there who'd be willing to suck off a stagehand to meet Liz Phair or Courtney Love? How would the guys out there feel if it were a REQUIREMENT that they show their dicks and then suck off a stagehand to be able to meet the rock women they admired?

## NOTES

1 This situation is, thankfully, changing, as female critics like Ann Powers bring a feminist sensibility to the music editorship of influential review journals, and published anthologies of writings by women on rock begin to appear, such as *Rock She Wrote*, edited by Powers and Evelyn McDonnell (1995).

2 See, for example, David Shumway's discussion of early Elvis Presley performances on US television in the mid-1950s: 'Elvis first reached a national audience on television, and a strong case can be made that the visual aspects of these performances were as significant in defining rock and roll as were the formal features of his music (1992: 125).

3 Glam rock is the obvious example which would refute this argument. However, I would argue that glam rockers such as T Rex, Roxy Music and the New York Dolls managed to perform the hypersexualised masculinity I refer to even while appropriating visual markers such as femininity via dress and make-up. Even David Bowie, for whom gender-bending is a hallmark, did not hesitate to 'perform masculinity' even in his most androgynous phases. For example, the original cover art for *Diamond Dogs* may have portrayed Bowie as a futuristic dog, but the physical sign of his 'masculinity' was literally hanging out for all to see. The offending bits were airbrushed out of the cover of the US release.

4 Information provided is from a personal interview with Chris Brokaw, lead guitarist for Come, designated by *Rolling Stone* (12 Jan. 1994) as Liz Phair's Svengali.

5 For example, black leather jackets and tight blue jeans signify sex, rebelliousness and 'rock and roll' when worn by a man. The same black leather jacket and tight jeans signify very differently when placed on a woman in a rock context. The woman is either discursively coded as a tomboy or a slut. Signifiers of rebelliousness and sex signify differently, therefore, in terms of gender performativity. When a woman appropriates performative aspects of the 'wrong' gender, discursive correctives are immediately introduced.

6 Sexuality, race and other axes of analysis could also be substituted for gender in the formulation.

7 For example, see Walser's description of heavy metal music and gender in Chapter 4 of *Running With The Devil: Power, Gender, and Madness in Heavy Metal Music* (1993).

8 Nike, for example, has used the Beatles' *Revolution* and The Stooges' *Search and Destroy* as the soundtracks to television ads.

9 Stallybrass and White (1986) list surrealism and expressionism as examples of bourgeois bohemias.

10 A derisive term coined by Courtney Love to refer to male America 'alternative' bands and singers.

## REFERENCES

Aaron, C. (1994) *Village Voice Pazz and Jop Supplement* 1 March 1994.

Attali, J. (1989) *Noise: The Political Economy of Music*, Minneapolis: University of Minnesota Press.

Butler, J. (1990) *Gender Trouble: Feminism and the Subversion of Identity*, New York: Routledge.

Butler, J. (1993) *Bodies that Matter: On the Discursive Limits of 'Sex'*, New York: Routledge.

Clawson, M. (1993) '"Not Just the Girl Singer": Women and Voice in Rock Bands', in S. Fisher and K. Davis (eds) *Negotiating at the Margins: The Gendered Discourses of Power and Resistance*, New Brunswick: Rutgers University Press.

De Lauretis, T. (1987) *Technologies of Gender: Essays on Theory, Film, and Fiction*, Bloomington: Indiana University Press.

Frith, S. and McRobbie, A. (1990) 'Rock and Sexuality', in S. Frith and A. Goodwin (eds) *On Record: Rock, Pop and the Written Word*, New York: Pantheon.

Gottlieb, J. and Wald, G. (1994) 'Smells Like Teen Spirit: Riot Grrrls, Revolution and Women in Independent Rock', in A. Ross and T. Rose (eds) *Microphone Fiends: Youth Music and Youth Culture*, New York: Routledge

Grossberg, L. (1992) *We Gotta Get Out of This Place: Popular Conservatism and Postmodern Culture*, New York: Routledge.

McDonnell, E. and Powers, A. (1995) *Rock She Wrote: Women Write about Rock, Pop, and Rap*, New York: Delta.

McRobbie, A. and Garver, J. (1976) 'Girls and Subcultures: An Exploration', in S. Hall and T. Jefferson (eds) *Resistance through Rituals: Youth Subcultures in Post-War Britain*, London: Hutchinson.

O'Brien, L. (1995) *She Bop: The Definitive History of Women in Rock, Pop and Soul*, New York: Penguin Books.

Reynolds, S. and Press, J. (1995) *The Sex Revolts: Gender, Rebellion and Rock 'n' Roll*, Cambridge, MA: Harvard University Press.

Rohlfing, M.E. (1996) '"Don't Say Nothin' Bad about my Baby": A Re-evaluation of Women's Roles in the Brill Building Era of Early Rock 'n' Roll', *Critical Studies in Mass Communication*, 13(2).

Shumway, D. (1992) 'Rock & Roll as a Cultural Practice', in A. DeCurtis (ed) *Present Tense: Rock & Roll and Culture*, Durham: Duke University Press.

Smith, M. (1992) 'Sexual Mobilities in Bruce Springsteen: Performance as Commentary', in A. DeCurtis (ed.) *Present Tense: Rock & Roll and Culture*, Durham: Duke University Press.

Stallybrass, P. and White, A. (1986) *The Politics and Poetics of Transgression*, Ithaca: Cornell University Press.

Thornton, S. (1996) *Club Cultures: Music, Media and Subcultural Capital*, Hanover, NH: Wesleyan University Press.

Walser, R. (1993) *Running with the Devil: Power, Gender, and Madness in Heavy Metal Music*, Hanover, NH: Wesleyan University Press.

# Part II

# MASCULINITIES AND POPULAR MUSIC

# 5

# LITTLE RED ROOSTER v. THE HONKY TONK WOMAN

Mick Jagger, sexuality, style and image

Sheila Whiteley

## INTRODUCTION

There is often a temptation to interpret the meaning of popular music through clusters of adjectives which articulate a stereotypical and pre-defined sexuality. 'Brutal, menacing, erectile, tough' are words that are embedded in the folk wisdom of rock. They simultaneously identify, describe and characterise the macho style of performance which was to be coined 'cock rock'.[1] It is not difficult to substantiate these adjectives by reference to the early career of the Rolling Stones, and yet a closer examination of Jagger's performance style suggests a more complex gendered identity. The songs may imply a heterosexual mode of address. There is generally an emphasis on the penis as the absolute insignia of maleness, but live performances disrupt any notion of 'normative' masculinity. Rather, they involve a self-presentation which is, at one and the same time, both masculine and feminine. As 'the king bitch of rock', and with a performing style derived largely from a careful scrutiny of Rudolph Nureyev and Tina Turner, Jagger promised fantasy gratification to both the heterosexual and the homosexual.

It is thus suggested that Jagger's performance style opened up definitions of gendered masculinity and so laid the foundations for self-invention and sexual plasticity which are now an integral part of contemporary youth culture. In Manchester the 'in clubs' of the 1990s are characterised by a new 'campness'. Masculinity has been replaced by a parody of the feminine, and transvestism is becoming an established part of the music scene.

My analysis of Jagger is based on the premise that performers and per-formances provide a particular insight into the meaning of rock and that this is different from listening to a song (on a CD, tape, record or radio). In the first instance, the imagination is freed to interpret the way that the

text structures meaning; in the second, attention is drawn both to the song and away from it as the singer imposes a particular interpretation of the lyric content. It is also suggested that identification with a band contextualises performances, that the experience of the song is shaped by what has gone before. *Their Satanic Majesties Request* (1967), for example, was greeted with adverse criticism as it failed to conform to the expectations of a band classified as rhythm and blues. It is equally suggested that perceptions of a band are partly shaped by the media and that press reports of, for example, licentious behaviour not only feed the image of the band but equally inform the reception of a song. A singer who has raped a fan, for example, would have little credibility as a romantic icon. Alternatively, a group who are associated with 'sex appeal' may well benefit from press reports which sensationalise their ability to attract 'desirable women'.

Thus, it is suggested that Jagger's role as singer is analogous to that of a complex character in an unfolding drama. He was, is Little Red Rooster, Jumping Jack Flash, Lucifer, the Midnight Rambler. His creation of a developing persona suggests an identity that is gendered and, at times, only ambiguously sexed. The effect is to provide a constructed 'reality' in which he assumes an iconic embodiment of power[2] which offers specific insights into the relationship between audience and performer.

## FROM COCK ROCKER TO DOMINATRIX

Early descriptions of Mick Jagger are remarkably consistent: sexist, an enemy of decency and society, uncompromising, rough, sensual, rebellious. It would be tempting to suggest that these images were initially encouraged to compensate for an early lack of musicianship. Charlie Watts was an accomplished drummer and constantly propositioned by other groups. Keith Richards was equally acknowledged as a fine guitarist. Brian Jones demonstrated a mastery of rhythm guitar, whilst Bill Wyman was recognised for a solid bass guitar technique. In contrast Jagger was a basic guitarist, a limited harmonica player. As lead vocalist his voice was unexceptional, a cross between Cockney and a pseudo-American accent derived from such artists as Chuck Berry, Muddy Waters and James Brown.[3] There was, however, little sense of pastiche in his performance. Jagger's art was to project sex and manipulate his audience. 'He knew how to bring them up and he knew how to tease them and taunt them.'[4] 'His act is to put himself out like bait and click away just as the jaws are about to close'.[5]

The early success of the Stones is well documented. In part it is

attributable to the 1960s British rhythm and blues scene, with Jagger and Watts gaining experience in Alexis Korner's legendary band, Blues Incorporated. In June 1962 the embryonic Stones gave their first performance 'Brian Jones and Mick Jagger and the Rollin' Stones'. In January 1963, having replaced drummer Tony Chapman with Charlie Watts and securing Bill Wyman as bassist, the band went on the club circuit with a repertoire based largely on Berry/Diddley material. After an 8-month residency at the Crawdaddy Club, Richmond, the band attracted the attention of Andrew Loog Oldham. Formerly in public relations, he recognised the potential of the band's nihilistic image and, as their manager, promoted them as sensual, insolent and undesirable. In terms of market potential, it was a shrewd move. The Beatles were fast becoming established as a clean-living, clean-cut Beat band and the Stones provided an ideal counterpart. Jagger's stage performance exploited the sexual connotations of the lyrics and Oldham's prime objective was to publicise the image and secure a recording contract. Executive Dick Rowe (probably best known for having once turned down the Beatles) recognised the group's potential and signed them to Decca.

On June 7 1963 their first single, a cover version of Chuck Berry's 'Come On' was released, and they made their first TV appearance on ITV's *Thank Your Lucky Stars*. Whilst the record only edged into the lower end of the UK Top 30, their next single, Lennon/McCartney's 'I Wanna Be Your Man', made the Top 20. Compared with the Beatles' version (best remembered, perhaps, for its coda of improvised blues riffs over a mixture of whoops, shouts and harmonised repetitions of the refrain line), the Stones displayed a rawness in delivery with Jagger, in particular, subverting the connotations of 'want' to one of possession through an overtly arrogant delivery. 'Not Fade Away' (Buddy Holly, February 1964) took the Stones to Number 3 on the British charts and heralded their first inroad into the American market. Although stylistically reminiscent of Bo Diddley, the song is again dominated by Jagger's swaggering delivery. *The Rolling Stones*, their first album, was released in April 1964 and went directly to the top of the popular music album charts, a position held by the Beatles for almost all the previous year. 'It's All Over Now' (Bobby Womack, 1964) provided their first British chart-topper.

It was, however, the controversy surrounding the band's cover version of Willie Dixon's 'Little Red Rooster' (1964) that finally established their reputation. Riots had broken out in Chicago when the Stones had attempted to give press interviews after recording the 'Five by Five' EP with Chess Studios. With 'Little Red Rooster' banned in the States for its overtly sexual lyrics, it is not too surprising that the attendant publicity

propelled the Stones into the limelight. Although arguably influenced by Muddy Waters and in a Chicago urban blues style, the characteristic sensual astringency of Jagger's vocal predominates. Indolent with sexual innuendo, and accompanied by a guitar slide which ranges from a throb suggestive of arterial blood to a quivering scream, the final verse links 'my' little red rooster to the penis itself. The record, not surprisingly, went to the top of the UK charts.

The sense of arrogance, which was already characterising the Stones' musical performance, was reflected equally in their public behaviour. Returning to London after their fifth tour of England, the Stones had pulled into a garage where Wyman had urinated against the wall. According to the station attendant, his behaviour 'did not seem natural or normal'. He was 'running up and down the forecourt, taking off his dark glasses and dancing'. Then 'eight or nine youths and girls got out of the car'. Sensing trouble, Keeley (the attendant) had told the driver of the car, Mick Jagger, to get them off the forecourt. Jagger had pushed him aside and said: 'We'll piss anywhere, man.' The phrase was taken up by the others who repeated it 'in a gentle chant'. One danced to the phrase.[6]

The publicity surrounding Wyman's plea 'I happen to suffer from a weak bladder'[7] and the payment of 15 guineas costs, the subsequent interview in Melody Maker 'Would You Let Your Daughter Go With a Rolling Stone?', and the ensuing riots following performances on their UK tour fed the public imagination – 'leering Rolling Stones locked in a savage embrace with an innocent young girl'. True or false, the image was too strong to be easily forgotten.

As a construct, the image was enhanced through performance. Bill Wyman appeared to endlessly chew gum, standing to one side, surly, bored and indifferent. Charlie Watts epitomised the mindless drummer, sagging jaw and drooping mouth. Brian Jones had a permanent pout crossed with a leer and an equally aggressive manner. At the start he characterised the image of aggression that was to be associated with the Stones as a band.

> On stage he appeared to incite every male in the room to hit him. He would deliberately play at someone's chick, and when the bloke got stroppy, he'd slap a tambourine in his face. The aggression had a tremendous sense of impact.[8]

Jagger had already established his reputation as a 'sexy' performer:

> he used to wiggle his arse – it was lovely . . . That was the best

time, although predictable, knowing that every time you did a certain set at a certain time, everything would explode. And sure enough it did, and it always ended up in an absolute . . . gyrating riot.[9]

This sense of predictability is equally present in early Stones' classics. There is a reliance on four-square rhythms, harmonic drones and negligible chord progressions. 'The Last Time' (February 1965), for example, is heavily riffed with a repetitive, loping guitar technique which results in a sense of perpetual motion. Mainly constructed on a harmonic-cum-melodic riff (E7-Bm7-E7-A) which supports the repeated vocal phrase, the effect is quintessentially dance-oriented. Initially the vocals come across as somewhat light, but at the same time there is an insidious slipperiness which is difficult to define and which leaves a ranker overall impression. Drawing on Jagger's already established image as 'Little Red Rooster'/'King Bee', there is a menacing swagger, the caustic tone constructing a musical gesture of male sexual autonomy.

Originally written as a 'bible' song by Pa Stapler for the Stapler Singers, and with the lyrics suitably amended by Jagger, the song is transformed into a projection of goading sexuality: sex on Jagger's terms. In particular, the repetitive structure of the chorus conveys the impression of a taunting chant, a hook line which attaches itself to the listener, pulling him/her into the experience of the song. The effect is to chorus assent. The listener's tendency to take possession of suitably formed phrases, chants, hook lines, ensures a sense of vicarious identification. The memorability of the chorus ensures that the words are admitted into consciousness, so effecting a certain complicity with Jagger's portrayal of aggressive and uncaring masculinity.

This sense of the 'uncaring' was equally prevalent in the band's attitude towards their fans.

They didn't seem human, they were like children off another planet, impossible to reach . . . They crossed towards the stage door and this was what the girls had been waiting for, this was their chance, so they began to surge and scream and clutch. But then they stopped, they just froze. The Stones stared straight ahead, didn't twitch once, and the girls only gasped. Almost as if the Stones weren't touchable, as if they were protected by some invisible ring. So they moved on and disappeared. And the girls went limp behind and were quiet. After a few seconds, some of them began to cry.[10]

With publicity celebrating the Stones' essential sense of 'otherness', calling them 'untouchable', 'god-like', and with songs expressing an overtly macho attitude, it is not surprising that Frith and McRobbie initially tended towards a deconstruction of style whereby performance was interpreted as a simple manifestation of cock rock:

> an explicit, crude and often aggressive expression of male sexuality – it's the style of presentation that links a rock 'n' roller like Elvis to rock stars like Mick Jagger, Roger Daltry and Robert Plant. . . . Cock rock performers are aggressive, dominating and boastful and they constantly seek to remind the audience of their prowess, their control . . . [11]

Jagger's delivery, whereby musical gesture is embedded within an overtly phallocentric performance style, would appear to conform to Frith and McRobbie's identification of the aggressive and boastful male. '(I Can't Get No) Satisfaction' (1965) is dominated equally by Jagger's assertive delivery and the lead guitar riff with which the song opens. The bare texture is underpinned by the deliberate punctuation on rhythm guitar which works to establish a powerful four-in-a-bar pulse. The verse is equally sparse, driven by overlapping riffs which support the fragmented vocal line. At the same time, there is an underlying tension, as the slow triplet rhythm of the opening words moves against, and frustrates, the relentless flow of the four-beat time.

Sexual arousal is musically encoded by the ascending sequence, the push towards the climactic 'get', the slide down to 'no' which prefaces the more languorous delivery on 'satisfaction' which is itself subjected to a more intensive sense of arousal in the repetitive fade-out. While the lead guitar emphasises the rhythm of the words through strongly accented chords, the rhythm guitar returns to the opening riff, increasing the level of excitement through a precise and calculated rhythm which works to undercut the losing streak inferred by the words. The insistent pulsating guitar riff, and the sexual connotations of '(I Can't Get No) Satisfaction' make it apparent that Jagger's appetite is insatiable and that no one person is capable of satisfying it. On disc, the song acquires its particular force from the graphic dislocation between the triplet rhythm of the opening phrase and the four-in-a-bar beat. In theory, it is a simple procedure. In effect, it provides a precise musical equivalent of grinding, physical blockage. In performance, this sense of excessive sexual drive was even more overt. Conquests are counted, as the connotations of 'try' are linked to the faceless 'you' in the audience. This mood of aggressive sexuality was

heightened in the Stones' late 1960s tours when a huge blown-up phallus dominated the stage.

Whilst it would be simplistic to suggest that masculinity in rock is determined by one all-embracing definition, Jagger's performance, allied to the phallus, appears unequivocal in establishing a male-dominated agenda. With pleasure, empowerment and satisfaction centred on the penis, the woman is defined as 'other', a sexual commodity whose role is to gratify. Identification with Jagger, then, offers a fantasy escape from humdrum reality into a world which promises a mythical power over women.[12] As Frith and McRobbie point out: 'Cock rock presents an ideal world of sex without physical or emotional difficulties, in which all men are attractive and potent and have endless opportunities to prove it.'[13] The emphasis, however, is on an ideal world, a world where women conform, to male fantasy. Repressed, she can be liberated by sexual servicing ('Little Red Rooster'); a challenge, she can be controlled ('Under My Thumb'). The woman who defines her own sexuality, who refuses to conform, would appear, potentially, to pose a threat. But even she is containable. As sexually aggressive, she can only be 'doomed and unhappy'.[14]

Whilst there are certain songs which lie outside Frith and McRobbie's identification of stereotypical women (e.g. 'Angie') as they, themselves, point out, 'even the most macho rockers have in their repertoires some suitably soppy songs with which to celebrate true (lustless) love' where there are 'messages of male self-doubt and self-pity'.[15] In general, however, the songs seem to reflect an obsession with dominance, power and aggressive sexuality.

This sense of the all-powerful male is equally present in the shock value of the Stones' visuals. The bound and gagged woman in the Hollywood billboard for *Black and Blue* with its slogan 'I'm black and blue with the Rolling Stones and I love it' presupposes an audience, traditionally a central taboo in sexual acts. The photo says 'Look at this. This woman is there for you to look at and you will enjoy looking at her.' There is a vicarious sense of ownership and a fluidity of engagement. The photo may evoke fantasies, memories of pleasures enjoyed by the spectator. There is also the possibility that the spectator (male or female) can identify with the woman in the picture, or that the woman (through the adoption of a masculine subject position) can identify with the Stones and their sense of power. Whatever position is adopted, the cock rock identification of the woman as 'anti-freedom, the ultimate restriction'[16] is symbolically subverted. Leather thongs highlight the body, reinforcing and, at the same time, redefining the emphasis on restraint and restriction as the woman willingly submits to the dominance of the Stones ('and I love it'). Pain, the act of

being tied up, tied down, 'Under My Thumb' is thus transformed into an act of pleasure. The photo says that this woman, and so perhaps all women, do really pleasure themselves in this way.

Within the public arena of press reports covering their 'private' lives, the Stones equally appeared to possess the right sort of power to attract desirable women. Marianne Faithfull and Anita Pallenberg both epitomised the desirable face of the 1960s – blonde, leggy and with a promise of sensuality. Brian Jones, in particular, confirmed the image of the archetypal cock rocker. His up-front, extravagant appearance, his succession of girlfriends, assaults on women, and illegitimate children were a public endorsement of the sexually aggressive, potent and macho stance of the music. It is hardly surprising, then, that the Stones increasingly attracted a male audience. With publicity confirming the image of the dominant male/submissive female, and songs expressing a defiant sense of self-assertion, there was a positive affirmation of hegemonic masculinity. As Hotchner points out:

> Prior to the advent of the Stones and the r&b music they played, audiences were very much segregated. If you went to a concert, the girls were all in the front and the guys in the back drinking beer, making derisive noises about the whole thing. . . . However, the Stones turned that around. Guys started sticking posters of Mick and Brian up on their walls and what happened was the audience became much more integrated. Then, it was the boys fighting their way to the front as much as the chicks. . . . The Stones ignited that and Jagger in particular.[17]

With the Stones ideologically defining the position of masculinity and femininity through an emphasis on sexual prowess, songs can be interpreted as acting out a particular sexual iconography. There is little subtlety or gentleness, no coaxing to orgasm, rather a rhythmic obstinacy, reiteration to excess and an obliterating emphasis on high decibel sound. As such, the structure of the music, the hypnotically repetitive phrases, coupled with the exhibitionist style of performance, push towards a sexual energy which, in turn, is emphasised by the slogan-like repetition of key phrases: '(I Can't Get No) Satisfaction', 'Let's Spend the Night Together'. As Jo Bergman, the Stones' publicity officer, pointed out, their lyrics weren't exactly subtle. Jagger had suggested releasing the title track 'Let It Bleed' as a promotion for their new album, but Jo had felt them to be too risky. '"Well, they're not just dirty, I mean they're *double entendre*," Mick said. "If you want someone to cream on, you can cream on me, is a pretty single *entendre*," Jo said.'[18]

Can it be argued, then, that the Stones' songs lack a sense of multi-codedness, that they work simply at the level of 'single *entendre*'? In terms of the music itself, there is little scope for contradiction. Rather there is an overall reliance on a standardised format. In terms of lyric content, the songs display an overt preoccupation with sexuality and physical gratification. As such, the Stones' music would appear to conform to a macho imagination. However, while the music and publicity would suggest a phallocentric drive and so conform to Frith and McRobbie's definition of cock rock, certain songs would suggest that the mode of address was not confined simply to the heterosexual male. Rather, Jagger provides a space for alternative sexual definitions and an openness to sexuality to include both the heterosexual and homosexual.

'Cocksucker Blues', for example, remains phallocentric in its emphasis on eroticism as a fixed object (cock, arse) and through a masculine mode of address (fuck, suck). As Easthope points out:

> swearing is aggressive, and so an exercise of the masculine ego. Aggression is particularly apparent in the repetition of 'fuck' as verb, adjective and noun. . . . [It] may recall its relationship to the German word *ficken*, to strike. 'Fuck' generally supposes that an active male does something to a passive female.[19]

There is, then, a certain sense of sexual ambivalence. Its mode of address is aggressive, so emphasising the masculine ego. At the same time, Jagger assumes a certain passivity and 'self-love fixed anally'[20] and, like 'Oh, Andrew' (1966), the song provides a particular insight to Jagger's alleged relationship with Andrew Loog Oldham.

A simple classification like 'cock rock' does not take account, therefore, of Jagger's essential androgyneity, an identity which is arguably synchronised in its affirmation of bi-sexuality. As Hotchner points out:

> The way he performed, he had . . . sexual attraction for the boys. And I'm not just talking about homosexual boys – Mick aroused heterosexual guys as well. The fact is that everybody has some homosexuality in his make-up, and it was probably the first time in their lives that it had been aroused. I'm sure if you asked any of them that question, they'd have denied it. But there was a duality, especially in the Stones, no denying it . . . his [Jagger's] dual sexuality . . . upset a lot of people. But what he did on stage did not come across as vulgar. It was a very sophisticated sexual performance.[21]

It is apparent, then, that any analysis of the Stones must take account of Jagger's stage performance and the way in which it exerted a fascination at fantasy level for both sexes.[22]

> Out front the lights were down again and the crowd was on its feet, stamping, the high metal arches ringing, Mick dancing, leaping high in the air, prancing, the Black Prince, swirling flowing scarf, blue-beaded moccasins . . . [23]

> The sprawling pink stage, with its two 30-yard purple catwalks, finally becomes too small to contain him. He dances down to the left, kicking out like a drum majorette, beckoning and taunting all 20,000 faces along that curve. He springs up the right-hand catwalk, leaps to the scaffolding, climbs six feet or so and hangs there, leaning out as far as his fingertips will reach. One whole side of the Rich Stadium strains to touch hands with him.[24]

The two reviews are separated by twenty years. Both focus on what had become Jagger's hallmark, physical display with the emphasis on the body as a site of desire. At the same time, they reflect a certain shift in emphasis. Whilst the first commentary is slightly ambiguous, the Black Prince with swirling scarf and moccasins, the second shifts the emphasis towards the feminine. The performance is provocative, but this time Jagger's role is more that of the striptease, framed by 'the sprawling pink stage'.

It could be argued that the conventional body-image of the male (muscle, tension, posture, feel and texture of the body) is subverted by Jagger's stage performance. There is muscle, but somehow it is transformed by an emphasis on preening narcissism[25] to be read as a sense of 'otherness'. The play between similarity and difference is thus blurred, replaced by a fantasy of eroticism which challenges the traditional sense of masculine/feminine dualism. As Jagger himself pointed out:

> What I'm doing is a sexual thing. I dance, and all dancing is a replacement for sex. What really upsets people is that I'm a man and not a woman . . . What I do is very much the same as a girl's striptease dance.[26]

Mirroring Tina Turner and the sexual nuances in her performance, it is not surprising that Jagger's stage presence expressed both a sense of female eroticism and the polymorphic.[27] His style of dancing, his use of make-up suggested that the whole of his being was directed towards arousing both

sexes and yet, at the same time, there is the suggestion of masquerade and play. There is an open invitation to take a good look, but if Jagger were to strip the illusion would be shattered.

It would appear that Jagger's ability to arouse both a heterosexual and homosexual audience is attributable in part to his own underlying femininity. As Robert Hughes points out, 'He is a butterfly for sexual lepidopterists, strutting and jackknifing across the stage in a cloud of scarf and glitter, pinned by the spotlights.'[28] Marianne Faithfull also points to this sense of bi-sexuality.

> Mick enjoyed wearing some of the clothing of the women they [the Stones] were living with. It was this strong masculine-feminine force, which manifested itself when they were performing, that caused some people to regard them as bisexual. . . . It's almost a stylistic thing, it's the very heart of narcissism. It's just the desire, a very strong desire, to have people be in love with you. Whether it's a man or a woman isn't really very important.[29]

Although the identification of the 'strong masculine-feminine force', the bi-sexuality, is helpful in discussing Jagger's essential narcissism, the actual construction of a specific femininity would appear to be centred essentially on a notion of power. There is little suggestion of the passive female in Jagger's performance. Rather, his dominating and provocative presence suggests more the image of the dominatrix, skilful and fully aware of her ability to control experience.

> One of the great things about sado-masochism . . . you just go ahead and say 'Whatever feelings there are to experience, I will let them happen'. . . . I really am tired of this romantic model for sex where it's all supposed to be hearts and cupids and valentines. I like to be able to get dirty and rough and to tussle around and sweat and be strong. . . . The public in general thinks of sado-masochists as a bunch of blood-crazed sadists who want to commit mayhem on helpless victims. In fact, the culture is full of people who want to be tied up and have their brains fucked out . . . who are looking for a sadist.[30]

Here, it is suggested that Jagger's bi-sexuality is pivoted on implicit s/m connotations. If the public, his fans, were looking for someone to 'fuck their brains out' then Jagger, in performance, came across as the ideal dominatrix. 'Brown Sugar', for example, is essentially sadistic in its mode

of address. Focusing race hate, race lust, Jagger aligns himself with traders in flesh, the slave owner, the taster of 'brown sugar',[31] but at the same time he eroticises the image. His separate/corporate identities, Jumping Jack Flash, Tina Turner, the strip artist, Red Rooster, subvert the fantasy of torture 'I'm going to hurt you till you break' to one of catharsis 'transcend the pain and get out of your body'. As dominatrix, Jagger can enjoy the feeling of being skilled, the feeling of precision, of leading the fan through an experience and showing them something new. The audience are invited to listen in, to focus on drum beats, whipping, forbidden pleasures, the tasting of young girls, and the realisation of illicit pleasure that comes through self-knowledge and power. As Jagger once commented:

> Of course, I do occasionally arouse primeval instincts, but I mean most men can do that. They can't do it to so many. I just happen to be able to do it to several thousand people. . . it's a dialogue of energy.[32]

Again there is a link with the role of the dominatrix, the notion of power linked to an audience. 'I'm an exhibitionist, so I really like doing something that's very hot, that's going to turn on more people than just my partner. I like having an audience. I like giving people spankings in public.'[33] On stage, the emphasis on the whip is enhanced by Jagger's dextrous handling of the microphone lead with the emphasis on pleasure as the audience is, at one and the same time, taunted and teased into an act of compliance as the black female slave, 'Brown Sugar', similarly acquiesces to the demands of her master.

The image of Jagger as dominatrix is equally present in the artist Guy Peelaert's 'Rock Dreams, Under the Boardwalk' (1974). Photographs of the Rolling Stones' heads are superimposed on to the bodies of women dressed in black underwear and bondage leather. Entitled 'The Rolling Stones as Females', the image is a visual commentary on what has been condemned as the evil, decadent and perverted aspects of the Stones' public image. At the same time, the photo arguably endorses what had become the essence of Jagger's performance style, an androgynous sexuality with the emphasis on pleasure-as-power/power-as-pleasure.

### 'PLEASE ALLOW ME TO INTRODUCE MYSELF . . .'

The emphasis on power-as-pleasure/pleasure-as-power was to find its ultimate resolution in Jagger's satanic image. Attributable in part to the band's increasing involvement with the 1960s drug scene, the band had

been getting deeper and deeper into the occult. 'Led by Anita Pallenberg, Keith and Mick had developed a kind of satanic identification, as if they were openly dealing with the devil'.[34] In particular, Jagger had become fascinated with *The Master and Margarita*, a book given to him by Marianne Faithfull, and which deals with satanic fantasy.

In terms of musical development, the emphasis on satanism linked to LSD was evident in their 1967 album *Their Satanic Majesties Request*. Considered at the time to be a pale imitation of the Beatles' *Sgt. Pepper's* album, *Their Satanic Majesties* marks a shift from rhythm and blues to psychedelic rock.[35] In terms of image, it heralds Jagger's musical self-identification as Beelzebub, a role already explored in Kenneth Anger's film *Lucifer Rising*.

In the opening track, the sound functions narratively. Electronically distorted piano chords are interrupted by jangling brass to suggest, in context, the tensions of the 'outside world', reality, before the explicit simplicity of the chant-like chorus. An up-beat tempo and directness of expression has the effect of drawing the audience into the experience of the song, 'Sing This Altogether (See What Happens)'. This, then, is to be a shared experience.

The lyrics are strongly focused on imagery. An alternative experience is offered, a celebration of life itself which, in its primeval simplicity, is in direct opposition to the tensions of the outside world as implied by the jangling brass interventions in the opening to the song. Rather than open our minds, we are invited to close our eyes, to feed our heads. As such, there is the implication of an anti-intellectual response which draws on the imagery of the verse and the promise of expanded metaphysical experience.

With symbolic communication established, the song moves into the verse, the change of key providing a musical metaphor for movement into the experience itself. There are strong psychedelic associations. The vocal sound is electronically treated to suggest a sense of distance, the timbres are hazy. Suggested as points of reference, the 'pictures' work on the subconscious to evoke a sense of communality before the brass interjects, calling the initiate deeper into the experience. Here the sounds support the connotations of the lyrics. The timbre of the tabla suggests the metaphysical, the incessant drum rhythm provides a sense of continuity as fragmentary motifs on piano, guitar and bells move in and out of focus.

The second and third verses take the listener deeper into the past, the evocation of drumming suggesting both a primeval communality where man has the power to make rain[36] and the internal primitive 'now' from which rock traces its descent − 'Long live rock 'n' roll, the beat of the drums loud and bold'.[37] In conjunction with the album cover photos of

79

the Stones as Warlocks, there are also connotations of the occult. The Stones, it is suggested, have the power to take us back to an alternative past, one which celebrates the living reality of Satan.

In many ways the track draws on Brian Jones's experience of the Joujouka festival. Muslim tribesmen from the Ksar-el-Kebir province of Morocco had, for centuries, continued to worship Boul Jeloud, Father of the Skins. The ceremony took place once a year on eight consecutive nights, with the tribesmen chanting against a background of reeds and drums.

> Who is Boul Jeloud? Who is he? The shivering boy who was chosen to be stripped naked in a cave and sewn into the bloody warm skins and masked with an old straw hat tied over his face. He is Boul Jeloud when he dances and runs. . . . He is the Father of Fear. He is, too, the Father of Flocks. . . . The music grooves into hysteria, fear, and fornication. A ball of laughter and tears in the throat gristle. Tickle of panic between the legs.[38]

The description of Boul Jeloud, which accompanied Brian Jones's recording The Pipes of Pan (Rolling Stones, 1971) had been written by William Burroughs's collaborator, Brion Gysin. Jones himself had added a brief introduction: 'I don't know if I possess the stamina to endure the incredible, constant strain of the festival. Such psychic weaklings has Western civilisation made of so many of us.' It is this contrast between primitive, collective energy and its realisation in rock, and the lack of psychic strength inherent in mainstream society that informs the underlying concept of Their Satanic Majesties Request. 'Sing This Altogether (See What Happens)' provides a particular insight into rock's primitivism. There is both an explicit rejection of rational thought and a celebration of collective energy through the emphasis on rhythm and its realisation in dance. Thus the song is far more than a 'toothless and boring' response to the Beatles' Sgt. Pepper's album. There may be comparability of technique in the opening tracks – the invitation to a shared experience – but instead of drawing on the sense of a past established 'twenty years ago today', the listener is invited to share in an alternative communal experience. The emphasis on drumming, dancing, the reduction of conscious intervention, the removal of inhibitions, can thus be interpreted as a prelude to rebirth, the ego temporarily destroyed before moving on to a changed state of consciousness. Analogous to the total instinctual liberation preached by the more extreme hippy communities at the time, there is an emphasis on the annihilation of individual consciousness linked to personal freedom and

subjective experience; a recognition that the combination of drugs and music can provide a route through to the tension and eroticism to be enjoyed through pantheistic primitivism.[39] At the same time it establishes a new and dangerous sense of personal identity. Boul Jeloud, Satan, the Stones are pulled into association, and Jagger assumes his new image as Beelzebub, inviting us, his established 'tribe', to meet him in the 'Citadel'.

'Sing This Altogether (See What Happens)' ends abruptly in brassy dissonance and moves into a strident rhythm and blues introduction to the 'Citadel'. In context, the words expose the decadence and inequality of a capitalist society, the crawling peasants juxtaposed with the concrete, steel and glass of urban life. At the same time, Jagger's delivery is both inherently sexual, menacing and celebratory. The strong rhythm, the leering tone accompanying the invitation to Candy and Cathy to 'see' Jagger in the 'Citadel' appropriately recentres the phallus as the focus of worship whilst anticipating the overt hedonism in 'Sympathy for the Devil' (1968).

The contrast between the contemporary world and the mythical world of cosmic energy continues throughout the album. 'In Another Land' celebrates the acid experience, reinforcing the 1960s focus on alternative experience, changed consciousness. This theme is also picked up in 'She's a Rainbow'. Initially the song suggests a reconstruction of the Lucy image, 'the girl with kaleidoscope eyes' (Beatles, *Sgt. Pepper's*). Both women draw on colour associations, both are objects of beauty. The emphasis is on melody, with the voice fronted against a rhythmic/harmonic accompaniment. Lyrical violins and 'cellos are introduced in the chorus, adding a certain romanticism to the otherwise restrained piano line. Overall the effect is of a carefully orchestrated psychedelic ballad. At the same time, the jittery breakdown at the end of the song, the scraping strings on 'cello and violins, the distanced tolling bells are curiously chilling. It is, perhaps, the allusion to 'shooting' colours that ties the song most strongly to heroin and the curious paradox of expansion and annihilation of the self. Hallucinogens may provide a sense of oneness with the universe, but rock, like jazz, was equally a culture of narcotics, the addictive opiates that obliterate consciousness.

'She's a Rainbow' thus focuses once more on escape from reality. The final sitar coda builds on the introduction with increasing intensity before a low chord on organ, followed by electronically distanced chords, moves the listener deeper into space. A continuous bass throb is lit by splashes of electronic colour as '2,000 Light Years From Home' picks up on the theme established in the opening track, the focus on the sun, a star with fiery oceans. Soft explosions and electronically mixed sounds evoke a sense of moving through space to extend the experience of the first track.

In one sense this appears a logical development. The love of exploration and novelty, the interest in oriental mysticism and the relocation of the self through performance were integral to much progressive rock. As such, the Stones' journey into space focuses on a realisation of the self as an energised centre of a new universe. At the same time, the track suggests loneliness, a realisation that space exploration ultimately reveals more space, a space which is interrupted, this time, by distanced conversations. At this point, the seemingly disjunct tracks which suggest 'reality' ('The Citadel', '2,000 Man', 'On with the Show') achieve a sense of clarity. Contemporary life is once again held up as mindless and degenerate. Interspersed with a parody of chopsticks, the Stones return to a typical theme, the celebration of 'adult' pleasures.

Within the context of *Their Satanic Majesties Request*, Jagger's assumed role as master of ceremonies presages his emerging presence as Lucifer, the ultimate master of ceremonies. There is, then, a sense of crossing the galaxies. For the critic, the Stones may have appeared 'lost in space', *Their Satanic Majesties Request* may have relied too heavily on studio production for an essentially live band, but at the same time there is a brooding sense of fantasy which is finally realised in 'Street-Fighting Man', 'Jumping Jack Flash', 'Sympathy for the Devil' and 'Goat's Head Soup'.

Although 'Street-Fighting Man', with its harsh timbres and basic aggressiveness, is focused by Jagger's experience of the Vietnam demonstration in October 1968, it also heralds Jagger's emerging persona as Lucifer. The call to overthrow established order may evoke memories of the Stones' role as symbolic anarchists; the sentiments may be focused by their interest in activism as evidenced by Jagger's attempt to join the demonstration at Grosvenor Square,[40] but essentially the focus is on the subversive potential of rock and his sense of self-identification as disturbance. In 'Sympathy for the Devil' Jagger's role becomes firmly established. His name is Lucifer. Interspersed with grunts and screams there is a sense of self-destructive jubilation. The pounding beat has a primitive energy which evokes an ecstatic tribal response. The master of ceremonies, 'His Satanic Majesty' finally emerges. Jagger is cast as 'leader of the dance' and the final coda is explicit in its demands 'I want ya baby'.

Live performance provided a visual endorsement of the role. The Los Angeles performance (7 November 1969) is remembered by Ossie Clark as particularly frightening:

> there was a strange look on Mick's face, a kind of sneer. . . . the Stones appeared, the first note was played and the whole place erupted like a tiger roaring. I almost blacked out. This was not the

wave of adulation I was accustomed to hearing, no this was like a mob being exhorted by a dictator. And then, when Mick went into his Lucifer routine with the black and red streamers flying, the audience seemed to spit out its defiance.

He introduced himself as 'a man of wealth and taste' who had been around a long time, had taken men's souls and achieved a catalogue of Satanic triumphs. I was trembling I was so frightened. And the more the audience's reaction intensified, the more Mick baited them. I expected a riot, an explosion. . . . I couldn't shake off the scar, the ominous feelings of that night. It stayed with me. For a week or more after that, I'd wake in the night in a heavy sweat. . . . I never designed another costume for Mick. . . . It was as if he had become Satan and was announcing his evil intentions. He was revelling in this role. Frightening, truly frightening. I always knew Mick had several clearly defined personas – talk about a split personality! But this was a side of Mick never revealed before. He was rejoicing in being Lucifer.[41]

It is arguably the case that Clark's identification of 'split personality' is reflected most in the contrast between Jagger's public and private life. As Keith Richards points out, 'He's got his own vision about himself, which is not actually who he is . . . he is secluded, secretive, and paradoxical'.[42] Whilst Richards's comments centre on Jagger's private life, his stage performances equally contain a sense of 'vision about himself' which is essentially one of power and sex-violence. It could be argued that this is no more than masquerade. However, Jagger's symbolic celebration of power, sexuality and satanism provides a curious parallel with the anti-authoritarian figure of the psychedelic satanist, Charles Manson.

Manson had drifted into Haight Ashbury, San Francisco in 1967 and had founded a community couched within a structure of extreme male domination and determined by a unification of sensuality and death through the occult. The focus on ritual lent sensuality to such crimes as ceremonial flailing, the drinking of blood, murder and sadistic fantasies of all kinds. Women were essentially robots, available for both sex and murder.

The symbolic celebration of the anti-authoritarian figure is strangely paralleled in the figure of Mick Jagger, where his satanic role-play evoked a response mid-way between devotion and horror.

As long as Jagger was only Satan on stage, the symbolic unity of unmitigated sex-violence was acceptable . . . when that symbolism began to realise itself in the real social assembly it became horror.

Rather than the culture hero representation of sex-violence without bounds, the social practice of the audience began to transcend the symbolic and transmit the utopian into practice. In a cloud of subjects swarming over one another, death and sensuality were united and what they exposed was civilisation in the nascent state.[43]

At Altamont, the hooliganism associated with many of the Stones' earlier concerts became a massive certainty when LSD was tied to orgiastic exhibitionism.

'And then it happened. Mick wrapped his cloak around him and the band struck up "Sympathy for the Devil", Mick's definitive Satan song in which he introduces himself as "a man of wealth and taste . . .". The Angels went berserk, the sickening sound of their smashing pool cues competing with the music.'[44] A young girl was clubbed right in front of Jagger as the stage became over-run with Angels. '"Rape, murder, it's just a shot away," Mick sang over and over.'[45]

In the Manson murders there was chaos, a commission of violence, rape and murder ideologically fused with a vision of occult sensuality. With Jagger, a similar position emerges. The symbolic celebration of satanism as presaged in *Their Satanic Majesties Request*, the association of Lucifer as Lord of the Dance, suddenly moved towards an enactment in reality.

What were those two people doing? It looked as if they were dancing and there was a flash of something shiny. The cameraman, his eye to the camera, said, 'What the hell goes on, two people dancing with all this shit going on?' The camera was on it, but what had happened was too fast for us. As it turned out, the camera had recorded the killing of the black kid. The dance we thought we saw was a dance of death.[46]

In retrospect, it would appear that the unprecedented and excessive violence at Altamont was due to the take over by Hell's Angels, whose policing of the concert was characteristically brutal. Initially, the Stones appeared out of their depth and unable to perform, but as they regained confidence the delivery of such songs as 'Midnight Rambler' and 'Brown Sugar' appeared to feed the volatile mood in the auditorium. 'Midnight Rambler' with its macabre lyrics, the night killer who waits in corridors with a knife ready to stab a victim, was particularly apposite to the occasion. In retrospect, it would appear unlikely that such songs would calm the already explosive atmosphere.

The Stones' role at Altamont raises once again the question of the

relationship between performer/audience, the performance, and the musical text itself. At one level, it could be argued that such songs as 'Midnight Rambler', 'Brown Sugar', 'Sympathy for the Devil' express particular insights into society. They are simply a personal expression of how society is. At the same time, it has to be acknowledged that no text has one definitive meaning, rather they work symbolically, connecting with the individual needs and experiences of the audience. As Grossberg points out:

> different people have different interpretive resources, just as they have different needs. A text can only mean something in the context of the experience. Equally important, texts do not define ahead of time how they are to be used or what functions they can serve.[47]

The unmitigated violence at Altamont suggests that for many the songs were interpreted as inciting brutality, that they provided a model for behavioural patterns. Jagger's stage performance, with its emphasis on satanism/sexual brutality can then be interpreted as both an expression and an active constituent in establishing particular behavioural patterns – this is how you can live/behave. As Roszak points out:

> even when crudity is meant to satirize or reply in kind to the corruptions of the dominant culture, there is bound to come a point where sardonic imitation destroys the sensibilities and produces simply callousness. . . . How is one to make certain that the exploration of the non-intellective powers will not degenerate into maniacal nihilism?[48]

Can it be argued, then, that Jagger's acting out of obsessive violence in such songs as 'Midnight Rambler' promoted instability?

> I saw him as he came down, burying a long knife in the black man's back. Angels covered the black man like flies on a carcass . . . five others joined, kicking the boy's head in. Kicked him all over the place. And then the guy who started the whole thing stood on the boy's head for a minute or so and then walked off.[49]

It would certainly appear that Jagger's position as symbolic anarchist resonated with the attitudes of the Angels who took on board the tensions and expressions of violence in the songs and reinterpreted them into their own experience. Impossibility, such as his self-presentation as Lucifer/the

Midnight Rambler, proposed 'other' meanings or realities which transcended the song itself and thus produced meaning by playing on ambivalence. Because 'Midnight Rambler' proposes a narrative structured upon a sexual/murder fantasy, the song presents something which cannot be, but which, through performance, is. As such, the song is not merely a projection of human fears and desires. Through a process of identification, it is equally a projection of what can be. At this level, the music can be interpreted as a symbol of solidarity with a vindication of violent action.

As Joli Jenson points out:

> The frenzied fan in a crowd is also perceived to be vulnerable, but this time to irrational loyalties sparked by . . . celebratory figures. As a member of a crowd, the fan becomes irrational, and thus easily influenced. If she is female, the image includes sobbing and screaming and fainting, and assumes that an uncontrollable erotic energy is sparked by the chance to see or touch a male idol. If he is male, the image is of drunken destructiveness, a rampage of uncontrollable passion. . . . If the fan ceases to distinguish the real from the imaginary and lets emotion overwhelm reason and somehow 'get out of control', then there are terrible consequences. These consequences are referenced in the cautionary tales of fans who go 'over the edge' into fanaticism, and thus pathology.[50]

Although Jenson points out that such pathological portrayals tell us more about what we want to believe about modern society than they do about the actual fan, there is nevertheless a certain relevance to the events at Altamont.

> A fat, black-haired girl, naked to the waist, was dancing, squeezing her enormous breasts, mouth open, eyes focused on a point somewhere north of her forehead. As the song ended, the girl, her skin rose-florid, tried to take the stage. Completely naked now, she climbed over the crowd to get a foot on stage, but five Angels were at once between her and the Stones. They kicked her and punched her back, her weight falling on the people behind her.[51]

Whilst the arrogance and brutality inherent in the songs suggest a certain correlation with the events at Altamont it would, nevertheless, seem somewhat simplistic to posit an unproblematic stimulus/response interpretation. Jagger might introduce himself as Lucifer, as 'the Midnight Rambler', but

overall it is suggested that his role was more that of the symbolic anarchist, expressing the right to personal freedom, the freedom to experience. As such, he provides an insight into degeneracy rather than an incitement to a pseudo-tribal response.

While Jagger's bewilderment over the violence against fans at a free peace-and-love concert is well documented, his reaction to the Maysles brothers' film of Altamont is interesting. The Stones:

> watched the screen intently and our cameras recorded their faces, which were expressionless, especially Mick's. When the film ended, there was a long silence, then Mick asked us to show it again, which we did. Again, Mick showed no expression on his blank face. He didn't say a word to anyone. He didn't look at Keith or anyone else, and he said nothing to us about the film itself. He just got up and walked out. So did the others.[52]

Clearly Jagger's reaction could be one of psychological distancing from the horror of Altamont. At the same time, there is a certain sense of fatalism. If Clark was right, and Jagger was indeed 'rejoicing in being Lucifer',[53] then the relationship between satanic identification and indifference is similar to fatalism where responsibility for both good and evil are located outside the merely human. Within the context of supernaturalism, human action is thus seen as operating under the controlling influence of providence; human responsibility is displaced on to the level of destiny. As Keith Richards points out: 'you can't be God, you can't ever pretend to play at being God. You don't shoulder any responsibilities when you pick up a guitar or sing a song because it's not a position of responsibility.'[54]

Jagger had been equally consistent in his refusal to accept any responsibility for leadership of allegiance on the part of his fans. His statement which appeared after the Harker trial may have referred to drug usage but it would appear also to reflect his belief in the autonomy of the individual:

> As far as I am concerned we did pretty well because we never said everyone should take this or that. We never said you shouldn't. We just left it up to everyone else which is the way it should be. Which is my version of responsibility.[55]

Altamont, then, can be read as a chilling metaphor for the way in which performance, musical experience and social reality can fuse together: one murdered, total dead four, two run over, one drowned in a drainage ditch, hundreds injured and countless more stoned on acid. Jagger offered no

explanation, no apology. Rather, the impression is one of fatalism and a rejection of personal responsibility:

> We gonna kiss you good-bye, and we leave you to kiss each other good-bye. We're gonna see you, we're gonna see you again, all right? . . . Well, there's been a few hang-ups you know but I mean generally I mean you've been beautiful . . . you have been so groovy. . . . Kiss each other goodbye.[56]

## RETURN OF THE HONKY TONK WOMAN

'Sympathy for the Devil' was not performed live again for another six years. In retrospect it is tempting to suggest that the decision was prompted by its Luciferian associations, the focus on the song's historical mayhem juxtaposed with the grim reality of Altamont itself. As such, Decca's release of *Get Yer Ya-Ya's Out* (29 September 1970) may read like a callous and opportunistic retrospective on Altamont in its collation of such songs as 'Midnight Rambler', 'Street-Fighting Man' and 'Sympathy for the Devil'. But then, as Keith Richards revealed in 1970:

> We found out, and it wasn't for years that we did, that all the bread we made for Decca was going into making little black boxes that go into American Air Force bombers to bomb fucking North Vietnam. They took the bread we made for them and put it into the radar section of their business. When we found that out, it blew our minds.[57]

Richards's response focuses the band's basic dilemma. In terms of personal conscience, Decca's investment in the 'little black boxes' stood for a misappropriation of the capital amassed for Richards/Jagger songs. At the same time, the bonding between audience and performer, which was fundamental to the Stones' essential sense of cultural and political subversion, had ultimately resulted in the death toll at Altamont. On the one hand, it was possible to sever ties with Decca and establish their own label, so placing them outside of the constraints and opportunism of the capitalist music business; on the other hand, the dilemma of personal direction was less easy to solve. It could be argued that the Stones were not unique in this respect. The early 1970s generally were characterised by a sense of underlying pessimism. The casualties at Altamont were curiously reflected at a macrocosmic level in the death of the decade itself: Martin Luther King

and J.F. Kennedy had been murdered; Hendrix and Joplin were dead – the former through an inhalation of vomit following barbiturate intoxication, the latter from an overdose of heroin. Jim Morrison had died of a 'heart attack' in Paris; Brian Jones had drowned in a swimming pool, the coroner's verdict: 'death by misadventure'. Marianne Faithfull, who had followed Jagger to Australia where he was to star in the ill-fated movie *Ned Kelly*, was to attempt suicide and Jagger was to break the relationship. At Kent State University, four students had been shot dead, tragically proving the depth of the gulf between those who wanted to change America and its policies in Vietnam and the conservative majority who believed in law and order politics at any cost. Finally, the particular association of LSD with satanism which had resulted in the Sharon Tate murders culminated in a panic reaction to the adverse effects of drugs. Personal survival, drugs and rock ideology generally were focused by the US broadcast licensing authorities warning radio stations that they would be subverting the government's campaign against drug abuse if they mentioned lyrics which referred, however obliquely, to dope.

Was it, then, a sense of fatalism that pushed Jagger back into the role of cock rock hero? Certainly, the release of *Sticky Fingers* (1971), with its masturbatory connotations, points to a characteristic narcissism and sense of self-involvement. At the same time, there is a curious juxtaposition of autobiographical self-pity in such tracks as 'Wild Horses' (reputedly written with Marianne Faithfull in mind), 'Dead Flowers' and 'Sister Morphine', and characteristic brutality in 'Brown Sugar' and 'Bitch'. In retrospect it would appear that this was a musical exorcism of the unhappiness of the last few years – the chronic heroin addition of Keith Richards, the death of Brian Jones, the attempted suicide of both Chrissie Shrimpton and Marianne Faithfull, the death of Anita Pallenberg and Keith Richards's baby.

In contrast, *Exile on Main Street* recentres the band within rock and roll itself. Again, it could be argued that the Stones were simply following the early 1970s trend towards a rock and roll revival which was heralded by the return of Presley as a live performer. Characterised by sliding guitars, thudding bass and jangling piano the double LP featured all the fashionable and evocative colours of rock: 'Rock's Off'/'Rip This Joint'/'Hip Shake'/'Casino Boogie'. At the same time, there is a cynical sense of self-recognition, 'we are what we are publicised to be'. The cover and the style of delivery recentres Jagger as the symbol of rock's insistence on youth and its associations with downtown life. Posed against a barely legible porn-palace poster which promises 'Hedonistic Pleasures' the album cover (with its American freak-show and low-life shots, the Sellotaped annotations and

the catalogue number itself – Rolling Stones Records Coc 69100) is reminiscent of Jagger's earlier role as 'Mr Turner' in the Nicholas Roeg movie *Performance* (1969). Turner lives in a basement flat, surrounded by beautiful women, musical instruments and drugs, and is virtually cut off from the outside world. As the archetypal hedonist, he pays the price of living free. The parallels between Turner and Jagger's well publicised commitment to sex, dope and lavish autonomy are disturbingly close. At the same time, the emphasis on privacy and the ultimate destruction of the individual are equally apparent. Jagger, like Turner, is the 'exile on main street', the existential rock star hero.

At the same time, it is difficult not to read the album as a rejection of the band's transitory involvement with psychedelia, as a celebratory return to rock's roots. Why, then, the somewhat bizarre *Goat's Head Soup* (1973)? Was its title simply a reflection of the Stones' ironic sense of humour – a *pot-au-feu*, a meal in Morocco with its connotation of Boul Jeloud, 'Father of Skins'? To what extent was it a reaffirmation of the underlying liturgy of rock, the equation of sexuality with energy and dance? Or was it a retrospective on satanism, a recognition of the consequences of an albeit misguided 'Sympathy for the Devil'?

Initially, 'Dancing with Mr. D' sounds like a celebration – a return to the pagan worship of Dionysos 'Down in the graveyard where we have our tryst the air smells sweet, the air smells thick. . . . Dancing, dancing, dancing so free'. At the same time, there is a ranker undertow. 'The palms of my hands feel clammy and wet. . . . Dancing Lord take your hands off me'. Again, it is difficult not to place the song within the context of the early 1970s. In particular the lyrics evoke the fantasies of death which had dominated much of the rock music of the time: the Grateful Dead, who had released their second live double album in 1971, and had originated as the Warlocks at a time when the whole death gestalt was unfurled; the death motifs of Alice Cooper in 'Love it to Death', 'Killer', the chopping up of dolls and use of such props as boa constrictors, gallows and guillotines in live performances. More specifically, 'Dancing with Mr. D' evokes memories of Jim Morrison who had established the sex and death motifs that were intrinsic to the Doors and which were reflected in his own death in 1971. 'Now I know his name he's called Mr. D – and one of these days he's gonna set you free'.

Dance, death, sexuality and freedom are thus pulled into association as if to emphasise the fact that the spiritual catharsis of tragedy has no place within rock. Rather, rock focuses energy. If there is death, it is centred on a loss of vitality which is, itself, a simple product of ageing. Within the community of rock, the deaths of Morrison, Hendrix, Jones and Joplin

nurtured the myth of the eternal young. Jagger's role, it appears, was both to defy the process of ageing and to focus rock's glorification of energy, the recognition that the only real response to death is to get up and dance. Again, it is tempting to draw an analogy with the band's own history, the juxtaposition of Brian Jones's funeral on 10 July 1969,[58] the release of 'Honky Tonk Woman' on 11 July with its decadent lyrics and compulsive dance beat.

At the same time there is a certain sense of continuity. The 'veiled' Jagger on the record sleeve refocuses androgyny within an overall context of death, sensuality and dance. As Elaine Showalter points out:

> veiling was associated with female sexuality and the veil of the hymen . . . it concealed sexuality. Furthermore science and medicine had traditionally made use of sexual metaphors which represented 'Nature' as a woman to be unveiled by the man who seeks her secrets. . . . The veiled woman who is dangerous to look upon also signifies the quest for the mystery of origins, the truths of birth and death. . . . what lies behind the veil is the spectre of female sexuality, a silent but terrible mouth that may wound or devour the male spectator.[59]

The veiled Jagger, the shrouding of his iconic mouth with its associations of sexuality, thus brings into association sensuality and death and can be interpreted as picking up on the underlying theme of 'The Lantern' (*Their Satanic Majesties Request*), the emphasis on deathly pallor and the veiled figure, its focus on the afterlife and the need to know 'what next?'

At the same time, the androgynous figure is about *seduction*; it can only live in the shadow area of an image; once unveiled, once held to the light, it becomes a woman or a man. Jagger's veiled head, the suggestion of the feminine, the iconic significance of the 'terrible mouth' suggests a certain dualism.

> Despite its 'uniquely feminine significance', the veil is a kind of permeable border, an image of confinement and enclosure that is also extremely penetrable, 'even when opaque it is highly impermanent, while transparency transforms it into a possible entrance or exit.' It suggests the possibility of access to another sphere, another sexuality, another self. . . . similarly there is always a veiled man hiding in fin-de-siècle stories about the veiled woman. She/he reflects the ambiguity of sexual difference and the sense of guilt, decadence, transgression and sexual anarchy.[60]

Jagger's veil, his sexual ambiguity, thus serves both to enhance the underlying narcissism in performance whilst marking him as deviant and decadent.

The conflation of masculine/feminine representation which is central to Jagger's stage persona is equally structured around a 'wish come true' device. Veiled or on stage, Jagger remains an idealised representation of himself: 'Jumping Jack Flash', the eternally youthful androgyne, focus of every possible sexual appetite. Off-stage, as press photos reveal, Jagger is no more immune to ageing than his fans. There is, then, a certain analogy with Dorian Gray's search for the immortality of his beauty.

> Although Dorian's beauty is described as the beauty of 'youth', it is clear that only male youth, the 'glamour of boyhood' qualifies for the Hellenic and Hedonistic ideal of art. Beginning as a mindless specimen himself, a masculine dumb blond, Dorian begins to believe in his own destiny as the theorist of the alternative New Hedonism. . . . Dorian escapes aging by becoming art, but Wilde also uses the late nineteenth-century obsession with visible vice to suggest that the degeneration of the painting is a sexual disease, the outward sign of Dorian's sexuality in a repressive culture. . . . Dorian escapes aging by becoming art.[61]

In Jagger, too, the image replaces reality.

> Mick Jagger at 38: from a distance almost eerily unchanged – body, slight and unaware, still thick hair, but face heavily made up to hide wrinkles and deep cheek grooves. His body keeps its girlishness by hard work. As years pass, it's more daunting to reach the peak of fitness required to sing 'Jumpin' Jack Flash'. "It means going into training, then on the wagon for three months."[62]

However, as '100 Years Ago' (the second track on *Goat's Head Soup*) points out, we all dream of a past when we were young and sometimes the decision not to grow up is, in itself, a form of wisdom. There is, then, a suggestion that Jagger's role is to provide a sense of vicarious identification for his fans this sense of 'be like you were in 1969' was reflected in the Stones' subsequent albums. There is little overall change. Rather the tracks focus a confirmation of past joys. *It's Only Rock 'n' Roll* (18 October 1974) features once again the occult binarism of dance and sexuality 'And when you're kickin' high, It makes me blood run cold'; ageing returns with 'Time Waits for No-one', 'Short and Curlies' refocuses the dominant female; 'Till the Next Goodbye', the recognition of transient love that

characterised 'Angie'. There is, then, a sense of rehashing the themes that had given the Stones their original status within rock – 'cock rockers', social commentators, and an up-front sexuality developed to unprecedented levels.

The juxtaposition of new and old releases on *Made in the Shade* (1975), *Black and Blue* (1976), *Love You Live* (1977) and *Some Girls* (1978) equally return to such established themes as female subordination, transvestism and sado-masochism. At the same time, there is an underlying sense of wry humour, a recognition of 'we are who you want us to be'. The cover of *Some Girls*, in particular, with its collection of star faces shifting across the cut-outs on the outer sleeve, suggests both seaside humour, 'stick your head through the hole and be photographed as . . . ' and the camp. The title track, in particular, with its stereotypical listing of women as 'girls', Black, Chinese, White, French, Italian, American, reads like a catalogue of Stones' success stories. Each 'girl' has her own attributes but essentially they are all 'willing and submissive'.

There is, then, no real sense of change and Jagger, in the most recent 1990s concert tours, appears intent on retaining the image which has imposed a certain regime upon his performance – teasing, goading, ritualised sexuality. At the same time, the repetitious nature of his performance style has moved increasingly towards self-caricature, 'everything is intensely rehearsed, every bump, every grind'[63] and thus there is a theatrical re-enactment of sexuality, a sense of contrivance and calculation. However, if contrivance equates with choreographed and carefully staged performances, if calculated revolves around giving the fans what they pay for, then Jagger's stage presence still ensures success. This is arguably due to his tacit recognition that sexuality revolves around objects of desire which are framed within a veneration of youth culture.[64] The Stones' songs are not about a rational time sense, rather vitality with an emphasis on sexual energy. The sleeve of *Sticky Fingers* had simply featured a well-endowed crotch-shot of a pair of jeans complete with zipper, an icon to penis worship and sexual endowment, and Jagger was long reputed to be the best-hung star of all rockdom. Whether fact or fantasy, this exaggerated sense of 'who you are', allied to an inflated performing ego and 'a reported contempt for women who have been no more to him than objects of carnal desire'[65] has remained central to his image. At 53 image and reality remain conflated. Recent (October 1996) reports on his separation from Jerry Hall castigate him as a 'serial womaniser', a 'roué of rock, growing up disgracefully', a 'hanky pank woman'.

It is unlikely, however, that Jagger's latest escapade will undermine his success, rather it will underpin a continuing sense of notoriety. If rock

continues to equate with penis-worship, whether this is ritualised through cock rock, cross-dressing, female impersonation or camp,[66] the sense of 'mastery of the feminine [will] remain a masculine phenomenon'[67] and Jerry Hall, like others before her, will become little more than 'yesterday's girl'.

## A FEW FINAL THOUGHTS

As this chapter has argued, Jagger's performance style has depended largely on the development of an image which has moved from an initial categorisation of cock rock to one which suggests a more ambiguous sexuality. To an extent the identities are superimposed. The flaunting of sexuality is present throughout, whether this is represented by the Luciferian image or the self-parody evident in his more camp persona. In retrospect, it is evident that this legacy has been passed on. In the early 1970s there was an emphasis both on Glitter and Glam with its vanity, irony and emphasis on androgyneity. In the early 1980s, the emphasis was on presentation – 'designer boys, material girls'. In the 1990s, there is a resurgence of camp. Image predominates.

Whilst it is, perhaps, a cliché to suggest that we design gods in our image, there is nevertheless a certain resonance with Jagger's fictional incarnations as cock rocker supreme, androgyne, dominatrix, Lucifer. In one sense these images can be interpreted simply at the level of performance, the acting out of role. At the same time, they lock into the discourses surrounding gender and masquerade, that masculinities vary not only over time but according to setting. As discussed earlier, many of the Rolling Stones' songs can be considered gendered, in particular they exhibit specific sexist sensibilities. The themes of relationships centre around an unequal relationship in which Jagger, as singer, acts out a sexual iconography which is generally aggressive, dominating and boastful, occasionally self-pitying. Since the early 1960s, performances have often been accompanied by inflatable life-sized women and/or an inflatable phallus. The effect is to undercut any sense of self-doubt. The male world is constructed as an ideal world of sex without physical or emotional difficulties and masculine vulnerability is generally marked only by its absence. As such, it could be argued that the original discussion of cock rock by Frith and McRobbie needs only to be extended. The power of the phallus is omnipresent whether as cock rocker or androgyne.

At the same time, the extent to which Jagger's more macho persona conflicts with his androgyneity does raise problems. Clearly there is no one interpretation, but it is suggested that the mysterious image of the

androgyne sets up an enigma which is focused on the interface between sexual difference (Jagger's real maleness, the androgynous performer) and the content of the song. As singer/songwriter he voices a male perspective, but at the same time his male/female persona serves to eroticise the songs by making him both the titillating/submissive woman and the male perpetrator of violence. The effect is almost one of rape fantasy – she led me on, she got her just deserts.

While it is not suggested that the Stones directly encouraged sex brutality, it could be argued that such songs as 'Under My Thumb', such album sleeves as *Black and Blue*, provide a cultural expression of female subordination. In particular, the notion of compliance would appear to work in a manner similar to that of pornography in that it articulates the disruptive potential of sexual passion. On the positive side, it could be argued that Jagger's sense of ambivalent sexuality opened up definitions of gender which were to dominate much of the early 1970s and which are still prevalent today. In particular, they provide a framework within which the male performer and fan alike can find a range of heterosexual and homosexual expression.

## NOTES

1 Frith, S. and McRobbie, A. (1990) 'Rock and Sexuality', in S. Frith and A. Goodwin *On Record: Rock, Pop and the Written Word*, London: Routledge, p. 375.
2 The representation of Jagger's mouth with the diamond set in the right incisor is iconic in representing the essential nature of the Rolling Stones: macho, sexually dominant, anti-establishment (see for example their album sleeve *The Rolling Stones: Get Stoned: 30 greatest hits, 30 original tracks*.
3     Mick wasn't a good singer then, just as he isn't a good singer now – in general terms. But it was the personal thing with Mick: he had a feel for belting a song even if he wasn't able to sing it. He has this tremendous personal thing – which is what the blues is about, more than technique. And he had this absolute certainty that he was right.
    (Alexis Korner in Booth, S. (1984) 'The True Adventures of the Rolling Stones', *Granta*, Cambridge: Granta Publications, Penguin Books, 12, 19)

4 G. Mankowitz in Hotchner, A.E. (1990) *Blow Away: The Rolling Stones and the Death of the Sixties*, New York: Simon & Schuster, p. 163.
5 R. Hughes in Hotchner, op. cit., p. 164.
6 Booth, op. cit., p. 17.
7 Ibid., p. 17.
8 Ibid., p. 25.
9 Ibid., p. 25.
10 Cohn, N. (1970) *Awopbopaloobop Alopbamboom: Pop From the Beginning*, London: Paladin, p.140. The implications of fandom will be discussed further in the section of the chapter dealing with events at Altamont.
11 Frith and McRobbie, op. cit., p. 375.
12 Ibid., p. 382.

Shickel suggests that celebrities act to fulfil our own dreams of autonomy (the famous appear to have no permanent allegiances) and dreams of intimacy (the famous appear to belong to a celebrity community). . . . To be a fan, Shickel and others imply, is to attempt to live vicariously, through the perceived lives of the famous. Fandom is conceived of as a chronic attempt to compensate for a perceived lack of autonomy, absence of community, incomplete identity, lack of power and lack of recognition.
(Lewis, L.A. (ed.) (1992) *Adoring Audience: Fan Culture and Popular Media*, London: Routledge, p. 17)

13 Frith and McRobbie, op. cit., p. 382.
14 Ibid., p. 374.
15 Ibid., p. 382.
16 Ibid., p. 374. See also Kuhn, A. (1985) *The Power of the Image: Essays on Representation and Sexuality*, London: Routledge, pp. 38–47.
17 Hotchner, op. cit., pp. 114–15.
18 Booth, op. cit., p. 15
19 Easthope, A. (1986) *What a Man's Gotta Do: The Masculine Myth in Popular Culture*, Boston: Unwin Hyman, p. 94.
20 Ibid., p. 94.
21 Hotchner, op. cit., p. 115.
22 Hinerman, S. (1992) '"I'll be Here with You": Fans, Fantasy and the Figure of Elvis', in Lewis, op. cit., p. 110, cites Laplanche and Pontalis (1973) *The Language of Psycho-analysis*, trans. David Nicholson-Smith, New York: W.W. Norton, who offer the following definition of fantasy (or as they call it, 'phantasy'):

'. . . Imaginary scene in which the subject is a protagonist, representing the fulfilment of a wish (in the last analysis an unconscious wish) in a manner that is distorted to a greater or lesser extent by defensive processes.
Phantasy has a number of different modes: conscious phantasies or day-dreams, unconscious phantasies like those uncovered by analysis as the structures underlying manifest content, and primal phantasies. . . .'
I would argue that many of the scenes in which fans confront the images of a star today are well within the parameters of this definition and conform to the description of fantasy. From day-dreaming about a particular figure to experiencing extra-sensory encounters (both of which fill the literature of Elvis fans), part of what it means to be a fan for some people in some places clearly involves fantasy-work.

23 Booth, op. cit., p. 32.
24 Norman, P. (1982) 'What Makes the Stones Keep Rolling', *The Road Goes on Forever*, London: Corgi Books, p. 19.
25 Lacan argues that the perception of the outside as narcissistic is the way in which the ego is built, commencing at childhood and continuing through adulthood. Through this process is built what Eagleton (1983: 165) calls a 'fictive sense of unitary self-hood' by identifying with objects in the world, apprehending them as extensions of self and therefore stable in their identity. Yet the stability of the outside world is only fiction, a fiction organised around our sense that the Other (external) is a reflection of our own unitary identity and therefore as apparently unstable as the 'I' we experience.
(Hinerman, op. cit., p. 112)

For psychoanalysis the two main forms of drive are self-love and sexual love for another. . . . Basic Masculinity is mainly concerned with sexual drive: The Masculine Ego mainly about narcissism.
(Easthope, op. cit., p. 57)

26 Christgau, R., 'The Rolling Stones', cited in DeCurtis, A. (ed.) (1992) *Illustrated History of Rock and Roll*, 3rd edn, New York: Random House, p. 182.
27 Jagger's performance style was closely modelled on Tina Turner.

> Mick was fascinated with the way Tina Turner moved on the stage. He studied her every gesture, her every move, all the nuances of her performance. And when he got back to his room, he would practise what he had seen in front of the mirror, endlessly dancing, gesturing, watching himself, moving his body rhythmically, the way Tina did. What seemed spontaneous on stage was really carefully rehearsed and plotted in front of the mirror.'
>
> (Marianne Faithfull, cited in Hotchner, op. cit., p. 167)

As Easthope points out:

> In terms of the myth masculinity wants to present itself as an essence – fixed, self-consistent, pure. In fact it has no essence and no central core. Gender is marked in three areas or levels of human experience – that of the body and the biological; that of social roles; and that at which gender is defined internally in the unconscious. The myth aims to bring all three levels in a perfect unity, the completely masculine individual.
>
> But it can never work like this because the levels are distinct and never simply overlap. If we use the terms 'male' for the body, man for the social identity, and 'masculine' for the subjective tendency then we can see that they will not fit together evenly to make up 'one' individual. There are essentially two reasons for this. One is that each term can only fully be defined by its opposite – male/female, man/woman, masculine/feminine. And the other is that the body always has to be installed in its social roles (this is what growing up involves) by means of an internal subjective process. And this process, which psychoanalysis describes as unconscious, always calls into play both masculine and feminine desire inside the individual.
>
> (Easthope, op. cit., pp. 166–7)

> The account of sexuality given by psychoanalysis assumes that the human infant is polymorphously perverse, exploring without inhibition any possible avenue and site for pleasure. It also recognizes that the adult does not give up all its early pleasures but rather keeps his or her bisexual potential.
>
> (Easthope, op. cit., p. 104)

28 R. Hughes cited in Hotchner, op. cit., p. 164.
29 M. Faithfull cited in Hotchner, op. cit., p. 208.
30 S/M, June 1988.
31 With its connotations of the black woman, dope or sodomy.
32 Hotchner, op. cit., p. 165.
33 S/M, June 1988.
34 Hotchner, op. cit., p. 344.
35 Psychedelic musical codes are associated with blurred or tinkly timbres, electronic distortion, soundscapes, etc. See Whiteley, S. (1992) *The Space Between the Notes*, London: Routledge, which examines the relationship between hallucinogenics and popular music.
36 The relationship of dance to the conjuring up of rain is also present in the 'Witchi Tai To' a Kaw rain dance which was covered by Richie Havens and later by Seals and Crofts.
37 Chuck Berry, 'School Days'.
38 The description comes from notes accompanying *The Pipes of Pan*, the recording made by Brian Jones of the Joujouka festival. The notes are written by William Burroughs's collaborator Brion Gysin. See Pattison, R. (1987) *The Triumph of Vulgarity: Rock Music in the Mirror of Romanticism*, New York: Oxford University Press.

39  This is acknowledged by the adoption of such names as Grateful Dead and a philosophy which draws on both drugs and the metaphysical.

40  Jagger had attempted to join in the demonstrations against the war in Vietnam at the American Embassy in Grosvenor Square but had been recognised by both the press and fans, who had asked for his autograph. He left, realising that fame could be counter-productive. The lyrics of the song were sent to the underground newspaper, *Black Dwarf*.

41  Ossie Clark in Hotchner, op. cit., pp. 345–6.

42  Keith Richards, ibid., p. 372.

43  Ewen, S. (n.d.) 'Charlie Manson and the Family', CCCS occasional paper 53, University of Birmingham.

44  Hotchner, op. cit., p. 20.

45  Booth, op. cit., p. 92.

46  Hotchner, op. cit., p. 21.

47  Grossberg in Lewis, op. cit., p. 52. As Grossberg points out:

> Audiences are constantly making their own cultural environment from the cultural resources that are available to them. Thus, audiences are not made up of cultural dopes; people are often quite aware of their own implication in structures of power and domination, and of the ways in which cultural messages can manipulate them.
>
> (Ibid., p. 53)

48  Roszak, T. (1970) *The Making of a Counter Culture: Reflections on the Technocratic Society and its Youthful Opposition*, London: Faber and Faber, p. 75.

49  Booth, op. cit., pp. 47–8.

50  Jenson, J. 'Defining Fandom', in Lewis, op. cit., p. 15.

51  Booth, op. cit., p. 91.

52  Hotchner, op. cit., p. 347.

53  Ossie Clark in Hotchner, op. cit., pp. 345–6.

54  Keith Richards comments:

> The siege mentality kind of worries me about Mick. Nobody can get in there, even me, who's known him longer than anybody. What bothers me sometimes about him is not being able to get through to him. He's got his own vision about himself, which is not actually who he is. So he has to play a game; he has to act. He's not about to give you anything. He's not about to give anything away.
>
> (Hotchner, ibid., p. 372)

55  Hotchner, op. cit., p. 26.

56  Ibid., p. 348.

57  Ibid., p. 373.

58  During the Hyde Park concert to commemorate Brian Jones's death Jagger had attempted to revitalise the proceedings after his somewhat pretentious reading of Shelley and the abortive attempt to release white butterflies to enhance the meaning of 'he is not dead, he doth not sleep . . . '. The band played an unrehearsed performance of 'Honky Tonk Woman'.

> Mick's performance got increasingly frantic as he tried to over-compensate for the band's sluggishness, with the result that he really went overboard. He stripped off his dolly tunic and was leaping around in his vest and pants when he suddenly went to his knees, stuck his mike on his crotch and put his mouth over it, leaving nothing to the imagination as to what he was mimicking.
>
> (Hotchner, op. cit., p. 330)

59  Showalter, E. (1991) *Sexual Anarchy: Gender and Culture at the Fin de Siècle*, London: Bloomsbury, p. 145.

60 Ibid., p. 148.

61 Ibid., p. 176.

62 Norman, P. (1982) *The Road Goes on Forever*, London: Corgi Books, p. 12.

63 Hotchner, op. cit., p. 370.

64 Ibid., p. 372.

65 Marianne Faithfull also comments on such songs as 'Yesterday's Papers' which she recognised as a 'horrible public humiliation' for Chrissie Shrimpton with whom Jagger was living when he began his affair with Faithfull: '"Who wants yesterday's papers, who wants yesterday's girl . . . ". "Under My Thumb" was also about Chrissie. You see, when he got her where he wanted her, he didn't want her any more' (Ibid., p. 39).

66 The discussion of 'campness' that follows is the result of extensive discussions with friends and colleagues, male/female heterosexual/homosexual/lesbian.

   *Camp*: attitude, a parody of both 'gay' and femininity. To an extent this is an offshoot of the feminised male, an affirmation of duality. Camp takes this to an extreme through gesture, style and attitude. The mystery of the androgyne is replaced by overt characterisation. Essentially this is a male display. Women who exemplify 'camp' (e.g. Victoria Wood) tend to emphasise a tripartite relationship, a woman parodying the male as female. Equally, whilst such artists as Julian Clary exhibit 'campness', and where jokes are anally centred thus suggesting gay male exchange, the attributes and characterisation remain one of excessive gesture and attitude and, as such, a travesty of the feminine. As such, sensuality is demasculinised to be replaced by the constructed and overt − the dramatic hand gesture, the overtly flirtatious gaze, the parody of coyness.

67 Cornwall, A. and Lindisfarne, N. (1994) *Dislocating Masculinities*, London: Routledge, p. 6.

# 6

# BRUCE SPRINGSTEEN AND MASCULINITY

*Gareth Palmer*

Since the mid-1970s the combined disciplines of philosophy, anthropology and cultural theory have set about deconstructing the 'crisis of masculinity'. Masculinity was revealed as a complex ideological construction whose intellectual power resulted from its historically validated claims to reason and whose physical power is destined by anatomy. Masculinity is a performance covering an emptiness, a cultural bribe, and a prime victim of the 'disturbing fragmentation of the social and cultural era'.[1] But men do not constitute one homogeneous group experiencing the same type of masculinity. They are all negotiating their own masculinities via systems of identification. For example, professional men are subject to entrepreneurial definitions of manhood which are quite different from those promoted in blue-collar culture. In view of this, it might perhaps be more accurate to say that masculinities are going through crises.

The exploration of masculinities has been the subject of extensive debate over the last decade. Groups ranging from punk Straight-Edge to the so-called Men's Movement in cultural politics have sought to define themselves in the negative: i.e. we are not nurturers or home-makers. In these models, masculinity is about exclusion and a rigid self-policing of identity. Given the changes in the post-industrial world it may be that such constructions are no longer tenable. However, these definitions of manliness are still prevalent in the world of signs. Films such as *Terminator*, *Die Hard* and *Judge Dredd*, and the hyper-macho posturing of rock stars such as Bon Jovi and Aerosmith are evidence of a desperate attempt to assert the continuing validity of the externally rampant male in a world which has little need of him. The humour that accompanies these performances helps diffuse the criticism but fails to disguise the desire to reassert the dominant male of patriarchy.

What is always true is that masculinity is not a gendered inevitability but something constructed by a variety of agencies through signs. The aim

of this chapter is to examine the work of Bruce Springsteen as a dominant force in promoting and signifying masculinity. In the first section, Springsteen is examined as a writer mapping the signifiers of the Western onto contemporary blue-collar culture. His figures patrol borders, real and metaphorical. They capture and keep their womenfolk, and they struggle with their fathers who are represented as embodiments of the patriarchal law. The tragedy of these figures lies in their inability to abandon the carefully drawn markers of masculinity which prevents escape into the world of feeling.

In the second section I shall discuss how Springsteen's performance, in a variety of formats, is another valuable indication of what his masculinity 'means'. The rock aesthetic 'depends crucially on an argument about authenticity'.[2] Thus, it is argued that Springsteen's performance can be interpreted as that of a man striving for authentic masculinity, and this will be discussed through an analysis of his relationship with his fans, his videos and his 'look'.

## SPRINGSTEEN'S WORLD

### Fathers and sons

Since the industrial revolution the father has represented the breadwinner in the home, but changes in the industrial and economic base have threatened this position. In XY magazine, a review of Stephen Biddulph's Manhood inadvertently reveals the bias towards the father that is the root of many definitions of masculinity and the need to reassert this power:

> Many men have missed out on good close relationships with their fathers and few of us have had close intimate relationships with other men.[3]

Springsteen responds to these changes by exploring the three stages that are said to be typical in the relationship between father and son — adoration, rebellion and rapprochement. What informs each stage is the power the father has as a mythical figure. The tragedy is that the son becomes disenchanted with the failure of his father to match the ideal. And although the ideal is eventually questioned it never loses its hold.

In the first stage masculinity is understood through a child's eyes as a pose or posture such as a way of walking. The Springsteen narrator remembers the image as an authentic sign of masculinity which he hopes will get him through his wedding day:

All I can remember is being five years old
following your footsteps in the sand
tryin' hard to walk like a man[4]

In the second stage comes the rebellion crucial to masculine develop-
ment and which has become the mainstay of much rock and roll. The
force of the narrative here is directed against the father's fatigue and
lethargy. Springsteen's sons want their fathers to be role models and yet
whether as parents, husbands, friends or workers each boy sees only fail-
ure and despair. The father remains a powerful but negative presence
expressing the sullen resentment of men who have not been taught to
articulate beyond resentful grunts. It often boils down to the elementary
'this town ain't big enough for the both of us' of the western.

Daddy worked his whole life, for nothing but the pain.
Now he walks these empty rooms looking for something to
    blame,
You inherit the sins, you inherit the flames,
Adam raised a Cain.[5]

The father is continually defeated by the work process and can offer his
family only an embittered husk at the end of the day. In songs like
'Factory', father is 'walking through them gates in the rain' like one of the
automatons in *Metropolis*. He can't escape his dull torment nor can he
comprehend it. The only way this father can express his anger is to fight
'and just you better believe boy, somebody's gonna get hurt tonight'. But
even this rage is a futile gesture directed at others emasculated by a lack
of power in the workplace.

In reflective moments father takes son out in his used car to look at the
Mansion on the Hill – signifier of an enduring class divide in Springsteen's
world. No words are spoken in this mute communion as father and son gaze
at this remote prize. The heroism of this still quiet figure is underscored by
the son's growing understanding that his father's failure may be down to
some problems with the economy. But by then it is too late – the process
of alienation has completely removed his father from the world of feeling
and communication is difficult. Not surprisingly the boy swears never to be
in the same situation: 'They ain't gonna do to me/What I watched them do
to you'.[6] He wants to take charge, gain control: 'It's a town full of losers and
I'm pullin' out of here to win',[7] but escape is difficult as the hero always
stops behind state lines, where the highway ends. All around him are cages
and prisons – real and metaphorical.

At the end of the long day's journey into night Springsteen's fathers are alone staring into an emptiness they can neither articulate or efface. Their prime function in the home is to provide a dull mute force against which the son – like all sons – must struggle to break free. This struggle itself is given mythic proportions by Springsteen's use of biblical imagery to frame the conflicts in this urban landscape, perhaps suggesting that conflicts between fathers and sons inhere in the nature of their relationship. The empty prize of masculinity is won by following a primitive code of loyalty which functions to limit its adherents. Men are condemned to be active, independent and dominating. Any hint of passivity or feeling risks fracturing the ideal.

The tragedy for these figures lies in the lack of alternatives offered to industrial man. Blue-collar culture is presented as relegating feeling to the feminine but its own sign-ideals of masculinity have disappearing referents. Springsteen presents the poses and gestures as a temporary haven from having to confront the failure of an unattainable masculine ideal. In the grim real world fathers and sons are left with few places to pitch the flimsy tent of masculinity. Where else can the anger go but into the domestic sphere, where men try to assert the masculine fantasy of control they have been taught is at the root of their identity as men?

Springsteen's characters experience a despair that has no object to focus upon. They know that what they have isn't working but they don't know what to do to change things: 'But it's a sad man who lives in his own skin and can't stand the company'.[8]

### Girls/family

Springsteen's female characters faithfully recreate the divide between good-time girl and wife that is rooted in the western. Occasionally a woman is a buddy but more usually women are decorative angels whose beauty is worn down as they become disenchanted with the husks of men their husbands have become.

Women first have to be captured then placed in the home where they come to represent the ambiguous prize of domesticity. The comforts women offer necessarily entail the end of those essential wanderings that define masculinity. 'Racing in the Streets' is typical in that the 'little girl' is the prize which the hero wins in a race. However she ends up alone and 'crying on the porch of her daddy's house, all her pretty dreams are torn'. Beyond expressing despair the heroine has little to do or say. Women are mysterious, impenetrable and other. No optimistic end is possible, for

both men and women are locked into blinkered positions on what is and is not their role.

Springsteen's women do not exist as characters in their own right but as signifiers of domesticity and commitment against which men define their masculinity. Men's right to 'fool around' becomes a part of their self-definition. The good times are celebrated in numbers like 'Sherry Darlin'' and 'Born to Run' which show women offering sensual delights. Here Springsteen expresses a true blue-collar authentic sexuality – 'Lovin' you is a man's job'. In these moments the hero is at one with a million rock stars demonstrating their commitment to a primitive model of sexual politics. At the risk of overstating the case, when Springsteen is rockin', his lyrics display increasing levels of crudity. It's almost as if the crowd-pleasers are designed with simple pictures in mind. Simply wrapping this up in a humorous package smuggles in the mythology propelling it. The difference between Springsteen and the rest is that the pessimism informing his more sombre numbers reveals the narrator/hero as a sensitive type 'after all'.

If we look at the language Springsteen uses we may gain an insight into his conception of women. For example in The River, an album considered one of his most profound and reflective, Springsteen offers one of the most restricted readings of women to emerge from an adult-rocker in some time. In nine of the twenty tracks women are referred to as 'little girls'. Further to this they are seen as hopeless figures in need of men to protect them via marriage, thus perpetuating the male/female divide of patriarchy. But the crudity of this picture is overlooked because Springsteen is seen as an authentic figure who lived in this world and can write authoritatively of it.

Perhaps Springsteen's pessimism helps underscore his authenticity. The good times don't last long and marriage is never far away. When the hero gets Mary pregnant in The River, 'man that was all she wrote'. A union card and wedding soon follow. As the hero figure moves from boyhood to adulthood he encounters further frustrations. Masculinity becomes a paradox of power and discipline. Man is encouraged to be a breadwinner which gives him certain power but it also represents a prison which denies him opportunities for independence and freedom which are the core of mythic masculinity. Springsteen's figures repeat a cycle of behaviour, the futility of which they realise too late. They are tempted by the cultural bribe of a masculinity which promises to give them identity but which remains unattainable and leaves them unfulfilled.

Some of the most touching moments come when Springsteen's heroes are close to their womenfolk, for example, in 'Drive All Night' when they 'lie in the heat of the night like prisoners all our lives'. But perhaps it is

revealing that these moments occur when the women in question are asleep – only then and in abstract can they be celebrated, only in silence can the true man whisper such devotions. Here then is another western myth – that of the strong silent type whose heart may be tender, but whose loyalty to a primitive code of masculinity with self-control at its core disqualifies him from expressing himself. The cautious Bill Horton can't believe his luck when he finds and marries a beautiful woman but he is haunted by the mystery of her and can't relax:

> Billy felt a coldness rise up inside him that he couldn't name
> Just as the words tattooed 'cross his knuckles
> he knew would always remain.[9]

Women's essential otherness is not something a man can understand so he stands apart, at best a witness to his remoteness.

Since *Darkness on the Edge of Town* Springsteen's figures have more moments of uncertainty and indecision when they become aware of their limitations as men. Sometimes the hero feels jealous or full of self-doubt: 'Is that you baby or just a brilliant disguise?'[10] This is the most modern aspect of Springsteen – that which allows a crack in the edifice of masculinity and reveals the new insecurity of male identity.

Moss has suggested a progression in Springsteen's representation of women which sees them go from flesh-pots to love objects.[11] For example in 'Spare Parts' the heroine brings up a child alone after being abandoned by an irresponsible man. As Springsteen himself defined it, this is a song about a woman 'struggling to understand the value of her own independent existence'.[12] But it is difficult to see a clear development as simplistic representations in songs dot all of Springsteen's albums. Thus on *Lucky Town* we hear: 'All I need is your sweet kiss/To get me feeling like a real man'.[13]

In tracing Springsteen's career we can note odd disjunctions between a rhetoric that expresses support for women as individuals with rights, and very narrow, stereotypical representations. In early songs like 'Mary, Queen of Arkansas' the gender identity is confused: 'You're not man enough for me to hate or woman enough for kissing.' In the 1970s and 1980s women are honoured with romantic lines such as 'You ain't a beauty but hey you're alright'[14] or celebrated as sexual figures in 'Candy's Room'. In the 1990s the only 'advance' offered is the 'honest' one that the hero has 'feet of clay'.[15]

If we take an overview of Springsteen's entire lyrical output it is perhaps instructive to note that if women are given an occupation it is most often

that of hooker. In this way women are preserved as sad and mysterious – innocent of true love and corrupted by the world. The hooker's body is literally in service to a masculinity founded on ownership and control. She has no character and is there simply to fulfil fantasies – the ultimate of which is 'all she wants is me'.[16] It is precisely this fantasy that men need in order to sustain the belief that a hooker is a forlorn individual simply looking for the right man to 'take charge' of her situation. Each visit is an opportunity to celebrate true masculinity and to take refuge in the fantasy that she can make fleetingly real. The man's body remains his own possession and crucial to his sense of identity. He cannot be corrupted by his visits to the hooker for he preserves the mind/body distinction. He is in control while the woman within, the threatening other of the unconscious, is symbolically controlled by his dominance of the hooker. Man is pure mind, women are flesh, the territory to be colonised and controlled. As long as he works within this framework man will maintain the distance he feels necessary to his self-definition.

## Work

David Morgan has written of how 'Work, in both the general and specific sense, is assumed to be a major basis of identity and what it means to be a man.'[17] Work is one of the key sites where masculine identity is formed and yet men have a complex relationship to their work: Men need to work in order to survive and yet it can destroy them.' The loss of the industrial base and the computerisation of many processes coupled with the erosion of union power and the loss of apprenticeship schemes has meant that men are left with fewer opportunities to define their masculinity. Springsteen's songs articulate the problems facing workers coming to terms with this transformed industrial landscape.

If we were to catalogue the occupations of Springsteen's characters, we would note that the predominant ones are factory hand and mechanic. Also significant are carnival workers, dockers, construction workers, police and hookers. It will be noted that these jobs are principally concerned with physical displays of masculinity – a disappearing world.

In Springsteen's world the men who work in factories see them as 'mansions of pain' offering little reward in terms of self-respect. The simple truths that emerge from such situations are that after such work men need to reassert their masculine power in some way. This often involves them in a great deal of 'face work', the exaggerated claims to potency that Adler saw as crucial to the construct of masculinity.

The work of the mechanic links to the mythic America where cars, like

horses, explore unknown territories. Cars are where men perform some of the last rituals of masculinity for a culture that has little need of them. After work, or in place of work, men work on their cars. The car represents an escape from the parental home and an opportunity to break free – although no one ever really escapes. The careful reconstruction of a classic car represents homage to an unfulfilled dream of freedom.

Another significant site for Springsteen's figures is the carnival. The middle-class flâneur visit the carnival to experience forbidden pleasures as it represents a licensed arena for experiment. But in Springsteen's world it has only a little tawdry glamour. The workers demythologise what they do while the hero sees only metaphors in the creaking motions of the Big Dipper and the Tunnel of Love. The carnival is a dark and dangerous place not because it is threatening or mysterious but because it foreshadows the grim world of marriage and disappointment to follow.

> It ought to be easy ought to be simple enough
> Man meets woman and they fall in love
> But the house is haunted and the ride gets rough
> And you've got to learn to love with what you can't rise above
> If you want to ride down into this tunnel of love[18]

The police/state troopers are the physical embodiments of the law and the state. But these men are not overworked for the limits are imprinted in the minds of these young workers. Borders are significant in that they represent the limits of the possible. If masculinity is about policing boundaries then these visits to imprecise borders are significant, for here men go through the tests they feel they must endure. It is at borders that men discover the limits of themselves and encounter culturally defined standards for masculine behaviour. On *Darkness on the Edge of Town* the possibilities of transgressing class boundaries are tested only to re-establish those relations of dominance which represent masculine identity. The narrator sings of an old flame who married into money:

> Well if she wants to see me
> you can tell her that I'm easily found
> Tell her there's a spot out near . . . the bridge
> and tell her – there's a darkness on the edge of town. . .[19]

On *Nebraska* lawmen express codes both ancient and inappropriate for the modern world: 'man leaves his wife and family – that man ain't no

good.'[20] Growing up in blue-collar culture means developing an awareness of the Law. This is either the law of the father embodied in the police and resented in a sullen way, or the unwritten laws of loyalty to the community. Adherence to laws gives men an identity. But the limitations of these laws are written on the body and deny men access to the world of feeling. Eventually the borders are internalised and passed down as the natural limitations of 'what a man's gotta do'.

In many Springsteen narratives the dead weight of tradition presses its characters into blind obedience to laws they don't understand but pass on to their sons. The powerlessness is eloquent in its simplicity but rather self-defeating. A man joins the union in the same way that he would join any organisation his friends did. But it doesn't seem terribly effective in this industrial land – perhaps an all too relevant comment on life within Springsteen's blue-collar milieu.

Masculinity is culturally and historically variable but not in Springsteen's world. The fact that men are now addressed as consumers, care-givers, objects of desire, etc. is never allowed to intrude on the landscape. Springsteen is holding on to the traditional icons of masculinity in the monument valley of rock. Given the rather bleak universe that Springsteen has built, how are we to explain its enduring popularity? It may be that those listening to his songs hear and take comfort in his clear definitions of men and women. The cracks of doubt in this masculine persona and the powerful pessimism give it authority and a point of identification. It may be a despairing picture but it's also a conservative one which many living in the new industrial revolutions might relate to.

## THE PERFORMANCE, THE FANS AND THE MAN

The live experience is the defining event for the Springsteen fan – the albums have been described by his most ardent fan as merely 'pale souvenirs' of the concerts.[21]

To a degree almost unfashionable in a world of video and delight in the inauthentic, Bruce Springsteen represents a journeyman musician who has paid his dues in clubs up and down the country and who derives his authenticity from this history. It is a crucial part of the Springsteen myth that he plays for his audience, his community of fans. This has sometimes meant deliberately refusing larger venues in order to reach people in more intimate places. After the Tunnel of Love tour Springsteen remarked: 'We don't want to get any bigger.'[22]

Springsteen was one of the first people to play the small and semi-private gig in order to try out his material on the faithful. The fan publications

that have sprung up around Springsteen include testimony from witnesses to these events. At a recent gig for *Top of the Pops* one fan wrote:

> Bruce came to the edge of the stage and was soloing right in my fucking face, dripping sweat on me. Fucking amazing. My shit was lost. The feeling you get is so pure.[23]

It is a truism to say that rock and roll bands are prime examples of macho posturing. However, the E-Street band articulate and play out a series of masculine fantasies that make strong connections to the blue-collar milieu of the songs. In short the performances can be read as celebrations and validations of heavy, physical unambiguously 'masculine' work.

The band are like a busy gang, acting together in perfect unison. To see them play is, to borrow a well-worn cliché, like admiring a well-oiled machine. They may run all over the stage, they might even seem ignorant of what one another is doing but at those crucial moments it all comes together. Here is a sight of men, and the token woman, acting out the industrial fantasy of efficiency. They celebrate work in the sweat and toil of the performance, work which has its counterpart in the heavy physical work that the songs' characters perform. In a sense the work we see keeps the myth of male potency alive. Such unrestricted yet perfectly measured effort defines the craftsmanship that the songs lament the decline of. Here at least men (the band) can celebrate the value of physical labour. The finely sculpted muscles and the sheer endurance of the band all help to legitimate masculine power and domination.[24] This is hardly challenged by Patti in a mini-skirt demurely gazing at her man during tender moments on 'Tougher than the Rest'.

The band on stage is like an idealised workplace representing a cross-section of American males – the African American, the Latino, the Caucasian intellectual, and the white-boy rocker, all working in perfect harmony. Whatever the conflicts in the world outside, these workers are united for a common purpose.

At the head of this gang is, necessarily, a boss, and Springsteen is the most famous 'Boss' in rock history. What we see acted out onstage is the actual relationship that Springsteen has to his band. After all he hires and fires them. But on stage he is a benevolent employer, perhaps the perfect foreman enjoying a casual but also strict relationship with the band. As boss he is also star and Springsteen is famous for concerts at which he has to be restrained by doctors from giving yet another encore. This 'selfless devotion' to performance is said to be a key to understanding of the man and his band and their aim to reach their community.

The performance is a validation of the virtues of hard physical labour but it is also an act of communion. This is close to the ancient folk bond expressed in the belief that songs are made anew in each performance. Each fan has the opportunity to hear the song and make it fresh again in each performance. It is also important to note here how very conservative much of the music is. But this is the point. True authenticity as a rocker involves strict adherence to rock and roll's traditions. A lack of innovation here is a sign of commitment to the fan – a willingness to serve his or her fantasies of 'those you have loved'.

In this light it is interesting to note that Springsteen, although famed as a live performer, was reluctant to release a live album. It is crucial to the myth of the live performance that such moments cannot be recorded. The music couldn't capture the feeling and the spontaneity of the live performance. The reason Springsteen gave for this capitulation to market forces was that bootleggers were making a hash job of live recordings and he didn't want to deprive his loyal fans any further.

In a culture where displays of masculinity are down-graded or parodied the E-Street band provides a legitimate arena for outlawed fantasies of direct male power. Springsteen has a very broad fan-base ranging from teenagers to the liberal intelligentsia who 'hear' the significance in his lyrics that younger listeners may not.[25] It may be that Springsteen's male fans may find this confident display of masculinity somehow empowering.

### The videos

Springsteen's reluctance to use video may express his fear that the new medium would detract from the authenticity of the true Springsteen experience. This rather primitive approach chimes with the old-fashioned characters who dot his songs. Springsteen here represents the craftsman's cautious approach to the new. A study of the eighteen videos on Springsteen's video anthology illustrates how the medium was used to preserve his authenticity.

Some of the videos use footage of real events, burning buildings, the Vietcong, to illustrate the meaning of the lyrics. This might be described as a sort of documentary realism, further tying the songs to the real. In songs such as 'I'm on Fire' and 'One Step Up' Springsteen has been encouraged to act – albeit very much in the familiar role of the blue-collar figure of old. But for the most part these videos are about Bruce and the band performing. Even in his fantasies Springsteen is in a rock 'n' roll band. This approach does not represent a lack of confidence – these

non-videos demonstrate Springsteen's commitment to the business of real performance. The dilemma that video represented for Springsteen is represented in 'Dancin' in the Dark'. Here Springsteen dances with a female member he pulls out of the audience. He doesn't look too comfortable. In an interview he reveals his trauma over lip-synching:

> Which is not what I want to do, because . . . the best thing our band does is address the moment. And we go for authentic emotion. . . . It was a kind of experiment.[26]

The video is very polished. Springsteen dances and doesn't sweat – which is in dramatic contrast to the mayhem that occurs on another video (Rosalita) when female members of the audience try to kiss the singer. It is clear that for Springsteen authenticity is best preserved by concert footage and fans.

Rock videos are characterised by 'segmentation, discursive practices of excess, contradictions, metaphor, metonymy, puns and interchangeability' amongst other things. Morse[27] offers an interesting comparison of music video to dominant realism which may be useful here:

| Rock video | Dominant realism |
| --- | --- |
| Non-consequential images | Cause/effect |
| Visual puns that parody accepted cultural values | Cultural values taken as a given |
| Juxtaposing of conflicting emotions | Consistent emotions for various situations |
| Displacement of time | Chronological time |
| Displacement of space | Continuity rules (such as the 180-degree rule) |
| Sometimes abstract | Usually logical (uses realistic conventions) |
| Excessive | Restrained |

Springsteen's lack of experimentation is more than a refusal. It represents a cautious maintenance of image by adopting his authentic video to reassert the value of dominant realism.

Fiske has argued that music videos offer up the pleasure of the 'semiotic democracy, the invitation to the viewer to participate in the construction of meaning'. Fiske also suggests that the final characteristics of 'segmentation; discursive practices of excess, contradiction, metaphor,

metonymy and puns; and its intertextuality, make it quintessentially tele-vision'.[28] Springsteen's restrained use of the form is a refusal to play with the polysemy of the image and is rooted in an entirely successful effort to maintain a distance from the elaborations practised by less authentic, and more manufactured bands in rock.

The distinctions between Springsteen's dominant realism and typical rock videos are like those between rock and pop.[29] Pop is commercial product based around the single and disposability. Rock aspires to be an authentic representation of lived experience. It sets in train narratives with characters. It has become an institution with social responsibility. The contrast is between the light-headed postmodern sensibility and the sober responsibility of Modernity. Springsteen's work is best seen in this light – less as videos (marketing tools/celebrations of the rootless image) and more as films (personal expressions/messages with meaning). This may not be unrelated to the fact that directors with working-class concerns such as John Sayles have been involved with Springsteen videos. The video for 'Philadelphia' with Springsteen merely mouthing the words as he walked through the streets or the 'Sun City' video with the stars simply singing the words with a street or studio for a backdrop typify this reluctant approach to experimentation and this hankering after a message.

It is interesting that Springsteen has described his own songs as work-ing like movies: 'The songs I write, they don't have particular beginnings, and they don't have endings. The camera focuses in and then out.'[30] His reluctance to translate them to video betrays a shrewd director demon-strating control of his image by refusing to perform as anything but the self he has so successfully marketed. The man with frills, the performer implied by actorly gestures, also conflicts with the models of masculinity discussed above and from which Springsteen as singer-narrator cannot stray.

Springsteen's apparent caution can be read as a marketing tactic. After all, a good percentage of his audience are not of the MTV generation. Such sparse use of the form further defines Springsteen as unique and authen-tically so. This reluctance to experiment is itself shrewd, for in this respect the videos compare radically in slowness with the frenzy of images else-where. Furthermore, Springsteen's fame is such that he can afford to ignore the video as a marketing tool. Another reason for his reluctance could be that video, unlike recordings and performances, are clearly not the work of one man alone. In videos we are not sure who 'the boss' is. It is important to Springsteen's image that his control is absolute – and this of course is a central pillar of masculinity.

These non-performances further underline and cement the construct that

is Springsteen. By demonstrating a reluctance to act or perform for the camera Springsteen seems more real. What we see on screen 'really is him'. To avoid the fictional layers that video implies is to strain effortlessly for authenticity. In this way the fans are not confused by a complex picture but can feel at one with the real man, the boss.

### The man

Springsteen's fans (or 'tramps') have two well-established and profession-ally produced fan magazines — Backstreets and For True Rockers Only — as well as a host of small-scale operations and sites on the Internet. And yet, despite this wealth of material, Springsteen is constructed throughout as an ordinary Joe. All publications conspire in the need to present him as authentically all-American and 'one of us'.

Such is the power of this construct that professional rock journalists, men (usually) paid to be cynical, find themselves writing about the image as if it were interchangeable with the knowable Bruce Springsteen. Academic critics such as John Street have also helped to cement this notion of Springsteen's authenticity.[31] Awkward facts such as Springsteen's wealth are not congruent with his ordinary Joe status so they are either overlooked or given as evidence of his generosity (connection to his roots).

In these fan publications Springsteen is presented as husband and father — in short he is part of a nuclear family. At the same time he is a working musician — this is his job. What makes Springsteen different is that he is also a mega-star. The writers and fans manage to balance the ordinary with the extraordinary by circulating 'true' stories and pho-tographs of the regular guy (with job and family) who inhabits the mega-star image/persona. Pfeil has written of how rock fans 'expect con-tinuity and coherence from stars between on and offstage'[32] and Springsteen is no exception to this. Thus in order to manage the poten-tially dangerous contradiction that threatens to rupture the bond that ties Springsteen to them the fans stress the signs and activities that make him normal. Thus pictures of Springsteen with Patti and the kids are prized not as glimpses of a forbidden world of glamour but as insights into the life of a genuinely private man. Springsteen's desire to stay in jeans, far from seeming perverse, is further evidence of how this guy has been unaffected by the trappings of wealth. It is this ordinariness that Springsteen and his fans draw strength from. Springsteen's reluctance to do the promotional tours, parade the celebrity circuit or conduct many interviews help rein-force this 'private' picture. With so little 'genuine' opportunity to discover the real man beneath the songs the fans claim the right to see the songs

as revelatory. The authenticity-effect is thus secured by 'unbroken organic affiliation and continuity'.[33] A brief glance at his media history reveals this continuity.

Springsteen's career has been dotted with examples of how his good (and innocent) intentions have come up against the big bad world of business. The first big storm was the fuss around management that delayed the release of the follow-up to the enormously successful *Born to Run* album. Critics explained that the sombre mood of *Darkness on the Edge of Town* was directly related to these troubles. These explanations are convenient and reinforce the status of Springsteen as an authentic rocker-artist pouring his heart into his songs. In a bad world of commercialism Springsteen at least is expressing himself.

From the early 1980s onwards Springsteen's performance as an ordinary guy has been enhanced by long rambling monologues in which he discusses his upbringing. The most famous of these have concerned his troubled relationship with his father also expressed in songs such as 'Independence Day'. The monologue is a point of connection, the private man reaching out to his fans. How can we doubt such a truth when it seems so sincere? Only a star with as carefully crafted an identity could possibly deliver such monologues without risking derision.

Alternatively only a very famous star with such a deeply rooted heterosexuality could sing 'Philadelphia' in the first person. A sexually androgynous singer might make the song threatening, reveal its connection to the world of sexuality. When Springsteen performs the song it is a tribute from one of rock's elder statesmen, and simultaneously a demonstration of concern from an ordinary Joe walking through the streets of the city in a leather jacket.

Over the past twenty-five years Springsteen's wardrobe has reflected rock's changing models of masculinity. In the early 1970s and up to *Born to Run* Springsteen dressed as the troubadour poet in floppy hat and loons – a hangover from the Woodstock generation. Following the success of *Born to Run* Springsteen emerged as a rocker, with a quiff and a casual jacket perhaps representing the tough and yet romantic sides of his nature. But in later phases as a mature rocker – from *Born in the USA* on – Springsteen has his hair slicked back and dons a leather jacket. But what is also interesting is the way in which Springsteen has become more muscular as his songs have revealed him to be more vulnerable. It is as if the body was trying to toughen itself against a world which has bruised him. This display of muscle is itself a 'natural' display of masculinity that supports patriarchy while the singer speaks of the limitations of such a system.

In the mid-1980s Springsteen's monologues began to include

increasingly bold public pronouncements on social issues. It was discreetly known that Springsteen had contributed to various strike funds and as he grew more confident he pronounced on the need for justice and compassion: 'he spoke up for local food banks and industrial strikers, against the maltreatment of Vietnam veterans and the victimisation of workers'.[34]

> We're slowly getting split up into two different Americas. Things are gettin' taken away from people that need them and given to people that don't need them and there's a promise gettin' broken. . .[35]

Springsteen's well-documented anger at Reagan's attempted appropriation of 'Born in the USA' and his refusal to take Chrysler's money to use the music in an advertising campaign were further evidence of a growing political awareness.[36] However, we have to bear in mind the breadth and depth of his appeal. As Pfeil points out, the people reading Springsteen as leftist may be those middle-class liberal progressives who can key into and share his idealism.[37] What the folksy *Ghost of Tom Joad* album and solo tour illustrate is Springsteen's growing concern with social issues.

Springsteen's mentor, Jon Landau, has provided him with an old-fashioned liberal education which has helped him to develop a brand of political thinking which 'might be closer to the New Deal than any more defined ideology'.[38] As Springsteen became one of rock's elder statesmen he developed a rhetoric to go with the new role. His acceptance speech at the Oscars was a perfectly honed example of how to seem modest while still carrying an awesome burden of responsibility.

> And it takes the edge off fear and allows us to recognise each other through our veil of differences. I always thought that was one of the things popular art was supposed to be about, along with the merchandising and all the other stuff.'[39]

The 'veil of differences' phrase could have come from one of Springsteen's songs. The relegation of merchandising to after thought fits perfectly with the popular image of ordinary guy. But the remark on the function of popular art could only have come from a man gently educated into an awareness of his significance as a popular balladeer with world-standing. The ordinary man works to keep the portentousness at bay. *The Ghost of Tom Joad* makes obvious reference to the 1930s, the New Deal and the struggles of workers, which may be an old-fashioned approach but may also appeal to the idealism of his older fans.

A harsher critic might light on moments that offer a different slant on

Springsteen's persona. We might discuss his expensive divorce from Julianne Philips, which is said to have resulted in a clause forbidding her ever to speak of their relationship. We might mention the fact that some songs are recorded for more than fifty takes in order to produce the right one. We could mention the speed with which he is said to have reacted to a London-based company's attempts to market some of his early unreleased material. But these facts can all be drawn back into the central construct informing all discourses about Springsteen. Thus the divorce settlement was not paranoia but the concern of a genuinely private man to protect himself; the work rate is an example of craftsmanship; the concern to look after his early material is nothing more than the care of an artist. In view of the longevity and strength of this construct one wonders what would have to happen to change it.

Springsteen's men are troubled. With fewer and fewer certainties in their lives they cling on to the last few icons of masculinity which they hope will give them identity. In many ways this may be an accurate picture of a blue-collar world coming from a genuine product of that culture. It is Springsteen's decency and growing dignity which help to overshadow the sexist themes in his work. His musical form helps maintain the hegemony of traditional rock 'n' roll – a conservative form whose dominance forbids creative outsiders and whose force can be appropriated by folk of all political persuasions. Springsteen's America is a conservative land where the heroes struggle to understand the limits of their horizons but can see little beyond them. As another archetypal hero once remarked: 'a man's gotta know his limitations'.

The problem is that these limitations are preventing men from changing. In a rapidly transforming post-industrial world the old models are useless. Springsteen understands this. His songs articulate some of the frustrations of men and in this sense his work will continue to have a melancholy relevance. What will be interesting to see is whether he can provide new icons of masculinity or simply continue to chart the frustrations of the old.

## NOTES

1 Frosh, S. (1994) *Sexual Difference: Masculinity and Psychoanalysis*, London: Routledge, p. 91.
2 Pfeil, F. (1995) *White Guys*, London: Verso, p. 78.
3 Review of Biddulph, S. *Manhood*, in XY Magazine, Summer 1995.
4 'Walk Like a Man' on *Tunnel of Love* (1987) Zomba Music Pub. Ltd (Bruce Springsteen).
5 'Adam Raised a Cain' on *Darkness on the Edge of Town* (1978) © Bruce Springsteen, CBS Records.
6 'Independence Day', from *The River*, CBS Records, Intersong Ltd, 1980.
7 'Thunder Road', from *Born to Run*, CBS Records, 1976.

8 'Living Proof', from *Human Touch*, Columbia Records, 1992.
9 'Cautious Man', from *Tunnel of Love*, CBS Records, 1987.
10 'Brilliant Disguise', from *Tunnel of Love*, CBS Records, 1987.
11 Moss, P. (1992) 'Where is the Promised Land? Class and Gender in Bruce Springsteen's Rock Lyrics', *Geografiska* 74 B: 3.
12 Quote from Springsteen, introducing 'Spare Parts' on his video anthology.
13 'Real Man', from *Lucky Town*, Columbia Records, 1992.
14 'Thunder Road', from *Born to Run*, CBS Records, 1976.
15 'Feet of Clay', from *Human Touch*, Columbia, 1992.
16 'Candy's Room', from *Darkness on the Edge of Town*, CBS Records, 1978.
17 Morgan, D. (1992) *Discovering Men*, London: Routledge, p. 76.
18 'Tunnel of Love', from album of the same name, CBS Records, 1987.
19 'Darkness on the Edge of Town', from album of the same name, CBS Records, 1978.
20 'State Trooper', from *Nebraska*, CBS Records, 1982.
21 Humphries, P. and Hunt, C. (1985) *Bruce Springsteen: Blinded by the Light*, London: Nexus, p. 7.
22 Cross, C.R. and Philips, C., the editors of *Backstreets* magazine (1989) *Backstreets*, New York: Harmony, p. 62.
23 Gorlechen, J.A., taken from Internet 5 April 1995.
24 Dyer, R . (1989) 'The Right to Look', *New Statesman and Society* 9 June: 31–4.
25 Pfeil, op. cit., p. 88.
26 Interview with Springsteen from *Backstreets* magazine (undated copy) p. 191.
27 Morse, M. (1986) 'Post-Synchronizing Rock Music and Television', *Journal of Communication Inquiry* 10(1): 15-28.
28 Fiske, J. (1989) *Reading the Popular*, London: Unwin-Hyman, pp. 115, 150.
29 Lash, S. and Urry, J. (1994) 'Postmodernist Sensibility', in *Reader in Cultural Theory*, London: Polity, p. 139.
30 Interview with Springsteen by Bruce Marsh.
31 Street, J. (1986) *Rebel Rock*, London: Blackwell, is a good example.
32 Pfeil, op cit., p. 81.
33 Pfeil, op. cit., p. 82.
34 From Phil Sutcliffe's collection of Springsteen's 'bonnest mots' on the Internet.
35 Springsteen's introduction to 'The River' at the Civic Arena, Pittsburgh, 22 September 1984.
36 Sweeting, A. (1992) 'The Boss is Back', *Guardian* 28 March.
37 Pfeil, op. cit., p. 88.
38 Marsh, D. (1987) *Glory Days* (London: Arrow), makes this connection.
39 Springsteen's acceptance speech for the Oscar Best Original Song in a movie ('Philadelphia') Hollywood, 3 March 1994.

# 7

# THE PET SHOP BOYS

## Musicology, masculinity and banality

### Stan Hawkins

## MASCULINITY IN THE 1980S

'For me, being in the Pet Shop Boys has always been a struggle between total embarrassment and total shamelessness', said Neil Tennant in his 'coming out' interview with Paul Burston in 1994.[1] Cool, ironic, camp, serious, gifted, intelligent, this duo has always been shamelessly British and 'completely misunderstood', which partly accounts for their appeal and huge success from the mid-1980s onwards. Endeavouring to understand the Pet Shop Boys is a useful start for evaluating the debates surrounding popular musicology and masculinity within a post-1970s setting. 'Obviously, people are going to look at our songs and read things into them,'[2] laments Tennant in reference to their sexuality. But it is precisely through a range of readings that various meanings are revealed. By disrupting stereotypical codes of gender and sexuality through a parody of artifice and masquerade that challenges patriarchy, these artists remind us that music can function as a key vehicle in deconstructing fixed notions of gendered identity in everyday life.

This chapter is an investigation into issues of musicology and masculinity through the analysis of some of the most banal and expressive music of the 1980s. What emerges during this survey is a recognition that masculinity is subject to alternative systems and readings based on the ways in which we live out our lives as gendered and sexual beings. Together with candid reference to sexual desire, it is the repressed expression of their delivery that characterises the Pet Shop Boys songs. Erotic qualities of the musical ideas are expressed through the somatic property of dance, and can be charged for sexing the groove. Pleasure derived from their songs is therefore rooted within the seductive nature of the dance grooves of the tracks.

What I want to consider here is a general shift in the position of masculinity through strategies of defiance, irony and cynicism. With the Pet

Shop Boys, a plurality of meaning is articulated through a diversification of style, which is also responsible for introducing a new camp sensibility into the marketplace. But how can pop texts capture the essence of the changes in masculinity in the 1980s? In what ways do songs offer up the possibility for constructing fresh discourses of meaning in postmodern pop? And how can a more critical approach to musicology serve to enhance our understanding of sets of differences in style, genre, gender and sexuality that have traditionally been subverted through the imbalances of power?

To initiate any musicological analysis of the Pet Shop Boys it is necessary to search beyond the confines of formalism and draw on a number of critiques emanating from postmodern theory. Many of my ideas are in opposition to the social positioning of the modernist left, as well as to that of traditional musicology and its ideologies that are entrenched within the undermining intentions of essentialism. A post-structuralist approach can aid us in reconceptualising the binarisms that have historically applied to gender and sexuality by 'revealing that they are not in fact symmetrical'.[3] How then can an analysis of masculinity assist us in formulating a musicological critique?

From a distinctly postmodern English culture the Pet Shop Boys emerged during the mid-1980s in the aftermath of the British 'new pop' scene, 1981–83.[4] Having met in a music shop on King's Road in London in 1981, Neil Tennant and Chris Lowe, both from the north of England, started working together on writing pop songs. Some time later, while in New York recording a number of demos, they had the opportunity to work with Bobby Orlando, the well-known New York producer who had launched numerous Hi-NRG[5] artists and groups in early 1980s disco. Up until March 1985 the Pet Shop Boys subsequently held a contract with Bobby 'O', who, in turn, played an influential part in launching their rise to fame. Shortly after they cut their ties with Orlando, the Pet Shop Boys had their first Number 1 hit, rocketing them to fame.

The politics of gender surrounding the Pet Shop Boys is without a doubt one of the distinctive features contributing to their popularity among male and female fans alike. To gain further insight into this aspect, it is necessary to examine the social backdrop against which their texts are conceived. During the 1980s, masculinity underwent significant changes, which is evident in much pop music from this period. As the Pet Shop Boys were making their name, the 'new' male in British society was being rapidly accessed and 'getting an airing at the popular end of the market'.[6] In other words, mainstream fashion became more popularised for males and blurred in its orientation; Gaultier drew on street style and

gay culture, Next was launched, Nick Kamen stripped down to his boxer shorts in a launderette for the famous Levi's ad, *Arena* became an outlet for male hedonism, and the marketplace boomed with male consumers. Frank Mort describes this new *bricolage* of masculinity to emerge in Britain during the 1980s:

> Images of affluence, the first teenagers, rock 'n' roll, are handled with a distinctly 80s sensibility. The Levi's ads were a tongue in cheek parody of 50s style. Young men in launderettes – not a common sight then in Britain or the US! Mean and moody looks on inner-city streetscapes reference, albeit in sanitized and glamorized form, unemployment, making one's way in a world in which the young – and now unusually young men – are short on the crucial element it takes to get by in a capitalist society – money. They have only their looks, their style, their bodies to display and sell. These are the cultural images framed both by recession and by the more fluid sexual scripts of the 80s, rather than 50s affluence and tight gender roles.[7]

We are reminded by the above account that the cultural politics of the marketplace form crucial narratives on sexuality and gender within any specific period of social development. Yet within a 1980s context, it is not only the changes in masculinity, but also the causes for these shifts that warrant close attention. During this period consumption was deeply rooted in Thatcherism and Tory popular capitalism which was hegemonically foisted on the population with 'an orgy of tax cuts and consumer durables'.[8] And it was from this turbulent yet fertile political environment of social decay that the striking narratives and incentives for the Pet Shop Boys were derived.

Experiences of enjoyment and the thrill of music are often wrapped up in the exploration of identities positioned at a distance from our own. The pursuit of escapism and pleasure in pop music allows us to rediscover, reject or even reconstitute personal concepts of gendered identity. Through parody, a prominent feature of the Pet Shop Boys, their progressive yet ambiguous texts surface as a prime focus of interest. Moreover, this duo offers up important readings of masculinity and identity within a postmodern British cultural context where the politics of the image have steadily become substituted for reality. What the Pet Shop Boys have simulated musically is an image that not only signifies what their masculinity means to them but also what it means in different ways to a wide range of other males and females. Since the early 1980s, eroticisation of

the male image within popular culture firmly moved gay erotica and the fetishism of maleness into the mainstream marketplace by constituting an array of disparate and often confused localised narratives. This would partly explain why images or signs are not always linked to their referents but rather operate as free-floating signifiers within the Pet Shop Boys' songs. Expressions of sexual difference therefore appear to function to a greater extent through the codes of the musical sound than through the lyrics and visual representations of their performance either live or in videos. The unlikely fusion of Hi-NRG disco with the serious, impassive, lyrical lines articulates a particular rhetoric that has made this eccentric duo unique. Similarly, in the majority of their videos the image often conflicts with the music itself, thus providing readings on many different levels. In the video of the song 'Domino Dancing', nuance and connotation under-lie the ambiguities of the narrative.

The sequences throughout this video position a 'romance' narrative at the centre, with the boyfriend/girlfriend scenario occupying the main focus of attention. A beautiful Mediterranean girl occupies a foreground position in the visual narrative, with two boys fighting over her for love. As the sequences progress, the camera becomes more engaged with the two boys, who finally end up jostling with one another in the sea, stripped to the waists wearing tight-fitting jeans. The girl is left alone as onlooker, while the two boys are shot wrestling and falling numerous times into the water. However, they never quite fall down, as the camera cuts and repeats the sequence four times. Interjected with this narrative are scenes of dancing taking place in a club, again with both boys competing to dance with the girl. A reading of the video 'Domino Dancing' quite clearly takes place on at least two levels: one, a heterosexual narrative of romance, sun, love, beautiful young people, idyllic surroundings, images of healthy bodies, all of which articulate a straightforward narrative. However, a second reading exposes a more subtle interpretation where the focus centres more on the males. Here, love 'of a different kind' is contested by both the homoerotic visual and lyrical narratives. In his analysis of this piece, Ian Balfour draws our attention to 'the camera's insistence on watching two half-naked men fall in each other's arms', which MTV refused to show without editing this ending.[9] Earnest disco riffs, with superimposed simple tunes on synthesisers, capture the romantic frankness yet exuberance of the musical text. The chorus hook, which is constructed on the lyrics, 'All day, all day, watch them all fall down, Domino Dancing', consists of a descending broken minor seventh chord, representative of the 'falling down' reference in the lyrics (see Example 1). Musical interest also centres around a Latin-style chordal riff in the

piano part, as well as a typical 1970s disco two-bar riff which is an embellishment of the first three notes of the chorus. Characterised by the falling and rising of a perfect fourth and fifth, this 'disco' riff functions as a unifying thread as it weaves in and out of the mix. As a distinctive feature in the song, this riff forms one of the various layers of the mix. In addition to functioning melodically, this riff also contributes to the harmonic, textural and rhythmic fabric of the song.

*Example* 1 'Domino Dancing'

Chorus melody

Two-bar 'disco riff' fill

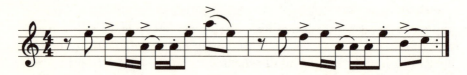

Shrouded in nuance and connotation, 'Domino Dancing' is one in a series of songs that registers the Pet Shop Boys' sentiments on AIDS. Repressed emotions of shock, anxiety and pain at having to deal with the death of friends by AIDS are emphasised by the relentless repetition of the song's hook, which is about dancing with danger and then 'falling down' one after the other, in a domino effect. Representations of subtle and serious address in the lyrics are set against blissful, escapist, party-time musical texts, constituting one of the most compelling forces inscribed in the Pet Shop Boys' music. In a sense the poetic scope of their lyrics can be taken more seriously than the music. However, this arguably insulates the musical sound against engulfing the effects of its own meaning.

Constrained gestures within fashionable oversize suits, stylish jackets and designer clothes soon became a camp trademark of the unsmiling Pet Shop Boys in the 1980s, with their sullenness, seriousness and sobriety in attitude blending in with the new face of the 1980s man, irrespective of sexual orientation. Through the 1980s into the 1990s, this new camp sensibility emerged as part of the acceptable face of mainstream pop, with new mannerisms and gestures all becoming 'part of the repertoire'.[10] Narcissism, in particular, started to dominate the male's perception of himself in no way more visible than through the processes of advertising. Highly sophisticated forms of marketing have become responsible for inducing significant changes in gender roles during the past fifteen years, as shopping steadily became a recreational pastime rather than merely a household chore. In broader terms, by the 1980s shopping had become as much part of the male's domain as the female's.[11] What also seemed pertinent to pop music of this period was that gender stereotypes ceased to function as the prime transmitters of ideology.

However, notions of difference in gender are not without their problems. From a feminist perspective, Chapman discusses how an uneasiness has gradually crept into society with the transformations in masculinity aligned to new trends in advertising:

> With its emphasis on artifice, on style over content, it caused a fragmentation in the image that the new man presented to the world. A narcissistic interpretation of the new man, with its stress upon style and personal consumption, could more easily and more usefully be assimilated into the prevailing consumerist ethos.[12]

These implications are further explored by Chapman when she stresses how the fragmented identity of the emerging 1980s male consisted of an amalgamation of conflicting historic traditions. The emphasis on hedonism, extravagant consumption, and a fashionable lifestyle which was mediated through the countless channels of advertising has undoubtedly had an effect on male identity in Western society throughout the twentieth century. However, within a 1980s context an ambivalence settled into our culture, which at times consisted of the politically correct man concealing his often sexist attitudes to varying degrees. Changes in male response might therefore be perceived as processes of modification rather than resistance to patriarchy. From a cultural perspective some theorists regard the 1980s male as having evolved into a more slippery animal, still fully in control of all structures of social and political power. In her critique, Chapman

describes this metamorphosis as a 'patriarchal mutation, a redefinition of masculinity in men's favour',[13] which is grounded in an essentialism constructed around assertions of physiological difference. While a flaw in her argument might be the over-simplistic categorisation of gender dualisms, we need to recognise the contradictions inherent in a 1980s social climate when we turn our attention to examining the function of music that either withstands or challenges ideological change.

## BEING BORING: STYLE AS RHETORIC

As we have seen, the Pet Shop Boys' gloomy lyrics, image and musical style articulate a distinct rhetoric. But how are their aesthetics grounded in musical sound? What comments do their songs make on masculinity and gender? And how significant is the correlation between the text and the packaging of image?

The rhetoric of (in)sincerity and seriousness in the Pet Shop Boys' lyrics often seems at odds with the simplicity, superficiality and accessibility of their music. What stands out is an intricate blend of politics with eroticism which functions as a main transmitter of musical style. Monotonous and void of dynamic colour, the 'being boring', almost expressionless style of Neil Tennant, appropriates the cynicism and despondency of British youth culture during the Thatcherite years. On the other hand, the politics of pleasure which underlie their musical address, continuously challenge and unmask preconceptions of male identity. As with all styles of pop music, theirs is marketed on a packaging of gender and identity skilfully confounded by an embarrassed, grey, sulky image. By often resorting to satire in their rhetoric, their obsession with class and consumerism in their lyrics elicits different interpretations from their fans. Sexual ambiguity, for example, which has always been a force behind their strategy, represents intrigue, speculation and self-mockery, thereby confronting each fan with different problems. While an openness to claiming love of an 'alternative' nature might be apparent to some through their texts, their narratives remain intentionally ambivalent, and can therefore be read as mainstream hetero texts.[14] Commenting frankly, Neil Tennant links pop music to a broader understanding of sexual expression:

> Our music is, and always has been, fuelled by a strong sexual undertow. Pop music is partially about sex. The two things can't be divorced.[15]

From this statement and others alike, Tennant masquerades in a manner

that comfortably blends into a postmodern 1980s discourse. However, any notions of gender and sexuality borne out of musical sound, lyrics, production techniques, visual images, are ultimately constructed around the identities and experiences of the fans themselves. Concepts of pleasure and power resulting from the 'sexual undertow' are never rendered fixed; everything is left open for negotiation, redefinition and reinterpretation. While gay fans may identify with the Pet Shop Boys from one perspective, their music remains totally accessible to groups and subcultures of hetero males and females during a period when club culture (disco, house, techno, rave) became absorbed by the mainstream. Furthermore, differences in the paradigms of sexual articulation inherent in pop music since the 1960s have always played a role in the construction of aesthetics. If the sombre and pensive mood of their lyrics is sincere, the wit in the Hi-NRG, euphoric musical content of their songs is unquestionably ironic. In direct contrast to the flamboyance of 1970s gay culture, which Neil Tennant claims to have disliked while growing up in Newcastle upon Tyne, the Pet Shop Boys offer a more modest face in terms of style. Most notably, Tennant has openly declared an unwillingness to be identified specifically with one single community:

> I don't want to belong to some narrow group or ghetto. And I think, if they're really honest, a lot of gay people would say they felt like that as well.[16]

Nevertheless, in an interview appearing in Out with Larry Closs, Tennant willingly acknowledges the 'strong "gay" subtext' of their work, but again emphasises that they have 'always hated being categorized'. He links this to notions of creativity, explaining that 'when you do anything creative, you give away of yourself what you want to give away'.[17] However, such guarded comments have evoked some sharp attacks from scholars and journalists in the gay community, who refute the Pet Shop Boys' stance especially in the context of the mid-1990s. In the wake of pop groups such as Frankie Goes to Hollywood, Soft Cell, Bronski Beat, Culture Club and Erasure, which enjoyed immense popularity in the 1980s, it has been argued that the Pet Shop Boys have had no cause to conceal their sexual orientation. Whatever their reasons for holding back what they might not wish to give away may be, in his book Queer Noises, John Gill is reluctant to accept any of this. Detailing their quality of image, attitude and sense of Englishness, he compares them to Noel Coward and questions their motives for appearing discreet, modest and generous:

The Pet Shop Boys may fall short of Coward's wit and sophistication, but they very much fit the bourgeois English tradition of discreet perversion and collusion with the establishment. The Pet Shop Boys may give a lot of money to AIDS charities, but they also feel an overwhelming need to keep quiet about it. This may be modesty, for they distrust the ostentatious compassion of Live Aid and other such charity events. But this modesty, if modesty it really is, has become a hostage to their refusal to make a simple statement about their sexuality.[18]

Gill also suggests that the Pet Shop Boys represent a new type of post-Thatcher conservatism through the compromising stance they take with respect to their sexuality. However, from a heterosexual perspective it is precisely this display of indifference or 'modesty' that accounts for their wide popularity, which, rather than marginalising, transports gay culture into the centre of mainstream pop for access by all consumers. For such a duo then, it was hardly surprising that the song that launched their careers reaching Number 1 world-wide in 1986 was entitled 'West End Girls'.[19]

## MUSICAL BANALITY: POLITICS OF PLEASURE, SEXUALITY AND POWER

They also did something unthinkable: they wedded the euphoric sound of gay disco to lyrics which sounded very serious. Before the Pet Shop Boys, disco records were noted for the vacuity of their lyrics. In many instances, the words provided little more than verbal echoes to the all-important beat. The Pet Shop Boys were keen on the beat too, but they weren't prepared to surrender everything to it. Even now, it is hard to imagine Neil Tennant ever completely surrendering himself to a typical disco lyric like, 'oooh, love to love you baby'. For one thing, it's too passionate .[20]

Having heard it just once on the radio, Simon Frith rushed out to buy the record of 'West End Girls', which became the first British Number 1 of that year. He describes his impression of them in 1986:

Pet Shop Boys are, after all, just another British pop group, show-room dummies with electronic equipment and a memory bank of old club and disco riffs. There are hundreds of duos like this. Pretty packages, synthetic centres, they roll off record company

assembly lines like new sweets from a candy factory. What makes
Pet Shop Boys special is their sense of tacky drama.[21]

Such an account of the Pet Shop Boys is revealing; Frith underlines the
importance of drama and packaging which function to transmit an array
of social signifiers. For me though, a prime source of pleasure is derived
from the actual musical sounds themselves; easily memorable melodies,
simple chord progressions, glittering orchestral arrangements, catchy disco
riffs, and flirtatious rhythmic and lyrical hooks. Asked on one occasion
whether their material was just 'fun' music, Tennant acknowledged '[i]t
masquerades as good time party music'.[22] The 1980s dance culture
undoubtedly had a major influence on the emergence of their style, and
had played a role in Chris Lowe's life ever since he started frequenting
clubs in the early part of that decade. Openly he has stated that their aim
has always been to write songs within a contemporary dance context. Over
the past ten years their musical texts have served to document some of the
developments in dance music, as well as in music technology.

Searching for musical meaning in the Pet Shop Boys requires some
understanding of how pleasure, desire and enjoyment derived from sound
converts into dance. One of my aims is to demonstrate how the compo-
sitional features of their songs function in constructing such an aesthetic.
To pursue this further let us take a look at the song, 'Yesterday, When I
was Mad', off the *Very* album.

Opening with a catchy cross-rhythmic (duple vs. triple) riff in a com-
pound duple metre, the dance groove provides the main driving force of
this song. Picking up speed, this converts suddenly into a straight, quadru-
ple Hi-NRG groove, enhanced by the entry of more percussion samples.
Characteristic of most dance music, the hi-hats are foregrounded in the
mix, with the bass parts accenting each main beat. Heightening the antic-
ipated entry of the lyrics, this introduction passage firmly establishes an
up-beat feel. 'Yesterday, When I was Mad' airs numerous sentiments, in
particular the frustrations of being famous and constantly in the public
eye.[23] Nostalgia, insincerity, regret, loneliness and anger are just some of
the feelings wrapped up in the song, with the chorus hook, 'yesterday,
when I was mad and quite prepared to give up everything, admitting I
don't believe in anyone's sincerity', preceded by a sweeping synthesised
string glissando, consisting of a memorable chorus repeated gratuitously
(see Example 2). While the lyrics wallow in a wave of self-pity and
gloom, in having been so 'mad' to give up everything for love and fame,
the music is charged with energised house riffs, yet cushioned by easy har-
monic progressions (I-III-VI-V-I-IV-V in the chorus) and simple melodic

tunes. Despite the simplicity of the chord progressions and the chorus melody, it is significant that the song never resolves in a traditional manner to the tonic. Instead, any such teleological outcome is denied by the song ending on a Bb major chord, subdominant of the home key F dorian.[24]

*Example 2* 'Yesterday, When I was Mad'

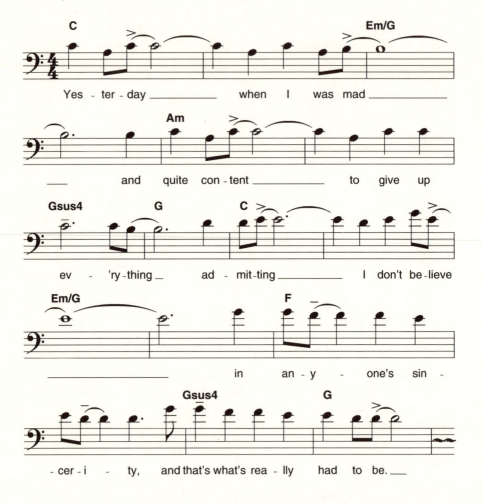

For the more traditional minded music scholar, the Pet Shop Boys might signify little more than a retreat into banality through their musical simplicity and blandness; the vocal delivery might seem unassuming, introspective and 'boring', the melodies trivial, with the synthetic, programmable quality of the production and instrumentation holding little

interest. But simplicity and banality in pop texts should not be underesti-
mated or detached from its musicological or ideological context. As Robert
Walser makes clear, popular musicians often invest great craftsmanship to
produce material that conveys a high degree of simplicity:

> The musical construction of simplicity plays an important part in
> many kinds of ideological representations, from the depiction of
> pastoral refuges from modernity to constructions of race and
> gender.[25]

As an integral feature of much pop, banality is contingent on our grasp
of it amongst a range of intersecting social, political and sexual discourses.
This might explain why in new branches of musicology modernist, eth-
nocentric qualitative assumptions of how musical complexity translates
into artistic merit have been constantly challenged through the critiques
emerging from popular music research.[26] Incontestably predicated on a
sense of banality, the Pet Shop Boys' style is displayed in a variety of inter-
esting ways. To expound on this, I have prioritised three parameters:
rhythm, vocal style and production.

The rhythm tracks implicit within all their songs articulate an array of
dance styles through which pleasure is located within the intricate details
of the compelling programming of the kit and percussion samples. By acti-
vating our physical response, the rhythmic grooves heighten the levels of
desire to escape, to dance, to fantasise and to reminisce. Through such
spontaneity and the bliss of the rhythmic riffs, exchanges of meaning
become negotiated via the beat, hence communicating the discursive
power of the musical style. In addition, the irony of the lyrics, always har-
nessed by a simple melodic vocabulary in the vocal lines (see Examples 1
and 2), has its references in the traditions of classical and popular musi-
cal idioms. While the vocal lines, cushioned by conventional chord
progressions, tend to flirt with closure and resolution, any such result is
rarely achieved. Through the use of samples, musical quotes are shame-
lessly lifted from a range of identifiable sources, creating a *bricolage* of
1970s styles and gestures that define the Pet Shop Boys' aesthetic. Much
of the appeal in the sound and the image then lies in the ways in which
the musical codes are rearranged and appropriated. Furthermore, the
banal, albeit profound quality of the lyrics is intensified by the often
expressionless and unemotional quality of Tennant's vocal style. Here the
controlled, cool and contemplative delivery resists any dynamic variation
in direct contrast to the colourful exuberance of the instrumental backing.

Moving on to the production, the aesthetics of the mix capture a distinct

sound which is characterised by the foregrounding of the rhythm tracks, the specific blend of the vocal parts, the predominant use of new electronic/digital equipment in terms of keyboards, samplers and drum machines, and the creative articulation of studio effects. The innovative spirit of their work strongly reflects the development and rapid changes taking place in the music industry. Their productions are highly programmed, slick and deliberately synthetic in flavour, with the emphasis firmly placed on the innovative use of music technology. Thus it is within the production and the assembly of all the musical components into the final mix that the Pet Shop Boys' language is shaped.

## TOWARDS A PET SHOP BOYS DISCOURSE

So far I have constructed this article around two premises: first, that the Pet Shop Boys' music offers up sets of questions and answers that warrant an investigation into the diversities of gender and sexuality within a 1980s British social context; and second, in being grounded culturally, sexually and socially, their musical strategies engender a specific ideological stance that constructs its own sense of 'authenticity'. Any claim to authenticity, however, depends on identifying its social and cultural location. In this light, postmodern pop is the outgrowth of an articulation and appropriation of various styles, images and modes of expression. Through creativity, authenticity in style inevitably surfaces as a critical point for consideration. Lawrence Grossberg has argued that in pop, aesthetic authenticity centres around notions of style and ideology:

> [it] becomes a self-conscious parody of the ideology of authenticity, by making the artificiality of its construction less a matter of aesthetics and more a matter of image-marketing. The result is that style is celebrated over authenticity, or rather that authenticity is seen as just another style.[27]

In problematising this concept, Grossberg goes on to claim that when linked to dance, music positions authenticity in 'the construction of a rhythmic and sexual body',[28] which leads to any number of impressions, such as those of fantasy, romance and sexual mobility. Here, integration of the visual images with musical sound shapes the experiences and responses of the listener. In pop, where authenticity is no longer measurable in terms of the 'real' or live performance, it is relatively unimportant that musicians might lip-synch their songs in live television, or that editing techniques might entirely simulate a performance. It is

more the 'ability to manipulate the presentation' that results in the 'measure of affective power'.[29] In their videos, for example, one constantly perceives the Pet Shop Boys' theatrical, camp and satirical gestures of expression as a confession of inauthenticity, or, as Tennant puts it, an admission of 'shamelessness'. But as Grossberg indicates, 'the only possible claim to authenticity is derived from the knowledge and admission of your inauthenticity'.[30] Grossberg's critique on postmodernism is thus useful to musicologists as it throws some light on the problems of reading pop texts. Because popular music always operates at different levels, yet on its own terms, all of which are predicated upon countless different discourses, we need to be alert to the causes and effects of trend.

In its move away from essentialist notions of high–low art, musicology has only just started to attempt any serious understanding of how pop music functions as a mechanism of social and cultural control. While the musical rhetoric of the Pet Shop Boys might be perceived as intentionally tacky and banal, I consider it as pop at its best; it stands as a strong catalyst against the chauvinist styles of heavy metal, rap and cock rock. Seeping out of every musical moment of their songs, elements of charm, superficiality and banality taunt the rigidity of binary empowerment found in the oppressive modes of many patriarchal texts of pop culture. In this manner, notions of 'difference' are always thematised, explored and problematised through their music.[31]

Finally, the Pet Shop Boys must be considered in the context of their particular social and political position, with the emergence of their style closely linked to specific cultural and historical locations. Their songs stand as narratives of masculinity and youth identity within a depressed 1980s and 1990s social landscape, where much mainstream popular culture has continued to absorb virulent machismo and latent violence in all forms of entertainment.[32] Exhibited and dramatised, but seldom resolved, the insecurities of the new male sensibility are stamped on all their introspective narratives. Visible through the mannerisms of polite yet insincere restraint, witty eccentricity and an acute sense of cynicism, the expanse of their iconography is typically English. In addition, seduction, which has always been threatening to white male politics, is always there in their texts. Of course, to pull any of this off successfully 'you have to be shameless', insists Tennant, 'otherwise you simply couldn't do it. You'd be too embarrassed.'[33] And shaped by a vibrantly passionate energy, it is the music itself that ultimately liberates them from the repression of their mannequin-like posturing. Slotting into some wider framework, all this seems to draw on a multiplicity of styles and texts that bring to mind that the pleasures (and displeasures) we experience from musical sound are

after all politically and culturally charged. Perhaps though we should afford the Pet Shop Boys the last word, when they remind us in no uncertain terms that as long as 'the music plays forever, it's gonna be all right'.[34]

## NOTES

1 'Honestly', interview with Neil Tennant by Paul Burston in *Attitude* 1994.
2 Ibid.
3 Ruth A. Solie (1993) 'Introduction', in R.A. Solie (ed.) *Musicology and Difference*, California: University of California, p. 19.
4 Will Straw (1993) 'Popular Music and Postmodernism in the 1980s', in S. Frith, A. Goodwin and L. Grossberg (eds) *Sound and Vision*, London: Routledge, p. 4.
5 Hi-NRG – an abbreviation for high-energy – can be viewed as a style of pop that has emanated from disco. It is thought to have started in the mid-1980s with Evelyn Thomas's smash hit, although there are strong traces of its conception some years earlier. Hi-NRG owes its success to the vibrant gay music scene, with its style formed by artists, such as the Weather Girls, Sylvester, Two Tons of Fun, Village People and Donna Summer. One of the first recordings of Hi-NRG is 'Hit 'n' Run' by Carole Jiani from 1981. Other notable recordings in this style have been made by Alison Moyet and Suzie Q, whose 'Computer Music' in 1985 was heralded as a standard of Hi-NRG.
6 Frank Mort (1988) 'Boys' Own? Masculinity, Style and Popular Culture', in R. Chapman and J. Rutherford (eds) *Male Order*, London: Lawrence & Wishart, p. 202.
7 Ibid., pp. 199 and 201.
8 Ibid., p. 215.
9 Ian Balfour (1991) 'Revolutions per Minute or the Pet Shop Boys Forever', in J.C. Guedon and Bill Readings (eds) *Surfaces*, Vol. 1.2. Folio 1, Montreal.
10 Frank Mort, op.cit., p. 205.
11 Rowena Chapman (1988) 'The Great Pretender: Variations on the New Man Theme', in R. Chapman and J. Rutherford (eds) *Male Order*, London: Lawrence & Wishart, p. 229.
12 Ibid., p. 230.
13 Ibid., p. 247.
14 In Paul Burston's *Attitude* article, he acknowledges that the references to gay culture can be read between the lines of the lyrics. Here he maintains that the Pet Shop Boys played an integral part in gay culture of the 1980s. Once again, however, it is necessary to stress that their popularity reached a wide range of the youth who were not always aware of the gay subtexts and levels of 'difference' portrayed by them. It was only during the 1980s that gay eroticism started filtering the pop mainstream to a significant extent, primarily through dance music, where it found a suitable place within the working-class lad culture.
15 *Melody Maker*, 27 November 1993.
16 Burston, op. cit.
17 *Out*, 'Pet Shop Boys, Frankly', interview with Larry Closs, December 1993.
18 John Gill (1995) *Queer Noises*, London: Cassell, p. 9.
19 It was from this point onwards that Neil Tennant and Chris Lowe continued to experience growing success with the following albums: *Please* (1986), *Actually* (1987), *Introspective* (1988), *Behaviour* (1990), *Discography* (1992), *Very* (1993), and *Disco II* (1994).
20 Burston, op. cit.
21 Simon Frith (1988) *Music for Pleasure: Essays in the Sociology of Pop*, Cambridge: Polity, p. 146.
22 *Melody Maker*, 27 November 1993.

23 Ibid.
24 Notably in a later remix of 'Yesterday, When I was Mad', off the *Disco II* album, the emphasis and euphoric quality of the music is even more intense than the original recording, detaching itself even further from the lyrics.
25 Robert Walser (1993) *Running with the Devil: Power, Gender, and Madness in Heavy Metal Music*, Hanover, NH: Wesleyan University Press, p. 128.
26 See Richard Middleton (1990) '"It's All Over Now". Popular Music and Mass Culture: Adorno's Theory', in *Studying Popular Music*, Milton Keynes: Open University Press, pp. 34–63.
27 Lawrence Grossberg (1993) 'The Media Economy of Rock Culture: Cinema, Postmodernity and Authenticity', in S. Frith, A. Goodwin and L. Grossberg (eds), *Sound and Vision*, London: Routledge, pp. 202–3.
28 Ibid., p. 202.
29 Ibid., p. 205.
30 Ibid., p. 206.
31 See especially 'Young Offender', 'To Speak is a Sin', 'One and One Makes Five' as examples of songs that thematise issues of 'difference'.
32 An example of one in a spate of films dealing with notions of machoistic manhood in the 1980s was *First Blood*, starring Sylvester Stallone as Rambo, who sets out to conquer all that is evil through the force of violent action.
33 Burston (1994), op. cit.
34 'It's Alright' (1989), Pet Shop Boys.

# Part III

# A TIME OF GROWTH AND CHANGE: FEMININITIES AND POPULAR MUSIC

# CAN A FUJIYAMA MAMA BE THE FEMALE ELVIS?

## The wild, wild women of rockabilly

### David Sanjek

I don't want a headstone for my grave. I want a fucking monument!
(Jerry Lee Lewis)[1]

You see, I was always a well-endowed girl, and the guys used to tell me that they didn't know how to fit a 42 into a 33⅓.
(Sun Records artist Barbara Pittman )[2]

Female artists just don't really sell.
(Capital Records producer Ken Nelson)[3]

In the opening scene of the 1993 film *True Romance* (directed by Tony Scott from a script by Quentin Tarantino), Clarence Worly (Christian Slater) perches on a stool in an anonymous, rundown bar. Addressing his comments to no one in particular, he soliloquises about 'the King'. Simply put, he asserts, in *Jailhouse Rock* (1957), Elvis embodied everything that rockabilly is about. 'I mean', he states, 'he is rockabilly. Mean, surly, nasty, rude. In that movie he couldn't give a fuck about nothin' except rockin' and rollin' and livin' fast and dyin' young and leavin' a good lookin' corpse, you know.' As he continues, Clarence's admiration for Elvis transcends mere identification with the performer's public image. He adds, 'Man, Elvis looked good. Yeah, I ain't no fag, but Elvis, he was prettier than most women, most women.' He now acknowledges the presence on the barstool next to him of a blank-faced, blonde young woman. Unconcerned that his overheard thoughts might have disturbed her, he continues, 'I always said if I had to fuck a guy – *had to* if my life depended on it – I'd

137

fuck Elvis.' The woman concurs with his desire to copulate with 'the King', but adds, 'Well, when he was alive, not now.'

In the heyday of rockabilly, one imagines more than a few young men shared Clarence's fantasy, although the urge to perform Elvis's music (even at the risk of repeating his premature and inglorious death) presumably exceeded that of making love to the 'King'. One observes in the features and the voices of any number of musicians – the well known, the unknown, and the obscure – the shadow cast by a young Southern man to whom fortune and talent ascribed the figure of royalty.[4] Furthermore, most histories of rockabilly, or the musical culture of the 1950s broadly speaking, characterise the period as one of wild boys at play, a brief moment when the grey-flannelled consciousness of American masculinity bordered on mania. Nick Tosches hyperbolically writes of the form as constituting 'the face of Dionysos, full of febrile sexuality and senselessness'; the vehement emotion at large in the culture aroused women, he adds, and made 'teen-age boys reinvent themselves as flaming creatures'.[5] The last two words of his comment, a reference to underground film-maker Jack Smith's 1963 paean to omnisexual behaviour, underscores the degree to which infatuation with Elvis not only crossed all gender boundaries but also fused if not confused those parameters. Bill C. Malone again encodes rockabilly as predominantly if not exclusively masculine. He underscores the synchronicity of the persona of the rockabilly musician with that of the prototypical white male Southerner as described by W. J. Cash in his epochal 1941 analysis of the region, as well as Jack Kirby's more recent observations on the region's entrenched myth of fevered emotionalism:

> If W. J. Cash had lived, he might have recognized them as the simple 'men-at-the-center' whom he discussed in Mind Of The South: men who felt rather than thought and who embodied, without hypocrisy, both hedonistic and puritanical traits . . . Jack Kirby in his recent book Media-Made Dixie, describes country musicians as conveyors of the myth of the 'visceral white Southerner,' a character who is 'languid, innocent of caprice and wisdom in handling money, moonstruck and often drunk.' He might have been more accurate if he had centered his discussion on the rock-abillies.[6]

John Morthland echoes Malone's gender-specific formulation when he describes rockabilly as 'the young white Southerner's every Saturday night blowout wrapped up in about two minutes of explosive music'.[7] Charlie Gillett does too in his standard history, The Sound of the City. The Rise of Rock

*and Roll*; rockabilly, he writes, 'suggested a young white man celebrating freedom, ready to do anything, go anywhere, pausing long enough for apologies and recriminations, but then hustling on towards the new'.[8]

The preponderance of white male rock historians themselves pause all too briefly and apologise all too little for the gender-biased narratives they propose. Unquestionably, they reconstruct the male-centred 'crucial image' that Greil Marcus asserts to be the embodiment of rockabilly: 'the sexy, half-crazed fool standing on stage singing his guts out'.[9] That notion continues to dominate in the popular music discourse surrounding rockabilly as constituting 'a moment when boys were men and men were boys' without somehow establishing the fact that the music these individuals performed and their fans admired remains curiously detached, 'almost self-contained, a world of its own'.[10] The milieu the predominantly Caucasian male performers inhabited routinely rejected the presence of women other than as the objects of sexual appetite. It should, therefore, come as little surprise how the public record of 1950s American popular music selectively acknowledges that, like Clarence Worly, many young women wanted not simply to fuck Elvis but, instead, to assimilate a portion of his authority and cultural power and assert that they too were ready, ready, ready to rock and roll, rip it up. Janis Martin, marketed by RCA Victor Records as the distaff version of the King, expressed that desire in song. On her 1956 release 'My Boy Elvis,' she expressed the desire to accompany the vocalist on the 'mystery train' of which he sang in his 'cover' version of the Junior Parker Sun classic and, by so doing, excise the pain and trouble of her life.[11]

I wish in this chapter to illustrate that women were fellow travellers on that 'mystery train' of which Elvis sang on its all-too-brief journey of rebellion and shared with their male peers a desire to exceed the familiar, worn-out parameters of social and cultural behaviour, thereby counteracting the prevalent 'predisposition to map processes of cultural reproduction onto processes of biological reproduction'.[12] Winning back a place for female rockabilly artists in the narrative of American popular music history constitutes more, however, than merely redressing an instance of cultural amnesia. It might as well, to some degree, facilitate the realisation that 'The existence of music, like the existence of women, is potentially threatening to men to the extent that it (sonically) insists on the social relatedness of human worlds and as a consequence implicitly demands that individuals respond.'[13] Both those men and women who created and performed rockabilly participated in the usurpation of cultural space and power from the dominant society by resisting incorporation into that society and insinuating themselves into those interstices where the predilection

for oppositional consciousness resided. Their raw energy and bravado, which was chastised in many quarters as juvenile excess at best and outright depravity at worst, resulted in the generational rearticulation of 'taste', which, as W.T. Lhamon, Jr. asserts, constitutes 'a euphemism for the inherited repertoire of shibboleths by which the empowered recognize one another'.[14]

The sheer force of women taking on the stylistic signifiers of rock and roll eroded those shibboleths as when, in the song 'Fujiyama Mama' incorporated in my title, Wanda Jackson sang in 1958 of eradicating the forces of male-centred social hegemony. The singer announces authoritatively that she has visited Hiroshima and Nagasaki and can display the same cataclysmic energy as did the devices dropped on those cities. In the final chorus she asserts, 'You can say I'm crazy. So deaf and dumb/But I can cause destruction just like the atom bomb!'[15] Ironically, in these lyrics, Jackson echoes the very language used to repress women during the Cold War and confirm them in a repressively maternal and familial role. As Elaine Tyler May observes, the fear of atomic attack was symbolically connected with anxiety over transforming gender roles, sexual chaos mimicking post-nuclear catastrophe.[16] Descriptions of nuclear warfare frequently incorporated feminine diction and imagery, thereby conflating atomic conflagration with the purported excesses of the 'second sex'. The predominant social and cultural discourse argued that family stability and serial monogamy provided a haven in a hapless world, but, in the end, neither bomb shelters nor basement rumpus rooms could keep at bay, particularly from susceptible adolescents, the energies unleashed by popular culture in general and rock and roll in particular. To wit, Wanda Jackson concludes 'Fujiyama Mama' by wailing, 'And when I start erupting, ain't nobody gonna make me stop!'

To illustrate the manner in which female rockabilly singers acted as, to borrow a phrase from Marshall McLuhan, 'counter-irritants' to the social consensus of the 1950s, I will first indicate the parallels with an earlier African-American female musical constituency of the 1920s, the 'blues queens', and how they too contested the male hegemony of the musical and social domain. Then, I will argue that rockabilly, and the female component of that form in particular, must be situated more fully in a historical frame by its continuity with certain sub-genres of Country music, specifically the honky-tonk compositions and performers of the 1940s and early 1950s. Finally, I will examine some of the key female rockabilly artists, dividing them into three categories: the nymphets (Brenda Lee and the Collins Kids), the heiresses apparent (Barbara Pittman and Janis Martin), and the unrequited queens (Rose Maddox and Wanda

Jackson). In conclusion, I will point out that the inaccessibility of recordings by many if not most of the female rockabilly singers constitutes an even more effective silencing than their (in most cases) truncated careers in the late 1950s and early 1960s. Their ride on that 'mystery train' may have been short, but the virtual absence of both track and engine in the present day reinforces that once the voices of history are extinguished, little can be done to resurrect them. The disappearance of a vast number of recordings from public circulation reminds one that there is an acoustic component to the 'tree falling in the woods' conundrum of Philosophy 101: if a recording is made, but no one can hear it, the performer effectively has been silenced.

The presence of black women in the history of the blues has been an active one, while the documentation of that presence remains spotty, even criminally undernourished. In few cases is that obliviousness more evident than the work of the performers often referred to as the 'blues queens' of the 1920s. While the accomplishments of such quintessential individuals as Bessie Smith remain a durable portion of blues history, as does Ma Rainey to a considerable though lesser degree, many other estimable if not so illustrious women have come to be the property of the cognoscenti. True, Mamie Smith acquires a presence in any creditable historical narrative by virtue of her recording the first credited successful blues song – Percy Bradford's 'Crazy Blues' (1920) – as does Alberta Hunter, less so for the work of her youth than the fact that she successfully retook the stage in her 80s. Many others, however, remain footnotes: Eliza Brown, Ida Cox, Mary Dixon, Lilian Glinn, Lil Green, Sara Martin, Memphis Minnie, Clara Smith, Victoria Spivey, Sippie Wallace, and Edith Wilson to name a few.[17] As a body, these women ritually exorcised the feelings of their peers, who collectively engaged in and suffered the benefits as well as the repercussions of the mass migration of rural African Americans to the urban centres of the North; they can be assessed as 'pivotal figures in the assertion of black women's ideas and ideals from the standpoint of the working class and the poor'.[18] While viewing them as a collective body too easily results in the reduction of concrete individuals into a unitary black female subject, who, as Hazel Carby observes, 'is frequently reduced to a single dimension of either suffering or nobility,' the manner in which these women's role in black musical history has been denied or reduced permits one some power of generalisation.[19] As Carby has written, their work collectively constitutes 'an alternative form of representation, an oral and musical woman's culture that explicitly addresses the contradictions of feminism, sexuality and power'; their lyrics and voicings of them:

articulates a cultural and political struggle over sexual relations: a struggle that is directed against the objectification of female sexuality within a patriarchal order but which also tries to reclaim women's bodies as the sexual and sensuous objects of women's song.[20]

While Carby's analysis remains incontestable, the reasons for these women's virtual expurgation from most histories of the blues are several and parallel, as we shall see, with the erasure of women from the delineation of rockabilly. They include, first, the false bifurcation between 'traditional standard' and 'nightclub' blues forms; second, the inference that since most of these women's songs were written by men, they must remain mere vessels of other individuals' sentiments; and third, the limited period of time during which these artists recorded and consequently the small number of available tracks they completed are employed as a means of belittling their contribution to musical history.

Few terms are as loaded or carry as much baggage as the blues, and few elements of its definition remain as contested as that of the 'authenticity' of performance. For some, only those blues that possess rural origins or can claim descent from rural forms deserve the nomenclature. Many if not most of the 'blues queens' came from rural backgrounds, but the places in which they performed exceeded that physically limited domain and the material they sang arose from a wide range of sources. In fact, should these performers have anything in common, Derrick Stewart-Baxter states, it is 'their comparatively wide range of material, including other songs than blues, and the debt they owed to the tent shows and the vaudeville stage'.[21] They sang what the circumstances required and retained few rigid stylistic distinctions about what material was appropriate and what verboten. A blues song delivered at the Cotton Club, on the stage of a London theatre, or in a rural juke joint remains similar in kind though different in place. The rounding off of the rough edges of melodies by those individuals pejoratively labelled as 'supper club' singers therefore remains a matter of semantics, not musicology. Regardless of the source of their material, these women brought to their performances a unique meaning as a consequence of their position as black females. That ability to translate into racial- and gender-specific terms material that does not fall under some people's definition of blues supports Daphne Duval Harrison's assertion that 'It is idle to argue whether they were closer to vaudeville blues or jazz singing than to authentic blues; what counts is that the audience for the recordings accepted and endorsed them as blues.'[22] As we shall see, female rockabilly singers often crossed generic and racial boundaries —

Wanda Jackson's 'Fujiyama Mama', for example, was a cover of a 1955 track by black rhythm and blues artist Anisteen Allen – but brought, by virtue of their gender, a distinct voicing to a disparate repertoire. Quarrelling over issues of definitional purity merely provides a convenient expungation of a body of artists from the history of a form that they practised, whatever its agreed-upon definition.

The fact that many if not most of the songs performed by the 'blues queens' were not written by them but, in fact, by men, and in some cases Caucasian men as well, equally does not take away from the substance or the significance of their achievement. The actual author of the material matters less than how the work was utilised to project an image of feminine autonomy and racial solidarity. Black women used the formal dynamics of the blues as a means of, as Daphne Duval Harrison argues, 'talking smart'; i.e. using language to 'go public' with attitudes and points of view that the dominant society, Caucasian and African American alike, wished to expurgate.[23] In the process:

> the silent, suffering woman is replaced by a loud-talking mama, reared-back with one hand on her hip and with the other wagging a pointed finger vigorously as she denounces the two-timing dude . . . . Going public is their declaration of independence. Blues of this nature communicated to women listeners that they were members of a sisterhood that did not have to tolerate mistreatment.[24]

Regardless of the origins of the material, it is the fact that the blues provides the female performer with an opportunity for 'going public' that matters. To think otherwise is to confuse issues of intellectual property with performance and, in the process, falsely valorise the 'author' as the sole source of meaning. Likewise, the female rockabilly singers were rarely in a position to write, let alone choose, their songs, but the opportunity to place their personal signature upon a song that implied if not endorsed individual liberation remains a rare opportunity not to be denied. Whether the flamboyant, gender-bending Little Richard or sexually aggressive Wanda Jackson sings 'Rip It Up', the call remains a potent exclamation.[25]

The limited number of recordings by the 'blues queens' constitutes an instance when an interested public succumbed to the collapse of the financial markets following the Depression. The bottom fell out of the recording business, and the manufacture of 'race records', as blues recordings were referred to at the time, ground to a halt. Similarly, the number

of public spaces in which the 'blues queens' appeared before the public evaporated. Paradoxically, those performers who were the most traditional suffered the greatest, whereas the 'supper club' artists possessed the range of experience and expertise to weather out the Depression and find alternate platforms to make a living musically. Admittedly, those individuals are often portrayed, even by the friendliest commentators, as 'selling out', reducing themselves to the lowest common denominator, whereas the individuals who disappeared from the scene – some, like Sippie Wallace or Alberta Hunter, to reappear years later – are valorised as not prostituting their talents. Such a reading seems to me to mistake circumstance with compromise and in the process once again conflate suffering nobility with the essential black female subject. Likewise, the fact that, like their male peers, the heyday of rockabilly's female performers was short-lived should not be held against them. It was stalled as much by the fickle will of the public as the loss of key figures from the scene: Buddy Holly and Ritchie Valens in a plane crash, Elvis to the army, Jerry Lee Lewis to public ignominy, and Chuck Berry to jail for allegedly breaking the Mann Act. In response to that truncating of rockabilly's ascendance, many of the female rockabilly singers either retreated from the genre to the Country field from which they originally arose, or from the recording studio, but not the public stage altogether. This should be viewed as an instance of women artists adapting their talents to an alternate domain, not abandoning them altogether. Too often, the scenario that occurs when an artist falls from commercial grace or becomes left by the wayside through a transformation of the zeitgeist is translated into an abnegation of a calling rather than an insightful renegotiation of uncertain circumstances.

The denigration of those artists who 'crossed over' (or in many cases 'crossed back') to Country music when the rockabilly bandwagon hit a speedbump reminds one that while the influence of Country music upon the rock genre remains considerable, most historians and analysts (and more than a few fans) downplay or deny it. By stressing the degree to which rockabilly broke away from the most staid and retrograde elements of Country, the continuities between the two forms remain obscured. Furthermore, those instances of dyed-in-the-wool Country musicians who unsuccessfully dabbled in rock and roll as well as the animosity held by members of the Country industry against rockers for curbing the ascendancy upon the pop charts of their efforts still colours the account of the two forms' interfusion. Few are the instances of tribute paid from one field to the other, as when Bill Monroe so admired Elvis's speeded-up cover of 'Blue Moon of Kentucky' that the progenitor of bluegrass forever after played it in overdrive. More common was the Maddox Brothers and

Rose's sarcastic but nonetheless telling bluegrass-tinged 'The Death of Rock and Roll', a cover of Ray Charles' 'I Got Woman' that concludes with the Maddoxes' characteristic high-pitched laughter. Nevertheless, rockabilly hardly arose out of a vacuum, and in the case of its female performers, their 'foremothers' include the honky-tonk singers of the 1940s and early 1950s who brought to the Country genre a refreshing matter-of-factness and exuberance that their successors emulated. As Mary A. Bufwack and Robert K. Oermann write:

> Honky-tonk vocalists went for unabashed theatricality. They wailed; they moaned; they whimpered; they shouted; they pleaded; they cried. With slurred phrases, bent-note effects, vocal breaks, and slippery yodel techniques, they practically wept in tune.[26]

However, one cannot consider the essence of honky-tonk and its influence upon female rockabilly artists a matter of vocal legerdemain alone. The continuities result more substantially from the manner in which certain female country vocalists transformed the affective register of the genre and ceased being the demure flower of earlier generations.

The influential figures in this context range from the renowned to the recondite. Of the latter, one can point to Ruby Agnes Owens aka Texas Ruby (1908–63), who was billed as 'the Sophie Tucker of the Feminine Folk Singers' and lived an off-stage existence as 'a hard-drinking, good-time mama with a cigarette in her red lips, a rowdy laugh, and a heart of pure gold'.[27] Possessed of a deep, almost masculine alto, conversant with a variety of genres, and gifted with a rare skill for profanity, her recordings for Columbia (1945–6) and King (1947) remain more memorable for their thematic content than their instrumentation, although one wonders what kind of public presence she presented during her years on the Grand Ole Opry (1944–8) and successful career at tent shows, where she was one of the first Opry stars to demand and receive top dollar – as much as $500 a night. Better known but not as widely as her considerable achievement deserves is the still-active Jean Shepard, whom Bufwack and Oermann consider the best female honky-tonk singer of all. Signed to Capital Records in 1952 at the age of 17, despite the animosity of staff producer Ken Nelson as quoted in one of the epigraphs to this essay, she scored forty-five chart hits. The bluntness of many of her songs mirrored her no-nonsense temperament; as she states, 'I've always been sassy to a certain extent. But I've had to be to survive.'[28] This led her to agitate for better union pay for her band members and participate in the back-to-

Country movement of the early 1970s that occurred in the wake of the Country Music Association's awarding of honours to performers that Shepard and others of her peers believed had little familiarity with or affinity for the genre. In addition to her many hit singles – 'A Satisfied Mind' (1954), 'Beautiful Lies' (1955), and 'I Thought of You' (1955) amongst them – she released in 1954 what might be considered the first female-centred concept album in the field, *Songs of a Love Affair*. A linked cycle of compositions that charted the trajectory of a belated romance from a woman's perspective, this long out-of-print album permitted Shepard to display a broad affective register that more adequately represented the range of female emotion than the restricted emotional palette of earlier Country performers. Best-known of all the female honky-tonk vocalists is the Country Music Hall of Fame honoree Kitty Wells, whose eighty-one charting singles began with the landmark 'It Wasn't God Who Made Honky-Tonk Angels' (1952). That song's piercing, though restrained lament of pent-up animosity against wayward men admittedly mirrored a longstanding tradition in Country music but gave it a stamp of unadorned directness that not only established Wells's career but also the public posture of women in Country as capable of asserting if not their independence then certainly their heart-felt point of view. At the same time, the trajectory of Wells's career remains perplexing. A mother, aged 33 when she recorded her first hit, Wells remains:

> as much a part of the dying, Victorian, old-time country culture as she was a standard-bearer of the postwar style. Publicly she sang of guilt and remorse, of illicit romance and sin, of betrayal and broken dreams. Privately, she was the polite mother of three and a shy, soft-spoken, dutiful housewife. She was steeped in tradition, but became a star as an innovator.[29]

The continuity of form and disparity of approach that Texas Ruby, Jean Shepard, and Kitty Wells took to Country music indicates that, like the 'blues queens', female honky-tonk singers, and the rockabilly artists that succeeded them, cannot be reduced to a single unitary subject. Neither the demure and abandoned wife nor the ballsy hell-bent firebrand constitute the whole of the genre. The women who sang rockabilly had a range of personae from which to choose, and many, if not most, assumed a portion of both these types.

There remains, however, a figure unknown to virtually all but the cognoscenti who prefigures, at the risk of romantic overstatement, the core of the rockabilly point of view before its time and whose early and ill-

timed departure from the scene constitutes all the impediments, then and now, to an unimpeded assertion of femininity in the musical arena. That hapless individual – one hesitates to say victim – was Charlene Arthur (1929–87). Stylistically and temperamentally out of step with her times, her stormy, explosive personality collided with the Nashville establishment in general and Chet Atkins, the father of 'the Nashville Sound', in particular. She recorded for RCA Victor Records from 1953–6, a total of thirteen sessions yielding twenty-eight sides. Like many of the rockabilly singers, she came from a large, impoverished family, the second of twelve children. Arthur wrote her first song at the age of 12. Titled 'I've Got The Boogie Blues', it was later to be her initial recording on Bullet Records in 1949. A featured artist on KERB in Kermit, Texas, she was discovered by Colonel Tom Parker, the handler of 'the King', and recommended to Gene and Julian Auerbach, the New York-based heads of Hill and Range Publishing, who sold her and her material to RCA Victor. There, as Bufwack and Oermann write, 'she fought to become country's first truly aggressive, independent female of the postwar era. Ultimately she lost.'[30]

Arthur's combative personality, so suited to the music she wrote and performed, failed her in the studio. It collided with the commercially-driven and head-strong A&R man Chet Atkins. She states:

> He and I would get up in arms. He always had songs he wanted me to record that I didn't wanta record, and I had ones I'd written that he wouldn't let me record. I'll give the devil his due: I admire Chet Atkins' talents, but I didn't like his guitar style, even though he played on my records. I just felt he didn't have the right substance for my vocal style. But he was top dog, and there was nothin' I could do. I remember the last time we recorded together, me and him had it out good and proper. I was cryin' so bad.[31]

At the same time, despite their animosity, a fair amount of Arthur's sensibility emerges from what she often felt to be unsympathetic material and production. 'Burn That Candle' in title and lyric comments on her hellbent point of view; while the title refers to a candle placed in the window by the singer's mother to light her way home, the lyrics and Arthur's treatment of them accentuate the manner in which she pursued her life without quarter. The tongue-in-cheek 'Kiss the Baby Goodnight', a paean to assertive romance, unsurprisingly inflamed the moralistic denizens of Nashville, and she was consequently made by Grant Turner of the Grand Ole Opry to screen her material prior to airtime. 'Welcome To The Club',

written by Mae Axton, the co-author of Elvis's 'Heartbreak Hotel', remains perhaps her most memorable side and the clearest precursor to rockabilly. The raw edge to her voice and sweeping delivery of the chorus still inspire dismay that Nashville was unable to accommodate her venturesome spirit.

That club to which Charlene Arthur belonged eventually broke her heart. Despite finishing second to Kitty Wells as 'Best Female Singer' in a 1955 disc jockey poll and touring with, among others, Elvis, Johnny Cash, Jerry Lee Lewis, Marty Robbins, and Lefty Frizzell, she was dropped by RCA in 1956 following her final 19 May session. The last track cut at that time was the touching 'What About Tomorrow?', a question whose implied answer, in Arthur's case, was truly heartbreaking. To add insult to injury, while that song was written by Charlene, the copyright is credited to her then husband, Jack. She thereafter drifted from label to label, state to state, and ended up in rural Idaho, crippled with arthritis, without a phone, and living on a $335-a-month disability cheque. Alice M. Michaels, who managed Arthur at the end of her life, reports that she would weep when seeing former friends and co-workers appear on the Nashville network. She died a year after Bear Family Records, a West German reissue label devoted to Country and 1950s rock and roll, released an LP containing sixteen tracks from the RCA sessions. 'I was a blues singer, and I wanted to sing something different. I wanted to be an original', Arthur asserted.[32] She was original, perhaps, but the legacy of her fate as well as her good fortune to pursue a memorable if truncated career is a reminder of all the obstacles that the female rockabilly singers who followed her had to overcome.

Concurrent with those obstacles was the emergence of that demographic bulge characterised as the 'baby boom': a confluence of adolescents who formed a generational constituency as well as the ripe target of eager advertisers. In 1956, the national census included thirteen million teenagers; they contributed seven billion dollars annually to the national economy, a twenty-six per cent rise over just three years before.[33] The average teenager earned $10.55 a week, of which boys saved twice as much as girls, but the boys spent a third more.[34] One of the principal consumer items purchased by teenagers was records. By 1959, seventy-five million dollars worth of 45s alone were sold annually, most of them to teenagers with young girls in the majority.[35] According to Ed Ward:

> Junior high school girls bought most of the records, with 61.7% of them buying at least one a month, as opposed to 46.6% of junior high school boys, 48.9% of senior high school girls, and

41.9% of senior high boys. The average buyer brought two records a month, but among the ones who brought over twelve a month, the boys took the lead.[36]

In the course of 1957 alone, rock and roll began to control that market and body of consumers. The ascendance was so swift that whereas in March of that year all the positions on *Billboard*'s Top Ten list were taken up by male pop artists, by the end of December they had been virtually replaced by rock and rollers, albeit still exclusively male.[37] Rock and roll successfully conquered radio before its domination of the charts, for, at the close of 1956, sixty-eight per cent of the public airwaves was occupied by disc jockeys dedicated to the genre, a two-thirds increase in the course of a single year.[38] Many advertisers complained that broadcasters single-mindedly devoted themselves to the young, who statistically constituted only twelve per cent of the population.[39] Nevertheless, in short order, the music produced by heretofore marginalised individuals in the music business – African-Americans, working-class whites, women, Chicanos, and others – occupied if not the centre of the national culture then certainly prompted many of those in the majority to reconsider their behaviour and point of view, some even further to constitute what Michel Foucault has called a 'counter-discourse' and W.T. Lhamon, Jr. designates 'an alternative pest consciousness'.[40] So accelerated and abandoned was the energy unleashed by popular music culture at this time that the very society frequently seemed as revved-up and hyperactive as the overwrought rhythms and hysterical vocals of the performers on the radio. And while portions of the country vehemently resisted the legal promptings towards integration promulgated by *Brown v. Board of Education* (1954), or the calling out of federal troops to integrate Little Rock, Arkansas Central High School (1957), a vast majority of the nation eagerly assimilated an acoustic equivalent of integration in the routine amalgamation of disparate music forms – blues, country, rhythm and blues, jazz, and pop – in rock and roll.

At the same time, that predilection for hybrid forms of expression was not without social or ideological impediments, particularly as regards female performers. It must be stressed that, for all the new-found liberality at home amongst the nation's youth, many if not most of the female rockabilly artists failed to appear on the national record charts at all. This reinforces one of the recurrent responses to any threat posed by any 'other', that in this case an uninhibited and sexually aggressive woman, was 'transforming it into a bit of exotica so other as to be meaningless.'[41] Such a strategy particularly influenced the careers of that first category of

female rockabilly performer I designate the nymphet: a pre-pubescent girl or adolescent young woman who was exploited by their record label as a sexually venturesome individual. Each of the female rockabilly performers began to sing at a young age, some as young as 5 years, and often came across as unselfconsciously flirtatious, but the manner in which they projected their sexuality was quite another matter when it comprised a portion of a corporate marketing scheme. These young women were often technical prodigies, gifted with voices whose affective range seemed in advance of their actual age. Producers took advantage of this discrepancy and accentuated the paradox of a sexually alluring adolescent through the choice of suggestive lyrics and the form of their presentation.

Chief amongst the rockabilly nymphets was Brenda Lee, nicknamed 'Little Miss Dynamite', who Decca Records signed in 1955 when she was eleven years old. Described by Red Foley, the country music veteran who sponsored the young girl on his ABC-TV series 'Ozark Jubilee', as 'a little girl with grown-up reactions', Brenda Lee found herself delivering words whose connotations she often did not understand.[42] She states, 'When I listen to the rock songs I sang, not knowing what the words must've meant, I was singing them like I knew.'[43] So successful was she at this process of imposture that portions of the public were convinced that Lee must be a midget. Others took the singer's physical appearance at face value, disregarding her affective maturity, only to be brought rudely to task, as when Decca executive Paul Cohen tried to explain something to the young girl in baby talk. 'Well, goo-goo!', she disdainfully is said to have replied.[44]

The early singles Lee recorded should have predisposed Cohen to act otherwise, as the authority of her voice goes against the grain of her actual appearance at the time: a diminutive, curly-haired child in puff-sleeved dresses. He had only, for example, to know her 1959 hit 'Sweet Nothin's' on which 'the then-fourteen-year-old Brenda shouts, pants and purrs over a steady beat, in a way that can only be described as "adult"' to realize the weight of his error.[45] With that in mind, when listening to her first million-seller, the stirring 'I'm Sorry' (1960), one might ask what she possibly could have need to apologise for? Her non-professional life remained squeaky clean – 'I *wanted* to get in trouble, but there was no way', she recalled as an adult – for parental intercession kept her publicly salacious but privately demure.[46] This strategy, whatever its psychic cost, paid off, for she scored the most hits of any of the female rockabilly singers during the 1950s and well thereafter, although some people found her undeniable skills smothered by her producer Owen Bradley's trademark studio style. (John Morthland castigates her as 'fulfilling the role of

Patsy Cline for kids'.[47]) Nevertheless, the discrepancy between her appearance and age still remains disturbing, especially when one encounters photographs of the young Brenda appearing uncomfortably world-weary or physically self-conscious for one so young.[48] Her early success reminds one that the public was, perhaps, most comfortable with female sexuality when they could distance themselves from it by reducing the phenomenon to a caricature. Brenda Lee's youth prohibited anyone from taking her expressions of desire seriously. Much as certain cinematic icons of the period, Marilyn Monroe or perhaps more so Jayne Mansfield, she exaggerated female sexuality to the point that it was effectively neutralised.

Such was not the case with the career of the adolescent Larry and Lorrie Collins, the Collins Kids. Even when their material addressed romance, it never even alluded to the sexually suggestive. Instead, their unthreatening, perennially upbeat wholesomeness radiated the effervescence and buoyancy of youth, not its delinquent darker side. Natives of Oklahoma, this sister and younger brother moved to California in 1953 at the respective ages of eleven and nine to appear on the popular 'Town Hall Party', hosted by the avuncular Tex Ritter. Two years later, they were signed by Columbia Records and remained on the label through 1959. Their first single, 'Beetle Bug Bop'/ 'Hush Money' (1955), typifies what followed: an uptempo nonsensical song backed by a domestic scenario in which Larry demands cash in return for his silence about his sister's romantic liaisons. As it illustrates, the duo, both on record and more vividly in their television appearances, contrasted in temperament and musical orientation: Lorrie comes across as a demure but nonetheless assertive lead vocalist, all the more so as she grew older, about whom her hyperactive instrumentalist sibling capered, his fingers leaping across the fretboard of his signature double-necked guitar. Even when their songs addressed affairs of the heart, the content remained incontestably adolescent, neither in advance of or behind their actual years. The fact that both siblings wrote a portion of their own material accounts for its thematic consistence and appropriateness. Some of the titles attest to their interests: 'In My Teens', 'Whistle Bait', 'Hot Rod', and 'My First Love'.

At the same time, however high-spirited and lightweight the duo's work may appear retrospectively, it holds up far better than the recordings of the other juvenile performers of the period, particularly the manufactured male and female 'teen idols' or any of the television actors who made their mark, however briefly, on the charts. (The sole exception to that rule remains Ricky Nelson, with whom Lorrie Collins had a heart-felt romantic relationship as an ardent 15-year-old.) Part of that durability results from Lorrie's vocal assurance and Larry's considerable instrumental

skills, attributable in large part to his tutoring by Joe Maphis, leader of the house band on 'Town Hall Party' and one of the West Coast's most renowned musicians.[49] Unfortunately, the Collins' unblemished youth lost its appeal when Lorrie met and married Johnny Cash's manager, Stu Carnell, nineteen years her senior, during a tour in 1959. Their relationship relegated her fresh-faced appeal to mundane matrimony. Furthermore, now that she was perceived as a woman, how could she innocently sing about 'soda poppin' around' with her sweetheart and be taken seriously?[50] The duo split up, but in recent years have revived their surprisingly undated material. In their heyday Lorrie and Larry Collins could address issues vital to the young without repercussions as long as they remained chronologically affiliated with the subjects and audience of their songs. Lorrie's sexuality, however unassertive, demonstrated in an audience-friendly manner the passions of youth. If she was a nymphet by virtue of her age, Lorrie Collins never displayed an unseemly or unsettling demeanour. An ironic footnote, Larry continued his musical career as a songwriter, most notably co-authoring 'Delta Dawn' in 1972. That song established the still vital career of then 13-year-old Tanya Tucker who authoritatively delivered its sexually potent content.[51] Her success indicates how the ambiguous maturity of the rockabilly nymphet could readily be recycled.

The second category of female rockabilly singers, the heiresses apparent, takes in the numerous young women who, like many if not most of the 'blues queens', never achieved the level of success necessary for long-lasting fame. Known only to devotees of the genre, they remain ciphers to the general public, faceless reminders of a day and sound gone by. In most cases, their commercial failure and obliteration even from the reputable histories cannot be blamed on technical ineptitude or a lack of moxie. More to the point, their record companies either were unable to perfect a winning promotional strategy or the public simply failed to recognise their talents. Bufwack and Oermann's book resurrects the careers of a number of these figures –- Bonnie-Lou, Jo-Ann Campbell, Jean Chapel, Sparkle Moore, Lauri Lee Perkins, as well as Lucille Starr and Bob Reagan to name a few – of which two, Barbara Pittman and Janis Martin, might be said to epitomise the also-rans that the record industry dismisses with the flip phrase 'one-hit wonder'.

Barbara Pittman, native of Memphis, Tennessee and classmate as well as neighbour of Elvis Presley, remains one of the few women to record on Sam Phillips's Sun Records. Signed to the label from 1956–60, she recorded more tracks than any other woman with whom the legendary producer worked, but he neither seemed to be capable of or, in Pittman's

eyes, interested in concocting the proper strategy or locating the appropriate material to make her a star as he had with so many other young men. Possessed of a rich, bluesy voice, Pittman's account of her commercially unremarkable recording career amounts to a litany of denied opportunities and dashed hopes, most of them, she believes, due to Phillips's implicit or unconscious misogyny. In the liner notes to the Bear Family reissue of her Sun recordings she states, 'Sam didn't like female artists. He had no confidence in them. Especially me. I had a low, bluesy, husky voice and his favorite female artist was Doris Day. That should tell you something.'[52] Pittman's comments might be said to amount to little more than sour grapes were it not for the fact that the only other women Phillips notably recorded were the Davis Sisters, a sweet-voiced duo who must have reminded him vocally of the blonde movie star. In light of her experiences at Sun, some of Pittman's song titles possess more than a touch of irony. 'I Forgot To Remember To Forget', in which the chorus states 'I think about him all the time', reminds one of her seeming obsession with Phillips's dereliction of his duties as a promoter of her talents.[53] Even more telling, the inclusion on the Bear Family album of three takes of the song 'I'm Getting Better All The Time' comes across as a cruel reminder of Pittman's truncated career. In the end, Pittman realises how little she fits the common pattern of feminine behaviour of the day. She was incapable of being, in her words, 'cutesy, petite, and pretty'.[54] As much as any of the female rockabilly singers, she protests against the gendered exclusiveness of the period by acknowledging that 'recording for Sun in the fifties was, for a woman, being part of a man's world.'[55] At the same time, whatever one might think of the quality of her work (much of it, admittedly, of dubious substance), it remains appalling that Pittman does not even rate a mention, let alone a footnote, in the standard history of the label by Colin Escott and Martin Hawkins, reinforcing many women's paranoia that the music business, then and now, remains a deck stacked in a man's favour.[56]

The career of Janis Martin, 'the Female Elvis', presents an equally unflattering example of corporate ineptitude and neglect. Her career was as abruptly curtailed as Pittman's, but, at the same time, resulted in a more demonstrable level of commercial achievement. John Morthland considers her the only female rockabilly singer, except Wanda Jackson, worth talking about and remarks that she 'phrased like running a line of jive came pretty natural to her.'[57] Like many of her peers, Martin began to sing professionally at a young age, in her case 11 years old, on the WDVA Barndance of Danville, Virginia. Her career took off when two staff announcers and part-time songwriters at SRVA, the station that carried the

Barndance over the CBS network, took notice of the teenage Martin and asked her to sing the demo of their rockabilly composition 'Will You, Willyum'. They succeeded in selling the song and its 16-year-old singer to RCA Victor Records in 1956. Interestingly the flipside to that first single, 'Drugstore Rock and Roll', was written by the vocalist, who seems, however, not to have had the opportunity to do so again in the future.

When that first release sold 750,000 copies, Martin's career took off. She appeared on a host of network television variety shows, including 'American Bandstand' and 'The Tonight Show', and was screen-tested by MGM. Two other RCA Victor singles made some headway on the charts, a cover of Roy Orbison's 'Ooby Dooby' and the aforequoted 'My Boy Elvis'. The entertainment press recognised her talents, for she was voted 'Most Promising Female Vocalist' at the annual disc jockey convention in 1956, an acknowledgement that Martin's clean-scrubbed looks and pert appearance, blonde ponytail bopping as she sang, made her an accessible representative of her generation, neither too aggressive nor too sugar-coated. However, the production of her material – too sedate for rockabilly, too wild for country – placed Martin's long-term career in jeopardy, devoid of a stable acoustic identity. Her facade, moreover, withheld a complex private life that proved to be her downfall. Married secretly to her childhood sweetheart since 1955 at the age of 15, Martin gave birth to a son in 1958. As in the case of Lorrie Collins, marriage and motherhood eroded her persona of the excitable teenager as well as her label's interest in her. RCA apparently felt that teenage motherhood and a career as the 'Rockin' Country Gal' did not go hand-in-hand and dropped Martin in 1959. Divorced soon after by her first husband, she remarried in due course just as a small label, Palette Records, began to record her. Her second husband, much like RCA Victor Records, felt motherhood and a performing career to be incompatible and demanded that she choose between them. Janis Martin got off the 'mystery train' and has not recorded since until a recent tribute album to rockabilly by Rosie Flores included a duet with her. Like the nymphets, Janis Martin possessed commercial credibility so long as her sexuality remained contained and composed; once maturity set in, that composure no longer proved creditable. It was one thing to sing about high school boyfriends; it was quite another, in the eyes of the public, to marry one. A sexually mature woman who celebrated her physicality in song walked, so it would seem, an uncertain path in Cold War America.

The third category of performer, the unrequited queen, includes that body of individuals who have affirmed the full affective range of the female personality but remain, despite all that, better known to the

cognoscenti than the general public. Two women who typify the unre-quited queen are Rose Maddox and Wanda Jackson. Both received awards and recorded hit records, but never in the numbers that they should. Rose Maddox, who rightfully deserves an essay all her own, could not officially be deemed a rockabilly performer, but needs to be discussed, however briefly, as a precursor of the form and an inspiration to many women who followed in her path.[58] A professional vocalist for nearly sixty years, at first alongside her five brothers as part of 'The Most Colorful Hillbilly Band In The Land' and later as a soloist, her stylistic range, like that of many of the 'blues queens', encompasses a variety of genres, including country, rock, gospel, and bluegrass. As the Maddox Brothers and Rose, her family, migrants in the course of the Depression from Oklahoma to California, reigned throughout the 1940s and 1950s as one of the West Coast's most successful and audacious live acts. Clad in their eye-popping Nudie-designed suits, they alternately clowned and crooned their way on three-hundred sides for 4 Star Records (1946–51) and another two-hun-dred for Columbia (1951–8), playing what John Morthland tags 'a weird kind of up-tempo post-country and western with some of rock 'n' roll's energy and humor.'[59] Rose's public persona was that of a no-nonsense, straight-from-the-hip young woman who, surrounded by her siblings, 'may have sounded like she just wandered down from the hills, but she took lip from nobody and held her own among the strong-minded men.'[60] Whatever obstacles she faced – and they were many, including a teenage marriage and divorce, loss of her only son at a relatively young age, loss of several of her brothers, and a recent series of crippling heart attacks – Rose Maddox has met them with good humour, energy and vigour combined with a clear-headed sense of making up the rules for herself. As she states:

> Back then, women were expected to get married and have chil-dren. That's all. Well, I just wasn't made that way. I wasn't married and music was all I thought about in life. So I plunged into it. The whole thing was such a terrific challenge. You had to give yourself support every day, because nobody else was going to do it.[61]

One hears that unequivocal sense of self-determination in such tracks as her covers of Woody Guthrie's 'Philadelphia Lawyer' (she knew the writer and his performing cousin, Jack, as fellow Oakie migrants to California) and Ruth Brown's rhythm and blues-inflected 'Wild Wild Young Men', a clear precursor, though played in a Country style, to rockabilly. Her sense

of humour pervades much of her work and that of her family's, whose recordings are regularly punctuated with whoops of joy and braying laughter that reminds one of the evocative interjections of western swing pioneer Bob Wills throughout all his material. One can hear it particularly in the riotous 'Ugly and Slouchy (That's The Way I Like 'Em)', a send-up of both male and female lust. Much like those 'blues queens' who found the means to continue a career when the Depression eroded the recording industry, Rose Maddox has availed herself of one opportunity after another to 'talk smart' in a world that wanted women to remain silent and routinely restricted the full affective range of their emotions. The fact that honourific organisations have not seen fit to reward her indicates that skill must always be its own reward, particularly for assertive women.

Of all the six vocalists discussed here, Wanda Jackson remains the most aggressive and sexually adventurous in her public persona. For Bufwack and Oermann, she 'captures the elemental, low-class wildness of this music better than any other female of her day', while Nick Tosches exclaims with characteristic enthusiasm that for him she is the 'greatest menstruating rock-'n'-roll singer whom the world has ever known', irrefutably 'one of the most exceptional rock-'n'-roll stylists of her or any other day.'[62] Her gruff, rough-edged voice still rises out of the speakers with unquestionable authority. Tosches memorably describes its range: 'a wild-fluttering thing of sexy subtleties and sudden harshnesses, feral feline purrings, and raving banshee shriekings, was a vulgar wonder to hear. She was a girl who could growl.'[63] It is that unrestrained intensity that makes her a potent symbol of the quintessence of rockabilly, which, Tosches asserts, constitutes a 'demonic incantation' and 'an invitation to holocaust', the latter attribute reinforcing the earlier reading of 'Fujiyama Mama.'[64] Jackson's career possesses a circular pattern, starting in the Country field, turning to rockabilly, returning to Country, taking a experientially determined side-route to gospel, and then, finally, taking up once again in middle age the rock and roll of her youth. Wanda Jackson began as a Country vocalist in her native Oklahoma and was the star of her own radio show on KPLR in Oklahoma City at the age of thirteen. Through that outlet, she came to the attention of honky-tonk star Hank Thompson, whose 1952 hit 'Wild Side Of Life' inspired in response Kitty Wells' 'It Wasn't God Who Made Honky Tonk Angels'. As a teenager, she toured with Thompson and his award-winning backup band, the Brazos Valley Boys, only to land a contract with Decca Records in 1954. Following graduation from high school, she toured with Elvis Presley in 1955 and the following year, at the instigation of her manager, Jim Halsey (who also represented Thompson), she signed with Capitol Records.

Wanda sentered the studios of the Capitol Tower in Hollywood for the first time in June 1956. Backed-up by, among others, the ubiquitous Joe Maphis, rocker Skeets McDonald, future Country star Buck Owens, and steel guitar virtuoso Speedy West, she cut two tracks: 'Half As Good A Girl' and 'I Gotta Know'. The former was a piece of routine Country sentimentality, but the latter rocked. Such a pattern continued in the sequencing of her 45 single recordings: one side appealed to the Country audience while the other was pitched to the burgeoning youth market. It was not until 1958 with the cutting of 'Fujiyama Mama' and subsequent sessions in 1960 and 1962 that her rocker side grew dominant, these recordings also being a vehicle for her integrated back-up band that included more than able guitarist (and subsequent star of 'Hee Haw') Roy Clark as well as black pianist/vocalist (and a recording artist in his own right) Big Al Downing. They produced what some have called the 'party trilogy': 'Let's Have A Party' (recorded 1958 but released in 1960), 'There's A Party Goin' On' (1960), and 'Man We Had A Party' (1960). The success of the 'party trilogy' led Capital to pursue more material of a similar nature. Therefore, Jackson tackled covers of a number of other rock hits or rhythm and blues classics, including 'Riot In Cell Block No. 9', 1960 (the Robins); 'Brown Eyed Handsome Man', 1961 (Chuck Berry); and 'Rip It Up', 1963 (Little Richard). Each offered the opportunity for her to rearticulate previously male-encoded lyrics with a feminine perspective and furthermore indicate that, contrary to the so-called experts, rockabilly did not end with the 1950s. Jackson energetically took the genre forward into the next decade.

At the same time, the record company's practice of segregating the portions of Jackson's repertoire into either side of a single paralleled the ambivalence she apparently felt towards the social community centred about rock and roll. While Jackson may sing on her recordings with a kind of unquenchable abandon, what Bufwack and Oermann call an 'almost frightening savagery', her comments on this period of her life lead one to question how much of that tone was a performance, not the expression of heart-felt passion.[65] The photographs taken of her during the time she recorded for Capitol remain testaments to the vigour, even audacity, of her personality. Nonetheless, she worried about appearing low-class. Jackson states:

> My mother and I designed a tight-fitting sheath with rhinestone spaghetti straps and a little short silk fringe. . . . I dreamed it up because I said that way I don't have to wiggle. I can just pat my foot, and the fringe will shake. I didn't want to look vulgar; I

wanted to look sexy. I wanted to look like a lady, but I wanted to cause a little stir, too.[66]

That uncertainty about her public persona, reflecting in turn the mixed signals society then as now sends women about adorning themselves, is paralleled by a further comment as to what she felt to be objectionable qualities of the ambiance surrounding rockabilly and the audiences who attended her shows:

> I love to sing the rock songs. . . . But I didn't like that rock 'n' roll scene that all of a sudden I was thrown back into workin' with. That whole scene – those little teenyboppers . . . the bubble-gum set – of course I wasn't that much older myself, but I thought I was grown up. And I just didn't like all that screamin' and hollerin'.[67]

This divided consciousness over her career and her fans reinforces how tenuous even the most seemingly aggressive behaviour may be. Maintaining the public posture of a counter-irritant to socially-generated gender stereotypes amounts to hard work, usually fruitless and more often destructive of one's equilibrium. Therefore, it should come as no surprise that by 1961, when rockabilly's commercial viability had waned, Jackson returned, almost exclusively, to Country material. Her self-penned song 'Right Or Wrong', its very title a reflection of her divided consciousness, was a substantial hit, rising as high as number 9 on the Country charts. In October of that same year, she married an IBM programmer and soon after gave birth to two children, a son and a daughter. For Nick Tosches, this amounted to a virtual fall from grace, proof that society can eventually contain and control virtually any alternate form of expression that the popular culture might unleash. She was, he concluded, 'too hot a package to sell over the counter', for 'what the Devil laced, God unlaced.'[68] The latter comment alludes to the fact that, in 1971, her marriage in disarray, Wanda Jackson found religion. Two years later Capitol Records released her from the further five years on her contract in order to sign with Word Records as a gospel artist. 'Wanda's fire was out', Tosches mourns; 'From Fujiyama Mama to hibachi hostess: such are the wages of survival in a democracy of mediocrity.'[69] Even though in 1984, aged 47, she recorded an LP of rock and roll with a set of Swedish musicians, Tosches' comments, for all their rhetorical excess, capture the evanescence of the lives of virtually all female rockabilly singers. The short duration during which they, and the genre that supported them,

captured the public imagination reminds one that the ability to act as a 'pest consciousness' lasts only as long as society at large lacks an effective form of extermination.

In conclusion, the role women have played in popular American music, and rock and roll in particular, remains a matter of public record, however hard that record may be to construct. Works like Bufwack and Oermann's *Finding Her Voice* or Gillian Gaar's *She's A Rebel* indicate how little we know, empirically and otherwise, of the contributions made by women to American popular music.[70] Nevertheless, as Mim Udovitch states in a recent special issue of *Rolling Stone* on 'Women In Rock':

> in rock as in life, what is male continues to be perceived as known, normal, and natural, whereas what is female is taken to be a mystery in need of explication. In other words, to most . . . female artists, to be classified as women in rock is not so much recognition as a cleverly disguised attempt to prevent them from speaking for themselves as themselves.[71]

Udovitch's article does permit a number of present day musicians to speak both for themselves and their gender, but their predecessors receive at best a token and at worst an absurdly selective role in the discussion. The timeline of performers accompanying the piece only dates back as far as 1945, and a paltry six individuals represent the mass of women who sang, played, or wrote music from that date until 1964. No 'blues queens'; only Wanda Jackson to represent the rockabilly singers; and no Country artists save Kitty Wells. If these are the 'foremothers' young women are to be presented with by the publication which more of them will read than any full-length history of popular music, then we have a lot of work ahead of us.

When compiling that record, too much time, in the past as well as the present, has been spent in the hagiographic mode alone. True, the documentation remains so paltry and fugitive that the facts alone bear exhumation, but they alone will not suffice. Insufficient attention has been paid to the consumers of popular music; we desperately need an ethnography of fanhood in order to discover what meanings specific individuals discovered in popular music and, even more importantly, what use they made of those meanings in their lives. Ray Pratt reminds us that not only is the personal political, but it bears cultural roots, too.

> It has long been a matter of debate whether the intentions expressed or 'encoded' in any song are received by those hearing

it. The ways any musical performance, song, or recording func-
tions politically is a complex matter of analysis and attribution
growing out of its essentially interactional character. The meaning
of any song, indeed any artifact in popular culture, is determined
by the multiplicity of uses it receives.[72]

We must therefore, in pursuing these questions, recognise that a political
existence ineluctably bears a cultural dimension; that consuming cultural
artefacts in and of itself may not change the world, but the transformation
of consciousness potentially encouraged by that consumption can. George
Lipstiz reinforces this possibility when he comments:

If one views politics only as the public struggle for political
power, then rock and roll songs (are) apolitical. But if one defines
politics as the social struggle for a good life, then these songs rep-
resent politics of the highest order.[73]

Who knows what effect the performance of any of the six women exam-
ined in this essay had on their audience, particularly the women who
watched them strut their stuff? By addressing their lives and work from a
principally hagiographic perspective, a fault of this essay as it is of too
much secondary literature, we potentially give too much autonomy to
individuals forced to work as agents of the culture industry and assume
that their perseverance diminished some of its hold over them. That is a
great deal to presume, but, again, George Lipsitz provides a sensible gloss
on this thorny dilemma: 'These songs do not plot social revolution, but
they do keep alive hopes for a better life . . . (each) carves away a limited
sphere of autonomy in an increasingly regimented world.'[74] The people
who sell culture cannot themselves create it nor can they determine how
or why individuals consume it. That remains in our hands and constitutes
a portion of our limited but genuine autonomy.

Still, plundering the past for solace in a limited present can breed a cor-
rosive nostalgia as well as impede the need to construct present-tense
forms of 'talking smart'. In desperation, we can ignore that 'The task con-
fronting us . . . is to be critical of cultural developments in the
representation of women without dismissing every instance of co-option
merely as evidence of the omnipotence of sexism, or celebrating every
shift as the beginning of the end.'[75] A loss of faith in the generation of our
own forms of meaning may lead to the construction of an alternate canon
to replace the inflexible systems of value placed before us, thereby form-
ing a hierarchy in spite of ourselves to replace the one which we feel

oppresses us. Angela McRobbie warns of the impasse to which that may lead.

> We have gone so far down the road of the popular (where there is no art/non-art, no good/bad ) that we are in danger of choosing our own canon for analysis and being able to justify this only on the grounds that it has mass appeal. . . . We produce our own inverted canon. . . . We have not entirely abandoned the notion of art even when it does not come with a prefix certifying the authenticity of its cultural origins.[76]

However, in the case of popular music, it is difficult to go 'down the road of the popular'. To continue the automotive metaphor, not only are maps unavailable but also many of the routes have been abandoned, the toll booths closed down. As the discographical notes at the end of this chapter indicate, my choice of the six subjects here under review remains driven in part by the weight of their achievements but even more so by the fact that their achievements can be judged at all. The reissue of historic material, for all the ballyhoo over box sets and back catalogues, remains itself a political process that determines the history of popular music by permitting only a fraction of existent recordings to be heard. One is forced therefore to take secondary scholars at their word when the empirical evidence remains out of reach. To wit, no CDs and in most cases not even out-of-print LPs are available by Bonnie-Lou, Jo-Ann Campbell, Jean Chapel, Joe and Rose Lee Maphis, Lauri Lee Perkins, Lucille Starr and Bob Reagan. They are therefore marginalised without possibility of recourse. George Lipsitz might state that 'no cultural moment exists within a hermetically sealed cultural present', but in this case, paradoxical though it may sound, the present will remain hermetically sealed unless and until our access to the past is unencumbered.[77] Furthermore that access should not be exclusively acoustic, for, as my periodic comments on photographs and costume indicate, the acoustic dimension alone obviously does not define musical expression. As much as we need to hear the recordings of as many of the female rockabilly singers as possible, we need even more to see any and all photographs, evidence of television appearances, and comments about them in the public press. One wonders, as I mentioned in the case of Brenda Lee, why certain photographs remain available while others are removed from public view. The past may be a distant country, but without full account of its substance, it continues to recede from view.

The female rockabilly singers themselves have not disappeared altogether, although hearing them in a live context can be as difficult as

finding their recordings. The rare opportunities when one of them takes to the stage and brings her material to life once again underscores that the 'counter-irritant' their careers have been to the dominant masculine heterosexual culture only ceases when either their lives end or their songs can no longer be heard. Until then, Johnny Whiteside's comments on a recent show by Janis Martin at the Palomino Club in Los Angeles should reinforce that sound itself can create a new space and posit a new order when those who hear it allow the music to help them to negotiate the contradictions of their lives.

> She used the Palomino bandstand like a playground, immediately turning on the juice that makes rockabilly an undying music form: the untamed, liberty-or-death defiance that stunned America four decades ago. The Virginia-born-and-bred Martin remains completely enchanted by the rebel attitude, gaudy parlance and spiritual freedom of the rockabilly threat. Her strong, fiery vocals, driven by the momentum of this ongoing fascination, gorged on the big-beat thrills. . . . Making all this stuff about huggin', kissin' and dancin' wash isn't easy, but Martin's reverent wail was as touching as it was powerful. . . . Simply put, Janis Martin popped off like a titanic Roman candle; she shook her hips, she roared, she strutted about the stage with enviable passion. She indulged in the art of true fine rocking. Hell, she positively luxuriated in it. 'You know, I'm 53 years old, but it still feels good,' she said, basking in the heat of adoration and beery abandon. 'Everything dies but this.'[78]

### DISCOGRAPHY

Regardless of my diatribe in the conclusion of this chapter, a significant amount of material by female rockabilly artists remains in print or is available on out-of-print vinyl that can be found with sufficient patience. To address them in alphabetical order: Charlene Arthur's pitifully short career can be heard on the Bear Family LP *Welcome to the Club*, and her first side, 'I've Got The Boogie Blues', released by Nashville's pioneering label Bullet Records, is on Volume 28 of the Dutch Collector Records' *Boppin' Hillbilly* series. Surprisingly, all the Collins Kids' Columbia sides remain in print and a good deal of the audio portion of their Town Hall Party appearances to boot. The Bear Family two-CD set *Hop, Skip and Jump* includes the Columbia work, while a shorter Sony Special Products CD, *Introducing Larry*

and *Lorrie*, picks out twelve songs. The television appearances can be located on two LPs: Country Routes' *The Collins Kids at Town Hall Party* and the obscure TV Records' *Television Party*. Wanda Jackson has also benefited from Bear Family's completist proclivities. All her work on Capitol from 1954 to 1962 is contained on the four-CD box set *Right or Wrong*, while Rhino has an abridged eighteen-track compilation, *Rockin' in the Country*. The 1984 Swedish recordings were released domestically on LP and cassette by Varrick Records, a division of Rounder Records, in 1986. Brenda Lee's major recordings on Decca are contained in a two-CD set, *Anthology 1956-1980* (MCA). Much of Rose Maddox's extensive discography remains readily available. Arhoolie Records released two LPs of radio performances from 1940 and 1945, *On the Air Vols 1 and 2*, as well as a twenty-seven-track CD of selected 4 Star Records sides, *America's Most Colorful Hillbilly Band, 1946-51*. They also pressed a CD of twenty-four early 1980s performances of acoustic bluegrass, *Rose of the West Coast City*. The Columbia sides of the late 1950s are on two Bear Family LPs, each featuring sixteen tracks and named after the group. They also market a four-CD package of all Rose's solo work on Capital Records from 1959 to 1965, *The One Rose*. Janis Martin regrettably only pressed 26 sides for RCA from 1956-8, all included on Bear Family's *The Female Elvis: Complete Recordings, 1956-60*. Certain of Barbara Pittman's Sun sides can be found on various anthologies and the complete work on the Bear Family LP *I Need A Man*. The label run by Nashville's Country Music Foundation released a long overdue selection of Jean Shepard's work, *Honky-Tonk Heroine: Classic Capitol Recordings 1952-64*. Bear Family followed with a five-CD package, *The Melody Ranch Girl*, of Shepard's complete works for Capitol from 1952 to 1964. The German Bronco Buster label compiled a set of twenty sides by Texas Ruby and Curly Fox, *A Memorial Tribute*, that includes material recorded for Columbia in addition to transcriptions of Grand Ole Opry programmes. Kitty Wells's work, like much of Country music's pioneers, remains in print but not as widely available as it should be. The MCA Country Music Hall of Fame series has a single CD of sixteen tracks, and Rounder Records released a set of a dozen more obscure sides on LP and cassette, *The Golden Years*. Bear Family once again takes the lead with *The Golden Years 1949-1957*, a six-LP box set of ninety-five Decca tracks. Finally, the Rounder collection *Wild Wild Women* – an indispensable anthology that highlights Janis Martin and the Collins Kids, key minor figures like Sparkle Moore, and such obscurities as Linda and the Epics or Alvadean Coker and the Cokers – remains technically out of print and not released on CD but can be found with a little luck and even greater perseverance. The Sparkle Moore sides are also available on an Ace CD of work released by the Fraternity label, *All American*

Rock'n'Roll, and the vocalist's striking features dominate the recording's cover. The rest remain in the domain of collectors and cognoscenti, subject to cultural amnesia and the perils of public memory.

## NOTES

1 Interjected after his performance of 'No Headstone for My Grave', a song made famous by Charlie Rich, on *The Complete Palomino Club Recordings* (Tomato R2 70385, 1989, distributed by Rhino Records). Of those performances recorded in 1979-81 and 1985, Robert Christgau observes that 'the Killer' sounds 'old, old and lecherous, old and lecherous and determined to enjoy it'. See *Christgau's Record Guide to the 90s* (New York: Pantheon Books, 1990), p. 246.

2 Randy McNutt, *We Wanna Boogie. An Illustrated History of the American Rockabilly Movement.* Revised, 2nd ed (Hamilton, OH: HIP Books, 1988), p. 185.

3 Mary A. Bufwack and Robert K. Oermann, *Finding Her Voice. The Saga of Women in Country Music* (New York: Crown, 1993), p. 185.

4 It is curious to note that, while the *auteur* theory has lost credibility virtually altogether in film studies, a species of it remains in the analysis of popular music, specifically the tendency to rank performers hierarchically. Even the nicknames – the 'King' and the 'Boss' – carry on the desire to concoct hierarchical taxonomies. This attempt to erect a set of disciplined standards colours Robert Christgau's influential consumer guides, printed monthly in the *Village Voice*; how many artists must feel as if they had returned to school when confronted by the critic's letter grades? One might easily read into this practice a carryover of the categories contained in Andrew Sarris's landmark canonic analysis *The American Cinema. Directors and Directions 1929–1968* (New York: Dutton, 1948). I leave it up to the reader who they might include in the acoustic version of Sarris's pinnacle, the 'Pantheon'; who would lose face when placed in the category 'Less Than Meets The Eye' or 'Strained Seriousness'; and who would be banished to the locale titled 'Subjects For Further Research'. (That last category led one film-maker to state, 'I thought that was how they referred to cancer.')

5 Nick Tosches in Patrick Carr (ed.) *The Illustrated History of Country Music* (Garden City, NY: Doubleday, 1980), p. 230.

6 Bill C. Malone, 'Elvis, Country Music, and the South', in George H. Lewis (ed.) *All That Glitters. Country Music in America* (Bowling Green, OH: Bowling Green State University/Popular Culture Press, 1993), p. 55.

7 John Morthland, *The Best of Country Music* (Garden City, NY: Dolphin Books/Doubleday, 1984), pp. 241–2.

8 Charlie Gillett, *The Sound of the City. The Rise of Rock and Roll*, revised and expanded ed (New York: Pantheon, 1983), p. 28.

9 Greil Marcus, *Mystery Train. Images of America in Rock 'n' Roll*, revised and expanded ed (New York: Dutton, 1982), p. 169.

10 Ibid., pp. 168, 170.

11 Janis Martin's song was written by Doc Rockingham and Virginia Fitting (Unichappel Music/Rachel's Own Music, 1956) and the lyric references Junior Parker's 1954 recording which he co-wrote with Sun's Sam Phillips (Hi-Lo Music; Unichappell Music).

12 John Shepherd, 'Music and Male Hegemony', in Richard Leppert and Susan McClary (eds) *Music and Society. The Politics of Composition, Performance, and Reception* (Cambridge: Cambridge University Press, 1987), p. 152.

13 Ibid., p. 158.

14 W.T. Lhamon, Jr. *Deliberate Speed. The Origins of a Cultural Style in the American 1950s* (Washington: Smithsonian Institution Press, 1990), p. 113.

15 Earl Burrows, 'Fujiyama Mama' (Hammer Hits, copyright 1954).
16 Elaine Tyler May, 'Explosive Issue: Sex, Women, and the Bomb', in Lary May (ed.) *Recasting America. Culture and Politics in the Age of Cold War* (Chicago: University of Chicago Press, 1989). This striking essay illustrates that this gender-specific rhetoric of repressive maternalism did not end with the height of the Cold War. As late as 1972, the Civil Defense authorities were utilising the figure of sexually aggressive women as a metaphor for nuclear power. A pamphlet featured the female figures of Alpha, Beta, and Gamma (see Figure 8.1 in May 1989) as personifications of dangerous radioactive rays and stated 'like energy from the sun, these rays are potentially both harmful and helpful' (p. 164). May adds, these images are 'powerful testimony to the symbolic connections among the fears of atomic power, sex, and women out of control' (p. 165). The soundtrack album to the 1982 documentary *The Atomic Cafe*, co-produced and annotated by country scholar Charles K. Wolfe and released on Rounder Records, illustrates the degree to which both the anxiety and enthusiasm raised by nuclear energy found expression in popular musical form in a range of genres: rhythm and blues, country, rock and roll, and gospel.
17 The historiography of female blues singers of this period is limited. The key texts include Chris Albertson, *Bessie* (New York: Stein & Day, 1972) and *Bessie Smith: Empress of the Blues* (New York: Schirmer Books, 1975); Paul and Beth Garon, *Woman With Guitar. Memphis Minnie's Blues* (New York: Da Capo Press, 1992); Daphne Duval Harrison, *Black Pearls. Blues Queens of the 1920s* (Brunswick, NJ: Rutgers University Press, 1990); Sandra Lieb, *Mother of the Blues: A Study of Ma Rainey* (Amherst: University of Massachusetts Press, 1981); and Derrick Stewart-Baxter, *Ma Rainey and the Classic Blues Singers* (New York: Stein & Day, 1970). The field is also inestimably in debt to the work of Rosetta Ruiz, whose Rosetta Records reissues the work of those women in blues, jazz, and gospel she calls our 'foremothers'.
18 Harrison, p. 10.
19 Hazel Carby, 'In Body and Spirit: Representing Black Women Musicians', *Black Music Research Journal* 11(2) (Fall 1991): 178.
20 Hazel Carby, '"It Jus Be's Dat Way Sometime": The Sexual Politics of Women's Blues', *Radical America* 20(1) (1987): 12.
21 Derrick Stewart-Baxter, *Ma Rainey and the Classic Blues Singers* (New York: Stein & Day, 1970), p. 7.
22 Harrison, p. 56.
23 Ibid., p. 89.
24 Ibid., p. 89.
25 Robert 'Bumps' Blackwell and John Marascalco, 'Rip It Up' (published by ATV Music, 1956).
26 Bufwak and Oermann, p. 168.
27 Ibid., p. 169.
28 Ibid., p. 186.
29 Ibid., p. 176.
30 Ibid., p. 173.
31 Quoted in the notes by Bob Allen to Charlene Arthur, *Welcome To The Club*, Bear Family LP BFX 15234 [1986].
32 Bufwack and Oermann, p. 173.
33 Ed Ward in E. Ward, Geoffrey Stokes, and Ken Tucker (eds) *Rock of Ages. The Rolling Stone History of Rock and Roll* (New York: Rolling Stone Press/Summit Press, 1986), p. 123.
34 Ibid., p. 123.
35 Ibid., p. 66.
36 Ibid., p. 123.
37 Ibid., p. 168.
38 Ibid., p. 134.

39 Ibid., p. 156.

40 Michel Foucault in M. Foucault and Gilles Deleuze, 'Intellectuals and Power: A Conversation Between Michel Foucault and Gilles Deleuze', in P.F. Couchard (ed.) *Language, Counter-Memory, Practice* (Ithaca: Cornell University Press, 1977), p. 209; Lhamon, Jr., p. 141.

41 Bruce Tucker, '"Tell Tchaikovsky The News": Post Modernism and the Emergence of Rock and Roll', *Black Music Research Journal* 9(2) (Fall 1989): 280.

42 Ibid., p. 234.

43 Ibid., p. 226.

44 Ibid., p. 226.

45 Ibid., p. 226.

46 Ibid., p. 226.

47 Morthland, p. 324. Owen Bradley produced all of Patsy Cline's major recordings and was a key figure in the formation of the 'countrypolitan' sound of the 1960s that assisted the genre in its ascendance once again to the pop charts. His works typically include lush orchestrations, dotted with smooth vocal choruses, decorative string sections, and the ubiquitous voicings of Floyd Cramer's piano.

48 The three images of Lee included in Bufwack and Oermann's pioneering article 'Rockabilly Women', *Journal of Country Music* 8(1) (May 1979) sum up this persona but did not for some reason appear in the recent volume *Finding Her Voice*. They range from a pert, crisp-dressed youngster to what appears to be virtually a ready tart. Nothing like the latter appears, I might add, in the MCA *Anthology* liner notes, yet a shot of Lee dancing in 1957 with a smiling Elvis comes across as at one and the same time wide-eyed and wanton. Maybe that's also due to the fact that the image just opposite it is of Lee smiling with a dollar bill in her hands.

49 Maphis and his wife Rose Lee were among the most estimable honky-tonk performers; John Morthland refers to the now unavailable sides they recorded for Columbia in the 1950s as 'West Coast honky-tonk at its most aggressive' (p. 229).

50 The title of a song performed by the duo and written by Johnny Bond, Harlan Howard, and Joe Maphis. *Red River Songs*, 1957. Bond was a popular West Coast performer and a featured star on 'Town Hall Party', while Howard, then a resident of Los Angeles, would in 1959 begin a career as one of Nashville's most successful and prolific songwriters with Ray Price's recording of 'Heartaches By The Number'.

51 Tanya Tucker's rocky but resilient career is chronicled in Daniel Cooper's 'Tanya Tucker Almost Grown', *The Journal of Country Music* 17(1) (1994): 10–25.

52 Quoted in the notes by Hank Davis to Barbara Pittman, *I Need A Man*, Bear Family LP BFX 15359 [1989].

53 Charlie Feathers and Stanley Kesler, 'I Forgot To Remember To Forget' (published by Hi-Lo Music, 1955).

54 Quoted in Hank Davis notes.

55 Bufwack and Oermann, p. 218.

56 Colin Escott and Martin Hawkins, *Good Rockin' Tonight. Sun Records and the Birth of Rock and Roll* (New York: St. Martin's Press, 1991).

57 Morthland, p. 259.

58 Johnny Whiteside has written the first biography of this major figure, *Ramblin' Rose: The Life and Career of Rose Maddox.* (Nashville: Vanderbilt/Country Music Foundation, 1995).

59 Morthland, p. 228.

60 Ibid., p. 228.

61 McNutt, pp. 185–6.

62 Bufwack and Oermann, p. 233; Nick Tosches, *Unsung Heroes of Rock 'n' Roll. The Birth of Rock in the Wild Years Before Elvis.* Revised ed (New York: Harmony Press, 1991), pp. 165, 167.

63 Tosches (1991), p. 167.

64 Tosches (1980), p. 230.

65  Bufwack and Oermann, p. 233.
66  Ibid., p. 235.
67  Ibid., p. 236.
68  Tosches (1991), p. 168.
69  Ibid., p. 169.
70  Gillian Gaar, *She's A Rebel. The History of Women in Rock and Roll* (Seattle: Seal Press, 1992).
71  Mim Udovitch, 'Mothers Of Invention', *Rolling Stone* (692) (6 October 1994): 50.
72  Ray Pratt, *Rhythm and Resistance. The Political Uses of American Popular Music* (Washington, DC: Smithsonian Institution Press, 1994), p. 5.
73  George Lipsitz, *Rainbow At Midnight. Labor and Culture in the 1940s* (Urbana: University of Illinois Press, 1994), p. 327.
74  Ibid., p. 327.
75  Margaret Marshment, 'Substantial Women', in Lorrain Gamman and Margaret Marshment (eds) *The Female Gaze: Women As Viewers of Popular Culture* (Seattle: The Comet Press, 1989), p. 29.
76  Angela McRobbie, *Postmodernism and Popular Culture* (New York: Routledge, 1994), p. 94.
77  George Lipsitz, *Time Passages. Collective Memory and American Popular Culture* (Minneapolis: University of Minnesota Press, 1990), p. 13.
78  Johnny Whiteside, *LA Weekly* (25 February–3 March 1994), p. 83.

# 9

# FEMALE IDENTITY AND THE WOMAN SONGWRITER

## Charlotte Greig

In this chapter, I'm going to focus on the way certain women songwriters have tried to incorporate specifically female issues into their work. I don't believe 'women songwriters' *per se* constitute a genre – we wouldn't talk about 'men songwriters' and expect there to be a unity of outlook and experience there – and in the same way we can't talk about women as if we were a subgroup of humanity that speaks with one voice. We don't, and there's the same level of diversity and conflicting points of view amongst women songwriters as you'd get anywhere else in music.

What I want to try and pinpoint, then, is not a generic similarity in women's songwriting, since I don't think one exists, but the way in which women have tried to write about the particular experiences in their lives that differ from those of men.

Well, what are these experiences? Obviously, the bulk of pop songs are about romantic love, and while it's certainly true that many women have contributed a very female 'take' on this, I don't think the subject of romantic love is any more the province of women than it is of men. In fact, when I wrote a book on girl groups in pop (*Will You Still Love Me Tomorrow?*, published by Virago in 1989) – groups like the Supremes, and so on – I was always rather taken aback by the complaint of pro-feminist journalists, whether men or women, that these songs were 'all about love' and therefore rather contemptible. What did they expect them to be about? The state of the economy, perhaps? Somehow, when the Beatles or the Stones sang about love – incidentally, often covering the same songs – it was fine, but when girls did it, it was evidence of feeble-mindedness.

Romantic love, whether approached from a cynical or idealised perspective, whether focusing on the sexual or the spiritual, isn't really women-only territory. For every female songwriter bemoaning an errant man, you could probably find a male songwriter doing the same about a woman. Maybe, in the battle of the sexes, different words are used as

weapons, but essentially, we're talking about the same war. For when it comes down to it, there are very few areas of experience that are unique to us as women, in contrast to the experiences of men.

But there are a few. One of the areas that is specific to us as women is to do with childbearing. So much of our adult lives is taken up with our emotional responses to the question of childbearing and motherhood – whether or not we actually have children, the question always hangs over our heads – that you might expect to find a wealth of popular songs dealing with this whole drama in all its complexity: songs about pregnancy, childbirth, about motherhood, about turning away from all this, about remaining single, about abortion, and so on. But even as I write those words like childbirth and so on I feel that somehow, they sound crass and out of context as regards popular music. Yet why should they?

I think the reason is, perhaps, because the pop song is bounded by some very strict conventions. In pop songs, the female protagonists don't, on the whole, get pregnant, have children, get married or divorced, or have any family problems of any kind. They exist in limbo, forever contemplating romantic involvement from one angle or another, but always remaining essentially free and unattached, untrammelled by the future consequences of their passion in the shape of husband, children and domesticity – while we suspend our disbelief, as though to wish all this reality away as well.

But the situation is changing. The pop song's idealised concept of the bachelor girl with no real family baggage, suspended in her early 20s, popping out with her overnight case to service a string of torrid love affairs over and over again, has begun to get too tedious to bear. After all, our heroine has been stuck in a time warp for over three decades now. It does now seem that in our so-called 'post-feminist' era, and particularly as audiences for pop music get older, the accepted pop ideal of womanhood has finally ceased to have an across-the-board appeal.

I want to argue here that we are now seeing a response by women songwriters to this state of affairs, and that we can trace a tradition, although a submerged one, of popular artists bringing their experiences of, and attitudes towards, childbearing and motherhood into their work. I think that in the last decade or so, it has become easier for women to raise these subjects in popular songs. In fact, I'd go even further and say that, since the 1970s, women songwriters – from Joni Mitchell to Bonnie Raitt to Mary Chapin Carpenter – have felt impelled to position themselves clearly vis-à-vis this central question in women's lives. More recently, this trend has begun to appear even within the pop mainstream, with songs by artists like Madonna, Sinéad O'Connor and Neneh Cherry.

## THE BRITISH FOLK TRADITION

I'd like to try and trace this development by going right back to a song
from the British folk tradition. It dates from the seventeenth century or
earlier and was revived in the 1960s by a singer called Anne Briggs. As
with many early traditional songs, the author is not known, but it is likely
in this case that it was collectively written by women, in the sense of
being orally handed down and re-told over centuries. The song is called
'Gathering Rushes in the Month of May', and it is worth pointing out that
'gathering rushes' is an activity often mentioned in folk songs as being
associated with sexual encounters of one kind or another.

A fine young girl all in the month of May
she was gathering rushes just at the break of day
But before she's come home she's borne a little son
and she's rolled him underneath her apron.

Well she's cried at the threshold as she's come in through the door
and she's folded in her apron the little babe she bore
Said her father, where've you been, my little daughter Jane
and what's that you've got underneath your apron?

Oh father dear father, it's nothing, then said she
It's only my new gown and that's too long for me
and I was afraid it would draggle in the dew
so I rolled it underneath my apron.

But in the dead of night when all were fast asleep
this pretty little baby oh it began to weep
Said her father, what's that bird a-crying out so clear
in the bedroom among the pretty maidens?

Oh father, dear father, it's nothing then said she
it's just a little bird that fluttered to my knee
and I'll build for it a nest and I'll wear it on my breast
so it won't wake early in the May morning.

But in the third part of the night, when all were fast asleep
this pretty little baby again began to weep
Said her father, what's that baby a-crying out so clear
in the bedroom among the pretty maidens?

Oh father dear father it's nothing then said she
it's just a little baby that someone gave to me
let it lie let it sleep this night along of me
and I'll tell to you its daddy in the May morning.

Well was it by a black man or was it by a brown
or was it by a ploughing boy a-ploughing up and down
who gave to you this stranger you wear with your new gown
that you rolled up underneath your apron?

No it wasn't by a black man, it wasn't by a brown
I got it from a sailor who ploughs the watery main
He gave to me this stranger I wear with my new gown
that I rolled up underneath my apron.

Well was it in the kitchen got or was it in the hall
or was it in the cowshed or was it in the stall?
I wish I had a firebrand to burn the building down
where you met with him on a May morning.

No it wasn't in the kitchen got it wasn't in the hall
and neither in the cowshed and neither in the stall
It was down by yonder spring where the small birds do sing
that I met with him on a May morning.

The most striking thing about this song, for me, is the direct, almost blunt
way in which it's told – and how emotionally compelling that honesty
makes it. We are given the facts of the story without any of the coyness
or euphemistic imagery that's so common in contemporary pop songs.
Simple words like 'by' and 'got' tell us who the father was and how the
baby was conceived; and the repetitions of question and answer ram the
harsh facts home.

In the story, the girl's lies about her long gown and the little bird
singing are, of course, soon unmasked, and we end up with a confronta-
tion between father and daughter that takes place in the middle of the
night. He subjects her to an interrogation as to which of his buildings the
lovers used, adding 'I wish I had a firebrand to burn the building down'.
Her final reply to his questions is a masterpiece of subtlety in songwriting:
no, she says, I didn't use any of your farm buildings: 'It was down by
yonder spring where the small birds do sing/that I met with him on a
May morning'. She refers back to the fiction of the little bird, and in

telling him that she conceived her baby out of doors by the river, not in any of his buildings or indeed in any place he could burn down, asserts her complete independence from him. No moral is added to the story, or is needed; and in the best tradition of folk songs, the emotion – in this case of a young woman with dignity and courage – derives from the telling of the tale itself, rather than from any expression of feelings within it.

It is difficult to find anything comparable in modern-day songwriting, because the popular song today drips with emotional and moral sentiment, as well as being overloaded with euphemisms. Why this should be so is an entire subject in itself, but suffice it to say here that it has a lot to do with the popular song's transformation since the eighteenth century from a collective form of expression within a given community to its existence as a commodity within the international marketplace.

## AMERICAN COUNTRY MUSIC

So who, these days, is managing to write about the real lives of real women? Well the obvious place to start looking is in Country music, where women songwriters and performers have, since the 1950s, made an immense impact. Country music is, of course, the home of the domestic melodrama, but having said that when you come to look into it it's surprising how few of the songs deal with the business of having children – they're mostly about love and marriage. Dolly Parton's song 'Down from Dover' is an exception. This is a narrative song, and its subject matter closely resembles 'Gathering Rushes in the Month of May', quoted above. However, the mood of it is quite different. In 'Down from Dover' a young girl becomes pregnant, is deserted by her lover, cast out by her parents, and ends up giving birth alone to a dead baby.

There are similarities between the two songs, apart from its subject matter of unplanned pregnancy. The directness of the narrative is still there – there's no doubt in our minds what this song's about. The lyrical and metaphorical imagery that characterises so many contemporary songs is kept to a minimum. And perhaps the real strength of American Country music lies in this preference for narrative over symbolism; on the whole, Country songs stick to the narrative form of traditional folk, telling a story to express an emotional truth.

Several common features of the two songs stand out: we hear again in 'Down from Dover' about the dress that conceals the baby's shape, and reference is made to nature and the seasons. But the similarities between Parton's song and 'Gathering Rushes' just about stop there.

'Down from Dover' is written as a first-person narrative, which immediately gives us a totally different perspective, one in which the girl is isolated and alone. Then, where the father in 'Gathering Rushes' was just downright furious with his daughter, the father in Dolly's tale is 'ashamed to show his face': where the girl in 'Gathering Rushes' was rebellious and, one senses, secretly rather pleased with her baby, surrounded as she was by her maidens, Dolly's girl is helpless, naive and totally miserable. She didn't even enjoy the sex, it seems; she did it because 'he' needed her and she could not refuse; she's alone and frightened, an outcast; and to cap it all, in an onrush of poetic justice, the baby dies at the end – quite sensibly, one feels, given the circumstances. Social morality is the out and out winner here, whereas in 'Gathering Rushes' precisely the opposite was the case. One can't help coming to the conclusion that although there's an obvious link between traditional European folk music and contemporary American Country music, there's also a world of difference between them in terms of the values they present – as we've seen just from this one example.

## THE FOLK REVIVAL

The folk revival in both America and Europe in the 1960s consciously attempted to rediscover the true radicalism of traditional folk music, and make it relevant to present-day civil rights and union struggles. In Britain, folk music had become a lost popular culture – and a treasure trove of songs were unearthed. Folk singers and activists were also inspired to write protest songs on the model of traditional folk – but in their own way the modern protest songs were as far removed from traditional folk music as was contemporary Country. In place of the amoral, simple and often mysterious narratives of traditional folk were songs with a burning, radical moral purpose. The worst of these were baldly stated, moralising political tracts that don't hold up very well today; the best were beautifully crafted songs that attempted the difficult task of making social and political issues into real and personal ones.

Not surprisingly, the women's movement of the 1970s attracted a number of fine women songwriters from the folk revivalist circuit. These included the American singer Peggy Seeger, who wrote a number of songs on the theme of motherhood, that range in mood from the tender and melancholy ('Lullaby for a Very New Baby') to the ironic and comic. 'Nine-Month Blues', a song in the latter vein, was a song commissioned by the National Abortion Committee in 1975, and its function was as much to inform, educate and entertain as it was to make real the

experience of repeated pregnancy. Thus, instead of focusing on the pregnant woman's weariness and personal despair, as she does in 'Lullaby', in 'Nine-Month Blues' Seeger uses a touch of music-hall comedy to lighten the situation and to describe the various inadequate methods of contraception that lead to unwanted pregnancy.

## WOMEN'S LIBERATION AND THE COUNTER-CULTURE

The counter-culture of the late 1960s and 1970s produced a number of women songwriters and performers, who had come up through the folk tradition, both in Britain and in the US. As they left this tradition behind, they came to form a genre known as 'singer-songwriters', which perhaps implied an arty, feminine kind of solipsism not present in the term 'folk singer'. The biggest talent to emerge from this new crop of solo women artists was, of course, Joni Mitchell. She was narcissism and self-indulgence personified – but her musical sophistication was stunning. I don't think it ever crossed Joni Mitchell's mind that she was part of a community of women who shared the same problems and dilemmas. Any problems and dilemmas she might have had always seemed to be hers, and hers alone; and they were probably more likely to be about whether to buy a mandolin than whether to have a baby. But even so, there are moments when she acknowledges that there are certain choices she, as a woman like any other, has to make. As I mentioned earlier, even the women songwriters who want nothing to do with the domestic scenario feel impelled to explore their relation to it.

An example of Mitchell's writing on this subject is 'Song for Sharon', from her album *Hejira*, which addresses an old schoolfriend, and compares their two very different lives: one is a farmer's wife, the other a rock star. In typical Joni Mitchell style the song is less a message to someone else than a conversation with herself. It's a long reflection on the allure of marriage, but it's made very clear that it's the romantic symbolism that attracts Mitchell, as it does almost every small girl, not the real nitty-gritty behind it. You sense that she had made a firm decision to remain single: she's having a good time, and she's powerful – whereas Sharon, one feels, isn't. Her summing up of the situation falls just short of one-upmanship: Sharon has 'a family' and 'a farm', but Mitchell remains the temptress with 'a diamond snake' around her arm. In the final lines of the song, however, there is a kind of generosity as the writer muses on how a life lived close to nature and to people in a family has a kind of musical spirituality to it.

Another major talent to emerge in the singer-songwriter mould was

Laura Nyro, who took the other path from Joni Mitchell, into mother-
hood and domesticity. She made a brave attempt to incorporate her
experience into her work, even though – as happens so often – once she
started having children her recordings were few and far between. She
put out a whole LP called *Nested*, which, as the title suggests, contained
a certain amount of sentimentality – but at the same time she did try to
deal with the tensions and conflicts of being a mother in a way that was
quite innovative. One of her most memorable songs is called 'To a
Child', in which Nyro captures something of the mother's intense, com-
plex feelings as she watches her child in the park. In the heightened state
of emotion that exhaustion brings, the mother swings from despair –
'crying by the washing machine' – to elation, as though she's comfort-
ing herself that her creative work as a songwriter has been supplanted by
her experience of producing this child. She finds nothing to mirror her
feelings in the culture around her and we are left with the picture of a
totally isolated woman, the mother, with this tumult of emotion going
on inside her.

There are other examples of women songwriters who, once they've had
children, try to bring this experience into their work, but it's surprising
how difficult this seems to be. Patti Smith, after settling down into
motherhood, came up with unbelievably twee songs about 'little blue
shoes' and so on. It sometimes seems that in rock, the more radical and
rebellious the artist's adolescent pose, the more conventional and trite their
adult writing eventually becomes.

The most interesting reflections to date on this issue of motherhood
don't come from former rock icons on the whole, but from the many
women songwriters working in the area of 'new country' or 'country
rock'. It's not so much that these writers discuss being a mother, as that
they 'position' themselves towards the idea, and explore the dilemmas
involved. Bonnie Raitt, Roseanne Cash and Mary Chapin Carpenter are
some of the names I'm thinking of. Bonnie Raitt's mature work finally
found a large public, with her song 'Nick of Time', which concerns itself
with the problems of ageing from a woman's point of view. She begins by
describing the dilemma of a friend who is worrying about whether or not
to have a baby, and continues by telling us how she sees herself and her
parents growing older. The song ends with a sigh of relief and joy that
she's found her man 'in the nick of time'. There's nothing competitive or
complacent here, though, vis-à-vis her friend; you sense that she feels she's
just been lucky.

The song may touch on one of the themes that Joni Mitchell was
reflecting on in 'Song for Sharon' – whether to settle down and have a

family or remain single – but there's a world of difference between them. Bonnie Raitt's song has all the vulnerability and self-doubt that comes with age, but also the confidence and honesty to express it. Joni Mitchell's has all the self-absorption but also all the courage of a younger woman with more choices before her.

## THE POP MAINSTREAM

Today, I think we're beginning to see some changes in the mainstream of pop and rock as a new generation of female artists bring the issues of childbearing and motherhood into their work. Madonna has broached the subject in her pop hit 'Papa don't Preach'; here we're reminded of the father and daughter confrontation in the traditional song quoted above, 'Gathering Rushes'. Madonna may not have an awful lot new to say about such elemental conflicts, but I think it's significant that she recorded a song on this theme and was so successful with it. Neneh Cherry has also brought the issue to the fore, both by flaunting her pregnant belly on Top of the Pops and with songs like 'Inner-City Mama'.

Another contemporary singer to mine this territory, though in a much darker, more serious vein, is Sinéad O'Connor. In her song 'Three Babies', she tackles the uncomfortable subject of abortion. Like 'Gathering Rushes', this song seems to be about dignity and choice, but while the message of 'Gathering Rushes' was clear and unequivocal – in having her baby, the young woman asserts her independence from her father and the social order – here things aren't quite so clear and we have to be careful not to misread the song. This is partly because a lot of Sinéad O'Connor's writing is pretty rough and ready, in keeping with the punk aesthetic, and is often impressionistic in style. But it's also because the song is written in a symbolic vein, rather than a narrative one.

In the song, the singer describes her three babies, each of which she will carry with her all her life. She tells how the process of holding and losing her babies, and of falling in love, has changed her and calmed her wildness. Much of the song is quite oblique in its references, but whatever its ambiguities, there are certain elements that stand out. The woman here is still mother to her babies, whether dead or alive; she is asserting her responsibility for them, and the emotional pain involved: she tells how she has wrapped the cold bodies of her babies around herself. The last part of the song is addressed to her lover; thus she brings him into the picture, making him part of what has happened. In its own way, this is as much a song about independence and rebellion from the social order – especially given Sinéad O'Connor's Catholic background – as was 'Gathering Rushes'.

I'm sure one of the reasons that 'Three Babies' was acceptable as a potential chart hit was because it is rather difficult to interpret – I may have misread it completely. At the same time, songs like these show that we can, as women songwriters, continue to build on a submerged but powerful female tradition within popular music, whether within the mainstream or outside it.

## BIBLIOGRAPHY

Greig, Charlotte (1989) *Will You Still Love Me Tomorrow?*, London: Virago.

# 10

# SINÉAD O'CONNOR –
# MUSICAL MOTHER

## Keith Negus

Sinéad O'Connor enjoyed considerable celebrity towards the end of the 1980s and beginning of the 1990s. Via four intense emotional albums, a series of equally passionate stage performances and some controversial media appearances she provoked strong reactions of both support and condemnation. Through her sounds, words and images she continually drew attention to social injustice and raised questions about Irishness, religion, racism, sexuality, childhood and motherhood.

In focusing on Sinéad O'Connor, this chapter is intended as a brief suggestive sketch of how the identity of a contemporary recording artist is produced, performed and communicated across a range of media texts that contribute to our knowledge of any star musician. In addition to the musical text, such performative texts include interviews, personal appearances, videos and all the public communicative actions that contribute to how we understand and interpret her music. We can rarely know any artist directly. The relationship between artist and audience is always mediated by the gatekeepers and intermediaries of the music and entertainment industries, and as such Sinéad O'Connor's musical identity is articulated and communicated across a web of mediations that link her as a recording artist with various audiences. Hence, my starting point is that a performer's identity cannot simply be understood by reference to the iconography and sounds of the artist alone, but through a process in which the intentions of the artist are mediated to various interpreting audiences.

As I have written extensively about these processes of mediation elsewhere (Negus, 1992, 1996) here I want to focus on how a performer participates in the authorship of themselves as a recording artist.[1] Sinéad O'Connor is a recording artist who, like other contemporary media stars, is constantly required to participate in 'making themselves into commodities' (Dyer, 1986: 5). In doing this, Sinéad has been engaged in pursuing a musical career route within an entertainment business that

requires her to present an identifiable public persona which should be continually interesting to both media personnel and audiences when promoting new products for sale.

For fans and many journalists, the central focus is usually the artist themselves and the main way of understanding any creative career is often through the narrative of personal biography which privileges the star as author or originator of meanings. In contrast, sociologists – myself included (Negus, 1992, 1995) – have tended to play down issues of authorship with the explicit aim of challenging romantic ideas about inspired individualism or genius, and to show that the production of creative work and aesthetic meaning involves complex processes of collaboration and mediation (Frith, 1983, 1988; Wicke, 1987). My aim in this chapter is to consider the artist as an 'author' actively participating in her own visual and audio self-representation. In doing this I am taking Sinéad O'Connor's music as part of an 'identity' that is articulated in various words, sounds and images – an identity that is produced and communicated across a web of mediations that link her as a recording artist with various audiences. My aim is not to get at the 'real' Sinéad or attempt to unravel the mediations and find the human being lurking within them, but to show how the meaning of Sinéad O'Connor is communicated and circulated through an identifiable series of authored but mediated 'texts'; images, words and sounds. Together these would constitute what Richard Dyer (1991) has called the 'total star text'. There is obviously a person named Sinéad O'Connor but her activities and art cannot be known in any straightforward sense as an 'expression' of a unique and specific personality or as a mirror-like 'reflection' of a series of experiences. In the following discussion I'll briefly mention how audiences can interpret a performer's words and music (and indeed their intentions) differently, and highlight how Sinéad O'Connor has experienced the constraints imposed by the different expectations of male and female performers within the music business, and focus on one aspect of the visual image to illustrate how artists have to legitimate themselves according to the gendered agendas of the music related media. Throughout I will refer to how Sinéad authors and frames various musical meanings.

As an example of Sinéad O'Connor's music, and as an illustration of how she articulates her identity around issues not usually addressed in pop and rock music, I want to start by focusing on the song 'three babies', which appeared on the top selling album I do not want what I haven't got. This song starts with a softly strummed acoustic guitar, playing major chords; C and F; with a quick G, before returning to C. The entire song is based around the continual shift between C ♪ F major chords, and is developed

with the gradual addition of dense string textures and a descending reso-
nant bass keyboard motif. The intensive and personal nature of the song
is signified in the sparsity of the arrangement, the closeness of the con-
fessional voice at the beginning, and also in the way we can hear the
hands moving over the frets of the guitar.

The idea of 'confession' is central to both the form and content of
Sinéad O'Connor's work. By confession I am not referring to the ritual of
the Catholic confessional, although this is an influence that prompted one
journalist to refer to 'the microphone in the confessional' when dis-
cussing Sinéad's music. Here I am referring to the codes and conventions
of the singer-songwriter using the popular song as a confessional.

The idea that the popular song serves as a form of personal confession,
and in addition that any accompanying interview is part of the same
process, is an aspect of the romantic aesthetic that guides the presentation
of many rock musicians and singer-songwriters. It has become an integral
part of the way in which these artists are marketed and presented to both
the music and media industry and to audiences. A number of journalists
have explicitly aligned O'Connor in a tradition of confessional music-
making, often mentioning John Lennon's *Plastic Ono Band* LP (a sparsely
instrumented collection of soul-baring songs, shouts and screaming, pro-
duced after a bout of primal therapy) when referring to O'Connor's
recordings (see Hayes, 1991; Guterman, 1991). In a leading article, the
trade magazine *Billboard* informed its readers that 'the fidelity of Sinéad
O'Connor's music to her own experience has always been apparent'
(White, 1992: 3) and even her album of cover versions, *am I not your girl?*,
was heard by one journalist as 'confessional . . . painfully honest' (Page,
1992: 33).

O'Connor has been located as part of this tradition and it has been cen-
tral to the way she has been positioned in the marketplace by the music
business and the way in which her 'authenticity' – the 'real' human being
(Dyer, 1991) – has been constructed and mediated by record industry
staff, journalists, fans and the artist herself. The confessional tone is very
apparent in her song lyrics and arrangements, production techniques and
musical textures. The confessional characteristics are signified musically in
the use of a restrained, intimate voice, recorded softly and close to the
microphone and with little echo, and by the repeated use of the first
person 'I'. It is also signified in the sparsity of many song arrangements –
the sense of emptiness and silence which suggests that only the singer
(rather than an ensemble) is present. The intimacy is also conveyed
through the way Sinéad's hands can frequently be heard moving over the
frets of the guitar on the recording. This is a particular way of recording

a guitar which makes audible the activity of playing – the listener seems close to those hands moving over the instrument. The acoustic guitar has accumulated a series of social meanings and cultural associations and is part of a long tradition that goes back through the blues, Country and folk traditions where it has been used to accompany the recounting of tales about intensely personal experiences.

The track 'Three Babies' also exhibits a feature that can be found in much of Sinéad O'Connor's music; the use of two distinctive voices: a more private, confessional, restrained and intimate voice, and a harsher, declamatory, more public and often nasal voice that frequently slides into a snarl or shout.[2] There is often a tension present throughout many of Sinéad's vocal performances, between a more vulnerable and uncertain voice, and a more imperative and assertive voice.

The lyrics to 'Three Babies' were included with the album, CD and cassette when it was released; printed in what appears to be a hand-written manner which also reinforces the 'personal' character of her singing style (and her wider media performance). The inclusion of the lyrics with the album suggests that the artist considers them important and that she wants or desires to reduce the ambiguity of the words the listener hears, to avoid misheard or mis-interpreted lyrics.[3] (The lyrics can be found at the end of the chapter.)

What does the song mean? Here are a few responses – all drawn from the press:

> a devotional tune, verging on being specifically religious . . . it elliptically celebrates hard-fought monogamy and motherhood . . .

> . . . the three babies could be the singer, her husband and their son . . .

> [the three babies] are the Holy Trinity . . .

and the rather coy:

> an intimate journey through Sinéad O'Connor's soul . . . three babies will make you squirm.[4]

Such interpretations are based on applying a knowledge about the artist that has been acquired from the 'paramusical context' (Tagg, 1991) of accumulated meanings, particularly those acquired from other communication media of television, press and radio that provide a grid of meaning

for understanding and interpreting the music. As I mentioned earlier, it is across these contextual mediations where clues and cues are provided that guide the ideas we use to interpret a particular artist's songs.

Sinéad herself has frequently given explicit directions to how her music should be understood. Here is a quote form her, explaining this song to an interviewer from a rock paper in 1991:

> I had a series of miscarriages. . . . That's what the story was with that. . . . Miscarriages and things like that never really get discussed . . . it's a grieving thing, and there's nowhere to go and talk about it . . .

The same topic appeared in the song 'My Special Child', recorded to raise money for Kurdish refugees. The cover of the single provides an explicit guide to how we should interpret the song (a drawing, done in the stylised conventions of a childish hand, of a baby with tears running down its cheek inside the stomach of a woman with very short spiky hair). In this song Sinéad sings of two children; one is her son Joe (who appeared in the accompanying video). The other is 'a little girl with yellow skin and her dark curls' who will not be with the mother she has chosen; this is a reference to a planned pregnancy that again miscarried, and that Sinéad has also spoken of in interviews.[5]

My point here is not about authenticity; not whether she is singing from the soul or whether this is the literal truth of personal experience: it is that this is how she is articulating her identity and performance in order to direct audiences to particular interpretations of her songs.

Such issues are not usually found on a top-selling album or chart single; neither are many of the themes of motherhood and family life, and also of child abuse. These are linked themes that feature prominently in numerous interviews and that resonate with varying degrees of explicitness in her music. O'Connor articulates a sexuality that problematises the naive macho stances, the 'rampant masculine sexuality' (Wise, 1990) and chauvinistic phallic posturing which rock performance began to acquire during the late 1960s and 1970s (Frith and McRobbie, 1978). Instead, her performance involves music, words and images that address issues of abortion, sexual abuse and the traumas of family life, and the pains and pleasures of pregnancy, birth and motherhood. If rock has been about sex and sexuality – as the cliché goes – then Sinéad provides glimpses of what has often been absent from the sexual discourse of Anglo-American rock music.

Not only has O'Connor sung about pregnancy, the issue became central to one of the ways in which, as a recording artist, she experienced the

sexism that is prevalent in the treatment and presentation of male and female artists in the music industry. A well-reported incident which involved an attempt to regulate her musical and sexual career came when she became pregnant during the recording sessions for her first album. Both Nigel Grainge and Chris Hill, the directors of Ensign Records, and the company's doctor tried to persuade her to have the pregnancy terminated. As O'Connor explained on television in the United States:

> I went back to the doctor, he said to me that I shouldn't have the baby, in fact that I couldn't have my baby because my record company had spent £120,000 on my album and I owed it to them not to have it. At the same time another man on the same label, his girlfriend was having a baby, and nobody said to him: 'You can't have your baby we've spent £120,000 on your album.'
>
> (Hayes, 1991: 63)

As O'Connor observed, it is female performers who get pregnant and as in many other occupations, female musicians are under pressure not to have any 'complications' that might disrupt the commercial cycles of albums, tours and promotional appearances.

It is worth noting again here that this is O'Connor's representation and a reported version of this (the dialogues that occurred with the record company may well have been more complex than the straightforward version presented here). Such comments are also part of the way in which she has constructed her difference from and opposition to the recording industry. As Dyer has observed, stars have varying degrees of influence within the entertainment industry and continually struggle and protest publicly about their treatment (whether by Hollywood studios, book publishers or the music industry). Dyer has argued, writing of Hollywood, that 'these battles are . . . central parts of the star's image and they enact some of the ways the individual is placed in relation to business and industry in contemporary society' (1986: 6). However, there is a tendency for such 'protests about lack of control over the outcome of one's labour [to] remain within the logic of individualism' (Dyer 1986: 7). Simon Frith (1983) has also noted how most rock musicians tend to adopt a particularly individualistic approach to their activities despite rock music often being characterised as a 'collective' activity (Wicke, 1987). Whilst Sinéad's protests are highly individualistic they are also grounded in her experiences as a woman and discourses of gender and sexuality have been central to how Sinéad has positioned herself in opposition to many of the practices of artist promotion within the music industry.

Sinéad has also experienced a related series of gendered constraints in the responses to her visual image. Although as fans our first contact with an artist may well be with the music alone, or with the music and images of a video, frequently the first signal comes from an image on a poster, on an album cover, on the front page of a magazine or from a photo that accompanies a printed article (we see the face and body before we read the words). The initial visual image of any recording artist is therefore crucial to the production and consumption of popular music.

The visual image is often the first signal to a potential consumer that an artist exists and immediately connotes a type of music, an attitude and a lifestyle; it denotes the artist as a particular type. One of the reasons why Sinéad O'Connor was so immediately recognisable and a focus of attention was because she had cropped hair; she was a bald woman. This was immediately visible as an act of choice. Women do not usually go bald; Sinéad had chosen to make herself bald. It's hard to tell whether she realised the effect that this would have, but she has certainly made enough public comments to suggest that she did not realise the consequences and connotations of many of the meanings that would be attributed to her appearance. Explanations that she gave during interviews suggested that there was not one reason that motivated her decision to cut off the hair; she obviously realised that it would be noticed but it cannot simply be explained as calculated marketing ploy (particularly considering that Ensign record company were anticipating very modest sales of her initial recordings and had not planned to invest heavily in promotion). Undoubtedly O'Connor rationalised and made the reasons she gave fit in with the style she was developing, the expectations of journalists and consonant with the public identity that she was suddenly forced to present due to her sudden fame. Perhaps she did it initially in a fit of temper. In 1991 she told a British rock paper that she had adopted this hairstyle because the directors of her record company 'wanted me to wear high heel boots and tight jeans and grow my hair. And I decided that they were so pathetic that I shaved my head so there couldn't be any further discussion. I also did it for other reasons, but that told them' (Wild, 1991: 13). A hint of the other more personal reasons was given in a reflective article to a British national newspaper in 1993: 'I shaved my head because I was an angry screwed up child. It was an expression of my anger and I wanted to shave my hair off and go out there and scream' (O'Kane, 1993: 29).

Whether or not O'Connor was fully aware of the effect it would have is unclear, but a knowledge of its implications and associations soon became apparent. In 1990 she acknowledged that she had been 'stupid' by not realising that people would perceive her as aggressive (Sprague, 1990).

A year later she seemed fully aware of the multiple connotations: 'It has certain associations . . . it has the whole fascist association. It has the whole lesbian association. And it has the whole aggressive-woman association, which, of course everybody hates' (Wild, 1991: p. 13).

Again my point in raising this issue here does not concern whether her explanation is true or false; it is that in being forced to explain this act to various journalists who then mediated this information to audiences, the reasoning became an integral part of the articulation of her identity. It became part of how her intentions were understood in a far more explicit way than a hairstyle would with many artists. Not only did the record company want her to adopt a more conventional feminine image, but in rejecting this she found she then had to confront a media who made this very act one of the central issues. In trying to negate a gender stereotype, her deviation from the conventional was emphasised, and this became part of the way in which her gender identity was reinforced in the media.

Female performers tend to be asked far more questions about their appearance than male artists (Steward and Garratt, 1984). As a consequence, this becomes part of the way in which their identity is articulated and their intentions are understood by audiences. Regardless of what her intentions were, or whether like most of us, she's only partially aware of them, the questioning forced her to provide an explanation, which in turn became part of her public identity.

Regardless of how the haircut came about, it took its place in a history of shaved heads; most notably the style associated with the English skinhead fashion in the late 1960s and early 1970s, which briefly combined a taste for ska music with xenophobic nationalism. There are, of course, a whole series of further associations and connotations. When writing about O'Connor, journalists have mentioned the shaving of the head by religious groups (as an act of penance or contrition) and the shaved heads of asylum inmates and prisoners (society's victims) – implicit comments on some of the meanings which have become attached to Sinéad.

Perhaps more importantly, and probably initially by coincidence, the shaved head fitted the marketing process of the music industry in two ways. First, it fitted the working beliefs of industry personnel that the image should in some way be suggestive of a type of music. By and large the music on the first album is heavily rock influenced and contains its fair share of shouting, screaming and, as O'Connor is reported to have said, was a deliberate attempt to counteract the image of Irish stereotypes by not looking or sounding like a wistful female Irish singer (Hayes, 1991). Second, it could be easily branded. The bald head became a metonym for

Sinéad O'Connor in the same way that the 'mop top' could stand in for the Beatles or dreadlocks for Bob Marley.

I have concentrated on the head because it has been the most consistent, conspicuous and commented upon element of her visual image, and integral to the way she was packaged, marketed and mediated through the cultural industry. A glance at her videos shows that the head remained constant up to and including the release of her third album (*am I not your girl?*) whilst the clothing on her body varied considerably within her repertoire of styles; jeans, T Shirt, Doc Marten's boots, jump suit or lycra body stocking and long flowing gowns.

One image that all those who purchased the album will see (even if they ignore the other media and merchandise that the bald head moves across) is the album sleeve. The cover of an album defines an artist in a specific way, locating them as a particular type of human being and as a product placed within the market categories of the music industry. The artwork and iconography is there to seduce the consumer to purchase the product. But album sleeves also explain how the music contained within them should be understood, interpreted and appropriated. Here album sleeves can enjoy a degree of independence from their specifically commercial function. Paul Gilroy (1993b) has argued that the words and images on them can serve an educational and agitational purpose; providing information about particular issues, and encouraging people to participate in a named activity or adopt the lifestyles signified by clothing and hairstyles.

O'Connor's first two album covers contain a mixture of the branded image of the pop star, combined with tangential images that comment upon, reinforce and work away from the music. The cover of *the Lion and the Cobra* has a bright slightly out of focus close-up of the artist, fist clenched at the top of her chest and face slightly distorted, with her mouth open in the act of shouting, singing or screaming (perhaps all three). The second album *I do not want what I haven't got* focuses on the face but below the cropped hair which is now kept out of the frame as it was in the video that accompanied the hit single 'nothing compares 2 U'.

The images on the packaging of the first album are of the artist. The second album sleeve, however, also contains a photograph of the parents of the teenager Colin Roach standing next to a photograph of their son. This is an explicit reference to and elaboration of the track 'black boys on mopeds' which narrates the tale of a teenager who died on a moped that had been borrowed by a friend whilst being pursued by police who had assumed the vehicle to be stolen, and then moves on to a scathing lament about the injustices of 1980s Britain that were often concealed beneath the

consumer boom of the time. Within this context, the image can be taken as a gesture of solidarity with black people in Britain. But a further series of connections can be established with O'Connor's acknowledgement of her debt to and use of hip hop, her vocal stand against racism, her references to connections between the colonial oppression of the Irish and black people by the English state, plus the very close syncretic fusion of music across the Atlantic between the black diaspora and the Irish diaspora (Gilroy, 1993a; O'Connor, 1991). Such meanings connect directly with O'Connor's use of musical signifiers of blackness and Irishness. One notable example of this is the track 'I am Stretched Upon Your Grave' from I do not want what I haven't got. This song constructs a very distinct sense of history, geography and cultural identity, one that is dislocated or abstracted out of place and time. Lyrically, 'I am Stretched Upon Your Grave' is a version of a twelfth-century Gaelic poem which has been translated by short-story writer and playwright Frank O'Connor. The lyrics narrate the ancient Gaelic practice of mourning which was carried out by a widow or lover who would lie or sit on the grave of the deceased. These sombre lyrics have been set to a melody by Phillip King, a television producer, archivist and musician. The music is written according to the specific practice of singing unaccompanied in an acapella style known as sean nós ('old style') which involves considerable melismata and vocal gymnastics.

Such lyrical and melodic patterns might suggest the signification of Irish tradition and a distinct musical coding of national history.[6] Yet these elements are combined with a repeated hip hop drum pattern that appears to be sampled, although unacknowledged on the album, from James Brown's Funky Drummer Part 1 (Gaunt, 1995; Guterman, 1991). This immediately adds the further meanings associated with James Brown's blackness to those of Irishness that have been signified by the lyrics and melody. The addition of Jah Wobble's deep and pulsating bass playing (influenced by dub reggae and funk) add further significations of blackness and the introduction of fiddle playing towards the end of the track by a member of the Waterboys provides a further signification of Irishness.

Listening to such musical patterns along with the accompanying words and images that were referred to earlier, this can be heard as a song that celebrates the cross-Atlantic movement and meeting of African-American and Irish musical styles; the cultural consequences of the interactions between the black diasporas of Africa and the Caribbean (towards Britain and Ireland) and the diaspora of Irish people (towards the United States and Caribbean). In recording this song Sinéad has combined various musical elements to create a very particular sense of identity – a transatlantic hybrid synthesis, an imaginary musical space that does not exist in any

physical location but which suggests solidarities between black and Irish people. It is a sound that is woven into and out of the historical and geographical routes through which her own artistic identity and cultural practice has been constituted, performed and continues to be made.

<div align="center">

*three babies*
(O'Connor)

*each of these*
*my three babies*
*I will carry with me*
*for myself*
*I ask no one else will be*
*mother to these three*
*and of course*
*I'm like a wild horse*
*but there's no other way I could be*
*water and feed*
*are not tools that I need*
*for the thing that I've chosen to be*

*in my soul*
*my blood and my bones*
*I have wrapped your cold bodies around me*
*the face on you*
*the smell of you*
*will always be with me*

*each of these*
*my three babies*
*I was not willing to leave*
*though I tried*
*I blasphemed and denied*
*I know they will be returned to me*
*each of these*
*my babies*
*have brought you closer to me*
*no longer mad like a horse*
*I'm still wild but not lost*
*from the thing that I've chosen to be*

</div>

*and it's 'cos you've thrilled me*
*silenced me*
*stilled me*
*Proved things I never believed*
*the face on you*
*the smell of you*
*will always be with me*
(repeat 1st verse)

'Three Babies': Words and music by Sinéad O'Connor © 1990, EMI Music Publishing (Holland) BV, UK

## NOTES

1 In her discussion of Madonna, Susan McClary has stressed Madonna's agency in her self-representation and noted that:

in a world in which many people assert that she (along with most other women artists) can't have meant what one sees and hears because she isn't smart enough, claims of intentionality, agency and authorship become extremely important strategically.

(McClary, 1991: 150)

2 Here I am drawing on the distinction between confessional and declamatory modes of address in the vocals of popular music, as developed by Philip Tagg (1991) and Dave Laing (1985).
3 As Simon Frith (1987) has often pointed out, lyrics are not poetry or simply words, but recordings of a particular vocal performance; sounds we that we frequently misinterpret and misunderstand as we impose our meaning on and over the ambiguities present in the performance. When lyrics *are* included with an album however, not only do they reduce this ambiguity, they can also enjoy an independent existence and be read separately from the voice and music.
4 These quotes have been taken from Dermott Hayes (1991) and Jimmy Guterman (1991).
5 Both quotes here are from Bailie (1991).
6 In referring to music as signifying Irishness I do not mean to imply that the Irishness is somehow 'in' the music, as an essential element. Rather, I mean to suggest that certain musical codes (instrumental, vocal and lyrical) are deliberately used to signify 'Irishness'. This involves the intentional employment of particular styles, techniques and instruments which connote a particular relationship to Irishness and an Irish musical tradition. These have been introduced and adopted through historical usage and communicate through their conventional use rather than through any essential connection to Ireland as a place or the people born there. As Stephen Feld has observed, people rarely hear musical sounds that are 'totally new, unusual and without some experiential anchors' (1984: 6). Sounds are recognised by listeners as communicating certain accumulated meanings, as part of 'the public's pragmatic knowledge of musical signification' (McClary, 1991: 21). Within this context, ideas about national identity have been an important part of the cultural knowledge through which particular musical sounds have been given meaning. It is in this way that Irishness is signified by music.

# REFERENCES

Bailie, S. (1991) 'Parental as Anything', *New Musical Express* 1 June: 48–9, 55.

Dyer, R. (1986) *Heavenly Bodies: Film Stars and Society*. London: British Film Institute.

Dyer, R. (1991) 'A Star is Born and the Construction of Authenticity', in C. Gledhill (ed.) *Stardom, Industry of Desire*. London: Routledge.

Feld, S. (1984) 'Communication: Music and Speech about Music', *Yearbook for Traditional Music* Vol. 16: 1–18.

Frith, S. (1983) *Sound Effects: Youth, Leisure and the Politics of Rock 'n' Roll*. London: Constable.

Frith, S. (1987) 'Why Do Songs Have Words', in A. White (ed.) *Lost in Music*. London: Routledge.

Frith, S. and McRobbie, A. (1978) 'Rock and Sexuality', *Screen Education* 29: 3–19.

Gaunt, K. (1995) 'The Veneration of James Brown and George Clinton in Hip Hop Music: Is it Live or is it Re-memory?' in W. Straw, S. Johnson, R. Sullivan and P. Friedlander (eds) *Popular Music – Style and Identity*. Montreal: International Association for the Study of Popular Music/Centre for Research on Canadian Cultural Industries and Institutions.

Gilroy, P. (1993a) *The Black Atlantic, Modernity and Double Consciousness*. London: Verso.

Gilroy, P. (1993b) *Small Acts: Thoughts on the Politics of Black Cultures*. London: Serpent's Tail.

Guterman, J. (1991) *Sinéad, Her Life and Music*. Harmondsworth: Penguin.

Hayes, D. (1991) *Sinéad O'Connor: So Different*. London: Omnibus.

Laing, D. (1985) *One-Chord Wonders: Power and Meaning in Punk Rock*. Milton Keynes: Open University Press.

McClary, S. (1991) *Feminine Endings: Music, Gender and Sexuality*. Minneapolis: University of Minnesota Press.

Negus, K. (1992) *Producing Pop: Culture and Conflict in the Popular Music Industry*. London: Edward Arnold.

Negus, K. (1995) 'Where the Mystical Meets the Market; Commerce and Creativity in the Production of Popular Music', *The Sociological Review* 47 (2): 316–41.

Negus, K. (1996) *Popular Music in Theory*. Cambridge: Polity Press.

O'Connor, N. (1991) *Bringing it All Back Home: The Influence of Irish Music*. London: BBC Books.

O'Kane, M. (1993) 'The Child Who Tore the Pope in 2', *Guardian* 1 May: 29.

Page, B. (1992) 'Torched by Your Presence Dear', *New Musical Express* 12 September: 33.

Sprague, D. (1990) 'Thrown to the Lions', *Select* July: 70–4.

Steward, S. and Garratt, S. (1984) *Signed, Sealed and Delivered. True Life Stories of Women in Pop*. London: Pluto Press.

Tagg, P. (1991) *Fernanado the Flute: Musical Meaning in an Abba Mega-hit*. Research Report, Institute of Popular Music, Liverpool University.

White, T. (1992) 'Sinéad: The "Girl" in the Woman', *Billboard* 5 September: 3.

Wicke, P. (1987) *Rock Music: Culture, Aesthetics and Sociology*. Cambridge: Cambridge University Press.

Wild, D. (1991) 'Men Have No Balls!' *New Musical Express* 2 March: 12–13.

Wise, S. (1990) 'Sexing Elvis', in S. Frith and A. Goodwin (eds) *On Record: Rock, Pop and the Written Word*. London: Routledge.

# 11

# MANNISH GIRL

## k.d. lang – from cowpunk to androgyny

### Stella Bruzzi

The Canadian singer k.d. lang (born Kathy Lang) comes from the tiny town of Consort, Alberta. She recorded her first single in 1983, and after assembling the Reclines (named after Patsy Cline) was signed by Seymour Stein, founder of Sire Records, whose previous finds had included the Talking Heads and Madonna. Until 1992 lang produced unconventional Country music, but although she won a Grammy in 1990 (Best Country Vocal, Female) for *Absolute Torch and Twang*, she was never fully accepted by the Nashville community, alienating them totally with her 1992 'meat stinks' TV commercial for PETA (People for the Ethical Treatment of Animals). The year of 1992 was lang's watershed. In August she came out to *The Advocate* after having released *Ingénue*, a radical musical departure into personal, anguished torch songs, which became by far her largest selling album to date, going platinum in America and selling more than 2 million copies world-wide. After a 1993 Grammy for *Constant Craving* and a period in Los Angeles, lang has now returned to Canada, and recorded her last album, *All You Can Eat*, in Vancouver. Although *All You Can Eat* is much more of a celebration of happiness in love than *Ingénue* had been, the album confirms lang's rejection of Country in favour of mellow pop.

In the Patsy Cline classic 'Three Cigarettes in an Ashtray' k.d. lang sings about unrequited, triangular heterosexual love:

> I watched her take him from me.
> Now his love is no longer my own.
> Now they have gone, and I sit alone,
> And watch one cigarette burn away.

When, for the Red Hot and Blue AIDS benefit video, lang collaborated with German director Percy Adlon for a rendition of Cole Porter's 'So in

Love', the gender identities of the lovers (although perhaps presumed) are not stated:

> Strange dear, but true dear
> When I'm close to you dear
> The stars fill the sky,
> So in love with you am I.

The shift from a woman/man dynamic to an ambiguous one is funda-mental to k.d. lang's re-presentation of herself through her songs (for instance the Joan Armatrading-style non-specificity of the love songs on both *Ingénue* and *All You Can Eat*). Such a transition is equally significant in terms of image, look and identity. The premise for this discussion will be lang's basic movement, both in terms of her musical development and her style, away from playing with ideas of performativity, distanciation and irony and towards a more homogenised, conventionally ambiguous androgyny.

In 'Three Cigarettes' (which lang did several times) there is an obvious play, in performance, between the straight conformity of the love triangle story and lang's rendition of it on, for instance, the video compilation *Harvest of Seven Years*.[1] lang is in a familiar version of her early 'cowboy punk' gear: a blue Country and Western tasselled shirt, a full patterned skirt and her pair of shorn off cowboy boots, courtesy of a Ukrainian farmer in Alberta. Her studied roaring girl appearance functions in ironic and self-conscious contrast to the misplaced but traditional passion of the Cole Porter song, and we in the audience are being invited to interpret the complex reflexivity of this image, the components of which include lang's presumed but unstated lesbian sexuality, her detachment from hair-and-spangles Country, the sincerity of her beautiful voice, the infatuation with Patsy. The pleasure is in not knowing why or how these elements fit together at all.

If we compare this to 'So In Love', the element which has been dis-pensed with is the difficulty – the incongruity, the play, the richness – of a cowpunk performing 'Three Cigarettes'. In its stead is a homogenised, androgynous lang in scruffy T-shirt, shirt and jeans, not filmed to look feminine at all, singing about an unidentified lover whilst washing *a woman's* clothes. The pleasure, this time, is in knowing, but, because lang is so emphatically boyish and is lit and shot by Adlon in such a way that her gender could be mistaken, her androgyny serves to camouflage rather than foreground the potential for lesbian desire. Elaine Showalter perceived in Virginia Woolf's *Orlando* an evasiveness, a 'flight into androgyny' that

was utopian and non-confrontational. Perhaps the options have, in a sense, been similarly cut down by and for k.d. lang. By deciding to blur rather than accentuate sexual and gendered difference the gap is closed, and something radical (though messy) has been lost. This chapter is partly an articulation of that loss, a reaction against lang's progression from female Elvis knocking at Nashville's door to a slick, mellifluous crooner who has, on more than one occasion, been likened to Frank Sinatra.

## THE SPACES BETWEEN THE NOTES

In a recent interview k.d. lang acknowledged the difficulties inherent in her relationship with Country when commenting: 'I made fun of Country music at the same time as I loved it.'[2] Nashville, which largely cold-shouldered lang, did not, it would seem, take kindly to irony, refusing (after the PETA storm)[3] to play even the Grammy award-winning *Absolute Torch and Twang* on the radio. lang's relationship with the Nashville sound remains, however, one of the defining factors of her pre-*Ingénue* period. Country is itself innately camp – or at least it elicits a potentially radical camp which 'is not simply a "style" or "sensibility" as is conventionally accepted' but rather a 'suppressed and denied oppositional critique embodied in the signifying practices that processually constitute queer identities'.[4] Thus Lyle Lovett's version of Tammy Wynette's 'Stand by your Man' can be viewed alongside lang's revisiting of 'Three Cigarettes'. Both, from vastly divergent perspectives, imply the same space between the notes. The space (where heterosexual conformity meets queer uncon-formity) is signalled in both as being the 'ontological challenge that displaces bourgeois notions of the Self as unique, abiding and continuous while substituting instead a concept of the Self as performative, improvi-sational, discontinuous'.[5] Lovett, as a heterosexual man, disrupts the traditional equilibrium of 'Stand by Your Man' as a song for women and gay men, whether it is performed straight or with twist, just as lang, as a then closeted dyke, unbalances the simple pain of the 'Three Cigarettes'. Both are a series of stylised acts of tension, difference and distance, very different from the safe gender reorientation of the 'my girl/my guy' switch of the Beach Boys' 'Then I Kissed Her'.

The subversive potential of performativity need not, however, be lim-ited exclusively to the act of performing as one can, I would argue, perform spectatorship. Theorising the disruptive possibilities of drag as a 'third term . . . which questions binary thinking and introduces crises' and is 'a mode of articulation, a way of describing a space of possibility',[6] Marjorie Garber, in ways which are directly applicable to Lyle Lovett and

k.d. lang, posits that performance and self should not be conflated. Most critics who have studied transvestism, as Garber observes, have tended 'to look through rather than at the cross-dresser',[7] to eagerly subsume the appearance into one of the two traditional genders, to interpret what is unstable through what is supposedly stable. If one looks through 'Stand by your Man' at Lyle Lovett, or through 'Three Cigarettes' at k.d. lang, one is by-passing the self/performance/audience juncture which activates them. Thus it is the dynamic tension between the straight male identity of Lovett and the Wynette track or the lesbian one that lang (implicitly) brings to the Cline and the melodrama of its narrative that is interesting and queers the performances. The 'space of possibility' in both instances is the collision between conventional and unconventional, fixed and fluid, straight and queer.

Country music, probably precisely because of its overt rigidity, has frequently been the site of irony and change. The emergence on the Country scene in the mid-1980s of a 'new wave' made up of artists like Lovett, lang and Dwight Yokham was facilitated by another period (echoing the post-psychedelia era when, for example, Gram Parsons engineered the Byrds' change of direction and Dylan recorded *Nashville Skyline*) in which mainstream pop artists like Elvis Costello briefly went Country. Although Nashville ignores open criticism (Robert Altman's film *Nashville*, for example, fails to even get a cursory mention in the Country Music Hall of Fame), its music has at least been receptive to ambiguity. To return to lang's own evaluation of her equivocal relationship to Country: that she both loved it and made fun of it. Her rendition of Country (although misconstrued by many in Nashville) was grounded in a knowledge and love of the fixed as well as the fluid aspects of the music, such as the predominance of narrative over abstraction when it comes to lyrics. Although lang's Country tracks do not follow as intricate a narrative trajectory as, say 'Long Black Veil', songs like the autobiographical 'Big-Boned Gal' and even the more emotive closing track on *Absolute Torch and Twang*, 'Nowhere to Stand' are built around action, characters and recognisable scenarios. It is often the most ostensibly inflexible story that offers the most satisfying avenues for subversion and rearticulation: the furtive love at the centre of *Brief Encounter*, the aching woman in 'Johnny Get Angry', a Girlie Group hit long before it became a staple in lang's stage repertoire.

What is productive is the creation of a dynamic, reflexive relationship between inflexible generic foundations and mutability or inflection. Lang's interaction with Country reaches its apotheosis and (excepting the soundtrack for *Even Cowgirls Get the Blues*, some of which were re-recordings), its conclusion with the great *Absolute Torch and Twang*. What makes *Twang* is that

it is a hybrid album, one that, within the parameters of Country, creates space for the 'Buddy Holly in drag'[8] cowgirl. *Shadowlands*, recorded only a year earlier with Patsy Cline's producer Owen Bradley and featuring three first ladies of Country (Brenda Lee, Loretta Lynn and Kitty Wells) on backing vocals, represents lang's total immersion in Country, although what is notably absent is any discernible distanciation and irony on lang's part as she is still very much stuck on Cline.

In *The Pleasure of the Text* Barthes differentiates between two types of 'pleasure': *plaisir* which is 'linked to a comfortable practice of reading' and *jouissance* or 'the text of bliss . . . that imposes a state of loss'.[9] Pursuing this model, excitement is generated by interruptions, breakdowns, and gaps in the text, as Barthes's analogy with the eroticism of clothes illustrates:

> Is not the most erotic portion of a body where the garment gapes? . . . it is intermittence, as psychoanalysis has so rightly stated, which is erotic; the intermittence of skin flashing between two articles of clothing.[10]

The radical displacements that occur in some early lang conform to Barthes's idea of gaps, not by simple fetishistic insinuation (always suggesting what is never shown) but by permitting the co-existence of the visible and the implied. In examining the relationship between camp and queer identity Moe Meyer outlines the complexity of the gay/lesbian performance:

> Because gender identity is instituted in repetitive acts, then queer performance is not expressive of the social identity but is, rather, the reverse — the identity is self-reflexively constituted by the performances themselves. Whether one subscribes to an essentialist or constructionist theory of gay and lesbian identity, it comes down to the fact that, at some time, the actor must *do* something in order to produce the social visibility by which the identity is manifested.[11]

This presupposes, of course, that the intention is, in some way, to perform gayness or lesbianness, to render the sexuality visible. Such a performative intention does not, I would posit, work for lang's early work, where the performances are rooted in *gender* and the *sexuality* resides only in the gaps, the absences between the 'stylised repetition of acts'.[12]

This, therefore, is to return to the Barthesian notion of *jouissance* and of gapes in the cloth. The tension between the implied and the overt is an essential and consistent component of lang's performativity in her pre-'So

In Love' period when, as one writer put it, she was 'a large-boned, tufty-haired character who looks like a genteel trucker, giggles like a schoolgirl and sings like Peggy Lee'.[13] Quoted in the same article, k.d. lang herself affirms 'I like to be cryptic', and from her earliest video recordings ('Bopalina' and 'Pollyanne') she conformed to this dynamic eclecticism. In both 'Bopalina' and 'Pollyanne' the cracks in the surface are more apparent than in some later performances as, dressed in 1960s middle-aged housewife dress and jacket suits made of glittering and garish nylon, no shoes and her then trademark horn-rimmed spectacles, she cavorts about the stage. That these rock and roll numbers are about imposing identities rather than inhabiting them is most categorically signalled at the end of 'Pollyanne' as lang, after having adopted a range of excessively clichéd images of femininity (fluttering eyelids, big Jackie O hair) and performing with would-be Beach Boys on backing vocals, rips off her wig to reveal her quiffed, short crop. The collision between the implicitly heterosexual and the implicitly lesbian elements in these instances does not attain any easy synthesis, as the ironic effect of the performances remains dependent on the simultaneous evidencing of both.

What characterises the early repertoire is the common heterosexual reference point, either in the lyrics or in lang's presentation of herself as raucously female, as emphatically non-male. In a fairly conclusive way she is, therefore, conforming to Joan Riviere's idea of masquerading womanliness that 'could be assumed and worn as a mask, both to hide the possession of masculinity and to avert the reprisals expected if she was found to possess it'. To Riviere (as to lang) womanliness itself is a mask, which does not denote (through difference) the actual presence of a 'genuine womanliness'[14] underneath. The high point of lang's excessively heterosexual drag phase is her version of 'Johnny Get Angry', which she only performed on stage and never recorded. In this track the distance between glanced spaces between words and the words themselves is at its most pronounced as lang, in wild cowgirl boots, skirt, shirt and neckscarf, sings:

> Johnny get angry, Johnny get mad
> Give me the biggest lecture I ever had,
> I want a brave man, I want a cave man,
> Johnny show me that you care, really care, for me.

Freud suggested that only opposites attract; by the same token opposites remain the most enduring shorthand for affirming what is Other, absent but there. As lang collapses crying 'Johnny!' banging her middle-aged

glasses against her troubled brow and clasping her hands to her heart, her non-heterosexuality, her non-passivity is at its most sublimely obvious – it just is not spoken. Unlike Mrs Merton who, in many of these early guises, she strongly resembles, lang's inconsistency of image is what is challenging, that she does not affect one style but brandishes many; the crowning moment of such self-conscious in your face-ness coming, appropriately enough, when she storms on to the stage to collect her first Canadian music industry award for the Most Promising Female Vocalist in ill-fitting bridal wear and white trainers. lang is thus, in these early years, using drag as her primary mode of self-identification, and drag is manifestly unstable and mocking of any notion of gender identity as Judith Butler suggests. lang's drag, not unlike the function of cross-dressing in other fields of performance, is both concealing and revealing, and just as the 'visual play simultaneously challenges and supports traditional gender codes'[15] in films such as Some Like it Hot, Tootsie and Mrs Doubtfire, so does lang when singing a song like 'Johnny'. The parodic rather than naturalising quality of characters who, out of narrative necessity, cross-dress is dependent for its success on the audience being in on the joke whilst the other characters prove gullibly 'tricked by the simplest of gender-coded costumes'[16] and the most clichéd of signifiers. So Tony Curtis in Some Like it Hot simply needs to don a big pair of earrings, and so Cary Grant in I Was a Male War Bride gets past immigration control with a horse's tail for hair, and so k.d. lang wears a wedding dress to pick up an award. lang is in drag because passing has nothing to do with it, and we the audience are meant to revel in the fissures. Parodic drag is the ultimate critique of 'the very notion of an original', because 'in imitating gender, drag implicitly reveals the imitative structure of gender itself – as well as its contingency'.[17]

At this stage in her career (basically, I would argue, until the 'So in Love', Salmonberries, Ingénue period) lang's performative matrix is gender and the accentuation of difference, which might seem tangential to the burning issue of the day: 'Is she or isn't she a lesbian?' This is the question that, with teasing responses like 'I'd like to make a confession – I'm a L-L-L-Liberace fan' she was tacitly acknowledging and vocally fending off at concerts. A cementing characteristic of many female singers of the late 1980s/early 1990s has been the repeated performing and questioning of feminine stereotypes and female identity. Country music, with its supply of anthems to monogamy, heterosexuality and sexual difference is an obvious site for such a critique, but in their putting on and taking off of categorically defined gender identities artists such as Madonna, Annie Lennox and PJ Harvey have contributed to the analysis. As Butler comments when referring to The Second Sex:

> If there is something right in Beauvoir's claim that one is not born, but rather *becomes* a woman, it follows that *woman* itself is a term in process, a becoming, a constructing that cannot rightfully be said to originate or to end.[18]

lang, Madonna, Lennox and Harvey all, in different ways, are performative in that they are constantly putting on show the moment of gender construction. lang's images are particularly disruptive in that they are never convincingly integrated, unlike those of Madonna and Lennox which are, in each performance, constructed to seem, for that moment, whole. In contrast to this, lang's signature is the arrangement of clothes and accessories into jarring, seemingly haphazard medleys: Mrs Merton and tomboy, cowboy and compliant woman. It's significant, however, that she is rarely slotted into the category of image-changing female singers but is rather bracketed with men, the famous example being Madonna's own comment 'Elvis is alive – and she's beautiful.' When considering lang's use of camp her counterparts and predecessors are taken by most writers to be men: Elvis, Bowie, Jagger and the original Queen of Rock 'n' Roll, Little Richard; similarly her voice is compared to that of lush male crooners like Sinatra, and lang herself has said 'I'm the Tom Jones of lesbians.'[19]

By way of an end to this section about the significance of gender in lang's performance, her masculinity rather than her deviant femininity should be signalled as the factor that, after 'So in Love', becomes dominant. lang's 'flight into androgyny' was seemingly made up of two primary factors: a surfacing of her big-boned gal-ness and her coming out (to *The Advocate* in June 1992); the two factors, therefore, that had been instrumental in creating the tension that informed the earlier performances. What has, by and large, been dispensed with (the video of 'Miss Chatelaine' in which lang looks like a man in drag being a delicious exception) is the ambiguity, the pulling between gapes and cloth. This, it seems, is what lang wanted when she makes comments like 'Now I realise people like me, I can be less theatrical. I don't need to hide behind facades.'[20] When discussing the reasons for coming out, lang frequently invokes the problematic idea of honesty, commenting that her statement has freed her:

> Not in the way that I felt I could now say 'she' in a song.
> That's not the pay-off. The pay-off is in your daily life, in your honesty. Just living in truth is different.[21]

Saying 'she' might be thought to be a likely concomitant of such honesty,

and lang's flight into masculinised non-difference could be interpreted as a denial of her previous queerness which made strange the relationship between image, body and sexuality. By retreating (with few exceptions) from her previously disruptive and troubling images and ostensibly bringing her image and body closer, more 'honestly' together, lang has precipitated, for me, a great loss. As a way of explaining this loss it is pertinent to return to Garber's notion of not looking through the cross-dresser's clothes to find the 'real' person. Ben Mink has criticised audiences for not looking beneath the exterior appearances lang projected, as if an integrity between image and body of sexuality is both desirable and attainable. What has been lost is the unsettling knowledge that this is a safe compromise.

## 'HONESTY' AND ANDROGYNY

What characterises lang's more recent performances is masculinisation, so it may seem perverse to attach the notion of drag to her previous ultra-feminine incarnations rather than to the mannish girl poses she has adopted since. Drag, though, has got a lot to do with danger and collision, whilst lang's masculinisation (conforming to the rather nebulous idea of 'honesty') is, perhaps, too fluent and homogenous to be considered in those terms. Since the period of 'Trail of Broken Hearts' and 'Pulling Back the Reins' (both off *Absolute Torch and Twang*) the journeying away from wayward femininity has been evidenced by lang's adopted personae in her videos. Whether in work clothes or sharp, bright men's suits (more Elvis than Patsy) lang is clearly de-emphasising both her sex and her gender. As Barbara Creed has noted 'historically and culturally the lesbian body . . . has been represented as a body in extreme'.[22] One of these 'extremes' is the masculinised lesbian body, which could be equated with lang's more current images; the butch suits of 'Reins' and 'Ridin' the Rails' being obvious examples. There is, however, something more complex occurring within the narratives of the video versions of 'Broken Hearts' and, more extremely, 'So in Love' that places lang's new butch performativity in direct contrast and opposition to the earlier zany girls. In both instances lang is obviously identified as the masculine figure in a relationship that includes a feminised partner: in the first, as the tomboy, she meets a bride fleeing from a church, and in the latter she is washing and disinfecting the overtly feminine clothes of a sick, absent partner. What has occurred, therefore, is a fundamental transition from the performing of gender and difference to androgyny, using the far more conventionalised masculinity as the visual reference point.

One stormy moment of controversy in the post-*Advocate* era was Herb Ritt's August 1993 *Vanity Fair* cover showing lang, in louche gentlemen's clothes being shaved by her 'dream date'[23] Cindy Crawford, dressed in swimming costume and heels. The pleasure is palpable, the naughtiness immense, especially when one arrives at the kissing photo inside. As with the masculine–feminine scenarios in 'Trail of Broken Hearts' and 'So in Love', though, the controversial could be more reactionary than it seems. The woman on woman connotations are radical, particularly in such a mainstream context, except that one woman is dressed as a man. Dressing one woman as a man, even giving one a pointed moustache as happens to Katherine Hepburn in *Sylvia Scarlett*, has traditionally been how mainstream cinema has 'sanitised' images of lesbian intimacy. In all these instances, including the raunchy *Vanity Fair* cover, one is being asked to look through the disguise to find the subversion. The androgynisation of the lesbian woman via overt masculinisation is itself hugely problematic, as it falls headlong into the uncomfortable realm of cliché.

Androgyny, because it refers to the smudging of difference between male and female but does not specify whether this is occurring on and through a female or a male body, is fraught with ambiguities. A positive reaction responsive to the radical potential of androgyny is articulated by Susan Suleiman:

> Androgyny in a new key? Why not? . . . The possibility of such multiple blurrings (which are not an attempt to deny differ-ence . . . but rather an attempt to redraw and mix up the lines of difference in new, energising ways) . . . is, I think, a dream worth pursuing.[24]

A dissenting view, as referred to earlier, is Elaine Showalter's understand-ing of Virginia Woolf's attraction to androgyny as a 'flight'. In *Orlando*, neatly done in Sally Potter's film version by Tilda Swinton pointing at her-self in a (Lacanian) mirror, Orlando calmly signals his/her sex change with 'Same person. No difference at all. Just a different sex.' In both *A Room of One's Own* and *Orlando* Woolf presents androgyny as a utopian ideal, as a sex-less state that can guard against repression. She advocates, as Kari Weil puts it, 'androgyny as a psychological and poetic ideal, a transcendence of sex, self, and language'.[25] This deliberate loss of gendered individuality is what Showalter reacts so violently against when condemning Woolf's androgyny as a mythical means of evasion and denial, as a fleeing from the problems she supposedly has with her own sex and gender.[26]

The crux of this debate is the very conception of 'no difference at all'.

The use of gender exemplified by lang's primarily Country phase created dynamism through conflict: between performances of gender, between what was spoken and what was left unsaid. It is obviously possible to, paradoxically, use sameness as a constituent of, to use Probyn's phrase, 'queer belongings'.[27] Although Butler focuses on Divine's subversive confusions in female drag, Divine is, I would argue, equally subversive in a film like Alan Rudolph's *Trouble in Mind* in which he performs a male mobster; in a sense a double, self-reflexive drag, playing off the expectation of single drag. There is likewise a use of sameness via androgyny in films such as Peter Weir's *The Year of Living Dangerously* or again Rudolph's *Made in Heaven* in which women (Linda Hunt and Debra Winger) both perform and pass for men. In both instances (as in *The Crying Game* until Dil reveals all) there is intended to be 'no difference at all' between the actors' gender and the parts they are playing, to the extent that Winger was not given a credit. The essential divergence between Divine in double drag and the audience being confused or duped by the other three performances is between critical and uncritical sameness, the latter being 'pure' androgyny which, by its very use, does not involve the audience in the critique. To return to lang. If one brackets together lang's assertions that she wants to dispense with theatricality, her desire to be honest and her androgynisation, one can perceive, although not through passing, a non-radical blurring and a homogenisation of her self and image. It is as if, by coming out, she has engineered her own flight into androgyny, and that her words in *The Advocate* are testimony enough to her queerness and subversiveness. They might be if she *did* say 'she' openly in her songs, but their frustrating universality and tentative equivocation could be construed as absenting rather than presenting her sexuality.

The crucial factor when considering how lang's androgyny functions in her music and her imaging of herself is the audience–performer dynamic. Since coming out, lang and those who have written about her have begun blithely to weld together sexuality and performance, as if the previous problematics were a 'phase' on the road towards a 'truer' expression. Here, for instance, are the comments of two journalists who recently interviewed lang following the release in the autumn of 1995 of *All You Can Eat*:

> It's an aspiration to eliminate your sexual orientation when you're on stage. That's what made Elvis successful, he turned the guys on. . . . The same with Annie Lennox.

> She has [charm] by the bucketload and, along with a ready wit and a drop-dead smile that could turn a straight woman at 20

paces, it captivates practically everybody who meets her, male or female, gay or straight.[28]

That lang has become the universal lesbian who we can all fantasise about is an all too convenient way of blurring her sexuality into extinction, but maybe this is the fate befalling the androgyne – it would certainly seem to be the fate of that new media babe, the 'lipstick lesbian'. Why should it be hailed as laudable that lang (more of a dyke icon, then, before she came out) is now up for general consumption? The lack of a direct point of identification with a mainstream context has obviously been a way for gays and lesbians to access and get turned on by straight images, hence the reclamation of a film about furtive, impossible, heterosexual love such as Brief Encounter as a gay film, and hence the by-passing of Elvis's sexuality by those who were turned on by him but would probably never have him. It is, thus:

> important to emphasise that images work not in relation to any supposed point of reference but in their movement, in the way in which they set up lines of desire. The image is lesbian because of the way it moves me to desire and of the way in which my desire moves it.[29]

The act of spectatorship or fandom can in itself be, as I have mentioned before, performative, but the ones who are having their cake and eating it too are, in k.d. lang's case, all those who are not lesbian. The arrival of the androgynous lang with masculine undertones, therefore, has effectively legitimised the absenting of her sexuality.

lang herself seems to desire and have nurtured this heady, generalised response, cultivating a view, through her looks and her songs, that what you see is what you get. End of question. Along with the copious comparisons with excessively mainstream performers such as Cole Porter, the Gershwins, and the Marvin Gaye of 'Get it On' which have been made in discussions of lang's latest album All You Can Eat, lang's own comment that 'pop is more interesting than alternative'[30] fits into this new-found universality. Before looking at the musical and lyrical style of her last two albums, it is appropriate to draw her sexual orientation back into the debate:

> One of the reasons I came out was because I could feel that my sexuality was going to become an issue totally out of my control. By coming out I've helped lesbianism become more accepted. . . .

but when homosexuality becomes more mainstream, it tends to lose some of its cryptic mysticism, and in a sense, the alternative nature of being gay. . . . In some ways, the more acceptable it becomes, the more its beauty and oppression disappear.[31]

Here lang is implicitly drawing a comparison between her sexual openness and the redirection of her music since departing from the Nashville-dominated sound of the earlier albums; and the site for this earned acceptability is her body and image. The Dolce and Gabbana dress she wore for the Wembley AIDS benefit 'Concert of Hope' in December 1993 (which one journalist described as being 'roughly modelled on the Turin shroud'[32]) is far removed from the eclectic, irreverent clothes she wore before, and commonly elicited adjectives such as 'comfortable', 'free' or 'cool' when being described. The cryptic tension between dress and implied identity, so prevalent at the time of quiffs, Hank Snow's discarded green suit and shorn off cowboy boots, has oozed away into unchallenging uniformity. However universal her desirability is now perceived to be, watching k.d. lang is no longer fun and difficult. She has entered the realm of easy-looking.

lang, with her growing aspirations towards pop and mainstream, has also become easy listening. *Ingénue* almost died from indiscriminate over-exposure, in shops, cafés and bars precisely because, it could be argued, it was beautiful but ultimately unchallenging pop music. This album is a collection of genderless torch songs and is about lang, we are later told, finding herself in 'pure, unrequited, unconsummated love'[33] with a (lesbian) married woman. As she had not, at the time of *Ingénue*'s release, officially come out, this album could, despite being a radical departure from the earlier Country style, be viewed alongside the earlier work in terms of ambiguous sexuality and lyrics: lang is still the L-L-L-Liberace fan. If one applies to the music, however, the protestations about honesty and not needing to use disguises or be theatrical, then the major work post-*The Advocate* might be expected to show lang admitting her sexuality and not adopting masquerades to deflect or complicate the desires and attention of her audience and listeners. The huge disappointment of this album is that it, once more, is an enigmatic, vague play on implied lesbian sexuality, but without the inherent danger of the work up to *Torch and Twang* which was informed by the *actual* absence of any explicit statement by lang about her sexuality.

There is a pervasive universality glossing *All You Can Eat* which is reminiscent of Joan Armatrading's use/non-use of her sexuality; the consistent application of 'you' and 'me' in the love scenarios, and the use of

abstraction to convey personal feelings as in the wondrous 'Infinite and Unforeseen'. There is a notable lack of gender-identification on *All You Can Eat*, therefore, which sets it apart from the cowboy punk phase and is an indicator of this album's all-encompassing androgyny and lack of subversive intent, as if coming out is enough to give safe banality a radical hue. Many (taken as heterosexual) love songs, however, do not specify gender in the way one might expect and utilise similar 'me' and 'you' narratives, thus lang's strained anonymity does not denote a particularly gay or lesbian mode of address. There are hints, as one would expect, at lesbian sexuality, represented in 'Sexuality', for example, as transgressive desire:

> Come on, come on, kiss away the ones who say
> The lust you feel is wrong.
> How bad could it be, if you amuse yourself with me?
> How bad could it be, sexuality?

But there is nothing that is direct, overt, 'honest'. The closest lang comes on this album to explicitly identifying her desires and sexuality is on the tracks 'Maybe' and 'World of Love'. In both the she/she attraction is signalled, but in coyly ambiguous terms. 'Maybe' begins by adopting (as most of the album does) one convention of the love song: the 'I'/'you' form:

> Maybe I'm crazy, maybe I'm confused
> Maybe I've misconstrued, or maybe I love you.

It then replaces this convention with another: the 'I'/'her' form:

> Maybe I'll ask her, or maybe I won't.
> It could be disaster, no but maybe it won't.

'She' is obviously in these lyrics, but who 'she' is is left (presumably intentionally) equivocal, so when, directly after the repeated 'her' refrain, lang sings 'Maybe if I do, then maybe, maybe, you'll love me too' the characters of this pseudo-narrative have themselves become shadowy maybes. Who, to be pedantic, is desiring whom? 'You' or 'her'? This squirming play on the dynamics of traditional love song scenarios is irritating in that it renders opaque what could be (and usually is) clear. The slippage from direct to indirect speech is, I think, indicative of the coy malaise that hangs over *All You Can Eat*. Not the aggressive masquerade of the earlier pre-*Advocate* 'phase', but a troubling, androgynous non-specificity that extinguishes rather than promotes tension. Another track to sail close

to explicit lesbianism but which changes course for the far safer domain of myth and abstraction just in time is 'World of Love'. Here the object of desire is unambiguously a woman ('The touch of the sun was caressing her skin'), although the onlooking lover/admirer is not a person but a female 'soul' (whose is never made clear):

> Far from above the soul watched in silence,
> She dreamed of love and innocence;
> Soul thought how odd and rare this beauty,
> This creature of god that lies before me.

Again there is distance imposed here, using reported speech: the singer (lang) is not identified as the soul but rather as the absented conveyor of the soul's attraction for another. This tautologous meandering is the final signal that androgyny (as far as lang is concerned) is a poor relative of gender play.

## VEGAS

The androgynous male counterpart to lang (the anti-muscle gangliness of a performer like Jarvis Cocker) is also currently in, but remains steadfastly removed from the gender-bending antics of, for instance, the Bowie of the Ziggy Stardust period and Marc Bolan who, in their time, were similarly labelled 'androgynous'. What's around at the moment is a dilapidated, disinterested masculinity grounded in denial rather than disguise, flirting with the attraction of sickness and incapacity not outrageousness. lang's image, though mellower, is now similarly unconcerned with boundaries and difference or the moments of change, tension and confusion. Having put away her Elvis suits, she is no longer amongst the Queens of Pop and no longer signals or re-signals the space between subject and construction. lang, as I have mentioned before, has spoken of this shift in terms of it being a de-performing, as if what is currently being presented is, in its consistency, an unproblematic belief in the complementary interaction between subjectivity and performance. Thus lang's masculinised androgyny is a critical loss, and one that denies that 'identification is always an ambivalent process'[34] and necessarily and forcibly unstable. The lesbian has replaced the L-L-L-Liberace fan, but rather than coming out in a mainstream musical context lang's sexuality has remained compartmentalised and is still to be only ambiguously inferred. Perhaps the space between the notes will one day be rediscovered if lang follows the male crooners she is now most readily likened to all the way to the night spots of Las Vegas. I hope so.

## NOTES

1 *Harvest of Seven Years: Chopped and Chronicled*, Warner (1991).
2 *The South Bank Show* (LWT 1 October 1995).
3 In a 1992 television commercial on behalf of People for the Ethical Treatment of Animals lang declared, with Lulu, that most bovine of cows beside her, that 'meat stinks, and not just for animals, but for human health and the environment'.
4 Moe Meyer, 'Introduction: Reclaiming the Discourse of Camp', in M. Meyer (ed.) *The Politics and Poetics of Camp* (London and New York: Routledge, 1994), p. 1.
5 Ibid., pp. 2–3.
6 Marjorie Garber, *Vested Interests: Cross-Dressing and Cultural Anxiety* (London: Penguin, 1993), p. 11.
7 Ibid., p. 9.
8 Seymour Stein commenting on lang's look when he first saw her (*The South Bank Show* 1 October 1995).
9 Roland Barthes, *The Pleasure of the Text* (trans. Richard Miller, London: Cape, 1976), p. 14.
10 Ibid., pp. 9–10.
11 Meyer, op. cit., p. 4.
12 Judith Butler, 'Performative Acts and Gender Constitution: An Essay in Phenomenology and Feminist Theory', in Sue-Ellen Case (ed.) *Performing Feminisms: Feminist Critical Theory and Theatre* (Baltimore: Johns Hopkins University Press, 1990), p. 270.
13 Robert Sandall, *The Sunday Times* (8 March 1992).
14 Joan Riviere, 'Womanliness as a Masquerade', in Hendrik M. Ruitenbeek (ed.) *Psychoanalysis and Female Sexuality* (New Haven: College and UP, 1966), p. 213.
15 Chris Straayer, 'Redressing the "Natural": The Temporary Transvestite Film', *Wide Angle* 14(1) (January 1992), p. 36.
16 Ibid., p. 40.
17 Judith Butler, *Gender Trouble* (London and New York: Routledge, 1990), pp. 137–8.
18 Ibid., p. 33.
19 *South Bank Show* (1 October 1995).
20 *The Sunday Times* (8 March 1992).
21 *The Independent* (18 September 1995).
22 Barbara Creed, 'Lesbian Bodies: Tribades, Tomboys and Tarts', *Sexy Bodies: The Strange Carnalities of Feminism* (eds Elizabeth Grosz and Elspeth Probyn; London and New York: Routledge, 1995), p. 101.
23 lang in *The Observer* (10 September 1995).
24 Quoted in Kari Weil, *Androgyny and the Denial of Difference* (Charlottesville and London: University Press of Virginia, 1992), p. 144.
25 Ibid., p. 147.
26 Elaine Showalter, *A Literature of Their Own* (Princeton, NJ: Princeton University Press, 1977), pp. 264–5.
27 Elspeth Probyn, 'Queer Belongings: The Politics of Departure', in Grosz and Probyn, op. cit., pp. 1–18.
28 Tony Parsons, *Daily Telegraph* (12 December 1995); Veronica Lee, *Guardian* (4 October 1995).
29 Elspeth Probyn, 'Queer Belongings . . .', p. 12.
30 *The South Bank Show* (1 October 1995).
31 *Observer* (10 September 1995).
32 *The Independent* (3 December 1993).
33 *Today* (3 December 1993).
34 Judith Butler, *Bodies that Matter: On the Discursive Limits of 'Sex'* (London and New York: Routledge, 1993), p. 126.

# 12

# THE MISSING LINKS

## Riot grrrl – feminism – lesbian culture[1]

### Mary Celeste Kearney

Don't spend time confusing issues. It's scary to actually consider
how much popular publications will totally just set you off on the
wrong trails of enquiry.

(Niki from Huggy Bear)[2]

In one of the first mainstream articles written about the burgeoning
female youth culture known as 'riot grrrl', Ann Japenga argues:

To call herself a Riot Grrrl, a woman need only rally to the slogan
'Revolution Girl Style Now' and appreciate bands like Bikini Kill
and Bratmobile, whose aggressive, unpolished sound has much in
common with the early punk rockers Patti Smith, the Raincoats
and Poly Styrene of the X-Ray Spex. Indeed, the movement is
above all a triumph of punk, a genre not normally noted for its
enlightened attitude toward women. Riot Grrrls say they owe
their existence to punk's do-it-yourself ethic: if you have some-
thing to say, pick up a guitar, write a song and say it.[3]

Since the female members of punk bands such as Heavens to Betsy, Bikini
Kill and Bratmobile were the first individuals to bond together as 'riot
grrrls', Japenga's privileging of punk in the hierarchy of alternative cultural
practices and ideologies relevant to this community is certainly com-
pelling.[4] But what is not said here about riot grrrl's roots is just as, if not
more, significant. Despite her reference to several punk-associated female
performers from the 1970s, Japenga's comment about punk's unenlight-
ened gender politics constructs punk as a masculine and male-dominated
genre and thus seriously underestimates the importance of females in
early punk and post-punk music. More egregiously, however, her

positioning of punk music as the father figure for riot grrrls dismisses many other important influences on this group which make it such a powerful force for female youth today, especially feminism, the mother figure that is obscured in this skewed genealogy.

Contrary to Japenga's and most other mainstream representations of riot grrrl's community (including most academic analyses),[5] 'riot grrrl' is not just an adjective for a sub-genre of punk music, nor does it describe only a group of female punk musicians and their fans. Given the many reports that define riot grrrl in this somewhat reductive manner, it is important to remember that the writing of cultural history necessitates certain exclusions as attempts are made to define and understand disparate social events and phenomena. However, as Clifford Geertz argues, cultural analyses must involve more than the 'thin descriptions' which interpret only surface details of social phenomena.[6] If we are to fully appreciate the various influences on any one of these phenomena, then we must be willing to see beyond the most visible (and audible) cultural signifiers and to think beyond the dominant frameworks of meaning on which we have come to depend.

I believe that one way to initiate a more complex ('thick') analysis of riot grrrl is to explore the elisions that occur in popular representations of this community, elisions which provide a base from which to launch an investigation of riot grrrl's larger cultural, social and political significance. Thus, while part of my project here is to reveal how cultural critics in the mainstream media have succumbed to 'thin descriptions' of riot grrrl's multi-dimensional community, I am less interested in analysing why these narrow framings of riot grrrl have occurred (although I entertain this question to a point) than with the effects of such 'thin' representations. My goal, therefore, is not to reveal the 'true' nature of riot grrrl but to analyse the various ways riot grrrl is popularly understood – specifically, how this community has been 'made sense of' by the mainstream press in the United States – and to restore to those common-sense constructions riot grrrl's links with other anti-hegemonic movements, especially feminism and lesbian separatism.

## RECUPERATION MEDIA-STYLE: RIOT GRRRL'S EMERGENCE AND ATTEMPTED CONTAINMENT

In his highly influential work, Subculture: The Meaning of Style, Dick Hebdige expands upon John Clarke's theory of the incorporation of cultural phenomena to explore how innovative social formations such as youth cultures become diffused and, most often, defused by dominant ideology and popular culture.[7] As he observes, the mass media hysteria which

often accompanies the emergence of new styles signals that the commercial and ideological processes of recuperation have already begun, as the new phenomenon is 'codified' at the same time that its potential threat to social order is denied or placed beyond analysis.[8]

Since their emergence in 1991, riot grrrls have been approached by a number of mainstream publications and journalists wanting to tell (and sell) the story of this radical female youth culture. Following repeated misrepresentation of their community by US newspapers and magazines such as the *New York Times* and *Newsweek*, as well as British publications such as *Melody Maker*, however, riot grrrls initiated a press blackout in 1993 and now refuse to speak with or be photographed by anyone associated with the popular media.[9] As their blackout suggests, riot grrrls are profoundly aware of how easy it is for those in control of mainstream representational discourse to exploit and commodify marginalised cultures, and how difficult it is for young people today to resist the misrepresentation, co-option and containment of their particular scenes and forms of cultural expression.

This is not to say that youth cultures such as riot grrrl exist in some 'free' or 'authentic' state before the mainstream media become aware of their existence. Indeed, riot grrrls' engagement with the popular press (especially via the teen girl magazine, *Sassy*) demonstrates youth cultures' reliance on the mainstream media in order to 'get the word out' about their communities, as well as their complicity in their cultures' incorporation in dominant ideology and discourse. It is important to note, therefore, that the blackout called for by riot grrrls was not initiated until they realised that their community had become tasty (and lucrative) bait in the massive feeding frenzy for commodifiable information and cultural artefacts. By then, riot grrrls had participated (albeit not always willingly) in the documentation of their community by almost all of the major US newspapers and popular magazines.

At the same time, however, riot grrrl's relationship with the popular press seems somewhat unique since its blackout helped prevent the massive exploitation typically experienced by new social movements, especially youth cultures.[10] Moreover, riot grrrl's cultural artefacts have resisted corporate co-option by being self-produced in small quantities and sold for minimal profit or traded within the alternative community. On the other hand, as Theo Cateforis points out, the riot grrrl blackout has failed to fully curtail their misrepresentation by the press:

> The journalistic media . . . deprived of a 'live' or willing subject, has an even more flexible opportunity to construct its own version

of Riot Grrrl. . . . They can build a Riot Grrrl prototype out of such things as fanzine titles and decontextualized quotations.[11]

Unlike most media accounts of this community, riot grrrl culture is diverse and dynamic, and the movement from which it arises is especially unique in the way it has reformulated adolescent girlhood as a powerful location of cultural and political identity. Because of that ruptural difference, riot grrrl's challenges to popular notions of adolescence, femininity, youth culture and political activism have resulted in repeated attempts to contain its threat to the dominant social order. Thus, the processes of ideological and commercial recuperation engaged in by the mainstream media and experienced by marginal movements are glaringly obvious when we consider riot grrrl's repeated representation by the popular press as a cultural (rather than political) phenomenon, especially as a *musical phenomenon*.[12] This situation would be somewhat more easy to explain (and dismiss) if it were only *music critics* who represent riot grrrl this way. However, given that virtually every mainstream article on riot grrrl contextualises this large, politicised community in relation to music, I believe that more consideration should be paid to such representations as they reveal how much the mainstream media rely on certain frameworks for understanding youth cultures.

As indicated above, the popular press's myopic focus on the music emanating from this community is primarily due to the fact that riot grrrl's philosophy and practices originated with and have been most widely disseminated by bands which were and/or are associated with riot grrrl, especially Bikini Kill and Bratmobile which are mentioned in virtually every article about this community and whose members are presumed to be the group's official representatives (if not leaders).[13] However, the limited perspective which sees riot grrrl only in terms of music also results from several simultaneous phenomena occurring during the last decade which have redirected the mass media's (and corporate marketers') gaze towards heretofore marginalised groups in the mainstream music industry, primarily: the overwhelming popularity of many 'alternative' punk bands whose work is produced by independent record companies (e.g. Sub Pop, Dischord, K Records); and the increase in successful female musicians and female-centred bands (spotlighted in the media as 'women in rock'). Because riot grrrl emerged alongside and not independent of these phenomena (which are, in turn, not mutually exclusive; many popular female-centred bands are considered 'alternative'), this radical girl culture has been all too easily understood as a chapter in one or both of these larger rock narratives. Thus, riot grrrl's expansive community is often

conflated with a few bands geographically located within the punk scenes of Washington, DC and the Pacific Northwest with little consideration of how such framings delimit the popular understanding of riot grrrl's transnational community and its broader social significance.

## GRRRLS AGAINST BOYS: RIOT GRRRLS AS GIRL PUNKS AND PUNKETTES

As Roland Barthes and others have argued, one of the primary ways the threat of difference can be neutralised and/or contained in dominant ideology and discourse is through the process of exoticisation wherein the Other is placed beyond analysis through the foregrounding of its divergence from the norm.[14] We can witness such attempts at containment in the mainstream media's representation of women (and girls) entering traditionally male-dominated practices. When women attempt to become a more active and assertive part of the mainstream rock industry, for example, the potential dangers these musicians pose to the male-dominated scenes and power structures of rock (i.e. females, femininity and/or feminism) can be somewhat defused, if not dismissed altogether, when these female musicians are collectively represented by a label that places them in a position no male musician can occupy – 'women in rock'. Since rock has been constructed as a naturally masculine sphere in which women, because of their sex and gender, can never be fully incorporated, 'women in rock' implies the contingency and incompleteness of female performers, as well as their inauthenticity in comparison with male artists. In addition, this label is certainly evidence that women musicians continue to be thought of in that order – first as women and only secondarily as musicians.

Many journalists indicate a similar desire to defuse the potentially disruptive force of riot grrrl's multiple forms of cultural expression and political activism by using labels which reduce the focus of this community to the different sex and gender of riot grrrl band members and their fans. For example, although many riot grrrls consider themselves punks, the representation of riot grrrls as 'girl punks' or 'punkettes' by the press uncritically portrays all riot grrrls as punk-identified, and thus limits the popular understanding of riot grrrl's diversity. In turn, the media's use of feminine adjectives or suffixes to describe riot grrrls' punk affiliations not only reproduces the popular understanding of this genre as masculine, but, because male punk is presumed to be more authentic, delegitimates riot grrrl culture.[15] Moreover, since much of the discourse about riot grrrls as 'girl punks' and 'punkettes' reaffirms the notion of punk's inherent

masculinity, the history of women in the punk movement since its emergence in the mid-1970s is effectively effaced.

By extension, in representations of this community as 'girl punks' and 'punkettes', there is often a misinterpretation of riot grrrls' self-privileging of their gender. Thus, those who argue that riot grrrl bands have formed in reaction to the patriarchy and sexism of various punk scenes mistake riot grrrl's pro-female attitude as anti-male but nevertheless position males and masculinity as riot grrrl's *raison d'être*, a strategy which displaces discussions of female empowerment and is strongly resonant of the popular (mis)understanding of feminism's pro-woman stance as a form of 'male-bashing'.[16] Though it is true that many riot grrrls have spoken and acted in opposition to the misogyny they have experienced in certain punk scenes (and society at large), not only do prominent riot grrrl bands like Bikini Kill, Mecca Normal and Huggy Bear contain male members, but various riot grrrl performers have acknowledged their debt to male punk bands such as Fugazi, Beat Happening and Nation of Ulysses.

On the other hand, by situating riot grrrls within the realm of male punk through a focus on their aggressive, in-your-face attitude and performance style, the media reproduce the age-old narrative of female musicians as appropriating masculine forms of music-making without problematising how punk's masculinisation has been socially (re)produced or how riot grrrl performers might be using traditionally masculine genres and performance styles in order to deconstruct the gendering of music.[17] Thus, the mainstream press can effectively reduce the threat of riot grrrls' Otherness by also foregrounding their *similarity* to male punks who occupy a social position which has been successfully recuperated in dominant ideology and popular culture (a process Barthes defines as identification).[18]

## CHERRY BOMBS: RIOT GRRRL AND/AS 'WOMEN IN ROCK'

While the description of riot grrrls as 'girl punks' or 'punkettes' has been one of the primary ways of representing and containing this community, a larger framework used to represent riot grrrl is the 'women in rock' narrative. Using this particular context, riot grrrl's large community is reduced to a few female-centred bands who are then connected with a variety of female performers, connections which in turn participate in the construction of a seamless historical narrative that homogenises all female rock musicians as 'women in rock'.[19]

Though we might understand the citing of older female performers'

influence on riot grrrl as feminist attempts to rewrite history as 'herstory' by restoring artists who have been dismissed in male-dominated and male-written histories of music, we must be mindful of how such celebratory, pro-woman narratives can reproduce yet another female ghetto. We can see this type of conflation in various histories written about women in popular music, especially Lucy O'Brien's *She Bop* in which performers as diverse as Debbie Harry of Blondie, Belinda Carlisle of the GoGos and Kathleen Hanna of Bikini Kill, along with other artists like Diamanda Galas, Lydia Lunch and Polly Jean Harvey, are homogenised under the moniker 'Final Girls', a cinematic term used to describe the female adolescents who outlive everyone else, including the monsters, in horror narratives.[20] While this description is innovative in its implication that these female artists are survivors, O'Brien does not adequately address the different structures, relations, and roles (the 'horrors') these musicians were (and are) fighting against.[21] Moreover, the use of 'Final Girls' suggests that those horrors have been successfully eliminated and, by extension, that the narratives of these women have somehow come to an end.

Thus, even if we accept the placement of riot grrrl *bands* (if not their entire community) in the history of 'women in rock' as somehow justifiable, we must be mindful of how attempts to incorporate riot grrrl in such a genealogy: dismiss riot grrrl music which is not categorisable as rock; displace the influence of male musicians on riot grrrl bands; and ignore as irrelevant the non-rock musicians (both male and female) who have inspired riot grrrl performers. More egregiously, representations of riot grrrl as merely the newest chapter in the 'women in rock' narrative efface the non-musical components of riot grrrl culture at the same time that they ignore those individuals who have influenced riot grrrl but are not involved in music.

In an attempt to position riot grrrl within this 'women in rock' frame, journalists (and marketers) have often labelled more experienced female rock musicians like Joan Jett, Chrissie Hynde and Kim Gordon the 'original Riot Grrrls' and 'troop leaders' for the riot grrrl community.[22] Other writers, updating this musical history, connect (and sometimes conflate) riot grrrl bands with contemporary (mostly) female hardcore bands like Hole, L7 and Babes in Toyland.[23] (Indeed, in some of the earlier articles on riot grrrl, Courtney Love of Hole was positioned as the typical representative of this diverse community in spite of her age and her unwillingness to occupy such a role.)[24] However, since several of these female musicians have stated publicly their uneasiness with labelling themselves and their art 'feminist', and most of them have struggled for

and earned recognition and success within the corporate music industry riot grrrls so rigorously oppose, the construction of these women as riot grrrls' matriarchs obscures the political nature of riot grrrl music, as well as the extent to which this community's objectives exist beyond the boundaries of musical culture.

Of the female performers included in the more detailed historical narratives constructed to explain riot grrrl's (musical) emergence, US performers like Patti Smith, Yoko Ono and Debbie Harry, who were active in New York's pre-punk underground during the early 1970s, are often listed as major influences, as are British performers like the Slits, Poly Styrene of X-Ray Spex and Siouxie Sioux of the Banshees who gained considerable recognition during punk's peak in the UK during the late 1970s.[25] Despite the many years (and many miles) between the emergence of female punks in the 1970s and riot grrrl bands in the 1990s, each group's opposition to the status quo of the mainstream music industry (and popular culture at large) is strikingly similar. British punk in the 1970s was a response to what some saw as pop's inherent inauthenticity and rampant commercialism and rock's move in that direction via spectacular arena-filling bands like Pink Floyd. Similarly, the rise of an alternative 'indie' movement in the United States during the late 1980s was a reaction to the commercial and corporate practices and structures of mainstream rock which were increasingly dependent on perfectionist aesthetics produced by expensive technology, as well as on the slick mass-marketing of musicians across a variety of media, especially MTV.

Though it is often helpful for consumers to know the influences on new artists so that we might have a critical basis for our musical choices, many journalists who draw straight lines from the female artists of previous periods to today's bands often fail to contextualise the *differences* that exist among these musicians. For instance, rather than tease out the dissimilarities between riot grrrl bands of the 1990s and punk performers of the 1970s, many journalists uncritically lump these disparate artists together in a somewhat haphazard manner, seriously distorting the histories of both punk and riot grrrl. For example, the 'riot grrrl-as-women in punk' narratives produced by the popular press consistently ignore the fact that most of the bands to which riot grrrl musicians are compared (e.g., the Raincoats, the Au Pairs, etc.) emerged during an era considered by many to be not punk, but *post-punk*, a period in the late 1970s and the early 1980s when, as Jon Savage argues in *England's Dreaming*, music was radically inflected with the politics of gender.[26] In turn, Rough Trade's Geoff Travis argues that the independent, DIY (Do-It-Yourself) ethos thought by many to be a purely punk inspiration, actually came later in other forms of

music; 'When we started our own record label . . . it wasn't Punk but post-Punk . . . and women's music: Kleenex, the Raincoats.'[27]

In reaction to the alienation of musicians and fans via the mainstream recording industry, the independent music scenes which emerged in the UK during the late 1970s and in the USA during the late 1980s both championed the anti-corporate DIY ethos, and thus provided a supportive climate in which anyone could feel empowered to form bands and play music. The major problem with this 'women in post-punk-to-riot grrrl' trajectory, however, is that this oppositional ideology was also advocated during the 1970s by many non-punk female musicians (especially lesbian feminists) who wanted independence from the mainstream music industry.

While it is not my intention to dismiss the relevance of punk's anti-hegemonic ideology for riot grrrl, I do believe it is important to pay attention to how uncritical accounts which position punk music as the originator of the DIY ethos seriously distort the lengthy history of DIY as an anti-corporatist ideology, an ideology which grounded various leftist movements committed to creating non-alienated forms of labour and social relations long before punk emerged in the 1970s.[28]

## DO IT YOURSELF: PUNK ETHOS/FEMINIST IDEOLOGY

What needs further exploration, therefore, is why punk has become associated with the empowerment of female musicians (not to mention female youth such as riot grrrls). Certainly, this is largely due to the fact that the amateurist ethos of punk culture gave many women the confidence to perform; but punk is not the only movement which empowered women to assertively express themselves. However, because riot grrrl is primarily contextualised in relation to punk music, the DIY ethos advocated and practised by the riot grrrl community at large is most often discussed only in relation to the practices of riot grrrl's punk musicians and their fans.[29]

For instance, riot grrrl zines – which frequently contain artistic expressions and information completely unrelated to music – are most often described as fanzines, a genre of publications whose roots are usually traced back only as far as the alternative press created to celebrate punk music in the late 1970s despite fanzines' roots in a variety of groups not associated with music (e.g. the science fiction press of the late 1930s and French leftist radicals of the 1960s).[30] Such facile connections of riot grrrl's DIY ethos with punk music not only reduce riot grrrl's larger movement to its musical artefacts, but ignore the many non-musical (and

non-spectacular) components of this culture and obscure many of the political motivations behind riot grrrl's anti-hegemonic practices.

The influence of feminism on the creation of music by women during the last twenty years seriously challenges the notion that the presence of women in punk (and in riot grrrl) is primarily attributable to punk's DIY ethos.[31] As Mavis Bayton argues:

> [F]eminism has been a major force in getting women into popu-
> lar music-making. It has given women access to instruments and
> provided safe women-only spaces for the learning of skills as
> well as rehearsal and performance; it has challenged ingrained
> 'technophobia' and given women the confidence to believe that,
> like the boys, they can be music-makers rather than simply music
> fans.[32]

As feminist ideology has broken free of its predominantly political grounding and become diffused throughout mainstream society, many women have been encouraged to see 'the personal as political' and have infused their cultural practices with feminist politics.

I do not mean to suggest that the early female punk (and post-punk) performers who influenced riot grrrl were avowedly feminist; indeed, many female musicians during the 1970s were hesitant to adopt this label, either because of the negative connotations heaped upon it by the mainstream media or because they felt their cultural practices did not measure up to the earlier radicalism of the women's movement. On the other hand, however, we cannot dismiss the influence of feminist politics and ideology on these performers, as Bayton notes in her comparison of feminist music-making with other radical musical forms:

> Like punks, feminists have rewritten the rules of public perfor-
> mance. . . . They have treated their audiences differently, and gigs
> have been physically transformed. But they have done this in a dif-
> ferent way from punk bands. By speaking and singing to the
> women in the audience – by prioritizing them – feminist bands
> have challenged the traditional taken-for-granted dominance of
> men at gigs.[33]

It is somewhat troubling, therefore, that despite the many narratives that describe riot grrrl as emerging from politically conscious, female (post) punk bands like the Raincoats, riot grrrls have been celebrated by some journalists as feminist pioneers in rock, as if the twenty-odd-year history

of feminist music-making never existed. For example, in one of the first mainstream reviews of Bikini Kill, Gina Arnold argues:

> But as traditional as their political style is, Bikini Kill is a new breed of rock band, one that blends the still-relatively-unheard voice of female anger with the still-more-positive voice of politics, youth culture, and the irrepressible *esprit de punk rock*.[34]

Such characterisations of riot grrrl musicians as the first feminists in rock effaces much of the history of feminism in music at the same time that it obscures riot grrrls' incorporation of feminist politics in their non-musical endeavours.

Given the widespread popularity today of hip hop music and the increasing presence of queer performers in mainstream culture, more thought must be given to why and how (mostly) straight white female musicians such as the members of riot grrrl bands are being celebrated today as the dominant force revitalising, if not transforming, popular music, while many non-white and non-straight performers who continue to revolutionise music are relegated to the margins of mainstream musical discourse. For instance, Kim France argues:

> Regardless of the rock cognoscenti's smug dismissal of their music as uncompelling and unprofessional, bands like Bikini Kill, Bratmobile and their cohorts Heavens to Betsy and Siren have sparked a new generation's interest in feminism and reopened the discussion on women in music and the industry.[35]

While we might want to applaud the gains many riot grrrl bands have made in male-dominated punk scenes, we do well to investigate how the privileging of riot grrrls as the revolutionary musical offspring of punk reaffirms, rather than deconstructs, the popular understanding of rock's heterosexual whiteness.[36] Furthermore, we need to problematise how historical connections of riot grrrl with 'women in punk' (and 'women in rock') are used to separate and distance these young musicians from other politicised forms of music-making, especially lesbian womyn's music which has had a traditionally antagonistic relationship with rock. What I want to argue, therefore, is that we can better understand the complexities of riot grrrl if we look beyond the conventional frameworks provided for us by the media (e.g. 'women in rock', 'punk', etc.) to other politicised ideologies and forms of cultural practice which also influence this radical female youth culture.

## SISTERS DOING IT FOR THEMSELVES: RIOT
## GRRRLS AND LESBIAN SEPARATISTS

While many representations of riot grrrl in the mainstream press note this community's ties to feminism and several make a more specific reference to its connections with the radical feminism that was dominant in the early years of the 'second wave' women's liberation movement, few go so far as to link riot grrrl's pro-female ideology and DIY, separatist practices with the lesbian womyn's community which grew out of feminism's radical wing during the 1970s.[37] Indeed, Val Phoenix is the only journalist to explicitly relate these two groups and their similar forms of cultural and political expression. As she notes in her article, 'From Womyn to Grrrls: Finding Sisterhood in Girl Style Revolution', both the riot grrrl and lesbian womyn's communities advocate and practise: an assertive pro-female stance; a radical opposition to patriarchy, misogyny and homophobia; the creation of safe havens where girls and women can gather and express themselves; grassroots organising strategies; and alternative forms of production strongly informed by the DIY ethos.[38] Considering the tremendous influence music has had on the formation and popular understanding of both riot grrrl and the lesbian separatist community (not to mention most cultures), it is not surprising that Phoenix frames her comparison of these diverse groups through descriptions of their musical styles and interviews with their musical 'leaders' (Kathleen Hanna and Alix Dobkin respectively).

Womyn's music, like the larger lesbian-feminist culture of which it is but a part, was and is inspired by a feminist ethos of transformation. The separatist ideology of womyn's music is particularly resonant of the pro-woman ideology of early radical feminism which inspired many women to resist assimilating in male-dominated society and to create alternative institutions, relations and forms of cultural expression separate from the mainstream. As Bayton argues:

> Excluded from the mainstream (male) rock world, 1970s feminists created an alternative musical world of their own. This world offered the chance to rewrite the rules: of lyrics, of band membership and organization, of the gig, of the stage, and even of the music itself. Feminists enthusiastically and optimistically promoted alternative values: collectivism and co-operation instead of competitive individualism; participative democracy and equality instead of hierarchy.[39]

In an attempt to create a form of music distinct and separate (i.e. 'feminine') from male-dominated rock, folk music (a genre with long-standing ties to politicised music-making) became the standard fare for womyn's musicians of the 1970s. Early womyn musicians such as Cris Williamson, Holly Near and Meg Christian tapped into a huge population of women who were looking for a music that not only spoke of their experiences, needs and desires, but one which was completely dissociated from the patriarchal and misogynist mainstream culture industries.

Playing different music was not the only agenda for feminists wanting to create a culture separate from the patriarchal mainstream, however. In addition to advocating a different form of music, lesbian separatists felt it was both culturally and politically necessary that the structures and systems of recording, distributing, marketing and consuming womyn's music be equally free of the taint of masculinity, male-domination and misogyny. In order to accomplish this agenda, several feminist recording studios emerged in the early 1970s: for example, Wax Records which released the first out lesbian album in 1972 (Alix Dobkin's *Lavender Jane Loves Women*); Redwood Records which was started by Holly Near in her home in 1973 (but was never a separatist endeavour); and Olivia Records which was launched in 1973 and is, perhaps, the most famous and longest-lasting of lesbian separatist businesses.

The feminist DIY approach to music and musicians of these women-run businesses was unusual in comparison to the major recording companies, and not only because of their focus on women musicians. Like other institutions and businesses formed via radical feminism's pro-women/anti-corporatist ideology, these feminist studios made a commitment to involve women who were not normally encouraged in the male-dominated mainstream music industry. As Olivia Records' co-founder Judy Dlugacz indicates:

> We started because we were political. We had a whole game plan as to how we were gonna change the world. What we were trying to do was reach as many women as possible with the concept of woman-identification, of relying upon yourself, of seeing yourself as primary and women as primary and considering other possibilities to heterosexuality, heterosexism, and sexism.[40]

The success of Olivia Records and its recording artists in the lesbian separatist community has been staggering, especially in establishing womyn's music as a distinct musical genre and contributing to the DIY ethos that has grounded womyn's culture for over twenty years. Indeed, Olivia

Records is said by many women to have been the inspiration for their own involvement in feminist music-making. (For instance, Boden Sandstrom, co-founder of Women Sound Inc., now City Sound Productions, has indicated that her inspiration to begin a women-run sound company came from watching Dlugacz mix sound at an Olivia concert.)[41] In turn, the emergence of feminist music companies such as Olivia Records coincided with the beginning of feminist music workshops and festivals (e.g. the National Women's Music Festival and the Michigan Womyn's Music Festival) which were formed to support feminist artists and the lesbian-feminist community at large.[42]

Despite the significance of Olivia Records, Women's Sound Inc. and other women-run musical enterprises in the creation and maintenance of a separate womyn's culture (indeed, many of these companies and festivals are still in existence), their place in feminist, women's and musical history is most often ignored. For example, as Gillian Gaar notes in *She's a Rebel*, when feminist artists like Tracy Chapman, Melissa Etheridge, Suzanne Vega and Michelle Shocked experienced mainstream success in the 1980s as part of the 'neo-folk' phenomenon, there was little acknowledgement by either these musicians or the media of the role womyn's music played in setting the stage for later feminist music-making.[43]

These elisions of lesbian womyn's music from the representation of feminist performers in popular music are repeated in mainstream constructions of riot grrrl's musical history as punk. Though Phoenix's article is an exception to the dominant 'riot grrrl-as-punk' narrative, there is no doubt that the erasure of the link connecting riot grrrl bands with womyn's music has been largely due to the popular understanding of the former type of music as punk and the latter as folk, as well as to the homophobia still prevalent in our society. Moreover, the erasure of womyn's music from the musical history of riot grrrl is due as much to the independent, non-commercial practices of womyn musicians which have kept them out of the public eye, as it is to the fact that punk, since its emergence, has been recuperated into dominant ideology and commodified in popular culture to such an extent that punk now exists as a readily available framework for use in such cultural comparisons.

In focusing on the representations of riot grrrl in the mainstream press, however, I do not want to dismiss as inconsequential or irrelevant riot grrrls' own participation in the framing of their community in relation to particular musical styles and scenes. Thus, we do well to ask why riot grrrls might choose to describe themselves as primarily 'punks' rather than 'feminists'. While I believe that the answer to this question is largely due to the changing face of feminism over the last twenty years, it also is due

in part to the radical queering of punk (as well as the radical punking of feminist music) in the last decade.

## MOSHING AT MICH: QUEERCORE CONFRONTS WOMYN'S MUSIC

In her article on feminist musical practice, Mavis Bayton notes that the question of what type of music should be performed by feminists 'is an interesting manifestation of the wider contradiction within feminism of, on the one hand, wanting to do what men do, and, on the other, wanting to create something altogether different, which expresses women's "femaleness"'.[44] With the incorporation of radical critical theory in popular culture in the last twenty years (especially the various strands of postmodernism and post-structuralism), political ideologies based on essentialist notions of identity and difference have been strongly challenged. We can witness the effect of those challenges in contemporary articulations of feminist ideology, particularly in the music-making of young feminists such as riot grrrls. Revealing the multi-faceted (and often contradictory) nature of subjectivity, experience and desire, the songs and performance styles of these musicians – although strongly informed by radical feminist ideologies of alternative musical performance and production – reveal less of an attempt to celebrate 'femaleness' via the rigid gender dualism advocated by radical feminists than an attempt to show how genders are socially constructed. Thus these young feminist performers demonstrate that adopting a pro-woman stance does not mean that feminists must rely on a dualistic system of identity that requires the rejection of males and traditionally masculine attributes for the celebration of females and femininity.

The ongoing debate of what music qualifies as womyn's music came to a sharp head in 1994 at the Michigan Womyn's Music Festival when Tribe 8 became the first punk band to perform there since the Contractions made a disastrous appearance in 1981.[45] Many women attending the festival were uncomfortable with the woman-on-woman violence believed to characterise Tribe 8's music and lifestyle, and, thus, were a bit put off by the band's self-description in the festival directory as 'San Francisco's own all-dyke, all-out, in-your-face, blade-brandishing, gang-castrating, dildo-swingin', bullshit-detecting, aurally pornographic, Neanderthal-pervert band of patriarchy-smashing snatchlickers'.[46]

Tribe 8's aggressive music and performance style directly confronts the 'political correctness' often associated with lesbian feminists and their culture. Indeed, Tribe 8's song 'Neanderthal Dyke' foregrounds many

young women's discomfort with the proscriptive nature of feminist/lesbian ideology ('my political consciousness is fried/and i'm not exactly woman-identified') at the same time that it speaks to the problem of infusing the traditionally folk style of womyn's music with more bold genres like punk ('Will it play at Michigan? Is it correct?').[47] However, rather than divide the Michigan crowd, as had the last punk band which played there thirteen years earlier, Tribe 8's band of queer punks not only brought together the various factions of Michigan's heterogeneous group (indeed, Alix Dobkin, who is widely hailed as the 'mother of womyn's music', stage-dived during their performance), but opened a forum to discuss the relevance of louder, in-your-face genres of music and s/m lifestyles within the lesbian community.[48] Evelyn McDonnell sums up her take on the 'Tribe 8-at-Michigan' experience this way:

> If Michigan's mixture of women provides a petri dish of feminism in action . . . then Tribe 8's success also says larger things about the future of the movement. Most women at Michigan welcomed the new angry, aggressive, sexually permissive feminists. More and more young women are neither afraid nor ashamed to call themselves feminists or lesbians. . . . Their tactics may be different, their music louder, but they are pushing the fight forward.[49]

In spite of the coterminous emergence in the United States of riot grrrl and queercore bands like Tribe 8, Random Violet, The Mudwimmin and Team Dresch, there have been relatively few links made by the mainstream press between lesbian feminism, queercore and riot grrrl.[50] In somewhat obvious attempts to distance this radical female youth culture from the taint of homosexuality, the press most often confine their discussions of riot grrrl's relationship with lesbianism to this community's appropriation of the practices and style of queercore. For example, in an early article on riot grrrl for the *L.A. Weekly*, Emily White represents queercore zines as the ancestors of riot grrrl zines without making the connection that some riot grrrls were (and/or are) participants in the queer punk scene. Instead, she uncritically portrays riot grrrls as (straight) outsiders who appropriated queercore cultural practices for their own purposes: 'The angry-girl zines, coming in homocore's wake, took advantage of an intact, politically fertile community to spread their own message. In many ways the angry-girl genre owes its existence to punk homocore zines . . . '[51]

Discursive formulations which position riot grrrl as emerging after and apart from the queercore scene help to reproduce the popular understanding of riot grrrl's members as predominantly straight.[52] Thus, while

'girl love' is advocated continuously in riot grrrl music, zines, videos and drawings, its more obvious meaning – lesbianism – has been downplayed, if not outright ignored, in mainstream accounts of this all-girl community. In an attempt to situate riot grrrls within the larger narrative of homosocial girl cultures, some journalists contextualise the riot grrrl notion of 'girl love' as a form of childish play rather than adult sexuality, while others efface the possibility of any homosexual desire or activity amongst riot grrrls by foregrounding the place of boys and heterosexuality in this community. For example, Lauren Spencer asserts, 'And make no mistake: Most Riot Grrrls still find boys useful for the usual teenage things.'[53] In using such rhetorical strategies, the press effaces the lesbian subjectivity and desire many riot grrrls are learning to embrace assertively as their own.

But certainly there *are* connections between lesbianism, queercore and riot grrrl, as Tribe 8's assertion, 'I read Kathleen Hanna', in 'Neanderthal Dyke' clearly attests.[54] As Phoenix notes, 'For some queer women, Riot Grrrl provides a refuge from a homophobic punk scene and a conformist gay culture.'[55] McDonnell makes a more explicit connection by labelling both lesbian punk bands and riot grrrl musicians 'punk feminists', noting that 'an increased feminist consciousness has arisen within the ranks. . . . [Punk feminist bands like Tribe 8 and Bikini Kill] come from a strongly feminist perspective, even when challenging what that means.'[56] In their recent text, *The Sex Revolts*, which explores the gendering of popular music, Simon Reynolds and Joy Press describe this punk challenge to feminism as 'postfeminist'.[57] Though I do not agree with their use of this term (its implication being that feminism is somehow archaic or has accomplished all its objectives), I do think that the emergence of radical young women such as those in riot grrrl and queercore are indicative of a new phase of feminist politics and ideology.

While the myths of 'postfeminism' perpetuated by the mainstream press efface not only the number of young people drawn to feminism today, but the relevance of feminism in the 1990s, the political activism of young feminists like riot grrrls reveals that many issues important to the 'second wave' have not been resolved, while other new issues need attention. In a society which has finally acknowledged, if not adequately eliminated, its problems with misogyny, homophobia, racism and, to a lesser extent, classism and ageism, the newest generation of feminists is dealing with issues barely foreseen during the women's liberation movement of the 1970s when liberal feminist concerns focused on establishing women's equality with men in the public sphere, and separatist feminists struggled to create an alternative culture by adhering to a pro-woman, DIY

ethos. In addition to 'older' feminist concerns such as women's reproductive rights, therefore, young feminists are actively involved in political issues like environmentalism, AIDS awareness, affirmative action and youth rights. In turn, members of feminism's younger generation are actively using various media and new technologies – especially the Internet – for their own political interventions, a move which indicates the extent to which activism has taken on different forms in the last decade.

So, the question is not so much 'Is the younger generation feminist?' as much as 'How is the younger generation feminist?' Often highly critical that 'second wave' feminism operated like a fundamentalist religion with prescriptions on how to dress, behave and think, young feminists such as riot grrrls are infusing feminist politics with forms of confrontational cultural activism which rely less on exposing gender differences than on deconstructing them. In turn, the incorporation of queer politics and theory in feminism has been largely responsible for refocusing discussions of gender and sexuality in provocative new ways.

Although it is not completely clear whether riot grrrls have injected feminism with the in-your-face, anti-corporatist attitude of the punk underground, or injected punk with the pro-woman, anti-sexist attitude of radical feminism, it is certainly apparent that riot grrrl's unique contribution, beyond their particular form of music-making, spreads much further than the mainstream press would have us believe.

## CONCLUSION: REVOLUTION GRRRL-STYLE

While the contextualisation of riot grrrl as a musical phenomenon by the media reflects an attempt to incorporate riot grrrl within popular frameworks for understanding (female) youth cultures, such representations more significantly reveal the desire to not speak about riot grrrl as a radical political community. Instead, riot grrrls are represented as 'women in rock' or 'girl punks' so that their difference can be naturalised and their culture more quickly commodified through purchasable products. Moreover, the reductive constructions of 'riot grrrl-as-punk' makes it easier to contain the feminist rage of this radical community by commodifying it as just another anarchic pose of youth like that marketed by master punk promoter Malcolm MacLaren and, more recently, MTV. Riot grrrl becomes threatening, therefore, only when its members publicly refute these framings of their group and demand that the rest of us rethink the social, cultural, economic and political power of female youth.

In 1980 Angela McRobbie articulated her hopeful prediction of future girl cultures:

To the extent that all-girl subcultures, where the commitment to
the gang comes first, might forestall [the search for boyfriends]
and provide their members with a collective confidence which
could transcend the need for 'boys', they could well signal an
important progression in the politics of youth culture.[58]

Formed to express rage and ignite action in female youth, riot grrrl has
become the community McRobbie dreamed of over fifteen years ago. By
providing girls with a collective confidence, riot grrrl's revolutionary
counter-culture and radical political activism empower female youth to lib-
erate themselves from the rampant commercialism, misogyny, ageism,
racism and homophobia they experience in their everyday lives. Indeed,
the in-your-face political activism of riot grrrls – whether marching in
feminist rallies, boycotting psychiatric institutions, volunteering at Rock for
Choice concerts, sponsoring self-defence workshops or organising gay
youth groups – indicates that this community is a significant progression
not only in the politics of youth, as McRobbie predicted, but in the poli-
tics of feminism as well.[59]

## NOTES

My thanks to the young women who shared with me their zines, music and videos and
talked with me about the riot grrrl community, especially Miranda July whose commitment
to creating alternative forms of cultural expression has inspired me greatly.

 1 This chapter is an extension of arguments made in 'Riot Grrrl: It's Not Just Music, It's
   Not Just Punk', *Spectator* 16(1) (Fall 1995).
 2 Niki, quoted in Amy Raphael's *Grrrls: Viva Rock Divas* (New York: St Martin's Griffin,
   1996), p.161.
 3 Ann Japenga, 'Punk's Girl Groups Are Putting the Self Back in Self-Esteem', *The New York
   Times* (15 November 1992), p. H30.
 4 The female members of Heavens to Betsy, Bikini Kill, Bratmobile, Kreviss, Tiger Trap,
   7 Year Bitch and Mecca Normal united as 'riot grrrls' during Girls' Night at the
   International Pop Underground convention held in Olympia, WA, during the summer
   of 1991.
 5 For example, see Joanne Gottlieb and Gayle Wald, 'Smells Like Teen Spirit: Riot Grrrls,
   Revolution and Women in Independent Rock', *Microphone Fiends: Youth Music and Youth
   Culture*, eds Andrew Ross and Tricia Rose (New York: Routledge, 1994), pp. 250–74,
   and Simon Reynolds and Joy Press, 'There's a Riot Going On: Grrrls Against Boy-Rock',
   *The Sex Revolts: Gender, Rebellion and Rock 'n' Roll* (Cambridge: Harvard University Press, 1995),
   pp. 323–31. Both of these texts frame riot grrrl as a primarily musical phenomenon.
 6 Clifford Geertz, *The Interpretation of Cultures* (New York: Basic Books, 1973).
 7 Dick Hebdige, *Subculture: The Meaning of Style* (London: Routledge, 1979), pp. 94–6. See
   also John Clarke's 'Style', *Resistance through Rituals: Youth Subcultures in Post-War Britain*, eds
   Stuart Hall and Tony Jefferson (London: Harper Collins, 1976), pp. 185–9.
 8 Hebdige op. cit. See also Roland Barthes, *Mythologies*, trans. Annette Lavers (New York:
   Noonday Press, 1972), p. 152. Though Sarah Thornton correctly argues that youth
   subcultures are always engaged in a complex *pas de deux* with the various media, and is

right to point out how academics often reproduce uncritically a division between youth cultures and the media, I believe that she is a bit too optimistic about the political, ideological and economic effects of mainstream press coverage on marginalised cultures. See 'Moral Panic, the Media and British Rave Culture', *Microphone Fiends*, pp. 176–92.

9 Some riot grrrls have willingly dialogued with journalists of alternative publications, however. See, for example, Melissa Klein's 'Riot Grrrls GoGo' *off our backs* 23(2) (February 1993), pp. 6–12, and Angela Johnson's 'Start a Fucking Riot', *off our backs* 23(5) (May 1993), pp. 6–10. Some riot grrrls have also participated in Raphael's text, Hillary Carlip's *Girl Power: Young Women Speak Out!* (New York: Warner Books, 1995), and *Listen Up: Voices from the Next Feminist Generation*, ed. Barbara Findlen (Seattle: Seal Press, 1995).

10 Since the riot grrrl media blackout in 1993, the only articles on riot grrrl in the USA have appeared either in more 'alternative' publications such as *off our backs* and *Deneuve*, or mainstream publications such as *The Los Angeles Times* which have printed articles proclaiming the death of riot grrrl. See Ann Japenga's 'Grunge 'R' Us: Exploiting, Co-Opting and Neutralizing the Counterculture', *The Los Angeles Times Magazine* (14 November 1993), p.26, and Lorraine Ali's 'The Grrls Fight Back', *The Los Angeles Times* (27 July 1995), p. F1.

11 Theo Cateforis, 'Riot Grrrls: Punk Rock's New Resistance?' Unpublished paper (Chicago, IL: Popular Culture Association/American Culture Association annual meeting, 1994).

12 The contextualisation of riot grrrl as a cultural (rather than political) phenomenon is apparent in the placement of articles about this community in the 'lifestyle' sections of mainstream newspapers and magazines which are popularly coded as feminised spaces of cultural trends, gossip and consumerism (as opposed to the 'news' sections which are widely thought to contain 'real' politics and 'serious' information). However, a few writers have attempted to understand riot grrrl as a community that exists beyond the frame of music, especially Emily White. See 'Revolution Girl Style Now', *L.A. Weekly* (10–16 July 1992), pp. 20–8.

13 While several journalists conflate this large community with a few of its bands (e.g. Reynolds and Press who uncritically reduce riot grrrl's community to Bikini Kill and Huggy Bear, and Christopher Napolitano, 'Rock Girls', *Playboy* 41(11)(November 1994), pp. 102, 104, many music critics attempt to identify every riot grrrl band in existence. See, for example, Sally Margaret Joy, 'Revolution Grrrl Style Now!' *Melody Maker* (10 October 1992); Kim France, 'Grrrls at War', *Rolling Stone* 660–661 (8–22 July 1993); Charles Aaron, 'A Riot of the Mind', *Village Voice* 38(5) (2 February 1993).

14 Barthes, op. cit., p. 152.

15 For example, see Elizabeth Snead, 'Feminist Riot Grrrls Don't Just Wanna Have Fun', *U.S.A. Today* (7 August 1992), p. 5D. Cateforis's essay contains an excellent analysis of how the media delegitimates riot grrrl as an inauthentic form of punk rock resistance.

16 Unfortunately, though such constructions repeatedly emphasise riot grrrl's reactionary stance to the male-dominated punk and hardcore scenes, they usually fail to identify the specific male bands and male-dominated scenes against which riot grrrls are allegedly reacting.

17 For example, Lauren Spencer describes punk as 'high testosterone' and riot grrrl as a movement that allows girls to include their femininity in this type of music. 'Grrrls Only', *The Washington Post* 116 (3 January 1993), p. C1.

18 Barthes, op. cit., p. 151.

19 Though the 'women in rock-to-riot grrrl' narrative is more typical in mainstream representations of this community, 'riot grrrl' seems to have become the new moniker for more assertive female performers. For example an *Entertainment Weekly* article labels Alanis Morissette 'The Quiet Riot Grrrl', while Amy Raphael's recent text on rock divas – significantly titled *Grrrls* – contains twelve chapters on contemporary female rock

musicians, only one of which is on a riot grrrl band. See Chris Willman, 'The Quiet Riot Grrrl', *Entertainment Weekly* 318 (15 March 1996), pp. 30–3; Raphael, 'Huggy Bear', *Grrrls*, pp. 146–72.

20  Lucy O'Brien, *She Bop: The Definitive History of Women in Rock, Pop and Soul* (New York: Penguin Books, 1995), p. 131.

21  O'Brien somewhat misuses the metaphorical figure of the Final Girl by dismissing Carol Clover's argument that, in order to survive a slasher film, the Final Girl must strip herself of her feminine attributes and take on masculine characteristics. As accomplished by women who often put on their femininity with a vengeance, the gender-troubling of riot grrrl musicians and previous female punk performers is far more complicated than that suggested by the Final Girl. See Clover's *Men, Women, and Chain Saws: Gender in the Modern Horror Film* (Princeton: Princeton University Press, 1992), pp. 35–41.

22  BMG Music Service catalogues, 1994; Aaron, op. cit., p. 63.

23  See Elizabeth Wurtzel, 'Girl Trouble', *New Yorker* 68 (29 June 1992), pp. 63–70; Kim France, 'Angry Young Women', *Utne Reader* 53 (September–October 1992), op. cit., pp. 24, 26; O'Brien, op. cit., pp. 158–71.

24  See Spencer, op. cit., p. C1, as well as Faria Chideya (with Melissa Rossi and Hannah Dogen), 'Revolution, Girl Style', *Newsweek* (23 November 1992), p. 84. YM magazine reproduced the 'Courtney-as-riot grrrl' myth with its report on Love's altercation with Kathleen Hanna last year in a story entitled 'Real-Life Riot Grrrls' (April 1996), p. 85.

25  See especially Gottlieb's and Wald's and Reynolds's and Press's account of riot grrrl's musical roots.

26  Jon Savage, *England's Dreaming: Anarchy, Sex Pistols, Punk Rock and Beyond* (New York: St Martin's Press, 1992), p. 418.

27  Geoff Travis quoted by Savage, op. cit., p. 515.

28  As Greil Marcus has brilliantly demonstrated, the roots of DIY as an alternative, counter-cultural and anti-corporate/-commercial ethos are not to be found in punk, but among the French leftist intellectuals of the 1950s and 1960s who advocated individual responsibility for revolution. See *Lipstick Traces: A Secret History of the Twentieth Century* (Cambridge: Harvard University Press, 1989). I would argue that the DIY ethos is also connected to what the French call *la perruque*, an anti-industrial practice in which a worker appropriates company resources (e.g. work time, materials, postage, etc.) for the creation of personal work (what Marx referred to as 'praxis' or 'self-activity'). See Michel de Certeau, *The Practice of Everyday Life*, trans. Steven Randall (Berkeley: University of California Press, 1984), pp. 25–6.

29  Japenga seems especially fond of this reductive narrative. For example, in her earlier article on riot grrrl, she argues, 'Adhering to punk's do-it-yourself ethic, they started recording cassettes in home studios or releasing 45's on small labels' ('Punk Girl Groups . . .' p. H30). In an article on Olympia, Washington's alternative scene, Japenga writes, 'One way [Kevin] Dolliff fends off homogenization is by adhering to an ethic invented by the punks: Do it yourself, or D.I.Y.' (Grunge 'R' Us', p. 45).

30  For a history of pre-punk fanzines, see Frederic Wertham, *The World of Fanzines: A Special Form of Communication* (Carbondale: Southern Illinois University Press, 1973).

31  In turn, we must be mindful that feminism was not the only politicised ideology to enter rock during the 1970s. In the UK, for example, race became perhaps an even more important issue around which to rally, as the success of the Rock Against Racism movement attests. While the influence of African-based music is certainly more apparent in British punk and post-punk bands of the 1970s and 1980s than in contemporary punk sounds, we should not dismiss the effect of African-based music on any youth culture. Thus, the influence on riot grrrl by rap artists who emerged in the hip hop scene during the late 1980s and early 1990s (especially assertive female rappers like Salt 'n' Pepa, MC Lyte, Queen Latifah and Yo Yo) calls for further exploration.

32  Mavis Bayton, 'Feminist Musical Practice: Problems and Contradictions', *Rock and Popular Music: Politics, Policies, Institutions*, eds Tony Bennet, Simon Frith, Lawrence Grossberg, John Shepherd and Graeme Turner (London: Routledge, 1993), p. 191.

33  Bayton, op. cit., p. 181.

34  Gina Arnold, 'Bikini Kill: "Revolution Girl-Style"', *Option* 44 (May–June 1992), pp. 44–5.

35  France, 'Grrrls at War', p. 23.

36  It is important to note that riot grrrls themselves are partly responsible for perpetuating the white punk framing of their group. Certainly, the 'riot grrrl-as-punk' contextualisation is due in part to the fact that those who have been given the privilege to speak on behalf of the riot grrrl community are the white members of riot grrrl's most prominent bands who have much at stake in perpetuating the notion that punk is the music of choice in this community. Although some riot grrrl performers have attempted to draw attention to the racism within their predominantly white group by directing others to read books by various feminists of colour, there appears to be little encouragement to listen to music by women (or men) of colour.

37  Both White (op. cit., p. 26) and Simon Price ('Rebel Grrrls', *Melody Maker* 6 March 1993, p. 30) connect riot grrrl with the ideology and practices of 1970s radical feminists.

38  Val C. Phoenix, 'From Womyn to Grrrls: Finding Sisterhood in Girl Style Revolution', *Deneuve* (Jan–Feb 1994), pp. 40–3. Gillian G. Gaar also suggests a connection of riot grrrl's 'feminist-punk' bands with womyn musicians, but does not make a broader connection between the two communities from which these musics arise. See 'Women in Rock '92', *The Advocate* 620 (12 January 1993), p. 77.

39  Bayton, op. cit., p. 179.

40  Judy Dlugacz quoted by Phoenix, p. 41.

41  Gillian Gaar, *She's a Rebel: The History of Women in Rock & Roll* (Seattle: Seal Press, 1992), pp. 144–5.

42  Karin Quimby's 'Notes for a Musical History of Lesbian Consciousness' (unpublished paper, University of Southern California, 1995) provides an excellent analysis of how these festivals have helped form a lesbian popular memory.

43  Gaar, op. cit., p. 378.

44  Bayton, op. cit., p. 186.

45  Gretchen Phillips, 'I Moshed at Mich', *Rock She Wrote: Women Write about Rock, Pop, and Rap*, eds Evelyn McDonnell and Ann Powers (New York: Delta, 1995), p. 85. Originally published in *The Village Voice* (6 September 1994).

46  Evelyn McDonnell, 'Queer Punk Meets Womyn's Music', *Ms.* (November/December 1994), pp. 78–9. In light of the Michigan crowd's initial difficulty with yet ultimate acceptance of a punk band at a womyn's festival, it is both ironic and unfortunate that at a riot grrrl convention held one year later in Los Angeles, folk singer Madigan cut her acoustic performance short since she felt the audience was more anxious to hear a 'loud rock' band.

47  Tribe 8, 'Neanderthal Dyke', *Fist City* (Alternative Tentacles Records, 1995). Tribe 8's most biting critique of traditional womyn's music and lesbian culture appears in 'Manipulate' (also from *Fist City*), a song in which the band members collectively sing off-key to Johanna Lee's 'Women's Love' whose lyrics ('women's love it's so friendly/women's love like herbal tea') are quickly bulldozed over by wailing guitars, hammering drum beats, and Lynn Breedlove's punk rantings about her obsessions with sadism.

48  McDonnell, op. cit., p 82.

49  Ibid.

50  In turn, Mark Fenster indicates that the representations of queercore that appear in the more mainstream gay publications have a history of dismissing the presence of lesbians

in the queercore culture. 'Queer Punk Fanzines: Identity, Community, and the Articulation of Homosexuality and Hardcore', *Journal of Communication Inquiry* 17 (1) (Winter 1993), p. 87. While Fenster is referring specifically to gay magazines, recent texts such as John Gill's *Queer Noises: Male and Female Homosexuality in Twentieth-Century Music* (Minneapolis: University of Minnesota Press, 1995) and the anthology *Queering the Pitch: The New Gay and Lesbian Musicology*, eds Philip Brett, Elizabeth Wood and Gary C. Thomas (New York: Routledge, 1994) are also without discussion of lesbians in punk today. (Though Gill discusses queercore, his focus is mainly on queer male bands/performers.)

51  White, op. cit., p. 27.

52  Interestingly, the histories of riot grrrl and queercore in England are reversed, with queercore emerging after riot grrrl. See Raphael, op. cit., p. xxix; O'Brien, op. cit., p. 265; and Gill, op. cit., pp. 168–9.

53  Spencer, op. cit., p. C2.

54  Tribe 8, 'Neanderthal Dyke', *Fist City*.

55  Phoenix, op. cit., p. 40.

56  McDonnell, op. cit., pp. 79–80.

57  Reynolds and Press, op. cit., p. 324.

58  Angela McRobbie, 'Settling Accounts with Subcultures: A Feminist Critique', *On Record: Rock, Pop, and the Written Word*, eds Simon Frith and Andrew Goodwin (New York: Pantheon Books, 1990), p. 80. Originally published in *Screen Education* 39 (Spring 1980).

59  For a more detailed discussion of riot grrrl's connections with radical feminist political ideologies and practices, see my article '"Don't Need You". Rethinking Identity Politics and Separatism from a Grrrl Perspective', *Subdivisions: Youth Culture and Identity*, ed. Jonathon S. Epstein (Cambridge, MA: Blackwell, 1997) (forthcoming).

# 13

# 'REBEL GIRL, YOU ARE THE QUEEN OF MY WORLD'

## Feminism, 'subculture' and grrrl power

### Marion Leonard

The year 1991 saw the growth of 'riot grrrl' in the USA. This feminist network grew out of the underground music communities of Olympia, Washington and Washington, DC. The original idea was promoted by the members of the bands Bratmobile and Bikini Kill, who voiced the idea of girls and women asserting themselves through underground music. The aim of this chapter is not to offer an incontestable version of riot grrrl but rather to give a series of impressions by detailing the words and activities of some of the girls and women who were involved. Whilst interpretation of these activities will be offered, this chapter wishes to deconstruct the roles of activist and theorist, and query the practice of considering these terms as isolated from one another. The chapter will explore how information about this network was disseminated via different media in order to problematise the way in which subcultures have previously been situated by theory and understand how riot grrrl offers a fresh challenge to academic exploration.

## CONTEXT

The time at which riot grrrl emerged and its promotion by 'indie' musicians is not without significance. The high profile of artists such as Babes in Toyland, L7 and Kim Gordon of Sonic Youth and Free Kitten illustrates the increasing visibility of female performers in this musical genre, whilst the signing of Hole by Geffen records, reportedly for the largest amount ever paid for a female-centred band, demonstrates the increasing public presence of 'women in rock'. The increasing voice of feminism within rock music was signalled by the foundation of a number of organisations by female musicians. Exene Cervenka of the band X, along with the rock promoter Nicole Panter, founded the 'Bohemian Women's Political

Alliance', aimed at promoting sexual awareness, feminism, organising voter registration, recommending candidates and organising benefits. In defence of reproductive rights, L7 and Sue Cummings, associate editor of *LA Weekly*, helped to implement Rock for Choice benefits. Supported by the Feminist Majority Foundation and Fund, concerts were organised across the USA 'to encourage audience members to educate themselves, speak out, register to vote and learn what they can do to protect their right to abortion and birth control'.[1] In 1993 a small group of women in New York formed Strong Women in Music (SWIM) 'to discuss their roles as women in the music community, and work out possible group solutions/supports/actions to problems that women have previously had to deal with on an individual basis'.[2]

The activities of riot grrrls should be situated within this context but also invite connections to be drawn with other groups. An obvious link may be made with the 'queercore' movement within 'underground' music. Performers such as Huggy Bear and Bikini Kill specifically link themselves with this movement, stating 'punkrock is a queer scene/punkrock is queercore a call to the multi trajectorised sex'.[3] This identification is made by many 'zine' writers who discuss issues such as lesbian visibility, include accounts of how girls 'came out' as lesbian and promote queercore bands.

## TERMINOLOGY

In the many journalistic pieces given over to riot grrrl, several terms emerge. Some writers chose to describe an identifiable collective: the *New York Times* referred to riot grrrl as a 'scene' (Japenga, 1992: 30) whilst *USA Today* detailed 'an underground group of punkettes' (Snead 1992: 5D). More common were the descriptions of a new 'movement' (found in American publications such as *Fiz* and *LA Weekly* and British magazines such as *Select* and *The Zine*) and the term 'network' (which appears in several articles including the coverage by *Crack DC*, *Lime Lizard* and *Elle*). Publications produced by those involved in riot grrrl reveal a similar range of collective terms. A zine produced by a New York group of riot grrrls illustrates how differing descriptions are encouraged and valued. A selection of quotes in this zine offers a variety of definitions of riot grrrl as 'a support network' (Polly O), 'a state of mind' (S.W.), 'a group of women (grrrls) who work together' (Elena) and 'a community of cooperative young women' (Sandra) (*Riot Grrrl* #5, NYC:1–2,21). This chapter will adopt the term 'network' to refer to riot grrrls collectively for whilst it identifies lines of interconnection, it does not suggest a singular voice or aim. This

term is particularly apt because of its reference to the process of making contacts through informal society meetings. Riot grrrls grew through such social communication at gigs and through zines.

The utilisation of the neologism 'grrrl' sets the agenda for this network. The feminist insistence on the use of the term 'woman' to some extent reduced the value of the term 'girl'. Where 'woman' was equated with an empowered feminist adult, 'girls', defined by their immaturity, were depoliticised. Riot grrrl was, then, a reclamation of the word 'girl' and a representation of it as a wholly positive term: 'she [a grrrl] can do anything she wants . . . she (you) are a powerful person to the degree that you can hold the powers that enable you to be free of a lot of things – sexism, phat-ism, racism, homophobia' (*Notta Babe!* #1: 46). The term 'grrrl' was invested with a new set of connotations. It signified an angry, assertive feminist who relished engaging in activity. The power inherent in this new ideological hybridity was something celebrated by those involved in riot grrrl. Kay, co-author of *Intimate Wipe*, comments on the strength she finds in bridging definitions: 'Not a girl because of the easy cook rice & the late bedtimes. Not a woman because of the pre-pubescent dresses, the messy bedrooms & the toys' (*Intimate Wipe*: 2).

To use the term 'riot' is also not without significance. Magazine reports, in attempting to understand the origins of the 'phenomena', state that a friend of Allison Wolfe, of the band Bratmobile, coined the term 'riot grrrl'. Inspired by the Mount Pleasant riots in Washington DC in 1991, she reportedly wrote to Allison proclaiming a desire for a girl riot in the DC underground music scene. Riot grrrls are less keen to historicise the network, aware of how this may curtail its dynamic energy. Whatever the origin of the phrase, it is effective both as a call to action and as a description of a state of rebellion. Yet the use of the phrase has a further dimension for it draws on the exaggeration of media language. Terry Ann Knopf's comments on the use of the term 'riot' are of some relevance. She notes: 'the continued media use of the term contributes to an emotionally charged climate in which the public tends to view every event as an "incident", every incident as a "disturbance" and every disturbance as a "riot"' (Knopf, quoted in Cohen, 1980: 32). The use of the term by this network of grrrls thus revels in the media's use of terminology to create public trepidation. Riot grrrl so named itself in incubus, inviting alarm and drawing on the concept of disobedience where no action had yet been publicly taken.

## TOTALLY GRRRL POWERED: BEGINNINGS AND DEVELOPMENT

The International Pop Underground Convention of August 1991, organ-ised by Calvin Johnson and Candice Pederson of the independent label K Records in Olympia, Washington, was a demonstration of what Bikini Kill named 'revolution grrrl-style now!'[4] The first night of this five-day event was 'Girls' Night' when female musicians performed, grrrl zines were dis-tributed, and female audience members collectively countered instances of sexism. As information about riot grrrl spread, networks of girls and women grew up across America and in Britain, communicating in letters, at meetings and through zines. Riot grrrl offered a vehicle for empower-ment for many of those involved. As Angel states 'it's about love and communication and networking and productivity and learning. . . we can get a lot done and have a lot of power if we just pool our ideas and resources' (*Persephone's Network*: 12). Visible instances of the spread of this network are the emergence of new zines and female bands identifying themselves as riot grrrls. It is very difficult to ascertain how many zines have been produced since 1991, as they were often produced in very small numbers with restricted distribution. I have personally collected close to 100 publications, although the actual number produced in the name of riot grrrl must be several times this amount. Distribution of zines was aided by the foundation of the Riot Grrrl Press in Olympia, Washington, which endeavoured to copy and distribute any grrrl zine which was for-warded to them. Again the number of bands inspired by riot grrrl is difficult to estimate. In December 1993 Karren, a British zine writer, identified forty-seven new grrrl bands which had formed that year,[5] although the exact number which formed in Britain and America is undoubtedly greater. Whilst this may serve as a brief description of riot grrrl activities it is not intended as a synopsis. Realising the flaw in attempting to present an 'objective definition', the following account will instead offer a collection of details of this grrrl network.

### PERFORMANCE

The musicians involved in riot grrrl challenged the notion that indepen-dent music was free from the discourse of patriarchy. On their joint tour, America's Bikini Kill and Britain's Huggy Bear problematised the gendered way in which an audience views a live performance. Before their shows they issued handouts requesting that girls and women stand near the front of the stage rather than toward the back. The handout commented that the

front of the stage usually excluded women due to the violence of slam-dancing or the potential for harassment. Moreover the text stressed the importance of female address and identification stating: 'I really wanna look at female faces while I perform. I want HER to know that she is included in this show, that what we are doing is for her to CRITICIZE/LAUGH AT/BE INSPIRED BY/HATE/WHATEVER' (Bikini Kill/Huggy Bear handout, 1993). The bands thus forced a re-negotiation of the spaces that girls and women inhabit at shows. Moreover, shows would be regularly stopped and house lights brought up when male audience members refused to move to the back or vocalised their irritation. The banter between the band and audience, with the temporary halting of a show, in some ways became a regular part of the performance. However, whether or not the conflict was encouraged or inevitable, the gigs did force the issue of how performances are viewed in a gendered way.

Such shows also undermined other music performance conventions. Riot grrrl opened up the gig environment as a place for debate, not just an area of passive viewing. By requesting that people change their viewing habits Huggy Bear and Bikini Kill stimulated a response. They ignored the customs usually employed in maintaining distance between performer and audience, thus breaking down their ideological separation. Hecklers were engaged with rather than ignored, and girls at the front of the stage were passed the microphone to voice their anger at harassment at gigs. Margaret Rooks, author of Quit Whining, comments that this new approach to performances was demonstrated on 'Girls' Night', an evening of female performance which formed part of the International Pop Underground Convention of 1991:

> Girl's Night seemed to be more than just a show; there was a sense of sharing between the performers and the audience. A forum. The arrangement of acts was informal and somewhat of an open mike, no order of importance.
>
> (Quit Whining #1:5)

In addition to dismantling the power relationship between performer and audience, these shows allowed other voices to be heard. The spoken word performer Juliana Luecking commented on the encouragement she received from Kathleen Hanna of Bikini Kill, who cut her own set short in order to grant Juliana time to recite a monologue. Juliana described how the audience was very receptive of her performance in which she communicated about the events and lifestyles of the people that surround her and attempted to demystify sexuality. Juliana states that the venues in

which she now regularly performs, such as galleries and community centres, do not allow for the same possibility of communication with the audience. She explains that the experience of performing between music sets is rewarding as it allows people to offer her an immediate reaction to her material: 'This audience of homofriendly punks is my absolute favourite. I learn more from these individuals . . . than I do from someone telling me about how my art fits into other artistic periods or groups'.[6]

The riot grrrl gigs also allowed for previously silenced voices to be heard. An incident which occurred at the International Pop Festival in 1991, is a very striking example of this (personal communication). A group of women became aware of a man who had harassed and date raped a number of women in the area. In response they composed a short written account of this man's behaviour to which they added an explanation of date rape and advice of what to do if you have experienced this crime. The text was produced as a 'flyer' and approximately 100 were distributed to the crowd. One woman, on receiving a handout, informed them that she had been raped by this man. Their activities were followed by a set by Fugazi where the lead singer Ian MacKaye took a break from one of their songs on street harassment to talk of the problems faced by victims of sexual aggression. At the invitation of the band, the woman who had been so abused climbed on stage and sang the close of the song. This highly emotive incident, whilst distressing in its acknowledgement of the prevalence of violent crime, demonstrates the opportunities for empowerment which were opened up by this female initiative. The incident allowed for a rape survivor to vocalise her distress and articulate against her attacker.

## 'HEY BABY, YOU LOOK SO GOOD': DISPLAY AND SPECTACLE

Riot grrrl bands, along with other riot grrrls, challenged notions of female display. Members of Bikini Kill would write such words as 'SLUT' across their midriff and arms in marker pen. This personal labelling pre-empted any derogatory term which might be directed at them. Thus these women were publicly confronting the viewer with the very terms designed to prohibit female display and curtail sexual activity. These statements also had specific non-permanence, allowing for particular responses to hecklers and playing with codes of exhibition. Moreover many grrrls chose to adopt particularly feminine dress codes, wearing bunched hair and hairslides with patterned dresses. The critique of the

construction of the feminine is abundantly clear when this attire is juxtaposed with bold words such as 'whore' written on the body. This chapter does not wish to reduce the movement into a simple spectacle, a point which will be discussed later; however, there is a clear semiotic intention behind such modes of display.

The project of questioning connotations of female display was a focus of many of the zines as well as a characteristic of stage shows. American and British zines commonly included detournements of images from fashion magazines, comic strips and advertising posters. In this respect the zines employed the situationist techniques which Jamie Reid utilised as part of the punk movement, taking texts from mass culture and endowing them with a new and subversive meaning. They also borrowed the Dadaist project of communication through a collage of cut-up words and images. The collage of photographs of smiling women juxtaposed with lingerie advertisements and soft pornography featured in *Girls' Annual* is a good example. Words and phrases such as 'bitch', 'anorexic/absolute beauty' and 'the psychology of rape' are scattered across the images inviting debate and gaining power from juxtaposition (*Girls' Annual*: 5–6).

This method of communication thus links riot grrrl directly into a punk tradition. However the context and audience for these messages offer a new frame of reference. The author of *Discharge*, for example, reprinted an advertisement previously published by *Sassy* magazine for a slimming product. The advertisement featured a photograph of a smiling girl in a bikini alongside a page of text encouraging readers to buy the product; the advertisement heading ran: 'Get the look that boys notice. How to lose weight fast and look great. You can have the cute, thin body you've always wanted – the kind of body that really gets boys attention . . .' (*Discharge* #3: 13–14). The zine writer placed the original text under erasure, by adding additional words in marker pen so that the advertisement read: 'How to lose weight fast and look like an anorexic with the body of a fucking twelve year old! Then you'll be the kind of girl every boy wants to fuck real hard. Order now' (*Discharge* #3: 13–14). Rather than a random attack on the advertising industry, the writer launched a feminist attack on a magazine aimed specifically at teenage girls. The criticism is specific as *Sassy* had championed the riot grrrl 'cause' featuring zine reviews and information. The editors of the magazine even released a single 'Hey Baby', highlighting the problem of street harassment, under the name Chia Pet. This writer is not alone in pointing to the disparity between the politics of the writers and the advertisers; *Kingfish* includes criticism of a similar *Sassy* advertisement (*Kingfish* #2: 12). These writers thus offered a critique of the ways in which the construction of femininity is conveyed

to them through the mass media and offered alternative models of behaviour through their own networks of communication.

## PUNK ROCK DREAM COME TRUE

Riot grrrl's link with the punk movement is worthy of further exploration. Rather than claiming to re-invent the punk movement, participants placed themselves in its ongoing tradition. This point is clearly expressed by Tobi Vail of Bikini Kill in her introduction to the album *Stars Kill Rock*, a compilation featuring several riot grrrl and queercore bands. Vail comments: 'despite the much publicized notion of the non-existence of such a thing, underground music is very much alive'. She warns against the 'dissemination of an ideology indicating otherwise' promoted by those 'busy trying to convince themselves that simply because they are no longer punk rockers, punk rock must no longer exist'.[7] The growth of new bands demonstrated an adherence to the punk ethos of creating music regardless of previous training: 'who cares if the boring musos whinge that we "haven't learnt to play our instruments properly" . . . anyone can write and play for as long as there's ATTITUDE/ANGER there' (*Kookie Monster's Free Peach Thingy*: 1). Members of the band Tsunami, who run the Simple Machines label, showed a dedication to the DIY spirit of punk, producing an information booklet on how to produce your own records.[8] Yet whilst embracing the spirit of punk, riot grrrls were aware of how this music genre had excluded girls and women. This is not to ignore female bands such as the Raincoats and the Slits which emerged with the punk movement, but rather to highlight that punk was problematic for female performers who are often considered incidental rather than central to the movement. Maintaining the energy of the original movement, riot grrrls presented a new 'punk rock feminism'.[9] A contributor to *Quit Whining* comments on the inspiration that this has given her: 'until Girl's Night, I never knew that punk rock was anything but a phallic extension of the white middle class male's frustrations' (*Quit Whining* #1: 5).

Whilst the activities of riot grrrls may clearly be understood as feminist, the relationship of riot grrrls to feminist academia is worthy of consideration. The authors of several zines demonstrate their familiarity with feminist and women's literature through the inclusion of book lists and recommended texts. Several zines recommend the work of Toni Morrison, Alice Walker and Luce Irigaray, authors often featured in university programmes, which may be linked to the fact that several of the zine writers are students. However, there is by no means a canon of riot grrrl literature. Several grrrls eschew 'traditional' feminist texts, identifying instead

with more 'radical' writers. Kathleen Hanna of Bikini Kill provides an illustration of this, citing author Kathy Acker and performance artist Karen Finley as her main influences (Arnold, 1992: 45). Responses to feminist texts by zine writers were varied and conflicting. Whilst some chose to valorise Valerie Solanas, founder of the Society for Cutting Up Men (SCUM) and author of the SCUM Manifesto, others distanced themselves from such texts: 'although I am politically active . . . I don't share a lot of Grrrls' views of "radical feminism"' (Persephone's Network: 12).

## ZINES: GRRRL LINES OF COMMUNICATION

The zine network is crucial to any understanding of riot grrrl. Several articles published in national papers and magazines first defined riot grrrl as a musical movement and then proceeded to discuss the musical work of a small selection of bands. Yet whilst initiated by musicians, riot grrrl was important as a system of communication amongst girls and women. Whilst many zines encouraged readers to get involved in music, writers were also keen to stress that this was not the sole motivation behind the initiative – as Kay and Josie state in Go-Go Grrl, '"Riot Grrrl" is not just about music. It's girl positive energy. Don't feel that you have to be in a band to do something constructive with your time' (Go-Go Grrl #1: 5). Certainly riot grrrl spawned a considerable number of new bands, but it also resulted in hundreds of publications, stressing the fact that the movement had a larger project. Whilst each zine offered an individual response to riot grrrl, all zines identified with a common goal of empowering girls and women. It was recognised that whilst distribution of any one publication may be small, each document contributed to the wider motive of spreading the word of riot grrrl. This attitude is voiced in Grunge Gerl #1, a zine written in Los Angeles: 'I know circulation will start small, maybe 20 copies or so, but with luck, once you all start reading – and contributing to this – we can get the word out that we're girls, we're angry, we're powerful . . .'(Grunge Gerl #1: 1).

Whilst the content of each zine was at the discretion of individual editors, certain styles of writing were common in riot grrrl publications. Many included traditional fanzine staples such as record and concert reviews, band interviews and artist profiles. However, the zines also acted as spaces in which grrrls could share information and voice opinions on issues affecting them. Zines included articles on date rape, abortion rights and discussions of the problems of walking home at night. In addition to being vehicles for the spread of information, zines offered a platform from which girls could share personal experiences. Such pieces ranged from

angry responses to sexism and discussion of broken relationships, to disclosures of sexual abuse. As distribution of these publications was limited to small numbers, zines offered the possibility of communicating experiences to a small group of like-minded people. This concept of a grrrl network is clearly apparent in *Hair Pie* written by two girls in Dyfed, Wales, who subtitle the publication, 'The isolated by geography but not attitude zine for girls' (*Hair Pie* #2: title page).

In the majority of zines studied for this paper, writers placed a central importance on the need for dialogue. Rather than using zines as a way to promote the self, most of the writers stress the need for feedback, presenting their views simply as a *way* of seeing. Ella, author of the Sheffield-based zine *Pariah*, stresses this point in her opening pages: 'It's up to you – this should be a dialogue, so take a pen and paper to continue this conversation' (*Pariah* #1: 2). The writers and people involved in the network embraced the idea of 'girl talk' as a means of overcoming isolation and alienation, and as a route through which to better understand the self. This was not a conclusion that writers came to, but one that was actively striven for. Bands, writers and activists all encouraged girls to involve themselves in this communication. The writer of *Hotskirt*, published in Little Rock, Arkansas, comments on the need for such networks:

> Girls, we all need to learn the incredible value and joy to be found in girl friends. It's not just a silly slumber party full of makeup and hair and boyfriend talk. 'Girl Talk' is cool, but that's not all it has to be about. It can also be about feelings, about being a girl.
>
> (Hotskirt: 2)

Riot grrrls did not limit their activities to the rhetoric of the zine, but rather aimed at mobilising grrrls to meet together and engage in activities such as music production. The Leeds and Bradford 'chapters' of the riot grrrl network organised a workshop event, entitled 'Bitch Schirmish', where they amassed musical equipment in a club and invited girls to experiment. Karren, author of *Ablaze!* zine and an organiser of the event, explained that the idea was to 'give girls a chance to try stuff out, to get comfortable with the idea of playing guitar without any expectations'.[10] Other events organised by this group included girls learning to DJ and organise gigs. This illustrates how, as information about riot grrrl spread, local groups of grrrls began to meet together and offer collective responses to the initiative. A zine produced in Arlington, Virginia, informed readers of weekly meetings and encouraged involvement:

the zine you hold in your hands is just one aspect of what riot grrrl is about. Riot grrrls meet and talk, and are also planning a workshop to learn how to run sound board and equipment, and other cool stuff as well. . . . . Come on by!

(Riot Grrrl #6, Virginia: 1)

## THE REVOLUTION WILL BE ANALYSED: RIOT GRRRL AS YOUTH SUBCULTURE

So far I have explored how riot grrrls have challenged the conventions of performance and female display. I have considered how they created spaces of communication at gigs and through zines, encouraging involvement and motivating other girls and women to assert themselves. I shall now examine riot grrrl in terms of youth subculture theory. There are inherent problems in doing so, not least of which may be understood as the very terms 'youth' and 'subculture'. However, it is with such problematics that this chapter will grapple, re-examining the theoretical ways in which the relationship between 'subcultures' and the 'dominant' culture have been modelled.

There are obvious reasons for adopting this mode of inquiry. Whilst the statement 'every girl is a riot grrrl'[11] aims to explode any notion of a definable 'subculture', one can decipher a certain shared knowledge by those involved. Details of live performances, record reviews and listings communicate a shared appreciation of indie music from Britain and the USA, with bands such as Nation of Ulysses, Bikini Kill, Tribe 8 and Voodoo Queens receiving frequent mention. Riot grrrls' identification with a continuing punk tradition further encourages a reading in subcultural terms, as does the frequent description of the network as a subterranean force: 'we're growing, we're underground, and we're denying their power by not talking to them' (Ablaze! #10: 15). Moreover, the response to riot grrrl in newspapers and magazines is consistent with the attention given to new youth subcultures, as journalists attempted to explain this 'latest nastiest phenomenon' (Barrowclough, 1993: 27) to readers.

Perhaps one of the flaws of subcutural theory is its tenacious grasp of the concept of delinquency. Youth subculture is positioned as oppositional to the parent culture and thereby at odds with societal norms. Mungham and Pearson (1976), recognise the tendency of social scientists to present youth as a problem category. However, despite this acknowledgement, they involve themselves in the romanticisation of deviancy and youth by

selecting theorists dealing with this theme for their collection, albeit to look at the 'issue' of problem youth. Rather than redressing the balance, Mungham and Pearson appear to contribute to this problematisation, concluding that 'youth is definitely troubled, and working-class youth seems to be more of a trouble than most' (1976: 9). However, by equating youth subculture with delinquent culture one immediately marginalises its position and undermines its importance as legitimate expression. This point has particular relevance with respect to riot grrrl. To place riot grrrl in a tradition of delinquent youth theory would be to ignore the nature of its protest and dismiss its feminist objectives as mere teen dissent.

The tabloid media response was indebted to this tradition of aligning youth culture with the character of the delinquent. The *Daily Star* published an 'exclusive' report on the 'new cult of outrageous, fast-living, dirty-talking, hard-drinking, all-girl bands . . . set to shake the pop world'.[12] However, the picture painted of 'teen female rebellion' (Snead, 1992: 5D) and of riot grrrls as 'screaming brats' (Goad, 1994: 22) cannot be set in the same tradition as that of the media reaction to, for example, the mods and rockers (see Cohen, 1980). This response to riot grrrl was clearly informed by a gendered discourse. Riot grrrls were unacceptable or, at least, shocking, not because they rioted on Brighton's beaches, but because they betrayed specific conventions of femininity.

This problem invites the question of whether traditional ways of modelling youth subcultures are adequate with respect to this movement. It seems even in defining riot grrrls as 'adolescent rebels' (Brown, 1993: 27) one is forced immediately to qualify the statement. Riot grrrl certainly embraced the title of rebel. Bikini Kill's 'Rebel Girl'[13] became somewhat of an anthem and Huggy Bear's statement that 'this is the sound of revolution'[14] became a stock phrase. However, simply to describe riot grrrl as a rebellious youth subculture seems to imply an opposition to a static (adult) dominant culture. Instead riot grrrl may be understood as having specific aims within a particular cultural context. Grrrls were repositioning themselves in terms of their involvement with live music, they were setting up new networks of communication and offering new modes of female expression. As Emily White commented in *LA Weekly*: 'Bikini Kill's show is not just a vague, fuck-society gesture, but a focused critique of the punk scene itself' (White, 1992: 22). Riot grrrls may be understood, then, as issuing a specific contestation of a particular male-dominated culture. Moreover, even the term 'youth' is somewhat of a misnomer. Ages of riot grrrls spread from around 14 upwards. Whilst most riot grrrls were below the age of 30, older women also aligned themselves with the network.

## BRITISH MEDIA NETWORKS

In Britain, whilst riot grrrl spread through zine and music networks, it was first given national publicity in the weekly music press. *Melody Maker* presented an 'exposé style piece in October 1992, an initially very favourable response (Joy, 1992: 30–2). As this chapter describes, whilst this publication sought to publicise riot grrrl, it also attempted to define it, thus representing a traditional media response. The initial publicity was then picked up on by other national and local papers.[15] Riot grrrl was given journalistic legitimacy through national media coverage, a point which is illustrated in American media coverage by the number of writers who list other publications who have carried a riot grrrl story.[16]

Whilst riot grrrl did not generate the media 'moral panic' often associated with youth cultures (Cohen, 1980), it did generate moral indignation as expressed in a number of journalistic articles. Anne Barrowclough's article in the *Mail on Saturday* fits neatly into the mould of journalistic moral panicking. Her emotive vocabulary constructs the image of invasive, irreverent, threatening youth:

> They screech, they spit, they snarl, they swear. Every word they scream is a prayer against men. . . . Meet the riot grrrls, the latest, nastiest phenomenon to enter the British music scene. . . . They call themselves feminists but theirs is a feminism of rage and, even, fear.
>
> (Barrowclough, 1993)

Yet as Hebdige has remarked, whilst it is tempting to concentrate analysis on such sensationalism, ambiguous reactions are often more typical of the press coverage of subcultures (Hebdige, 1979: 97). Daisy Waugh's article in the *Evening Standard* illustrates this point, adopting the stance of a fascinated outsider. Having attended a Huggy Bear gig the journalist 'retreated to where I knew I belonged, which was anywhere but there. To a quiet coffee bar nearby and with one of their damned elusive and utterly incomprehensible "fanzines" for company' (Waugh, 1993: 10).

Hebdige's analysis of the punk movement provides a useful working model with which to understand riot grrrl. The extensive coverage that riot grrrl received in the weekly music press, national newspapers and monthly magazines[17] is consistent with the media fascination Hebdige highlights. Hebdige's statement that the media evolve subtle methods through which to contain the culture also has some currency in riot grrrl. Writers sought to limit the radical potential of this initiative by young women by

interpreting the age and gender of the participants as an in-built limitation. They sought to disarm the threat of this united Other by trivialising the movement and couching praise in condescension: 'Their ideas may be babyish. But at least they have some' (Waugh, 1993: 10). As discussed above, riot grrrl traversed a broad range of feminist viewpoints and allegiances. However, several critics keen to locate this network within an academic feminist tradition, sought to undermine the validity of riot grrrl on the grounds that participants were not au fait with feminist theory. In 1993 Anne Barrowclough informed readers that riot grrrls had not read de Beauvoir or Germaine Greer (Barrowclough, 1993); ten months later a *Melody Maker* journalist commented: 'The best thing that any riot grrrl could do is to go away and do some reading, and I don't mean a grubby little fanzine' (Manning, 1994: 35). Whilst riot grrrls were collectively seeking to combat day-to-day sexism, dismissive journalists argued for a cessation of activity until all participants were familiar with feminist theory. Again this may be understood as a gendered response as previous youth subcultures have not had to intellectually contextualise their dissatisfaction.

However, this chapter wishes to resist the temptation of slotting riot grrrl into a simple model of media containment. As McRobbie argues, analyses of a news item covered in today's postmodern mass media require an appreciation of the complexity of communication systems and a revision of the old model of the moral panic (McRobbie, 1994: 198f). To attempt to place riot grrrl in a model of media fascination and public appropriation seems a misguided pursuit. Whilst coverage of the mods, rockers and punks was explained by the theoretical frames devised by Stan Cohen and Dick Hebdige, riot grrrls demonstrated a sophistication which demands a revision of these approaches.

Sarah Thornton, analysing acid house and rave, has argued that there is a need to discard the notion of a binary opposition between the public mass media and the private sphere of the subculture (Thornton, 1994: 176–92). She demands that instead we should be aware of the networks of media communication in operation. Thornton takes issue with the notion of a romanticised 'authentic' culture theoretically located outside of media and commercial structures. Instead she comments on how subcultures employ media networks. Thornton's description of the acid house 'craze' is one of a spread of information from micro media such as rave flyers, through niche media such as the weekly music press, through to the mass media of the tabloid papers. Thornton argues that the tabloids did not commandeer the rave scene but were fed information about it through media systems of the culture itself.

Thornton further argues that whilst the mass media are usually positioned as unwelcome intruders in the camp of youth, they simultaneously serve to legitimate the status of youth subculture. Thornton notes how subcultures revel in the notion of rebellion, yet she comments that this is more a homage to the construct of the rebel than a threatening reality. She notes how the underground, 'Imagines itself as an outlaw culture, as forbidden just because it's unauthorised, and as illicit even though it's not illegal' (1994: 179). Moral outrage in the national press thus endorses the assumed rebel guise, authenticating its cultural status.

Thornton's comments on media processes highlight the dynamic aspects of publicity and demonstration. Moreover she demands that we should not view those involved in a youth subculture as 'innocents' unwillingly exposed to media focus. The growth of riot grrrl and the expansion of knowledge about this network can be linked into the micro, niche and mass media communications Thornton identifies. Information was spread and a community delineated through a network of zines. These activities were publicised in national music press articles such as Sally Margaret Joy's 'revolution grrrl style now' (Joy, 1992). It is notable that this and future articles did attempt to 'construct as much as they document' (Thornton, 1994: 176). *Melody Maker* attempted to present definitive guides to the movement in the form of Top 10 charts listing 'vital' releases, girl influences, quotes and 'cool' zines (Joy, 1992). Subsequent articles collapsed the breadth of musical activity inspired by riot grrrl into the output of a small number of bands. By closely tracing the Huggy Bear/Bikini Kill split tour they claimed to be documenting the subculture. Tabloid and broadsheet attention further publicised as well as distorted 'girl action'.[18] However the next section will explore how riot grrrl demands a further refinement of Thornton's model to understand the relationship between a subculture and the 'outsider' media. Whilst riot grrrls clearly shared a relationship with other media networks, those involved were also aware of the ultimate limitations of such a symbiotic relationship. The participants displayed a comprehension of the processes of containment and incorporation initiated by media interest, and developed a strategy of resistance.

## MANAGING THE MEDIA

Those involved in riot grrrl showed an awareness of the danger of being co-opted by the niche and mass media and translated into a new trend to be celebrated and then discarded. However, participants did not adopt a straightforward oppositional stance to all media attention, recognising the benefits to be derived from new publicity. In Britain Sally Margaret Joy's

initial coverage in *Melody Maker* was welcomed as a positive piece of pub-
licity which encouraged girls and women to become involved. This
coverage became a facet of riot grrrl itself as it was instrumental in shap-
ing its growth. A copy of a zine produced by grrrls in Leeds and Bradford
states 'we might be called RIOT GRRRL, but we're aware of the media
deadtime deadlines that crush anything it discovers. . . . Seeing all that, we
use their media whilst we sneakily construct girl lines of communication'
(*Riot Grrrl!*, Leeds and Bradford: 6). As media interest grew those involved
were responsive to the potential problems of usurpation. Jenn and Soph
commented on this in *Hair Pie*:

> I've noticed (as I'm sure you have) riot grrrl is getting more press
> (daily star) for fuck's sake, we've gotta stay underground and
> undermine the corporate rock press by doing it ourselves so we
> can talk about our beliefs to people without fear of being misun-
> derstood or the truth being distorted'
>
> (*Hair Pie* #2: 1)

Riot grrrls continually adjusted their stance in response to differing media
reports. As riot grrrls became renowned for writing words such as 'whore'
on their bodies, one American girl responded by writing 'media scam
property' on her torso and arms – a photograph of which was duly pub-
lished in *Newsweek* (Chideya, *et al.*, 1992: 84).

Musicians and zine writers attempted to arrest journalistic misrepresen-
tation through a refusal to participate in the interview process. Whilst they
could not prevent inaccurate media reports, this strategy prevented jour-
nalists from selecting quotes to reinforce their opinion and so was effective
in exposing journalism's system of operation. The band Linus initially
refused permission for the publication of band photographs: 'There is no
photo to accompany this article because Linus don't want there to be any;
instead, they've drawn a picture of themselves. It's not wilful petulance,
merely a desire to show up the interview process for what it can be'
(Terry, 1993: 14). Journalists were placed in the perverse position of for-
mulating articles on the subject of a media silence: 'This, in case you're
wondering, is not an interview. It's an article written with the band's co-
operation. My fee for the article will be donated to the King's Cross
Women's Refuge' (Wells, 1993: 13). The media silence, with the converse
media frenzy, perpetually returned authority to the riot grrrl participants.[19]

Another way in which riot grrrls deferred reappropriation was in their
refusal to invest in common semiotic signifiers. In order for the dominant
culture to appropriate subcultural signs there has to be some consensus of

opinion on what actually constitutes these symbolisations. The 'Destroy' T-shirt had first to be understood as a symbol of punk's nihilism before it could be capitalised on as a desirable authentic fashion garment. Riot grrrls did not offer clear symbols which could be extracted, thus undermining their subcultural currency and working against the dynamism of the network. This is not to say that riot grrrl is devoid of any symbolic systems, but rather to comment that participants frustrated attempts to precipitate certain essences from the fluidity of its underground network.

Riot grrrl could be conceptualised in terms of fashion, a project which was attempted in American and British publications. The American magazine *Glamour* informed readers that riot grrrls 'mix baby-doll dresses and bright red lipstick with combat boots and tattoos' (*Glamour*, May 1993: 134). In Britain, *The Independent* published an article which stated: 'theoretically you could be a Riot Grrrl in Laura Ashley florals. However, it seems unlikely', commenting instead that 'black and denim were *de rigueur*' (Mattthewman, 1993). These descriptions do not, however, distinguish riot grrrl from the clothing styles worn by other girls and women who, whilst perhaps sharing an interest in indie music, would not describe themselves as riot grrrls. The attempt at such definition was met with mockery by riot grrrls. Bidisha, author of the London zine *Girl Pride*, parodied the fashion magazine format to highlight the reductive tendencies of such publications and the inaccuracy of their copy:

> with this guide you can look and sound like –
> hey you can BE a riot grrrl
> without knowing anything about it – be trendy kids!
> *THE CLOTHES*
> D.M. boots (let's hear you squeak in those new boots)
> some kind of old dress,
> cardigan or navy jumper . . . use Dad's sandpaper to make holes
> in the fabric.
>
> (*Girl Pride* #6: 10)

This is not to suggest that the music and zines of riot grrrl form a remarkable oasis of self-reflexivity within a greater dogmatic popular culture. It may be argued that stylistic and musical movements have become increasingly reflexive, as have publications such as *New Musical Express* and *Melody Maker* which display many instances of self-parody. However, this self awareness does need to be acknowledged when considering riot grrrl in terms of subcultural theory, especially if we are to understand such instances of parody as a resistance to 'outside' discourses. Riot grrrls

further undermined attempts to close off the movement by claiming that it did not attempt to alienate any girls, stating 'every girl is a riot grrrl',[20] and through their insistence: 'this name is not copyright . . . so take the ball and run with it' (Riot Grrrl, Washington DC: 2).

Subcultures have tended to define themselves against the dominant culture. Their ideological location is established in opposition to prevailing cultural practices or values. Media moral panicking inflates the idea of these cultures as a threat to parental or 'straight' culture. Rather than effecting an erosion of the dominant culture through their existence, subcultures paradoxically depend on reinforcing its precedence and even exaggerating its cohesion and dominance. As Stewart Home comments: 'those whose identity is based on "their opposition" to the world as it is, have a vested interest in maintaining that status quo'.[21] Of course this is not to say that a subculture may not work as an opposition, but rather to highlight the irony of its chosen stance. Many of those involved in riot grrrl have sought to avoid this definition in opposition, aware of the limitation of such a conceptualisation. As Karren states:

> We are aware of the dialectical nature of protest, which ensures that dissenters are relegated to the role of 'other', thus playing a necessary supportive role to the mainstream ideology. We refuse to give credibility to traditional modes of protest.
>
> (Ablaze! #10: 16)

Instead riot grrrls have aimed to educate and empower other girls and women to obtain their potential, unfettered by an ideology of femininity. Rather than railing against the mainstream, riot grrrl has focused its activities, targeting the perceived sexism of the independent music scene and working toward specific goals. Riot grrrl music performances, for example, aimed to convey certain feminist messages within a gig environment to a particular music audience.

It could be argued that riot grrrl did not seek the legitimating force of the mass media to define itself as 'authentically' rebellious. This, perhaps, reflects the aims of riot grrrls. The goal of many of those involved was not to gain mass attention but to encourage girls and women to communicate with each other. As Tobi Vail of Bikini Kill remarks: 'We're doing so much now that it [mainstream attention] seems kind of unimportant. . . . We've really aligned ourselves with the underground' (quoted by Arnold, 1992: 46). Yet riot grrrls' methods of expressing dissent are distinct from those of other youth groups. Rather than seeking to attain the status of rebel through inference, as might a spectacular fashion, this network defined

itself as such in its choice of a moniker of revolt. Moreover it continued to re-establish this concept of boisterous activity in slogans such as Bikini Kill's 'revolution girl style now'[22] and zines such as *Girlfrenzy* which describes 'Girlspeak. The organ of GIRL POWER INTERNATIONAL; a worldwide network of Girl Revolutionaries' (*Girlfrenzy* #3: 30).

The anachronistic quality of such terms of revolt did not go unnoticed by its users. However, rather than attempting to clarify their meaning, many grrrls delighted in frustrating the etymologist by employing personal definitions. Ella's comments in *Pariah* may be taken as an illustration: 'it's not my fault that words like "revolution" and "manifesto" have become so hackneyed and meaningless – because I MEAN THEM. It's not my problem, you know? I want to restore their power' (*Pariah* #1: 8). She follows her point by quoting Lewis Carroll: 'when I use a word, it means just what I chose it to mean. . . . The question is which is to be master – that's all' (*Pariah* #1: 8). Huggy Bear explain their use of the word 'revolution' as a celebration of dynamic energy: 'REV-o-LUTION a going round thing . . . cars racing, the hype-know-sis of motion itself . . . revolution is toy. Totally a phenomenon of temporanety' (*Reggae Chicken*: 13). Yet whilst this explanation is put forward, Huggy Bear also recognise that the message of their text may get altered through the individual interpretations of different readers. Rather than view this as a failure, this is noted as a positive quality, eluding stasis and stimulating new understandings: 'if it gets understood by some and misunderstood by others then hopefully you get all these interesting cross signals to stimulate thought rushes, confusion, random arguments bastard seed patch weeds could be revolution let's see . . .' (*Reggae Chicken*: 13).

It might be suggested that the call to arms that riot grrrls issued and bands such as Huggy Bear articulated were somewhat empty threats of revolution. The prophecy of a grrrl-powered end point, whilst being commended for its positivity, may be criticised for its clear lack of possible location in a concrete reality. A degree of female empowerment may result, but a desecration of all bastions of patriarchy is hardly achievable given the nature of the movement. However, Huggy Bear acknowledge that utopianism is flawed by the very goal of its idealism. Thus, rather than postulate a purely teleological philosophy, they adopt a chimerical stance: presenting counterfeit manifestos and celebrating an indulgence in the fanciful. Whilst issuing cries such as 'boredom – rage – fierce – intention . . . the arrival of a new renegade . . . her jazz signals our time now,'[23] they acknowledge that goals are rarely achieved, 'revolution fails' (*Reggae Chicken*: 13). In a similar sense, whilst Huggy Bear were noted for their promulgation of manifestos, they also issued refusals of adherence to rigid

statements. On a cassette release of a live London performance they responded to their critics, stating: 'All you want is like simplistic responses and I'm not prepared to do it. You want manifesto, we don't give manifesto'.[24]

## WHOSE HERSTORY? LOCATING RIOT GRRRL

So far this chapter has considered how newspapers and magazines attempt to define as well as document subcultures and how riot grrrls, demonstrating an awareness of this tendency, employed techniques to return authority to those involved in the network. Yet it is important that, in writing this chapter, I should not extricate myself from the process. The rigour of analysis encourages the scholar to define and interpret a culture and thus to present an *understanding*, yet, this objective carries the potential for misrepresentation.

Whilst any definition of a subculture demands identifiable lines of connection within the group, it would be false to extend this premise to state that one could extract from all subcultures a cohesive identity. This point has particular pertinence, for it is tempting when analysing riot grrrl to extract identifiable strands and thus attempt to present the 'essence' of the culture. Such a mode of investigation suggests a homogeneity that riot grrrls have tried to resist. If one wished to identify a common goal it was that riot grrrls allowed and encouraged individual responses. In this sense riot grrrls echoed the works of feminists who have demanded that we think in terms of feminisms rather than a monolithic block – thus allowing for a variety of responses and ensuring that no viewpoint is excluded on the grounds that it does not fit with the dominant view. This sentiment was voiced by Liz Naylor of Catcall Records in a *Melody Maker* debate surrounding the 'issue' of women in rock. The debate, published two weeks before *Melody Maker* 'discovered' riot grrrl, was an opportunity for female performers and women involved in the music industry to respond to inflammatory questions set by journalists. Liz Naylor expressed concern that some of the women felt they should present a united front: 'Why not criticise me? I hate that thing where women are supposed to be "politically correct" and, like, not slag a *sister*' (*Melody Maker* 26 September 1992: 27).

Riot grrrls demonstrated an awareness of, and set a challenge to, the academic practice of locating and defining meaning in subcultures. Subcultural theorists have previously approached their subject as interested outsiders hoping to decipher the systems of signification in a chosen group and explore the power relations between the group and dominant

culture. Theorists are thus distanced from the culture but still invested with the authoritative task of uncovering its significant aspects and rendering their meanings. The self-reflexivity of riot grrrls arrests this method of investigation by challenging the authority of the cultural archivist. Riot grrrls displayed an awareness of themselves as academic curiosities. Karren comments in *Ablaze!* that they have purposefully blocked any attempts at academic intrusion on this movement:

ACADEMIA IS A SHITTY PLACE for me . . . So we thought we'd try something without them. Of course, they're [academics] very upset and rarely give up that fearful howling on our doorsteps, but you know that in a while they'll quieten down and leave us be.

(*Ablaze!* #10: 15)

This self-awareness demands a dramatic shift in the way in which we conceptualise this network. Moreover, the fluency with which several riot grrrls use the theoretical language previously employed to position them forces a renegotiation of the relationship between researcher and subject.

Riot grrrl may be understood as a network of activity seeking to elude the paralysis of reification. The quote from *Ablaze!* states the intent of preventing a flow of information about riot grrrl from entering the 'long tall twisting staircase' of academia (*Ablaze!* #10: 15). However, participants did more than block information, they actively sought to frustrate attempts to historicise the movement and interpret its collective 'intent'.

The awareness that several zine writers and bands have of the progress of the History of Art was influential in directing their output and shaping their public statements. The content of many zines shows a clear indebtedness to Dadaism and employs sloganeering and *détournement* practices used by situationists. The band Linus displayed their acknowledgement of the avant-garde in the zine they produced by the inclusion of quotes and photographs of the work of Meret Oppenheim, Alberto Giacometti and Man Ray (*Plague Your Eyes*: 16–17). The name of their zine, *Plague Your Eyes*, also nods in the direction of art activists such as Stewart Home involved in dismantling notions of individual artistic genius. A manifesto entitled 'Towards Nothing', issued by Home under the name of the Generation Positive, proclaimed: 'we affirm that plagiarism is the truly modern artistic method. Plagiarism is the artistic crime against property. It is theft and in Western Society theft is a political act.'[25] Just as with spectacular youth subcultures, the very radicalism of such art projects is subject to conversion into commercial terms, antithetical to its original purpose, and to the

process of canonisation. One may consider the example of the art strike of 1990–3 when a group of 'militants' declared that they would 'cease to make, distribute, sell, exhibit or discuss their cultural work' (*The Art Strike Papers*, in Home, 1991: 1) within a three-year period. Those involved wished to draw attention to the hierarchy of the arts and extricate themselves from the capitalist consumption of art. However, the refusal to create cultural capital was not a defence against recuperation: the very notion of abstention became in itself an art statement, put forward by a notable few, located in time and open to incorporation into the History of Art. The knowledge that grrrl bands and writers have of the forces of recuperation informs the way in which they present themselves as riot grrrls.

One of the ways in which grrrls have prevented the movement from becoming static has been their use of contradiction as a tool. Many of the zines vocalise the problems that their writers face in trying to develop a personal identity. They comment on how they find being female is a constant negotiation of different constructions, so that they are continually switching between the passivity of femininity and their need for 'girl action', their need to dismiss conventions and their desire to conform to standard images of beauty. Kathleen Hannah of Bikini Kill expressed how this imbues her with a sense of displaced identity: 'Because I live in a world that hates women and I am one . . . who is struggling desperately not to hate myself . . . my whole life is felt as a contradiction' (*Jigsaw* quoted by White, 1992: 23). Rather than deny this sense of complex identity and differing positions, grrrls have embraced this as a facet of their existence. Whilst zines contradict each other, individual writers also present conflicts in their texts. Irene Chien, editor of *Fake* zine, published in Potomac, Maryland, opens the publication with the statement: 'I don't claim to be revolutionary, consistent or even coherent in my feminist theory or anything . . .' (*Fake* #0: 1). This romance with contradiction may be understood then as a response to the complexity of female experience. In effect it inhibits an easy reading of the author's stance. Emily White describes this as having a definite subversive quality, 'creating a kind of paralysis, or night blindness, in the man/boy imagination' (White, 1992).

Whilst some women have used contradiction as a testimony to their experience, others have utilised it as a playful method of inviting debate, employing a scheme of anti-information to stimulate a response. This approach is articulated by Karren in *Ablaze!*:

> Our fight is adrenaline-fuelled and essentially fun, following no pre-set programme. . . . We are prepared to (ab)use philosophy,

to put forward statements we know to be untrue, in order to stir up stagnant ponds of thought into newly rushing fountains of debate.

(*Ablaze!* #10: 17)

This mischievous refusal to present a 'truthful' singular account is a way of allowing other discourses to come through the zine medium. Seeking to escape the construction of a definitive riot grrrl tract, those involved also dissuade the reader from viewing the zine writer as author, encouraging the publication to be seen rather as a writerly text:

Non passive reading − like a heckler with a brain as well as a tongue and a beer. A righteous interruption . . . so reader know that you aren't looking for a bottom but exploring the multi-trajectorised paths and cross roads of the text. There is no proper, no real, no single meaning.

(*Reggae Chicken*, back page)

## CONCLUSION

In criticism of the movement some people have asked rhetorically: 'What has riot grrrl achieved?' Yet gesturing to the continual prominence of males in independent music seems a rather specious reply. Huggy Bear's comment that 'revolution fails' (*Reggae Chicken*: 13) seems crucial in summation for, despite this acknowledgement, they continue to declare 'our time now'.[26] The importance of the movement can be measured not in its final 'result' but in the effect it has had on individuals. Riot grrrl opened debate concerning the position of girls and women creating and performing music. The politics may be understood as being of personal achievement and empowerment rather than of solid movement policy and goals. Its dynamism may be viewed as its strength: an illustration of which is the emergence this year of a new group entitled Females Being Independent (FBI) in York, taking inspiration from riot grrrl, but choosing to use another name.

It is ironic that whilst riot grrrls, aware of their position as cultural curiosity, adopted methods to control outside media and academic interest, this further heightened the attention of such parties. In writing this chapter I am acutely aware of my own involvement in this process. Other researchers writing about riot grrrl have also commented on the necessity of analysing their own position in relation to these girls and women. The

experience of ethnographer Lori Taylor is most enlightening. City *Paper* rejected the article they commissioned Taylor to write on riot grrrl as they considered it too sympathetic and were unhappy with her decision not to describe participants in terms of fashion. Taylor posted the article to her main riot grrrl contact, explaining what had happened. A defence of her standpoint was subsequently included in a Washington DC zine. Rather than a detached ethnographer, Taylor had become a visible figure for riot grrrls. She comments on the uncomfortable sense this gave her: 'I was pleased that I came out on the right side, but I was very embarrassed to have been noticed at all' (Taylor, 1993: 14). She stresses how respect for riot grrrls was her uppermost concern and comments on how this experience caused her to reassess her role as researcher: 'Maybe any scholarly investigation of girl culture is an unjustifiable invasion of privacy. Maybe girl culture should remain an undeveloped wilderness preserve on our cultural landscape' (Taylor, 1993: 14). In another study Gottlieb and Wald explain that their academic interpretation of riot grrrl was met with resistance by participants because they had attempted to speak for this group (Gottlieb and Wald, 1994: 270).

This chapter has illustrated the complexity of riot grrrl through an exploration of some of its facets. The aim has not been to present the substance of a network which has striven to avoid cohesion, but to highlight some points of interest. Whilst bands and zines issued declarations of intent under the name of riot grrrl, they were quick to stress that these were not representative of all grrrls, offering individual and sometimes conflicting responses. This chapter has considered how participants reworked conventions of female display and performance, allowing girls and women new possibilities of discourse. Examination of niche and mass media reports, whilst revealing somewhat predictable responses of fascination and dismissal, has focused on the relationship between reporter and subject. Demonstrating media literacy, riot grrrls involved themselves in the process of publicity and skilfully managed their own promotion. Riot grrrl sets a challenge not only to the authority of the journalist, but to the academic and begins to close the gap between critic and subject, as Huggy Bear state: 'you're involved in this argument as much as we are'.[27]

## NOTES

1  Sleeve notes to *Cause*, 'a spoken word and musical celebration of our right to choose' (Piece of Mind, Los Angeles).
2  'SWIM NOTES', *The Strong Women In Music Newsletter* #1, New York, 1993.
3  Sleeve notes to Huggy Bear, . . . *Our Troubled Youth*/Bikini Kill, *Yeah, Yeah, Yeah, Yeah* (Catcall, London).

4   Bikini Kill, Bikini Kill (Kill Rock Stars, Olympia, Washington).
5   Quoted from paper given by Karren on 'Girl Love and Girl Action' at the Institute of Contemporary Arts, London, 4 December 1993.
6   Juliana Luecking, personal communication, 20 August 1994.
7   Tobi Vail, sleeve notes to *Stars Kill Rock* (Kill Rock Stars, Olympia, Washington).
8   *An Introductory Mechanics Guide to Putting Out Records, Cassettes and CDs*, produced by Simple Machines, Arlington, Virginia.
9   Ibid.
10  Karren, op. cit., 4 December 1993.
11  This statement appears in *Riot Grrrl #8* (Washington DC). The declaration is also in evidence in the British media, an example of which was when it was written on a naked woman's body, photographed and included in the article: 'Who are the RIOT GRRRLS?' Susan Corrigan, i-D 115 (April 1993): 28, 30.
12  *Daily Star*, March 1993, republished in *Melody Maker* 20 March 1993: 38.
13  'Rebel Girl', on split LP: Bikini Kill, *Yeah, Yeah, Yeah, Yeah*/Huggy Bear, . . . *Our Troubled Youth* (Catcall, London).
14  'Her Jazz', Huggy Bear (Wiiija/Catcall, London).
15  One could alternatively trace the American response to the riot grrrl 'phenomena' in the publications *Rolling Stone*, *Spin*, *Option*, *Sassy*, *New Yorker*, *LA Weekly*, *USA Today*, *Interview*, *New York Times*, *Washington Post*, *Ms*, *Newsweek*, *Seventeen* and *Billboard*.
16  See articles published in *Option*, *The New Yorker*, *LA Weekly*, *Spin* and *Village Voice*.
17  Riot grrrl articles were published in *Melody Maker*, *NME*, the *Daily Star*, the *Evening Standard*, *The Zine*, *Lime Lizard*, *Elle*, *The Independent Catalogue*, *The Wire*, *Lip 1*, *The Face*, *Ms London*, *The Guardian*, *Vox*, *i-D*, *Select*, *Indiecator*, *Shebang*, *Girl about Town* and *The Independent*.
18  See Daisy Waugh (1993); Anne Barrowclough (1993); Hester Matthewman, 'Rock against Men is Music to the Riot Grrrls' Ears', *The Independent on Sunday* 14 March 1993.
19  See also Miranda Sawyer, 'Life's a Riot with Grrrrlvsboy!' *Select* May 1993: 24–5.
20  See note 11.
21  See Stewart Home quoted by Sadie Plant in 'When Blowing the Strike Is Striking the Blow', published in *The Art Strike Papers* (AK Press, Stirling, 1991), p. 4.
22  Bikini Kill, Bikini Kill (Kill Rock Stars, Olympia, Washington).
23  'Her Jazz', Huggy Bear (Wiiija/Catcall, London).
24  Huggy Bear, live at Harlow Square, London, 22 March 1994.
25  Steward Home, 'TOWARDS NOTHING: Notes From the Generation Positive on the Nature of Conspiracy', Oct. 1982, collected in Steward Home, *Neoist Manifestos* (AK Press, Stirling, 1991), p. 6.
26  'Her Jazz', Huggy Bear (Wiiija/Catcall, London).
27  Huggy Bear, live at Harlow Square, London, 22 March 1994.

## REFERENCES

Arnold, G . (1992) 'Revolution Grrrl-Style', *Options* 44 (May/June): 44–6.
Barrowclough, A. (1993) 'Save the World? Not a Hope Grrrls', *Mail on Saturday*, 27 March: 27.
Brown, B. (1993) 'Riot Squad', *The Zine* 1 (July): 27.
Chideya, F., Rossi, M. and Hannah, D. (1992) 'Revolution, Girl Style', *Newsweek*, 23 November: 84.
Cohen, S. (1980) *Folk Devils and Moral Panics: The Creation of the Mods and Rockers*, Oxford: Martin Robertson.
Glamour (1993) 'Grrrl Talk', *Glamour* May: 134.

Goad, D. (1994) 'Riot Grrrls Rrreally Borrring', *Your Flesh* #29 (10 Year Anniversary 1984–1994): 22.

Gottlieb, J. and Wald, G. (1994) 'Smells like Teen Spirit: Riot Grrrls, Revolution and Women in Independent Rock', in A. Ross and T. Rose (eds) *Microphone Fiends: Youth Music and Youth Culture*, London: Routledge.

Hebdige, D. (1979) *Subculture: The Meaning of Style*, London: Methuen.

Home, S. (1991) *Neoist Manifestos/The Art Strike Papers*, Stirling: AK Press.

Japenga, A. (1992) 'Punk's Girl Groups are Putting the Self Back in Self-Esteem', *The New York Times* 15 November: Section 2: Arts and Leisure, 30.

Joy, S.M. (1992) 'Revolution Grrrl Style Now!', *Melody Maker* 10 October: 30–2.

McRobbie, A. (1994) *Postmodernism and Popular Culture*, London: Routledge.

Manning, S. (1994) 'Viewpoint', *Melody Maker* 29 January: 35.

Matthewman, H. (1993) 'Rock against Men is Music to the Riot Grrrls' Ears', *The Independent on Sunday* 14 March.

Mungham, G. and Pearson, G. (eds) (1976) *Working-Class Youth Culture*, London: Routledge and Kegan Paul.

Naylor, L. (1992) 'Grrrls! Grrrls! Grrrls!', *Melody Maker* 26 September: 27.

Sawyer, M. (1993) 'Life's a Riot with Grrrrlvsboy!', *Select* May: 24–5.

Snead, E. (1992) 'Feminist Riot Grrrls Don't Just Wanna Have Fun', *USA Today* 7 August: 5D.

Taylor, L. (1993) 'Riot Grrrls Respond to Fame', unpublished paper presented to American Folklore Society, Eugene, Oregon, 30 October.

Terry, N. (1993) 'Linus', *Lime Lizard* September: 14.

Thornton, S. (1994) 'Moral Panic, the Media and British Rave Culture', in A. Ross and T. Rose (eds) *Microphone Fiends: Youth Music and Youth Culture*, London: Routledge.

Waugh, D. (1993) 'Don't Mess with the Girls who Just Wanna Be Grrrls', *Evening Standard* 16 August: 10.

Wells, S. (1993) 'Ready, Teddy, Go!', *NME* 6 March: 13.

White, E. (1992) 'Revolution Grrrl Style Now', *LA Weekly* 14 (32) 10–16 July: 22.

## Referenced zines (produced between 1991 and 1994)

*Ablaze!* #10 (Leeds, England), *Discharge* #3 (Richmond, Virginia), *Fake* #0 (Potomac, Maryland), *Girl Pride* #6 (London, England), *Girlfrenzy* #3 (London, England), *Girls' Annual* #1 (London, England), *Go Go Grrl* #1 (London, England), *Grunge Gerl* #1 (Los Angeles, California), *Hair Pie* #2 (Dyfed, Wales), *Hotskirt* (Little Rock, Arkansas), *Intimate Wipe* (London, England), *Kingfish* #2 (Berkeley, California), *Kookie Monster's Free Peach Thingy* (Cardiff, Wales), *Notta Babe!* #1 (Arlington, Virginia), *Pariah* #1 (Sheffield, England), *Persephone's Network* (Cleveland, Ohio), *Plague Your Eyes* (London, England), *Quit Whining* 1 (S. Hadley, Massachusetts), *Reggae Chicken* (London, England), *Riot Grrrl* #6 (Arlington, Virginia), *Riot Grrrl!* (Leeds and Bradford, England), *Riot Grrrl* #5 (New York City), *Riot Grrrl and Riot Grrrl* #8 (Washington DC).

# Part IV

# MUSIC, IMAGE AND IDENTITY

# 14

# SEDUCED BY THE SIGN

## An analysis of the textual links between sound and image in pop videos

### Sheila Whiteley

## INTRODUCTION

In recent years there has been considerable debate on the extent to which the musical content in pop videos has become subordinate to the visual realisation. Whilst there are some exemplary texts on the analysis of music video (not least in Kobena Mercer's reading of Michael Jackson's *Thriller* tape,[1] Jody Berland's exploration of the relationship between sound and image in music videos[2], and Andrew Goodwin's evaluation of the problems in applying postmodern theory to music video[3]) there is still a marked absence of theoretical models which move beyond the limitations of content analysis, and which allow for a critical examination of the textual links between sound and vision in establishing meaning.

This chapter discusses the relationships between visuals and music in the perception of music videos, so opening out the premise that pop videos impose a visual interpretation of the song, that the preferred meaning is largely weighted in favour of the image. It proposes an analytical methodology based on Barthes's codes of narratology[4] which is applied to an independent consideration of Madonna's single 'Justify my Love'. The vocal line of the single is then situated within a content analysis of the video to determine the synchronicity between the vocal/visual mix. My discussion of the three paradigmatic codes (semic, cultural and symbolic) is informed by a questionnaire and subsequent discussions with students from the BA (Hons) Popular Music and Recording and the BA (Hons) Media Production courses at the Faculty of Media, Music and Performance, University of Salford.

The purpose of the questionnaire was twofold. Question 1 asked whether students (a) heard the single first, or (b) saw the video first. Those students who had heard the single first were then asked to describe

briefly the extent to which the images on the video confirmed or changed the perception of the song, and hence its meaning. Question 2 was not designed to quantify individual responses but rather to provide a lift-off point for seminar discussion. Relevant points are incorporated into my analysis.

Questions 3 and 4 were similar in design. Question 3 provided quantifiable data: 'Do you think Madonna engages with (a) the male viewer (b) the female viewer (c) both the male and female viewer?', whilst the purpose of question 4 was not to produce quantifiable responses, but to generate a discussion of cultural and symbolic coding which focused in on such points as characterisation and whether the meanings of the music/video were similar for males/females. As a preliminary survey, the insights gained were useful and it is considered that this approach could be adopted for further sociological study.

## DISCUSSION OF METHODOLOGICAL APPROACH

Whilst 'a single can exist (technically, at least) without the video, . . . the reverse is not the case'.[5] Thus an independent musicological analysis of the single 'Justify my Love' can provide an insight into its structures and a tentative reading of the connotations of the lyrics. In conjunction with the video, however, the question arises as to whether the meaning of the single remains the same. Unlike a soundtrack, which provides an atmospheric environment for the visual content, the pop video is essentially a specific visual representation of the musical content.

Whilst it is demonstrably the case that the music video does not generally change the sound or structure of the song, it is equally true that few videos successfully cut to the beat.[6] 'Vogue', (Madonna, 1991) is a rare exception. It works, as Sean Cubitt points out, because:

> we are invited to look at a series of poses, effectively at still images rather than moving ones . . . they succeed one another in time, thereby achieving motion, and some rely on choreography. But the motion of the piece is entirely held in the transitions from one tableau, one post to another.[7]

At the same time, the majority of videos, with their sequencing of images, seem to respond to the underlying rhythm which appears to lead both the ear and the eye. The primacy of rhythm would thus appear to be fundamental to the functions of the narrative. Events are organised sequentially and are therefore basic to the unfolding of the plot. Rhythm

analysis might, then, provide one approach to understanding the synchronicity of the visual and musical texts, but clearly the problem is to find a methodological approach which provides a suitable framework for the analysis of both the musical and visual content of a video in determining meaning.

Whilst Barthes's 'codes of reading' in S/Z[8] are applied most generally to an analysis of the written text, they have, nevertheless, a relevance to the deconstruction of musical structures. This is exemplified both by Barthes,[9] and Carolyn Abbate's reading of, for example, the opening of 'The Sorcerer's Apprentice'.[10] My musical analogies for Barthes's codes depend largely upon the premise that 'music analysis is itself born of a narrative impulse. . . We create fictions about music to explain where no other form of explanation is possible and look to literary categories to endorse them'.[11] Clearly the kind of narrative incited and the questions posed by the musical structures vary, depending on musical-stylistical conventions[12] as well as the mode of listening applied.[13] With regard to pop videos, it is suggested that the implied rhythmic synchronicity between visual and musical content impacts upon the viewer to inform both the underlying structures and the surface details. As such, it is integral to the effective functioning of the narrative.

According to Barthes the proairetic (or narrative) code, provides a common-sense knowledge of what is going on. Sequences are ordered within the narrative and we order the sequences in our mind to make sense of the narrative. The hermeneutic code poses and reposes questions. Information is gradually revealed which stimulates interest as we move towards the final solution of the story. The semic code works at the level of the signifier (denotation, connotation, etc.) whilst the cultural code is related to our narrative competence, how we pick up references, clues (and potentially snares) which are seeded into the text. Finally, the symbolic code pulls us into the system of textual relations, drawing on preconceived ideas which are often based on our positioning in culture as male/female, heterosexual/homosexual, White/Black, middle/working class, etc. and with a privileging of first terms.

With regard to the musical content, Barthes compared the syntagmatic codes (proairetic, hermeneutic) to long pedal points and typically continuous instrumental timbres; the paradigmatic codes (semiotic, symbolic, cultural) to instantaneous sixteenth or eighth-notes, flashes in the percussion or brass. Whilst these are a useful guide to Barthes's thinking, I would suggest that the proairetic code (the syntagmatic code of action) organises the sequence of events through rhythmic and/or harmonic structures, which, as functions, are irreversible in time. In effect, they provide a way

of analysing how events are linked, how they begin and end. These, in turn, allow for the music itself to predict events through:

(a) repetition
(b) variation
(c) transposition

and which end in stasis.

The hermeneutic code (also syntagmatic) poses and reposes the central enigma, with both the musical content and the words regulating the disclosure of information by, for example:

(a) delaying cadences or phrase endings,
(b) extension,
(c) elaboration (of a motive or rhythmic cell),
(d) improvisation.

These, in turn, sustain interest until the climax or resolution of the song. Extended improvisation, for example, delays the end of the song, engenders suspense before the final resolution.

The three paradigmatic codes (semic, symbolic, cultural) can, by analogy, be described as musical and historical references. The semic code deals with atmospheric characteristics in the form of scattered connotations at the surface level, for example:

(a) the use of pitch distortion,
(b) vibrato,
(c) timbre,
(d) textural change.

The cultural code refers outwards and draws on the listener's competence to pick up on the references seeded into the music and its lyrics, for example:

(a) the stylistic characteristics of the singer, performer and musical idiom;
(b) issues surrounding, for example, sexuality and gendering.

Finally, the symbolic code draws the listener into the system of textual relations and focuses on such questions as whether the meanings of the music/lyrics are similar for males/females, Blacks/Whites/ethnic minorities, heterosexuals/homosexuals/lesbians, etc.[14]

Whilst the principal aim of my research was to determine the usefulness

of applying Barthes's codes of narratology to the analysis of music videos, the cultural and symbolic codes raised problems. As a white, heterosexual female I felt that my reading of the text could not adequately explore, for example, the male perceptions of Madonna's characterisation of the female protagonist and its exploration of sexualities. So my reading of the text is informed by ideas arising from student debate and relevant points are incorporated into the discussion. Direct quotes are given in italics.

## 'JUSTIFY MY LOVE'

### Analysis

An analysis of the single 'Justify my Love' (written by Lenny Kravitz, with additional lyrics by Madonna) shows that the song is organised rhythmically through the repetitive mid-tempo (98 bpm) drumtrack pattern which continues without variation from the opening two bars to the end:

This is overlaid with a basic 'strings' pattern which centres around the chord of F♯ minor. The figure, in terms of traditional harmony, uses two voices which describe the following four chords:

$$F\sharp m, \quad F\sharp m7, \quad \frac{B^{\text{add }9}}{F\sharp} \quad \text{and} \quad \frac{Bm^{\text{add }9}}{F\sharp}$$

with the bass note F♯ acting as pedal point throughout the track. Both voices are given a distinctive and continuous timbre, which, in conjunction with the unvarying tempo, dynamic and rhythmic levels work syntagmatically in establishing a sense of underpinning and ordering the sequence of events.

Initially, the introduction has the feel of a dance track with its stabbing drum line, but the strings move against the rhythm, and the low pitch of the sustained F♯ creates a hole in the musical texture. As such, the semic code (the scattered connotations) work in tandem with the cultural code to suggest a feeling of emptiness which is enhanced by the use of an echo effect. As the song unfolds, there is an increasing sense of predictability in the musical form. This is enhanced by the introduction to each verse,

where the drum track plays alone, followed by four repeats of the parallel 5th which, in its upward movement from E to F♯:

draws on the hermeneutic code to initiate a feeling of anticipation, an underlying tension which is released by Madonna's spoken delivery of the lyric line.

Although the unchanging musical structure of the song could be described as informationally closed, the contrast between the spoken verse and the sung chorus regulates the disclosure of information whilst posing and reposing the central enigma surrounding the title, 'Justify my Love'. In terms of vocal timbre (semic code), the verse has a sense of intimacy in the breathy delivery, whilst the low-volume, bluesy vocal in the background, which anticipates Madonna's spoken 'I wanna kiss you in Paris', provides atmospheric and psychological coding, focusing on the cultural/referential code and the ability of the listener to access the symbolic conventions and historical connotations of 'blues'. Deeper in the mix, continuous slow breathing adds to the overall texture whilst underpinning the overall feel of sensuality.

Initially, the lyrics imply a specific relationship in the heavy reliance on I/You:

> I wanna kiss you in Paris
> I wanna hold your hand in Rome . . .

which is enhanced by the romantic connotations of the cities which are partially engendered by association with such American films as *An American in Paris*, *Gigi*, *Three Coins in a Fountain*, *Summertime in Venice*, for example (cultural code).[15]

The chorus signals a certain change in atmospheric characteristics (semic code). Here, the breathing initially punctuates the 'wanting, needing, waiting' which prefaces the doubled-tracked 'for you to justify my love'. It then subsides deeper into the mix (as the voices pan between foreground/background on the repeated 'my love') to provide its own sensual rhythm as the voices duet, evoking a feel of complicity before the return to the drum track. This time it, too, is overlaid by the breathing which climaxes with a slow, hiss like breath and an uttered 'OK' before the second

verse. Whilst the formal characteristics of the music continue, the 'OK', nevertheless, suggests a move in direction – a point which is reflected in the 'I wanna know you . . . no, not like that' of the second verse. The overall effect, as one student suggested, is of being:

> suspended in foreplay, anticipatory (waiting for you), with the cycles of the sequence providing a musical analogy for the fluttering surges that flow through the body (fading in and out) as you get turned on until you reach the point of no return, but this is still kept on hold musically through the constant emphasis on the F$\sharp$ pedal.

In terms of cultural coding, listeners are quick to pick up on the vocal delivery which is quintessential Madonna. The emphasis on sexual nuance, which has characterised her songs, is effected through the vocal timbre which has a sense of intimacy in its breathy quality. At the same time, whilst the vocal timbre of Madonna's voice emphasises the sexual impact of the song, it also engages extra-textually, not least with her own previous recordings, but also in the media reports and myths which surround her. Whilst it is well-established that meanings are relative and varied, the constant play on Madonna's established sexuality, from the fixation on her navel, through to the overt pleasuring in her own physicality in her much discussed book SEX, the emphasis on her independent, self-defining sexuality and her parodying of conventional representations of women, both draws on and informs the listener's competence to pick up on the references seeded into the music and the lyrics.

> I expect highly sexual images from Madonna – the breathy delivery and the slow repetitive rhythm implied this.

> Due to the pulse of the music, I presumed the video would involve some sort of simulated sex scenes.

There may be the suggestion of the submissive in the first verse, but listeners are aware that Madonna's popularity is a complexity of power and resistances, of meanings and counter-meanings, of pleasures, and the struggle for control and, as such, the song contains imagined possibilities.

The chorus, for example, with its emphasis on the incantatory present participle:

'Wanting, needing, waiting
Hoping, praying . . . (first chorus)
Yearning, burning . . . (second chorus)

draws initially on the connotations of the supplicant (a position also adopted in, for example, 'Like a Prayer', 'La Isla Bonita') before the explicit focus on the song's enigmatic 'justify my love'. For the listener, certain questions are raised: why 'justify', what is it that needs justification rather than, say, 'satisfy' or 'return'? At the same time, the chorus triggers a certain change in direction in the move from the instructive 'I want to know you – not like that' to the challenging imperatives 'talk', 'tell' of the third verse. Here, the sexual nuancing on dreams ('am I in them?'), fears ('are you scared?') and stories ('I'm not afraid of who you are') imply more the position of a woman sexually in control, leading the 'man' (for whilst the 'you' is sexually ambiguous in its mode of address, the penultimate couplet would imply a heterosexual relationship) from fantasy to a sexual realisation of hidden desire. This sense of confidence is reinforced by the two final couplets:

Poor is the man whose pleasures depend
upon the permission of another . . .

with the underlying connotations of domination, and the imperative

Love me, that's right, love me
I wanna be your baby

While the lyrics imply an overall focus on sexual fantasy, from the innocent 'I wanna kiss you in Paris' to the implicit s/m of pleasuring allied to 'permission' in the penultimate couplet with the suggestion that, perhaps, certain pleasures need to be justified, of the 66 per cent of students who had heard the single first, only 16 per cent felt that the video confirmed the expectations generated by the single. This was often qualified by, for example:

I expected it to be sexually controversial.

I presumed the video would involve simulated sex scenes.

I quite expected something like this from the video of whatever sexual persuasion.

A further 42 per cent felt that the video didn't make any difference, and of these, the majority commented upon its commercialism 'Just there to sell' and accordingly felt its content to be 'irrelevant' to them. Comments such as 'good song', 'crap video' were qualified by such phrases as 'just a commercial that worked as it got banned and people talked of nothing else'. The remaining 42 per cent felt that the video changed their perception of the song whilst agreeing that it confirmed the sexual theme implicit in the single. The diversity of response as to 'why' makes the answers unquantifiable, but subsequent discussion indicates that for the majority, 'it completely changed my perception of the story'. In particular, students had not anticipated the lesbian scenes or the bondage tableaux and were unaware of 'the sexual ambiguities inherent in the song'.[16] Others felt that 'the track lost its ambiguity through the concrete images'. As such, there was a general feeling that individual interpretation was moulded by Madonna's construction of sexuality as the site of power, fantasy and polysexual eroticism.[17]

What is interesting, however, is that so many pointed to the fact that the ambiguities in the track were lost in the video, and that 'whilst opening up the text by focusing on lesbian scenes' the images projected were somehow immutable, 'concrete' and, as such, denied any fluidity of interpretation. Indeed, discussions at seminars revealed a general consensus that once the video was seen, the underlying connotations of the song were made both explicit and plausible. In other words, the visual images would appear to structure the meaning, so giving rise to a sense of 'of course, that makes sense, I just hadn't thought of it like that'. An analysis of the video indicates that this could be attributed to the clear synchronicity between the vocal/visual mix.

### 'JUSTIFY MY LOVE' – THE VIDEO

Filmed in black and white, Madonna is first seen walking down a hotel hallway. Dressed in an overcoat, carrying a suitcase, her hand is held to her forehead.

| | |
|---|---|
| 'I wanna kiss you in Paris' | Profiled close-up of Madonna, her hands initially caressing her neck before they move down to part her coat. Camera pans left to reveal out-of-focus male figure (Ward) emerge from door on screen left. As he starts to walk slowly towards her the camera pans right eliminating him from the frame. |

| | |
|---|---|
| 'I wanna hold your hand in Rome' | Madonna plays with hair, then neck. Camera pans left to include male figure then cuts to reverse angle shot, positioned behind male figure, as he slowly walks towards her. Caresses face, mouth open, profiled. Madonna moves slowly against the wall. |
| 'I wanna run naked in a rain storm' | Camera cuts to reverse angle shot of male legs which frame Madonna. Camera and Ward track towards her. |
| 'Make love in a train, cross-country' | Cuts to close-up profile of Madonna revealing bra-strap. Mixes through to shot of shoulder as Madonna sinks slowly down. Focus on hand as she appears to simulate masturbation. |
| 'You put this on me' | Camera tracks into her thighs which part, and tilts up to reveal her looking up at male figure. She lifts her hands to him. |
| 'so now what?' | Lifts her hands to Ward. |
| 'so now what?' | Camera tightens to a big close-up profile of Madonna. |
| 'Wanting' | She stands. Camera travels up with her, blurred shot as Madonna pulls Ward towards her. |
| 'Needing', 'waiting' | Blurred shot of Madonna and Ward kissing. |
| 'For you to justify my love' | Refocuses and pans off to Ward's hand on wall supporting them. |
| 'My love' | Pans back to momentary shot of them kissing and goes beyond to the empty corridor. |
| 'Waiting' | Cut to tracking shot down corridor past slightly open doorway. Male in black leather |
| 'Praying' | lacing female into bustier. |
| 'For you to justify my love' | Cut to woman in bustier who turns to camera, thrusting her breasts forward. |
| Drum link to chorus | Mixes to shot of door opening to reveal androgynous figure silhouetted against window in what appears to be a hotel sitting room. Heavily posed dancing. Camera tracks towards figure then cuts to tighter shot of Ward, the back of Madonna's head blurred in the foreground. |

'OK'                        Cuts to high-angle reverse shot of Madonna
                            on bed looking up at Ward
'female vocal'              as she slowly raises her hands to her head.
                            Camera travels behind Ward. Madonna
                            slowly revealed, hair down, subsides on to
                            bed. Ward takes off his braces and shirt.
                            Low angle shot of his bare chest with cru-
                            cifixes, from Madonna's point of view.
'I wanna know you'          Ward leans over her.

## DISCUSSION

In addition to the careful mixing of the vocal/visual, it is equally appar-
ent that the ordered sequences open out and 'make sense' of the narrative
exposition of events in the song. The opening vocal line 'I wanna kiss you
in Paris' informs the location of the video. Madonna is there with a suit-
case, in a corridor which suggests 'hotel'. The intimacy of the spoken
utterance, the self-caressing gestures suggest an auto-eroticism which
becomes focused as Ward appears and the narrative unfolds. At the same
time, there is a play on the hermeneutic as information is gradually
revealed and focused by the lyrics. The initial 'for you to justify my love'
may suggest a partial sense of fulfilment as Madonna and Ward kiss, but
the repeated line is opened out to bring into play alternative sexualities
which inform the enigmatic quality of 'justify' (as implied in an analysis
of the single) and the nature of 'my love'. At the same time, the images
of s/m stimulate the imagination and push towards a desire for resolution
which is only partially satisfied by the shots of Ward and Madonna and the
questioning of 'I wanna know you'.

The use of soft focus and the connotations of documentary, as the hand-
held camera makes the viewer 'aware of its presence', its revelation of
something already happening, enhances the sense of voyeurism as the
hotel corridor is opened out to scenes of alternative sexuality whilst the
viewer picks up on the clues ('Is this what she had in mind?') and snares
('Is Ward, her real boyfriend at the time, the centre of her desire?') that are
seeded into the text. As the song progresses, information is gradually
revealed which stimulates interest, posing and reposing the central enigma
surrounding the nature of 'justify my love'. The camera privileges scenes of
alternative sexualities: female couples drawing moustaches on each other,
male couples in drag caressing as Madonna watches whilst Ward, disem-
powered, is worked over by a dominatrix. The video ends with Madonna
hurrying down the corridor, stifling a laugh and shaking her wrist.

At the same time, the video provides a sense of femininity as play. It is an act, a screened performance which involves dressing up, make-up, lighting, camera styles. Madonna acts out a series of roles where she engages with the viewer's awareness that these are both choreographed images and familiar poses made unfamiliar. There is a problematising of what constitutes femininity, in its relationship to sexualities, which is expressed through a sense of fantasy which challenges stereotypical responses to what constitutes the 'male', the 'female'. As such, the video allows both for the possibility of an entirely self-involved sexuality in its auto-eroticism, and a complex range of identification and desire for Madonna as opposite sex/same sex. Gay black sexuality, lesbianism, androgyneity and an engagement with sexual fantasy and voyeurism (as exemplified in the choreographed shots of staged tableaux) disrupt any sense of normative heterosexuality (as implied by an unmediated reading of the song) to focus instead on themes of multi-gendering. At the same time there is an emphasis on the fetishistic in the specific focus on parts of the body – the drawing of moustaches on the lesbians, the exposed breasts, the eroticised clothing and the returned gaze, as Madonna looks directly into the camera in the knowledge that she is being looked at, simultaneously both submitting to that inspection and controlling it.[18]

Whilst Madonna's live performances and videos equally explore a range of sexualities, the latter clearly privilege a more intimate viewpoint by accessing eye-contact and subtleties of facial expression. In 'Justify my Love', voyeurism comes from inside and outside the narrative as the viewer is also cast in the role of voyeur, watching the unravelling scenes of sado-masochism and gay/lesbian eroticism, whilst experiencing (through Madonna's eyes) her view of Ward's body as he folds over her. In 'Open Your Heart' voyeurism is contained within the narrative through, for example, the play on one-way mirrors. There is, then, a distinction between a 'sujet d'énoncé' and a 'sujet d'énonciation' in the two videos. Nevertheless, the filmed images, whereby the songs are framed by the narrative exposition, invite the viewer to look rather than listen. Sexual pleasuring is displayed for the viewer, implying that knowledge is to be secured through pleasurable looking. The exhibitionism suggests a sense of display and is a central axis in the video's production of meaning as facial expressions (Madonna's 'come-on' look, for example), and bodily display sustain interest whilst providing a preferred reading of the lyric text.

Finally, I will explore briefly the notion of 'character' as portrayed by Madonna. Whilst it is evident from the onset that this is Madonna, playing Madonna, demonstrating her knowingness about sexuality, the character in the video is first and foremost illusional, i.e. distinct from

Madonna's persona. At the same time, the fact that it is Madonna accesses particular attributes which have an ambivalent relationship as they play upon reality/non-reality (she is sexual, mature, powerful and understands the processes of video-making, etc.). Her relationship to the other characters in the video also draws on character attributes both real (Ward, who plays the lover, was her lover at the time, but he, too, is a character within the unfolding narrative) and unreal (the fictional playing out of lesbianism, sado-masochism). Whilst this draws on symbolic coding in its emphasis on textual relations and preconceived ideas ('how do lesbians behave?') it equally points to the differing interpretations of Madonna within feminist debate (is she providing insights into repression in her shot of a male in bed with two women (presumably lesbians), is she pandering to the typical role of woman within pornography, or are there careful symbolic containment structures which define the woman as 'in charge', so providing symbolic satisfaction rather than male fantasy?

My own reading of the video would suggest that Madonna is very much in charge, not least because of her own control over the production process itself.[19] I would also draw attention to the final shot which situates her as independent, confident at both entering into and controlling a 'fantasy' world. The problems surrounding what appears to be a male representation of lesbianism to sell the product does, however, raise problems. The fact that she appears only to work with very decorative people (i.e. exploiting what Bourdieu calls 'bodily capital') suggests that she may simply be marketing sexuality. At the same time, this should be contextualised by Madonna's endorsement of all forms of sexuality whether gay, straight or auto-erotic, and an acceptance that any artist who deals with controversial or personal issues within the public arena of entertainment can be labelled as exploitative. However, I would suggest that Madonna's affirmation of positive and creative sexuality has informed many of the debates around sex and sexuality, not least in lesbian/gay studies, and that her popularity with female fans has provided them with a sense of self-empowerment and control over their own sexuality.[20] At the same time, the symbolic code raises problems – not least whether my reading of the video (and hence its meaning) is shared by male viewers. In particular it raises the question of the extent to which the video is seen as alleviating masculine psychological insecurities or simply stimulating masculine pleasure. This point was examined in the final question addressed to my students which asked: 'Do you think Madonna engages more with (a) the male viewer (b) the female viewer (c) both?': 95 per cent answered 'both'. Clearly a straight response to the question does little to answer the questions raised above but class discussion provided more insight:

The autoerotic opening plays on male fantasies but as the video progresses there is a suggestion of engaging with both sexes to create a sense of sexual ambiguity.

Those students who found it engaged more with the male viewer (2 per cent) suggested, for example:

> by exploring characteristics of sexual dominance she refers to patriarchal ideology. However, her portrayals utilise the technique of role reversal and in this way the narrative tends to challenge that ideology. In this sense I would argue that she engages the feminine anima of the male viewer but in terms of addressing its taboos as opposed to its compassionate characteristics.
>
> (male student)

The 3 per cent who felt it engaged more with the female viewer were similar as to their reasons why:

> she gives a positive, strong image of women, not of subjugation but of control in a sexual environment, equal to, if not more powerful than the male.
>
> (male student)

> She makes the female more domineering in order to contrast with the typical stereotype of the female as less dominant in a relationship.
>
> (female student)

However, when we discussed the last shot of Madonna, hand to mouth, laughing as she moved down the corridor, male students felt that she was laughing, symbolically, at them. They were disturbed by the shot, and said how it made them feel insecure. In contrast, the women recognised the laughter. We had experienced the feeling 'Now what have I done?' the suppressed, but very real, giggle. The look was complicit and addressed to us.

## APPENDIX 1   STUDENT QUESTIONNAIRE ON
## 'JUSTIFY MY LOVE'

I would be grateful if you would answer the following questions. The results will be incorporated into my current research into an analysis of meaning in music videos.

1   Did you
    (a) hear the single first
    (b) see the video first
    Please tick the appropriate answer.

2   If you heard the single first, please describe briefly
    (a) the extent to which the images on the video confirmed your
        initial interpretation of the song, or
    (b) changed your perception of the song
    Your response may include, for example, references to the subject matter addressed by the lyrics, the musical style, the extent to which the images suggest alternative interpretations of the lyrics, etc.

3   Do you think Madonna engages with
    (a) the male viewer
    (b) the female viewer
    (c) both the male and the female viewer
    Please tick appropriate answer.
    Why?

4   Any other comments on the recording or the video.

Thank you for responding to this questionnaire.

Please ring as appropriate

    male        female

## ACKNOWLEDGEMENTS

In many ways, this article attempts to respond to a problem I raised in my review article of *On Record: Rock, Pop and the Written Word*,[21] viz. that whilst the book addresses arguments about music and its meaning, any sustained analysis of musical content is sadly missing. As Susan McClary and Rob

Walser point out, there is a 'need to analyse verbal texts, performance styles and video imagery in tandem with the musical components'.[22] The 'in tandem' was intellectually intriguing, and I hope that this article provides some insight into how this can be achieved.

I would like especially to thank my colleagues Derek Scott, Gareth Palmer, Lesley Blaker and Nicola King for their helpful comments and advice, much of which has been incorporated into my discussion.

## NOTES

1 Mercer, K, (1993) 'Monster Metaphors: Notes on Michael Jackson's Thriller', in S. Frith, A. Goodwin and L. Grossberg (eds) *Sound and Vision: The Music Video Reader*, London: Routledge, pp. 93–108.

2 Berland, J. (1993) 'Sound, Image and Social Space: Music Video and Media Reconstruction', in ibid., pp. 25–43.

3 Goodwin, A. (1993) *Dancing in the Distraction Factory: Music, Television and Popular Culture*, London: Routledge.

4 Barthes, R. (1990) S/Z, trans. S. Heath, London: Fontana.

5 Berland, op. cit., p. 32.

6 However, it should be noted that cutting to the beat is regarded by many editors as somewhat of a cliché. Many prefer to use movement and action with the frame to monitor cuts, or to employ more subliminal ways of marrying pictures to the beat.

7 'In film theory, this is seen as "fetishistic", in the technical sense that it evokes a bond between display and the viewer, as if the image said "I know you're looking – and I like it"' (Cubitt, S. 'Rolling and Tumbling', Ch. 16 in this volume, p. 301).

8 Barthes, op. cit.

9 See 'The Full Score', in ibid., pp. 28–30.

10 Abbate, C. (1991) *Unsung Voices*, Princeton: Princeton University Press, pp. 41–6.

11 'Music is not a narrative but an incitement to make a narrative' (Natiez, J.-J. (1995) 'The Concept of Plat and Seriation Process in Music Analysis', trans. C. Dale, *Music Analysis, Theory and Practice* 4: pp. 107–18.)

12 As early as 1945, Adolf Bernhard Marx suggested a construction of gender related to first and second themes.

> The concept of the gendered theme emerges frequently in the written tradition as an Adam-and-Eve norm of masculine first themes and (as afterthoughts) feminine second themes. And clearly, to pursue Marx's biblical metaphor (Genesis 2: 4–5), it is the Composer Himself – assumed to be masculine – who is playing the role of God the Creator.

For contemporary musicologists, this assertion has become both disturbing and deeply problematic.

See Marx, A. (1845) *Die Lehre von der musikalishcen Komposition*, 2nd edn, vol. 3 (Leipzig) in Hepokoski, J. (1994) 'Masculine–Feminine', *The Musical Times* (August) Orpheus Publications Limited, p. 494. See also, McClary, S. (1991) 'Introduction: A Material Girl in Bluebeard's Castle', *Feminine Endings: Music, Gender, and Sexuality*, Minneapolis, Oxford: University of Minnesota Press.

13 See Introduction to this volume.

14 To an extent the semic (atmospheric characteristics) and cultural codes (stylistic characteristics of the musical idiom) raise problems in that they imply knowledge on the

part of the listener. Jimi Hendrix's performance of 'The Star Spangled Banner' provides one example of the way in which the two codes work. With regard to the semic code, there is an emphasis on distortion, delay, feedback, etc. At the same time, the critics' general response to his performance as undermining the sentiments behind the national anthem relies on the listener's understanding of the conventions and meaning of national anthems (cultural coding), the conventions of heavy rock, and Hendrix's position within the counter-culture and its attitude towards the dominant ideology. Whether meanings are shared depends largely upon cultural conventions and textual relations (symbolic code).

The symbolic code also raises issues such as whether the meaning of rap, for example, is the same for a Black, inner-city underprivileged male and a White, middle-class female academic.

15 As suggested by my colleague, Derek Scott.

16 Although this could point to the notorious insecurity of students when discussing either sentimentality or the ambiguities of sexuality and gender.

17    For utopian postmodernists this [i.e. the notion that there is no content to sexuality as it is a discursive and visual construct] points to the importance of potential parody and pastiche or ultimately transgression and subversion of sexual meaning. This comes through the decentring of sexual objectivity and subjectivity, the inversion of masculinity, femininity and the overall confusion of sexual categories temporally and spatially as present is past is future and heterosexual is homosexual is heterosexual.

(Edwards, T. (1994) *Erotics and Politics: Gay Male Sexuality,*
*Masculinity and Feminism,* London: Routledge, p. 140)

18    For Freud, the true fetishist is involved in a disavowal of sexual difference: the sight of what, biologically, defines the woman's body as different would cause anxiety, since it is the proof of infantile beliefs in castration. The fetishist's gaze is stopped at some point before the fatal sight is seen, blocked and entranced by the vision of a specific piece of clothing, gesture, display. . . . But if sexual difference is the price of admission into language and the world of meaning, the first difference that organises all those other differences that make a difference, then the fetishist is locked into a curious oscillation at the threshold of language and meaning, shuddering between the sight and the symbol that hides it.

(Cubitt, op. cit., this volume, p. 301)

19 As my colleague Gareth Palmer points out, 'Is it this surprising? Madonna is a gifted marketer, a multi-millionairess who *Forbes* magazine made businesswoman of the year, a capitalist whose own production activities are about making profit.'

It is certainly interesting to note that MTV refused to accept the video for pre-broadcast screening and that the 5-minute clip was marketed as a video single. Initial orders were so great that Warner/Reprise had to rush 250,000 copies. It would appear, then, that this is a case where the video was bought in preference to the song and during the week before Christmas 1990, *Video Insider* magazine listed 'Justify my Love' as Number 2 video, with 'Immaculate Collection' taking the Number 1 spot.

20 See also Lisa Henderson who believes that Madonna's work advances the cause of queer culture: 'For many young gay people . . . Madonna came closer to any other contemporary celebrity in being an above-ground queer icon.' As Kirsten Lentz explains, since Madonna deals with bi-sexuality in her work she is bound to be labelled with its traditional connection to images of greed and corruption, whether this is the case or not. See Henderson, L. (1994) 'Justify Our Love: Madonna and the Politics of Queer Sex', in L. Frank and P. Smith (eds) *Madonnarama: Essays on Sex and Popular Culture,* New York: Cleis Press, and Lentz, K.M., 'Chameleon, Vampire, Rich Slut', in ibid.

It is also interesting to note responses to the birth of Madonna's baby in October 1996, in particular the accolade that it is another instance of 'Express Yourself', the freedom to choose – not least, the father, and that motherhood and career can go hand-in-hand.

21 Whiteley, S. (1992) review article of S. Frith and A. Goodwin (eds) (1990) *On Record: Rock, Pop and the Written Word*, London: Routledge, in *Popular Music* (1): 123–6.

22 Ibid., p. 125.

# 15

# FEELING AND FUN

## Romance, dance and the performing male body in the Take That videos

### Paul McDonald

They appear from between a line of pillars. First Howard, elegantly curving his arms over his head. Then Robbie, who brings his hands together in prayer. Jason emerges, bends, and arches his back. Gary just sort of stands. Finally, Mark saws the air with his arms. For most of the video the boys will individually occupy separate spaces, with each lost in his own world. As the image cuts from colour to black and white, Gary – the one who sings – is caught alone on a beach. He sings to the sky, he sings to the sand. His song is addressed a lost loved one. His dark shirt hangs open to reveal his bare torso. He shows how he feels about the one he loves by opening his arms into empty space. Elsewhere on the beach, Mark is found frozen in a pose. His left arm covers his eyes and the right is held out straight behind him. Like Gary, Mark wears his shirt open to show off the chest and stomach. Jason is found at the edge of the shore, hands clasping an unseen object close to his chest. Howard is seen on the shore wrapping an arm around himself. Back to Mark. In slow motion, Mark's body is captured in an emotive moment, as he tosses his head backwards while bringing his hands together in prayer. Gary strokes his own chest and the inside of a thigh. Mark waves his shirt in the air. Robbie poses, holding a rock above his head. In colour, Howard, dressed in swimming costume, appears kneeling at the foot of a fountain. Mark stretches. Howard prays in the sand. Robbie hides in some vines. Robbie appears shirtless with water pouring over him. Jason still stands on the shore and as the camera pulls away it is clear he has no trousers. In one smooth gesture, Jason pulls his hand away from his chest to reveal a mirror he is holding against the place where we might imagine his heart to be. As sunlight catches the mirror, it glints. Gary sings, his face creasing with the feeling of the experiences he sings about. Intermittently, an unidentified woman, draped in flowing cloth, appears. She is on the shore, in the

vines, and by the fountain. Gary rubs his thighs. Robbie wipes thick make-up in lines down from his eyes. This action is reflected in the next shot, as thick lines of dark tears run from the unknown woman's eyes. Mark tosses sand about. Jason strikes a crucifix pose with the mirror glinting in his right hand. Whatever is going through his mind, he is clearly unconcerned about showing his underwear to the viewer. Oh, and now the woman also holds up a glinting mirror to the viewer. There is more stretching from Howard and Mark, and Robbie hugs the vines. Gary covers his eyes with his hands. Striking a high note, his hands embrace his chest. Before the end, Gary will open his arms up to the sky; Mark will arch his back and offer his torso heavenwards; Jason and the woman will shine their mirrors; Howard will stretch and haul himself along the side of the fountain; and Robbie will get wetter.

These are just some of the scenes from the video to 'Pray' (dir. Greg Masuak) by the boy group Take That. The boys, Gary Barlow, Howard Donald, Jason Orange, Mark Owen and Robbie Williams, became a group in September 1990. Released in July 1993, 'Pray' was their first Number 1 in the British charts. They achieved a total of eight Number 1 singles in Britain, and similar success was found elsewhere in Europe. Throughout their career, Take That retained a predominantly pre- or early teenage female audience, and continued to have a following amongst young gay males. In July 1995, Robbie departed to pursue a much-publicised solo career, and soon after the rest of the group split.

The videos by the group always focused on the spectacle of the male body. In a discussion of theatre, Bernard Beckerman (1990) defines 'presentation' and 'performance' in the following terms: presentation describes 'what is offered to the public', where performance is 'the rendition of what is shown' (p. 1). Performance 'contains the idea of process . . . stress[ing] the doing of the show', with presentation 'stress[ing] the giving of it' (p. 1). In the Take That videos, the male body was given to the viewer and acted as the centre of performance spectacle. The video for 'Pray' 'gives' the body in several ways. By centring the body in the frame, the eye is unavoidably drawn towards looking at the male physique. Use of slow motion at many stages of the video retards the movement of the body to make actions available to steady scrutiny. By organising the body so that it faces front on to the camera – for example Mark's arching and Jason's crucifix – the boys also appear to acknowledge the look of the viewer, and to willingly give themselves to that look. Areas of intimate flesh are offered to the viewer by the various states of underdress displayed by the boys. Additionally, lighting, colour and make-up, each contribute to presenting the flesh of these bodies as a smooth, firm, surface. By these

means, the body was 'given' to the viewer as a spectacle to be desired.

However, in 'Pray', the bodies of the boys were not only presented as desirable, but, by their actions, the boys also produced performances of desiring. The lyrics to 'Pray' tell of loss, parting, guilt, longing and the wish to be together with 'you' again. In the video, the boys did not dramatise a narrative situation but rather a sense of feeling. Their bodies performed on screen as the indices of desire. By their looking, holding, touching, arching and stretching, the boys showed that desire is felt by the body. Howard's stretching flexes the body, reaching for the lost one. Jason's clutching at his heart indicates where love is felt. Gary's touching of his chest and thighs signifies how the body experiences the pain of parting. Robbie's wistful melancholy look through the vines tells of the emptiness when 'you' have gone. Mark's arching to the heavens, pleads for a return. Above all else, such actions show how these are bodies that feel. Desire is signified by the performance – that is to say by the 'doing' – of the body.

In this chapter I intend to look further at the presentation and performance of the male body in the Take That videos. Film theory has seen some developments in conceptualising how the body is presented and performs on screen. This work has contributed to a critical discussion of gender representation in film. In the first part of the chapter I shall consider these developments, and argue that it is necessary to revise these perspectives for a discussion of music video. The second part of the chapter will explore how the videos produced different modes of presentation and performance, and discuss how these modes inflected the spectacle and action of the male body.

## GENDER AND THE PRESENTATION AND PERFORMANCE OF THE BODY IN SCREEN MEDIA

Thinking about the presentation of the body in music video is concerned with how the body is given as something to be looked at. Reading the performance of the body is then concerned with how the body presents particular forms of action and behaviour. Critical studies of cinema have explored how the look and performance have contributed to the construction of gender differences. Here I will assess the value of this work for a reading of the male body in music video.

## The look and the presentation of the body

Various developments in film studies have examined how structures of looking in film produce relationships of desire between spectators and the spectacle presented on-screen (an overview of this work appears in Mayne, 1993). The influence of Lacanian psychoanalysis on spectatorship theory has led to the conclusion that conventionally, narrative film organises ways of looking which concentrate on the bodies of women as objects of desire, thereby reproducing the pleasures of male heterosexuality (e.g. Mulvey, 1975). Although theoretically elaborate, spectatorship theory has tended to ignore the many ways in which visual media have repeatedly made the male body an object of spectacle, frequently eroticising the body in the process.

Andrew Goodwin (1993) has warned against the imposition of ideas from film theory on the reading of music video. The danger of reading music videos through film theory is that evident formal differences between music video and realist narrative film become interpreted as disruptions of a classical form. Goodwin's concerns arise from seeing how commentators have used the concept of the 'classic realist text' in film theory as the yardstick for taking music video as an innovation in audio-visual form. For Goodwin, the problem with such conclusions is that radical breaks are seen in what are actually the conventional forms of popular music performances (p. 76).

Similar difficulties emerge from imposing theories of spectatorship from film theory on to music video. First, television is not watched with the same concentrated gaze as film, but instead entertains a distracted glance (Ellis, 1982). A second difficulty with applying spectatorship theory to music television is that music video has habitually chosen to display the male torso as a spectacle for the distracted viewer's attention. From the viewpoint of spectatorship theory, the desirable presentation of the male body in the Take That videos would suggest a disruption of gendered conventions in looking. However, I would suggest that the effects of looking cannot be detached from the medium of looking. Music video has routinised the erotic spectacle of the male body, so that it has become a convention of the music television performance. Although the modes for presenting and performing the male body in the Take That video would appear out of place in narrative film, viewers greet music videos in the full expectation that such presentation belongs to the conventions of music television. Additionally, the look at the male in music video cannot be dissociated from a historical context which has increasingly produced the eroticised spectacle of the male body as one of the common signifiers of

contemporary consumer culture. Therefore, I would argue that the erotic spectacle of the male body is an established convention of music video, and my interest is to use the example of the Take That videos to describe some of the conventions by which the male body is presented and performs in music video. Although work already exists on how the male body is presented in heavy metal videos (Walser, 1993), what I will look at here is how the images which accompany the romantic ballads and dance tracks by Take That produce different conventions for showing the body on video.

### Performing gender

To concentrate on the body as an object presented in a structure of looking leads to a reading of the body as a static signifier. Reading the body as a performing body requires viewing the body as a source of action and movement. The relationship of gender to performance has been approached in recent cultural theory using the concept of 'masquerade'. This concept is derived from the work of the French psychoanalyst Joan Riviere, who argued that femininity was an act in which there was no 'genuine' womanliness separate from the masquerade (1929: 38). Commenting on Riviere's work, Stephen Heath explains '[i]n the masquerade the woman mimics an authentic – genuine – womanliness but then authentic womanliness is such a mimicry, is the masquerade; to be a woman is to dissimulate a fundamental masculinity, femininity is that dissimulation' (1986: 49).

According to this view, gendered identities are produced and performed in forms of doing, and there is no gender identity separable from the performance. As Judith Butler argues:

> gender is an identity tenuously constituted in time, instituted in an exterior space through a stylized repetition of acts. The effect of gender is produced through the stylization of the body and, hence, must be understood as the mundane way in which bodily gestures, movements, and styles . . . constitute the illusion of an abiding gendered self.
>
> (1990: 140)

Speaking of performance invokes notions of acting, in which a performer constructs a fictional identity. The concept of masquerade retains this sense of identity as something acted and constructed, but rather than see gender as the construction of a fictional person, masquerade is read as the reality of how gender differences are produced by the body.

Feminist film theory adopted the concept of masquerade for the anti-essentialist perspective it proposed for reading gender differences as constructed. The introduction of the concept arose from problems with the conclusions of spectatorship theory. By seeing cinema as an apparatus for the reproduction of male heterosexual desire, spectatorship theory argued that women could only appear in film as a projection of male desire. A difficulty with this monolithic description of narrative film was that it could not explain how female movie-goers formed their desires and pleasures when watching films. In response to the absence of the female movie-goer in film theory, Mary Ann Doane (1982) adopted the concept of masquerade to argue that in cases where the fetishisation of women on screen produced an excess of femininity, a position was constructed in which female movie-goers could potentially take pleasure in reading femininity as masquerade, that is as something only acted, made up and potentially changeable. In a manner similar to the concept of 'distanciation' in Brechtian dramaturgy, Doane argued that reading the masquerade could allow women to form a critical reading of gendered performance: 'masquerade, in flaunting femininity, holds it at a distance' (p. 81).

Although the concept of masquerade is useful for how it enables a reading of gender as a performative construction, some problems exist in how it has been applied to the reading of screen performance. Butler argues that any gender identity is performative, where Doane seems to regard only certain cases of performance — those which display an excess of femininity — as masquerade. This could then imply that there remain some forms of femininity — those which did not produce 'excess' — which are not performative. Doane's use of the concept could therefore lead to the conclusion that some representations of femininity cannot be read as performance. Second, excess appears to mean a superfluity of the costume codings which signify femininity. The difficulty with limiting the reading of gendered performance to items of costume is that it can suggest that while forms of dress are obviously something put on, it could be presumed that the body which lies underneath is a natural and inevitable fact. Third, in keeping with Beckerman's description of performance as doing, by only reading masquerade as items of clothing, analysis neglects how forms of action produce gendered meanings. Here, I want to retain the idea of masquerade — of gender as performance — but my focus will be on performance as the signification of the body in action.

Finally, as Chris Holmlund (1993) has argued, by the concentration on femininity as masquerade, critical analysis of screen performance has failed to address how constructions of masculinity are also performative. Indeed, in cultures where the production of feminine appearance has

required cosmetics and clothing to create a glamorous surface – so that it is known that femininity is 'made up' – it could be argued that definitions of masculinity are in contrast imagined as apparently unconstructed authentic identities. In such contexts, attempts to read masculinity as performance may be actually more difficult than seeing femininity as a construction.

Butler chooses to use a psychoanalytic framework to explain masculinity as the performance of 'having' the phallus (1990: 46). It is because, in psychoanalytic thinking, the phallus is a signifier of power which cannot be naturally possessed by either men or women, that masculinity constructs a performance of 'having' the phallus. Masculinity must therefore produce various paraphernalia and posturings which can only achieve the appearance of having the phallus. In other words, the masquerade of masculinity is produced in actions and signs which connote ways of performing powerfully.

A difficulty with such a view is that it begins to produce a rather restricted reading of the performances constructed by the male body. The danger of the psychoanalytic framework is that it can ultimately reduce the multiple ways in which gender is performed into the restrictive dichotomies of 'having' or 'being' the phallus, active and passive, or powerful and submissive. Clearly the body of the male hero in action cinema produces a performance of having phallic power. Here I want to explore how in music video, the male body is presented and performs in ways that do not conform to the construction of phallic power. However, I am not suggesting that these ways of performing therefore result in what, from a psychoanalytic viewpoint, could be read as a 'castrating' or 'feminising' of the male body. Rather, I want to look at some of the diversity in the ways that the male body is presented and performs on screen. My interest is not, then, in the male body as an essential natural signifier of masculinity, but rather in how the transformation of the body in its presentation and performance produces different ways of being male.

## MODES OF PRESENTATION AND PERFORMANCE OF THE MALE BODY

Attempts at a general generic classification of music videos suffer from the rapid changes and hybridisation which music television undergoes (for example see Kaplan, 1987). Unlike the literary or filmic genre, which constructs a type by unifying conventions of narrative, character and action, a single music video may mix conventions from several sources at once. Additionally, the classification of the video text may shift depending upon

whether it is counted according to musical categories, iconography, star images or type of action. There is a question, therefore, of at what level is a video to be classified.

Here, I do not intend to offer a general typology of music video categories, only to look at how at the level of the male body, differences are produced between the videos of Take That. Instead of making generic differences, I will use the term 'mode' to describe variations in presentation and performance. My choice of the term 'mode' is made for how it draws attention to differences in the way or manner in which the body is presented and performs. Differences in the presentation and performance of the body are produced in how the bodies of the boys are looked at, styled, move and behave. These differences produce inflections of the group image, with the body acting as a link between assorted meanings. Inevitably, many of the videos see shifts between modes, and the classifications below make divisions according to what appears to be the dominant mode for any video.

## Yearning mode

Showing the male body as desirable and desiring is common to representing discourses of love and romance in music video. In her study of music television, E. Ann Kaplan (1987) saw the romantic video as constructing an 'overall nostalgic, sentimental and yearning quality' (pp. 58–9). The drama of the romantic video arises from a 'love relationship . . . presented as central to the protagonist's life', which is seen as 'something that would "solve" all problems' (p. 59). What characterises the spectacle which I call the 'yearning mode' is how the body is involved in performing the trauma or problem which romance promises to solve. The yearning mode is exemplified by the video for 'Pray', where the arching, stretching, praying and wistful looks of the boys, present and perform the romantic 'problem' sung about in the lyrics. As the lyrics speak of emotional pain, the bodies of the boys are given and move in ways that show the body as suffering. The presentation and performance of the body in the yearning mode therefore signifies romantic loss as embodied sentiment.

Goodwin refers to videos where the image directly represents the content of the lyrics as examples of 'illustration' (1993: 86). Goodwin sees the use of illustration in videos where the image visualises a narrative told in the lyrics, but also in dance videos where the image does not try to tell a story but to 'signify a mood' (p. 87). With the yearning mode, the body is placed in an emotional situation rather than a narrative situation. The

body is presented and performs in ways so that a degree of physical pain signified by the body is used to illustrate the emotional pain of romantic loss. The suffering of the body is therefore read as showing the mood of romantic yearning.

However, illustration may be too literal a way of describing the relationship of the body to the lyrics in the yearning mode. The video for 'Pray' could have been produced without the same images of suffering bodies. The use of these images therefore adds to the meaning of the lyrics, in the manner which Goodwin describes as the 'amplification' of meaning by the image in music video (p. 87). The bodies become a form of 'excess', as they amplify meanings which are already present in the lyrics. Also, the exaggerated gestures of the body in these images represent an excess of feeling, so that the body is seen to produce meanings which are not contained in words but are specifically shown in physical terms. The excess of the body in the yearning mode represents romantic love as something which cannot be adequately represented by language. The body in the yearning mode is therefore central to illustrating and amplifying what romantic longing is.

The same emotionalising of the body can be found at points in nearly all the videos by the group, but is most concentrated in the videos for 'Why Can't I Wake Up with You' (dir. Liam Kan and Grant Hodgson), 'Love Ain't Here Anymore' (dir. Liam Kan and Grant Hodgson), 'A Million Love Songs' (dir. Brad Langford) and 'Back for Good' (dir. Vaughan and Anthea). 'Why Can't I Wake Up with You' has the boys situated in various spaces around a large house. Again, each occupies his own individual space, and the largeness of the building adds to the feeling of loneliness. Heavy shadows and slow moving camerawork construct a moody mise-en scène. One of the boys, it is not clear who, is showering. This scene will be returned to intermittently. Elsewhere, a telephone is off the hook. Gary sings alone in a chair. His legs are curled under him and he looks intensely out of frame. As he sings about being called on the phone, he plays with a watch in his hand. Each of the other boys is seen singing the backing vocals. Mark sits on the floor, languidly tossing playing cards into a vase. As the camera tracks over his body, Jason is seen laid on a bed, clothed in only his underwear and an open shirt. Later, it will be revealed he is reading a letter. Robbie lies on the floor, occasionally playing with a side lamp. It is Howard who emerges from the shower. Draped in a towel, he moves to a large window, opens the shutters, props himself against a wall, and turns towards the window to sing to the world outside. What is striking about this video in comparison to most of the others is the stasis of the body. The male body is seen passing the time, idly waiting, while singing

for the lost one. The body performs the pain of loss together with the expectation of return.

Something of this quality is retained in the 'Back for Good' video. The boys are brought together as a group, and together they just hang around to sing the song. They collect at what appears to be a dam or some sort of industrial site, Gary singing the lead, with the others on backing vocals. Water features again, as the whole set and the group are soaked in rain. The water in these videos seems to have several effects. Water forms a shine on the body which highlights physical shape. Given the romantic problem of the yearning mode, water could also be taken as an analogue of tears. The deluge of rain in 'Back for Good' then immerses the boys in a soft, liquid environment. The body is therefore 'soaked' with the emotional consequences of loss.

For most of the Take That videos, the torsos of the boys were only partly covered, or were stripped to the waist, or appeared in tight ribbed lycra to show the lines of the body even when clothed. It was very clear therefore the type of bodies which the boys had. Each member of the group displayed muscle tone which could best be described as 'defined' and 'lean' rather than 'built'. The muscles were visible but were not built to an exaggerated degree. To build the body requires disciplined weight-training. Due to the participant's self-conscious concentration on sculpting the body, weight-lifting is often identified as a narcissistic practice. Although still maintained by exercise and dietary planning, the lean body has the appearance of requiring less effort than full-blown training. In contrast to the disciplined regime of weight-training and possible steroid abuse, the lean body has the look of just being 'well kept'. Unlike the built body, the definition of the lean body has an apparent naturalness about it. While the lean body does not have the same overblown signifiers of phallic power as the built body, the lean body still shows the male body as strong.

The naturalness and strength of the lean body reflects on the quality of feeling embodied, presented and performed in these videos. By its apparent naturalness, the lean body signifies feeling as something which is unconstructed, that is to say as something 'true'. The arching and stretching of the yearning mode show off the muscle definition of the lean body, indicating the strength of the body, but as the body in the yearning mode serves to signify feeling, physical strength also signifies strength of feeling. Where the built body's exaggerated signifiers of strength are readable as potentially dangerous and destructive, the muscles of the lean yearning body perform the strength of desire for the other.

## Dance mode

Dance is a key element of performance style in the videos. The video to 'Back for Good' is divided between the boys hanging around yearning and other shots in which they perform short snippets of dance moves. In that video, the exuberance of dance contradicts the emotional pain of the song. Where the predominant meaning for videos in the yearning mode is to present the body as feeling, dance presents the agility of the body. If the yearning mode presents and performs embodied emotional pain, dance celebrates the physical skill of the body as a performance of pleasure.

Differences in the presentation of the dancing body produce a distinction between what I'll call the 'dance' mode, and the 'party' mode. The dance mode characterised the group's earliest videos, representing a particular phase in the group's image, and was returned to briefly with the video for 'Sure' towards the end of the group's existence. In the dance mode, the boys perform choreographed dance routines. These routines are staged in special studio spaces specifically constructed for the performance of the routine. Unlike the isolated, lonely performances of the yearning mode, choreography co-ordinates the movements of the group in unison, timing actions so the boys perform as one. For the dance routine, the boys position their bodies to face forwards in recognition that their movements are presented to the viewer. In the dance mode, it is acknowledged that the body is being shown.

In the video for 'Do What You Like' (dir. Ro Newton and Angie Smith), the group's first video, the boys dance in leather jackets and lycra cycling shorts. At intervals, they also appear naked, as they lie on the studio floor while having their butts wiped by a female model with a mop. Although the scene set by the video has sexual connotations, and the visual image of the group is strongly homoerotic, the smiling and jumping of the boys during the dancing produces an overall feeling of good clean fun which is more innocently playful than seriously sexual. In fact, fun is central to conceptualising the link between the body and pleasure in the dance mode. In a study of the Hollywood musical film, Richard Dyer (1977) argues that the musical constructed a feeling of utopianism in how song and dance performed 'answers' to real social problems. For Dyer, these answers include the generation of abundance in place of scarcity, and energy to replace exhaustion. In the musical, dance integrates these two qualities in an abundance of energy. It is this mixture of meanings which is also performed in dance music videos, presenting the body as escaping mundane social routine to signify a sense of fun. The dancing body is

more energetic than everyday behaviour, representing a physical release from social pressures as they impinge on the conduct of the body.

Despite differences in costume and set, this same message carries across from 'Do What You Like' to the other dance videos: 'Promises' (dir. Willie Smax), 'Once You've Tasted Love' (dir. James LeBon) and 'Sure' (dir. Greg Masuak). Along with abundance and energy, Dyer also sees the generation of community as a characteristic of the musical's utopianism. In the dance videos of Take That, the synchronisation of the dance routines constructs the community of the group, contrasting with the lonely isolation of the yearning mode. In the early videos, community was therefore very important in constructing the image of the group as precisely a group. Rumours over Gary's inability to dance do seem to be supported by his performances in the videos (frequently, he does not dance with the others, or only completes the most rudimentary moves), and it was only his central song-writing contribution which could keep him in the group. Robbie's much-publicised split from the boys fissured the community of the group's image, and press stories read his departure as signifying actual or imagined animosity between members of the group. Significantly, this disruption of the group's image implied that the fun was over. The video for 'Never Forget' (dir. Dave Amphlett), released shortly after Robbie's departure, therefore constructed the community of the group by using old footage of live performances, including dance material, together with archive footage of the boys as children.

## Party mode

The form of the party mode is the gathering of the group in a space where they are seen in different ways to be enjoying themselves. The group are joined by various others who become in effect 'friends' of the group. While dance is one of the ways in which the assembled group are seen to be having fun, it is not the only way. Although the group are together – i.e they are all in one place – they pursue individual activities. The party mode changes the way in which dance is performed. Instead of choreographed routines, in the party mode, dance appears to be a more spontaneous or improvised activity. Where the dance mode acknowledges that performance is organised and rehearsed for the viewer, the improvised quality of the party mode seems to catch the boys in more 'off duty' moments. It would be wrong to read this type of spectacle as capturing the boys in private moments behind their public performances (which is the purpose of the camcorder links in the *Greatest Hits* video collection). What the party mode does is construct a scene which shows the boys at leisure,

playing amongst themselves, which contrasts with the controlled work and effort of the body in the dance mode.

Different leisure locations operate as the space for the party: in 'I Found Heaven' (dir. Willie Smax), it is the beach; 'Everything Changes' (dir. Greg Masuak) happens in what looks like a café bar; a nightclub setting for 'Relight My Fire' (dir. Jimmy Fletcher) forms a conventional space for dance and leisure. The video for 'Could it be Magic' (dir. Saffie Ashtiany) transforms the traditionally male working space of a garage into a place of play. The video opens with a woman, dressed in dungarees, finishing working on a car. She closes the bonnet and shuts up shop for the night. The piano intro starts. Garage doors roll back to reveal the boys. There's Robbie, then Mark, Howard and Jason and Gary behind. They have leather jackets with jeans or dungarees. Mark's all smiles. In the midnight blue light, they bounce into the space. Mark cartwheels. Robbie slaps hands with Jason, kicks, struts, and starts the first verse. The song is 'Could it be Magic', the Barry Manilow number. The beat is made more dancey than the original. To camera, Robbie sings and nods his head to the rhythm. Then it's Mark, twitching his shoulders to the beat. Someone – is it Howard – sort of breakdances on the bonnet of a Jaguar. Gary gets behind the wheel of the car. Mark swirls around, letting his jacket begin to fall from his shoulders. Before the verse, the boys group together for some 'wo wo wo wo's'. Alone in medium shot, Mark makes a gesture which involves the fingers of his right hand touching his lips and then a point on his chest. Clenching his eyebrows together forms that cleft on the forehead that lets it be known that love is hard and that he really means it. Together, Mark and Robbie bounce sideways. At the back of the garage, the girls arrive. The boys are oblivious to their arrival. The girls skirt the edge of the space looking in on the boys who carry on dancing. Other boys join the girls and dance with them. Meanwhile, the boys continue the play. Mark lifts his jacket to reveal his bare shoulders. In time to the brass, Howard mimes blowing a trombone. A mountain bike is made to skid in a circle at the front of the space. Meanwhile the girls and other boys dance in the background. Back to Mark, who performs an agile piece of hip thrusting. After more bouncing around, Mark falls to his knees, throwing his head back, offering his torso to the camera. It is off with the jacket for Mark and down to the white vest. He drops to the ground and humps the floor. Jason does a one-armed cartwheel and then spins on his head. Robbie pull his jacket and vest open to show his chest. Then Mark lifts his own vest to show his bare stomach. More bouncing, pointing at camera, spinning and acrobatics are seen. Somebody's tattooed stomach, probably male, is isolated in close-up. There is moisture on the skin and a female

hand rubs the flesh just above the top of the trousers. In the final images, Howard pulls open his shirt to reveal his naked torso to the camera, Robbie swings on the garage chains hanging from the roof, Gary briefly appears to grin, and Mark gyrates his partly exposed torso once more. The party continues as the music fades. Clearly disturbed by the noise, the garage worker returns to find the space deserted, and she turns out the light to leave everything in darkness.

This performance redefines the muscles of the lean body as signifiers of pleasure instead of labour. Falling between the dance and party modes, the video for 'It Only Takes a Minute' (dir. Willie Smax) exemplifies this trend. The setting is a gym, the traditional space for the development of the built body. However, the only evidence of any training here is the multi-gym exercises performed by the unknown woman in the video. Instead of sparring, the ring becomes a space for synchronised dancing. Jason and Howard in particular perform amazing feats, spinning and cart-wheeling their way around the space. Although the song is addressed to a 'girl', and although the woman hovers around the group, the boys only interact with one another. Gary and Robbie remain outside the ropes, and the dance spectacle performed in the ring meets their look throughout. Their enjoyment results from the performances of the other boys. The video therefore sanctions male-to-male looking as part of pleasurable performance.

In both the dance and party modes, the movement of the male body shows physical skill, but unlike the displays of musical virtuosity found in some rock videos, the actions of the male body are not producing displays of mastery but a show of enjoyment. The male body shows its strength, but having fun becomes central in these videos to defining the male body as the site of excitement and joy rather than control and power.

**Narrative mode**

The yearning mode uses the body to perform ways of feeling, and the dance and party modes present the body as illustrating fun. With each, the actions of the body do not tell stories but rather signify sensation. Narrative form is largely missing from the Take That videos. However, the videos for 'Babe' and 'How Deep is Your Love' produce fractured narratives. In the yearning, dance and party modes, the construction of spectacle over story is integral to foregrounding the body. A collection of spectacular moments present the body over and above any dramatic situation. With the narrative mode, the body is comparatively de-emphasised. In the videos for 'Babe' and the cover version of the Bee Gees' 'How Deep is

Your Love', the states of undress familiar in the other modes are replaced by heavy overcoats. In the narrative for 'Babe' (dir. Greg Masuak), Mark seems to have been away for some unspecified time. He returns to a desolate landscape searching for a lost loved one. At the home where 'she' used to live, there is an old man who can only provide a phone number. Mark calls the number and reaches the one he loves. The scene shifts to a woman in a dark cape alone in an enormous room. Mark continues his search, with the other members of the group appearing in the places that his hunt takes him. Fur hats, big coats and snow all work together at imagining a vague winter landscape. The woman is finally found in a fantastic castle. As Mark hugs the woman closely, he see a young boy, who the lyrics would indicate is a child he never knew he had, or at least has not seen for some years. As the song plays itself out, the camera revolves to show the film-making equipment, and the cast play amongst themselves. Although the song shares with the yearning mode the themes of loss and return, the body is not foregrounded in the same way to convey feeling. I suggested earlier that in the yearning mode, the presentation of the body amplified the meaning of the lyrics, signifying how feeling was embodied in actions which exceed linguistic representation. In the narrative mode, the body is used more directly to illustrate the lyrics, performing actions which correspond to situations described in the words of the song. Together with the covering of the body, performance in the narrative mode de-emphasises the body by submerging its signification into the illustration of dramatic scenes.

'How Deep is Your Love' (dir. Nicholas Brandt) opens on a profile of Mark with his head hanging slightly. He is weary. At a sound of footsteps, he jerks his head up. When the musical intro begins, a woman appears at the top of a steep flight of stairs dressed in a full length red evening dress. At the start of the song, there is a cut to a close up of Gary. He is also looking towards the woman. As the camera pulls out we see Jason and then Howard. They are in a dark cellar. Each is tied to a chair. Both Jason and Howard slightly flex their torsos to indicate the discomfort and suffering which their tethering is causing. The woman prowls behind the boys. Her generous application of heavy eye shadow, mascara and lipstick would appear to suggest that she is both sexual and mad. She strokes Gary's blonde (dyed) locks. Suddenly, the woman violently tugs Gary's hair to pull his head towards her. The pain of the action raises Gary's voice higher, his eyes smarting at the assault. There is no elaboration of the circumstances which have led to this narrative situation. From what is presented, the story seems to be that a crazy woman, who desires the boys, has kidnapped them and is holding them prisoner in her cellar. As

Gary sings of love to her, he holds his head upright to show how stead-fast he is in what he says. His eyes blink briefly in recognition of the genuineness of what he feels. To back him, the other boys also adopt his manner. The woman is clearly pleased, as she now sways in a dreamy soli-tary dance to the gentle rhythm of the track. Unseen to the boys, she picks up a fork. Standing behind Gary, she strokes his shoulder, caresses his chin, and brushes her cheek against his. Taking the fork, she draws it down the side of Gary's face before sticking it into his throat. Gary's pain appears to arouse the woman, and she catches a breath, parts her lips, and her 'evil' eyes turn towards the other boys.

A shift in location moves to a van on the motorway. The woman is dri-ving into the countryside with the boys tied up in the back. The suffering then continues at a disused quarry. Still tied in their chairs, the boys are arranged in a line, and behind them is a small cliff that drops into a water-filled pit. The woman prowls along the line again, pointing to each of the boys in turn. She is making a selection. Each of the boys communicates the sincerity of his feeling with direct eye contact, with their brows hooding the eyes to convey the seriousness of their emotion. In this situation, their very lives depend on performing the appearance of true love. Although Gary is performing with as much sincerity as the others, he is the one who is selected. The woman pushes him backwards to plummet over the cliff, but before he can fall, she catches the rope which binds him. Across his face, he registers fear, loving and pleading. All is to no avail, as the woman lets go and allows him to fall. The rest of the boys are shocked and the woman also seems shocked, but that soon disappears as she smiles menacingly and moves toward the remaining victims.

'How Deep is Your Love' was the final release by the group, and the video provided an unusual end to the group's career. The sado-masochis-tic scenario bound the bodies of the boys, containing the activity and energy of the group. The implied death of the singer would be a supris-ing move in any music video, but it was particularly significant for Take That's image, where the implied injury to the body broke the means for performing feeling and fun in the other videos. After the abundant energy of the dance and party videos, the destruction of the body provided a final image for the ending of the group.

## CONCLUSIONS

There are always difficulties involved with imagining audiences from media texts, and attempts to define the responses of the young female and gay male fans of Take That from a reading of the videos would be

extremely problematic. However, the masquerade of the male body in these videos can be seen as constructing potential positions which are not defined by the meanings of phallic power. Across the videos, modes of presentation and performance produce different meanings for the male body. In the yearning mode, the body appears as both desirable and desiring. The performance of yearning represents feelings of loss, which shows the body experiencing feelings of incompleteness. With the dance and party modes, the body performs feelings of abundance, energy and community. Although agile, the actions of the dancing body represent strength which is not directed towards mastery. The body in the yearning mode represents problems and pain. The body in the dance and party modes represents utopian solutions and pleasures. With each of these modes, presentation and performance produce a physical excess which foregrounds the male body. For the narrative mode, the body is still visible but is relatively de-emphasised. The body becomes submerged into the dramatic situation of the story. With each of these modes, it is not enough to determine how desire is produced in acts of looking alone. The appeal of the male body requires an understanding also of how the body performs on screen.

The Take That videos belong to the routine presentation and performance of the male body in music video. In particular, the images of recent boy groups have used the male body as a central spectacle. Boyzone, heralded in Britain as the heirs to Take That's crown, have also built an image around the performance of romantic longing. East 17, recognised as Take That's direct competitors, produced a harder image, which flirted with gang style and a white appropriation of the vocal and physical manners of rap performance in the construction of streetwise authenticity. The example of East 17 raises the issue of reading masquerades of masculinity as also racially defined. The soul tradition has seen more recently the emergence of boys groups like 3T. The video for 3T's 'Anything', shares the conventions of the yearning mode but shows the boys in street styles and moving through urban spaces. While the woman in the video is still anonymous, she appears as a more continuous presence than in the Take That videos. The song is clearly sung in homage to her, where the Take That videos leave more open the question of who the song is for. With 3T, the potential homoerotic implications of the boy group are therefore contained by the figure of the woman.

The categories proposed here are only suggested as indicative ways for reading the performance of the body in music video, and further work would necessarily find other modes of presentation and performance in the construction of gender, sexual and racial differences. In wanting to

concentrate on the image of the body, I have not explored the relationship between the music and the image. A more elaborate analysis would examine such connections to consider how the body 'illustrates' or 'amplifies' the music track. In general, any reading of how the body performs in music video must address the ways in which the body appears as a moving collection of signifiers that are active in representing forms of action and feeling.

## REFERENCES

Beckerman, B. (1990) *Theatrical Presentation: Performer, Audience, and Act*, London: Routledge.

Butler, J. (1990) *Gender Trouble: Feminism and the Subversion of Identity*, London: Routledge.

Doane, M. (1982) 'Film and the Masquerade: Theorizing the Female Spectator', *Screen* 23(3–4): 74–88.

Dyer, R. (1977) 'Entertainment and Utopia', *Movie* 24: 2–13.

Ellis, J. (1982) *Visible Fictions: Cinema, Television, Video*, London: Routledge & Kegan Paul.

Goodwin, A. (1993) *Dancing in the Distraction Factory: Music Television and Popular Culture*, London: Routledge.

Heath, S. (1986) 'Joan Riviere and the Masquerade', in V. Burgin, J. Donald and C. Kaplan (eds.) *Formations of Fantasy*, London: Routledge.

Holmlund, C, (1993) 'Masculinity as Multiple Masquerade: The "Mature" Stallone and the Stallone Clone', in S. Cohan and I.R. Hark (eds.) *Screening the Male: Exploring Masculinities in Hollywood Cinema*, London: Routledge.

Kaplan, E.A. (1987) *Rocking Around the Clock: Music Television, Postmodernism, and Consumer Culture*, London: Methuen.

Mayne, J. (1993) *Cinema and Spectatorship*, London: Routledge.

Mulvey, L. (1975) 'Visual Pleasure and Narrative Cinema', *Screen* 16(3): 6–18.

Riviere, J. (1929) 'Womanliness as a Masquerade', in V. Burgin, J. Donald and C. Kaplan (eds.) (1986) *Formations of Fantasy*, London: Routledge.

Walser, R. (1993) 'Forging Masculinity: Heavy-Metal Sounds and Images of Masculinity', in S. Frith, A Goodwin and L. Grossberg (eds.) *Sound and Vision: The Music Video Reader*, London: Routledge.

# 16

# ROLLING AND TUMBLING

## Digital erotics and the culture of narcissism

*Sean Cubitt*

In video media, especially as they have developed lately, there is the possibility for a profound remaking of the ways we represent sex, eroticism, gender, sexuality. But there is also the strong likelihood that these new techniques will be recruited for a remaking of the old ways. This chapter is about the struggle over the means of representation, and over representation itself.

To begin with, a simple film-theoretical point about the ZZ Top tape 'Rough Boy'. There are several examples here of what film theory calls fetishism, and they're fairly obvious: the selection of a woman's legs, through costuming and performance (poses) and through framing and digital editing within the frame, for a special erotic interest. Film theory's analysis of the subject positions available to viewers of the classical Hollywood cinema distinguishes between voyeurism and fetishism: the voyeur's pleasures are in watching, unseen, as events unfold – a kind of power trip. The fetishist's pleasures come from a specific kind of display which is laid on, as it were, especially for him. I say 'him', because the argument continues that classical film is dominated by patriarchal structures of looking – centrally voyeuristic and fetishistic gazes – and is shaped entirely for the pleasures of a male and heterosexual viewer. One problem is then: how might a woman derive pleasure from this tape – or any other?

It's possible to begin by pointing to the leakiness of the classical system itself, and especially of its permutations in pop video. Here we need to look closely at the fetishisation of the faces and hands of the band members – dismembered members. This is clearly not in parallel with the fetishisation of the woman's legs. But it suggests that there are other kinds of interest being mobilised, as there are in shots of male stars in Hollywood. And the tape boasts its technical effects, like a magician showing off the empty box from which, impossibly, rabbits have been

pulled out by their ears. In the case of 'Rough Boy', a rock ballad rather like those ballads that accompany film releases, the imagery is drawn from the kind of 'new bad future' movies that populated the mid-1980s: *Blade Runner, Alien, RoboCop, Terminator*. The music is 'spacey' as well as sexy. Space, outer space, as we shall see, is very important to digital erotics, and far less easy to isolate within a single sexual orientation.

But these rufflings of the surface of the normative styles and procedures of cinema aren't enough to give us the fundamental critique of patriarchal image industries we need. The critique might begin with a reading of femininity as masquerade, and in particular Judith Williamson's reading of Madonna as a cultural phenomenon (Williamson, 1986). Williamson sees in the Madonna cult the image of every teenage girl who has dressed up to dance in front of the bedroom mirror. It seems to her, therefore, a culture that can be understood and supported from a feminist viewpoint. The tape for 'Vogue' in particular enacts a sense of the essence of femininity as a play, an act, a performance. It involves dressing up, and, in media terms, make-up, performance, lighting, camera styles. There is no essence to this femininity, save only the essential acting out of what is, in some senses, expected in a patriarchal schema of looking.

For Mary Ann Doane, in her remarkable essay on femininity as masquerade (1982), this acting out of what is expected acts in two ways simultaneously. On the one hand, it colludes with patriarchal expectations. On the other hand, by merely acting out the part, rather than actually becoming it, it is a parody of those expectations, and so subverts them. Drawing on feminist psychoanalysis, she argues that men discover, in their negotiation of the traumas of growing up, that lack which is said to lie at the heart of language and meaning (if there were no lack, there would be no desire – to speak, among other things). Women, on the other hand, 'lack lack'. Since they cannot go through the processes which psychoanalysis identifies as the castration complex, they cannot completely enter the world of language and meaning. There is, then, a profound disjuncture between what it is to be a woman, and what it is to be a speaking subject, a subject of the enunciation. Women cannot speak from a position guaranteed within language, as men can. The word 'I', for a man, denotes that empty space which they must constantly try to fill by speaking. But women lack that nub of emptiness. There is no core, as in men, that demands their attention. Driven by a lack in their being, men pursue completion down the corridors of language. But women, lacking lack, have no place in language at all. Instead, Doane argues, there is the masquerade.

So in 'Vogue' (dir. David Fincher, 1990, Sire Records) Madonna doesn't express an essential femininity, since there can be no such essence, as there

is for men (whose essence is their lack). Instead, she acts out a series of roles, predetermined in the language of that most patriarchal (and whitest) of symbolic systems, the Hollywood cinema.

Doane goes further, however, in arguing that this is the prerequisite for female 'identification' with the image. In her founding essay on 'Visual Pleasure and Narrative Cinema' (1975), Laura Mulvey had argued that in the classical Hollywood cinema, women could only identify with the image through a kind of psychic transvestism, by taking on, for the duration, the masculine way of looking, since Hollywood (and perhaps every regime of looking) foreclosed on the possibility of a female gaze. Doane argues in reply that through the masquerade of femininity on screen, a woman viewer has two further options: 'the masochism of over-identification or the narcissism entailed in becoming one's own object of desire'. As I understand the argument, this means that the options are:

1 to imitate a masculine way of looking – for example, to engage with the image of Madonna as sex object;
2 or to immerse yourself totally in the image, without the masculine escape clause which Mulvey and others identify, whereby men can say to themselves 'I know that I am identifying (here with the look of the camera) but all the same I also know that I am a separate individual': to find, in identification, a pleasure in Madonna's image because she is unlike me;
3 or, finally, to identify with the female image whilst retaining a sense of one's own femininity, so that the woman on-screen becomes a signifier of your self, again without the escape clause of 'I know . . . but all the same . . .': to find pleasure in Madonna's image because she is like/is me.

In the acting-out of masquerade, however, Doane sees the possibility of something new: a distance between screen and (female) viewer, who is enabled by the self-conscious acting out of femininity, to see that she is watching, not femininity, but a discourse about femininity. Because Madonna acts out a series of tableaux which derive entirely from the classical representation of the love goddesses of the silver screen, she can simultaneously engage with the female spectator's awareness that these are constructed images, fantastic symbols, roles played and familiar poses made unfamiliar. By adding this kind of distance between image and viewer, she makes possible a new kind of viewing, one which frees women of the closed loop of the male gaze.

In his critique of Doane's article, D.N. Rodowick (1991) suggests that

there are two fundamental flaws to this argument. First, he accuses Doane of giving an enormous amount of power to the text of a film, so much so that it can, by the use of quite subtle formal techniques, effect a radical change in the psyche of the viewer. Second, through a close reading of her text, he suggests that she shares with many other film theorists an unjustified belief in the primacy of biology. By this I mean that they seem to believe, despite themselves, that we are born not only with a particular set of genitalia, but with all the social and cultural meanings that they come to have for us later in life. Implicit here too is a belief that there is such a thing as a collectively experienced femininity, despite the fact that psychoanalysis is founded on the idea that gender is only acquired relatively late in life, long after birth, and often in despite of the biological difference between the sexes, and in any case experienced totally differently by different men and women. As long as sexual difference is tied to the simple biological differentiation between two sexes, there will be no accounting for the central problem of difference: that it is not just the difference between men and women.

Psychoanalysis offers a far richer ground for understanding the variety of sexualities and sexual identifications. In his classic essay 'A Child is Being Beaten' (1919), Freud analyses that one phrase, unearthing within it at least half a dozen permutations – I am beating the child, I am the child, my father is beating the child/me, the child is doing the beating . . . ; and then a similar series beginning with 'a child is being loved', suggesting something of the richness of our fantasy lives. We need then to consider two further aspects: first, that our responses, 'male' or 'female', to a particular text are likely to be far more complex than the simple, predictable, unified response posited by most theories of representation; and that they cannot be tied solely to the supposed influence of a media text. On the contrary, media gain their power by the proximity to the processes of human psyche. They need our investment in them far more than we need their messages.

So how to read the Madonna 'Vogue' tape? First we need to recognise the roots of voguing in the black gay clubs of New York. The first move in the genesis of the tape is the extrapolation of a camp sensibility, itself already marked by cross-gender identification, but also with a kind of male exhibitionism, and with a specifically male narcissism. The 'postmodern bisexed she-man', as Chris Straayer calls this complex figure (Straayer, 1990), is characterised not only by these contradictory positions, but also by the way in which they are recombined and moved between in a continual flux. Madonna's videotape might then be read as a relation – an impossible relation, perhaps – between her as love goddess and the one

group of people who can be relied upon to see her as anything but a potential sexual partner or object of desire.

At the same time, she offers to a (male) viewer both the possibility of being (as well as watching) a sexual object, and the possibility of identification with her as a woman cross-dressing as a cross-dressed man. At which point, 'heterosexual' men are confronted with the possibility of both a homosexual and a heterosexual identification, and with taking Madonna as a simultaneously male and female, narcissistic and object-oriented, object of desire. What is more, the tape also re-enacts a self-consciously autoerotic action, one which, rather than promoting identification with oneself, inveigles you into taking your own body as love object. Madonna-as-gay-man allows for the possibility of an entirely self-involved sexuality. Nor do I think that women have a less productively complex set of possible identifications and modes of desire for Madonna as same sex/opposite sex/third sex performance. For both sexes, the 'perversion' of sex across races is engaged too, the more powerfully for being couched in the visual language of the Hollywood pin-up and the platinum blonde. The scandal of black gay sexuality – re-engaged perhaps through the remaking of 'Black Athena' in relation to the classical statuary of the first shots of the tape – is compounded with the peculiarly North American fear of miscegenation, just as the scandal of the high Parisian lesbianism of Tamara de Lempicka (of whose canvases Madonna owns an impressive private collection, one of which appears in the tape) informs the caressing hands of the singer and her female entourage, black and white.

Nonetheless, we have to be aware that the society we live in is founded upon sexual and racial difference of a less fluid kind. To some extent, Madonna's tape is legible, in the context of her global marketing as star and as product, through a return to the 'Yes I know . . . but all the same . . .'. Yes I know 'Vogue' allows some free play of the sexual imagination, but all the same I am a red-blooded man, and know really that ultimately she is (just) a woman. So, cynically, we might see the tape as Madonna's further bid to construct herself as the image of desirable femininity, from whatever standpoint an audience might look, and to acquire, through osmosis with the gay scene and black music the air of authenticity without which no rock star is complete. The vocal line 'It makes no difference if you're black or white, if you're a boy or a girl' can, indeed be read as an erasure of difference, an indifference to cultural struggle, a universalising assumption of knowledge about what's hip: 'this safely heterogeneous yet hegemonic multiculturalism excludes nothing' (Becquer and Gatti, 1991: 80).

At the risk of repeating the obvious: there is nothing natural, permanent

or immovable about the regime of sexual difference that governs our society and culture. This fundamental division, which psychoanalysis sees as the first sense of law acquired by an infant child, is not just about sexual inequality, but the foundation on which all laws, rules and rule-governed systems (table manners, sphincter control, language . . . ) is based. But it changes, just as they change. If sexual division were natural, there would be no need to talk about it. Instead, we should observe the endlessly repetitive discourse of sexual difference. Why do we need to be reminded so often? Is it because we might otherwise forget that we are supposed to hanker only for the romance of the nuclear family?

One of the central tenets of contemporary media theory is the intense mutual interdependence of meaning and sexuality. That having one kind of body signifies being male is not an intrinsic quality of having a penis. It is precisely the *meaning* of the penis, what it signifies. And the meaning is a social and historical product, not something that grows out of the earth. What's more, such meanings cannot be relied upon to stay the same. They have to be reiterated, reworked, made new, reproduced, given a novel slant, but without rocking the boat. That was the function of rock and roll: rebellion into heterosexuality. Its power derives from the trenchant way it can affect us here, inside, where we live. For the problem of sexual difference is not only sociological: it is psychological too. We have to be reminded of the social meanings of male and female, because we are not, intrinsically, one or the other. But living out that instability can be frightening, and might shake up the other rules that are based on a rigid division of the sexes. So rock and roll offers us dreams of fully achieved gendering, fully achieved masculinity and femininity. But at the same time, in order to affect us at all, it must also offer some sense of the instability and danger of sexuality, even if only to bring it to some kind of normative (hetero)sexual conclusion. You have to have disturbance of the norm to get a story started, a move away from the tonic to get a tune rolling, a move out of sexed stability to get our emotional involvement. The problem is that the sense of an ending derives from restoring the norm, the tonic, the stable identity. So 'Vogue' disrupts and disturbs normative heterosexuality. But there is potential resolution of the themes of multi-gendering and polysexuality, a resolution that reorganises all this flux around the scene of a meticulously reconstructed patriarchal image of femininity.

One of the more curious aspects of 'Vogue' is its editing, a rare example of successful cutting to the beat. The edit works, I think, because we are invited to look at a series of poses, effectively at still images rather than moving ones. Certainly they succeed one another in time, thereby

achieving motion, and in some way rely on choreography. But the motion of the piece is entirely held in the transition from one tableau, one pose to another. In film theory, this is seen as 'fetishistic', in the technical sense that it evokes a bond between display and the viewer, as if the image said, 'I know you're looking – and I like it.' The returned gaze, the eroticised clothing, the singling out of specific body parts (especially here the face) for sensual attention – all of these characterise the fetishistic look.

For Freud, the true fetishist is involved in a disavowal of sexual difference: the sight of what, biologically, defines the woman's body as different would cause anxiety, since it is the proof of infantile beliefs in castration. The fetishist's gaze is stopped at some point before the fatal sight is seen, blocked and entranced by the vision of a specific piece of clothing, gesture, display. . . . But if sexual difference is the price of admission into language and the world of meaning, the first difference that organises all those other differences that make a difference, then the fetishist is locked into a curious oscillation at the threshold of language and meaning, shuddering between the sight and the symbol that hides it. To this extent, Madonna's 'Vogue' is still a cinematic text – working at the level of the infant child's first inklings of desire and its regulation, the first wakening of self-consciousness.

There is, in Freudian theory, a prior stage, which Freud calls 'primary narcissism'. It's my contention that digital imaging can begin to work at this prior level (for in psychoanalysis, nothing is ever forgotten), and that we are witnessing the first blows in a struggle over the regulation of a digital erotics of the culture of narcissism.

A transitional piece like Jim Blashfield's 'And She Was' for Talking Heads (Warner Bros, 1985) addresses the construction of a kind of female spectatorship in a quite different way. The tape visualises the flight of an airborne woman largely from her point of view, so that her hands and legs appear in frame while the rest of her body is only implied (for example in the popping of the flash camera at the place where her face should be). 'She's drifting this way and that', but the images move pretty consistently from right to left, giving her an implicit motion from left to right, except for two upward movements. This is the movement of Western writing, and it helps give the tape its air of constructedness.

Where 'Vogue' still implies a dialectical wobbling between the presence and absence, the authenticity and the masquerade, of the star, 'And She Was' dispenses entirely with the logic of authenticity. Every image is processed and reprocessed, photocopied, re-photocopied, given jerky animation that belies the probable cost and certain skills of the animators. Even the bric-à-brac of suburban Americana that passes for postmodern is

marked culturally with the signs of inauthenticity: painted nails, a plaster Eskimo, crumpled newsprint, stop-framed toothbrushing, the television itself. The world of the tape is a shadow of itself, and a shadow of a shadow.

In his work on narcissism (especially in the analysis of Senatspräsident Schreber), Freud identifies this loss or lessening of authenticity in the world with the withdrawal of interest due to a turn of libido away from objects and towards the self: a narcissistic turn, in fact. In Schreber's case, the fantasy took the form of visions of the end of the world and of his hospital companions as 'miracled up, cursorily improvised men' (Freud, 1911: 207). Freud understands this perception as being rooted in a with-drawal of affection and energy from the world – in fact, as a step on the road to recovery, reserving energy for the cure. 'The aim and the satis-faction in a narcissistic object-choice', he adds in 1914, 'is to be loved' (Freud, 1914: 93). Like the infant at the breast, the narcissist feels (or wants to feel) that the entire world revolves about him/her – which is why it relates so closely to the paranoia of Schreber. Either all love flows towards the subject, or all hatred, but in either case, it is the self which forms the centre of the universe.

Which may explain a little better the point of view in 'And She Was'. For there we are offered as viewers the position of the woman floating above the world, a position which is however marked by absence in the text. Unlike the cinematic mode of 'vogue' playing between presence and absence, we have only absence. Except that that is not the whole story. For we are present. The pleasure on offer is that of being seen, not of seeing. Every image looks back at the viewer. The camera snaps – intrusively, or flatteringly, as you care to take it. Eyes are turned up, in amazement or accusation, as you choose. An out-of-body experience that has taken the body with it, a dream of flying, with all its erotic connotations.

It remains only to add that, for Freud, a narcissistic object-choice – the choice as object of desire of a partner who, same sex or other, resembles you yourself – is a negotiation of the narcissistic position, and his obser-vation that in pioneering studies of paranoia, 'We were astonished to find that in all of these cases a defence against a homosexual wish was clearly recognisable' (Freud, 1911: 196). The turn, again, of object-libido towards ego-libido; of an outgoing effusion of psychic energy into an inward-directed one. The matter in hand, in 'And She Was', is then not the star's narcissism, but ours.

Yet if we are present, we are only present as a lack, indeed as the representation of a lack (a lacking in the lack then), in which we are to supply the face, and the torso. So we might perhaps read the legs and

hands as fetishised – separated off from the rest of the body for a special attention – in order to mask a fundamental lack at the site of sexual difference – which is ourselves, as viewers. Certainly there is a great degree of fluidity about the ways in which these elements of ego-libido can flow through the viewing of the tape. The attention to the viewer as filling in the missing space can be experienced as narcissism or paranoia, as active or passive, as pleasant or threatening; it can be repressed, or it can be sublimated – for example in a reading of the work as a celebration of a spontaneous rebellion against suburban expectations, a hardy stand-by of rock criticism: the sublime narcissism of Do Your Own Thing. I prefer to see it as a visualisation of 'A Child is Being Beaten', revolving through the possibilities, or rather allowing us to do so.

There is another quality of 'And She Was' that should interest us here: that it is, even after several viewings, fairly opaque. There is a link between images and vocals, but the lyrics are themselves not simple to translate into everyday language. What is this 'she' – not, in every instance, necessarily a human woman. Does the line 'And she was' reaffirm her existence, like some kind of art-rock existentialism, or does it insist that she exists, but only in the past? Does that ambiguity give us a sense of her constantly blinking out of existence? And us? Do we too blink in and out of existence as the subjects of, listeners to, a song that is always fading into the past, and a visual track that is insistently mobile (where 'Vogue' is insistently still)?

Such musings can lead us in two directions. Down one path, there are speculations concerning the fading of the subject, its constitutive instability. To be human, to acquire the sense of self of an adult, is not a once-and-for-all achievement. On the contrary, selfhood, or the sense of selfhood, is fluid, unstable, ever-changing, and the self, subjectivity, needs constantly to be rebuilt. 'And She Was' can be read as mimetic of that process: playing out the constant vanishing of a fully constituted self, the way in which, in relation to language or the rule-governed system of music, we flutter in and out of existence as conscious human beings, losing ourselves in the transitory delights of sound, re-finding ourselves, but changed, delighted, renewed, different. Music, of all symbolic forms, seems to play out the internal dynamics of the psyche; and pop music, more than most, in its formulaic structures realises that dynamism and fluidity in its constant problem of finding an ending. Few pop songs come to the kind of resolution you would expect of a symphony. They stop after a suitable amount of time dictated once by the playing time of 78 rpm records, and now largely by habit and radio plays or the stamina of DJs and dancers. And they conclude, not with harmonic resolutions, but with

flailing about on drums and feedback, with improvised segues into the next song or a bit of chat (on DJ consoles or Grateful Dead gigs), or with fade-outs (see Cubitt, 1984). 'And She Was' ends in an abrupt stop, the slight echo on Byrne's vocal giving only the tiniest cushion to the sharpness of the ending, like the hollowness in the eardrum after thunder. As if an exercise in the switching on and off of lights ended with a rapidly fading after-image in total darkness. In coming to a musical resolution, but one of the most startlingly sudden kind, it seems not so much to ratify the coherence and wholeness of the tune – and by inference of psychic processes – but to give witness to its fundamental nature as fluidity, transition, change – processes without which subjectivity and music do not exist.

At the same time, down the second path, the mobility and asymmetry of the visuals, and the unusual tactic of minimising both the band's rôle in the image and lip-synched vocals moves against more common forms of identification – especially with the lead singer – to provide for this uncomfortable – because incoherent – place of identification with the subject of the song, 'she'. This produces another aspect of the tape's opacity: even such minor changes to familiar regimes of looking make for quite extreme difficulties in making sense of the tape. Such disruptions, especially more extreme variants like early Scritti Politti songs ('Hegemony', 'Scritlocks Door') or the Captain Beefheart of Trout Mask Replica, can produce a sense of disorganisation, experienced as boredom, anger or comedy. On the other hand, fans of atonal music from Schönberg to Sun Ra know that there is also a great pleasure in the way some such music produces responses of sheer bafflement.

Theodor Adorno, probably the most important materialist philosopher of our century, argued in the Aesthetic Theory (1984) that bafflement too has its functions. For him, a pupil and champion of Schönberg, the avant-garde serves a negative purpose, in constantly demonstrating the obverse of dominant culture. And since, for him, there was no possibility of a utopian solution to the problems of modernity, this constant negation of all that exists is the last bastion of resistance to nazism and US hegemony. Though by no means as extreme as the twelve-tone row, 'And She Was' makes a virtue of its own opacity, the difficulty we have in understanding it. Though it could be argued that in Talking Heads and other cross-over pop/avant-garde artists (Laurie Anderson, Philip Glass . . .) we see what Adorno feared, the hijacking of avant-garde techniques by mass culture, we also perhaps can sense an internal contradiction within mass or popular culture, between the reproduction of the dominant and the need for novelty, but couched within that another dialectic between the dominant

and what it seeks to repress but never can: the constant failure of the system to provide a lasting, coherent place to be happy in.

I'm aware of the dangers here of formalism – of the line of thought that says that aesthetic form determines subjective response. I would argue, instead, that form provides the opportunity for fantasy, for a freer play of identifications, meanings and pleasures that we normally allow ourselves. At the same time, formal properties are not utterly bereft of power, if not to determine, then at least to constrain the patterns of mental activity associated with watching and listening. My argument then is that the new forms of image-making opened up by digital media allow for a new play of fantasy, possibly one that, freed of the necessity of reference to any pre-existing reality, might become a gateway through which contradictions of patriarchal heterosexism might be spied, or from which they might emerge altered. But this utopian image needs tempering with two cautions. One should never underestimate the power of dominant culture to remould almost any technical novelty – technological or stylistic – to its own ends. Nor is any technology free of its own contradictions, or of the struggle over the means of representation that characterises so much of what's interesting about contemporary culture.

Don Searll's 'Killer' for Seal (ZTT, 1991) is a case in point. The song's chorus ('Solitary brother, is there still a part of you that wants to live? Solitary sister, is there still a part of you that wants to give') anchors the lyric in sexual difference. The close-ups and lip-synch provide a double authenticity: that of the presence of the singer to the song, and that of black culture, redoubled by the Africa signified by Seal's ritual scars. The tape's imagery derives from familiar New Age sources: dolphins, the yin/yang symbol, the graphics of M.C. Escher, Star Trek, an iconography that mixes the sacred and profane, the authentic and the artificial. But the whole of the visual system is anchored in a form of perspective that would not be un-familiar to a fifteenth-century Italian. The monocular point perspective of the early Renaissance serves to tie the flickering images into a framework that is wholly familiar and unchallenging, the framework of a perspectival system which is widely held to take its ideological rationale from the emergent individualism of the earliest phases of capitalism in Europe.

Looking is not something that comes naturally to us, even though it is articulated upon an instinctual pleasure in the excitation of the optic nerve. That instinct is structured as we move through the phases of social-isation, shaped and instructed by dominant regimes of vision, just as surely as infantile gurglings are structured into language. Monocular perspective is, alongside the map, the dominant mode of vision in our period of history – despite the enormous subversion of it as natural,

unique and necessary undertaken by the artists of the early twentieth century. It represents a mode of looking in which the world is organised in order to be seen from a single place. This in turn carries the sense that there is a single place from which it is possible to see – the place set up by the geometry of perspective. That place becomes a seat of power, from which the world is not only visible, but to which it reveals itself – this is the seat of knowledge too, of science, rationality, of human empire over the natural. It is the seat of the ego, of conscious thought, and of the ideologically and symbolically constructed subject. As such, even as it offers pictures ostensibly deriving from fantasy, it actually reduces the free play of fantasy by overstructuring it in advance. You can see whatever you like – but only from here, only in this way.

And as to gender. Seal has been directed to perform the kind of guitar heroics that executives equate with sexiness. So much is this the case that they have become entirely legible, as conventional signs for machismo rather than enactments of it. What interests me more is the kinds of surfaces that are generated by the digital techniques used here – ray-tracing, anti-raster, texture-mapping. The tool-box of contemporary digital animation falls largely into two camps. There are those who generate images from the internal workings of the computer, relying on algorithms to produce displays like the Mandelbrot set or the virtual sculptures of William Latham, IBM UK's artist in residence. And those who use 'paint' systems to create (often illusionistic) spaces and surfaces. 'Killer' falls into the latter category. And it is the language of surfaces and spaces that intrigues me. The skin of the dolphin that leaps through the framing arches is pristine, smooth, integral – and hollow. You almost feel the emptiness of it, know that at the flick of a switch it would flicker into a dust of pixels, not a living mass of inner organs.

The intensity of attention applied to creating these supple surfaces is enormous, and the skills involved hard to acquire, expensive and precious. But they are also, and I think quite clearly, suffused with a mode of sensuality, sexuality, and of a quite familiar sort. In infantile development, we have to learn about inside and outside, about the skin that separates them, and in doing so, we lodge at last into our sense of ourselves that gratification occurs most of all at the epidermis. But even so innocent a thing as skin is loaded with meanings, none more so than the simple binary that runs through this tape, opposing rough and smooth, scarified and immaculate, male, certainly, and not-male. Whether that not-male – the fantasy architecture, the dolphin (animal world) or the natural environment (in and out of male control) – is to be read as female is less important than the ordering of the tape's world about a masculine pole and a non-

masculine. Patriarchal sexual difference is, in any case, dedicated to the construction of a workable masculine identity: the problem is that in distinguishing what is not in itself distinguishable (it has no inner essence, permanence, nature of its own), the only strategy is to distinguish it from its others, and most commonly from femininity. Here the novelty is in the distinguishing between masculinity and a wider range of non-human others – a kind of reverse ecology, seeing the separation of human and natural rather than their continuity – perhaps correctly. But that distinction still rests, whether human/animal or male/female, on the centrality afforded under patriarchy, to masculinity, as locally defined.

It cannot be stressed too much that masculinity is a construct, and a fragile one. A thousand Hollywood films retell the differences between real men and less real – the over-violent, not violent enough, too anarchic, too rule-bound, too white, not white enough . . . . Though pop video allows a far broader play of sexualities, many still enact these kinds of distinctions, while others play with androgyny – especially those aimed at the younger market and girls' culture – only to recover it through the 'I know but . . .' mechanism. To some extent, masculinity's constructions of self-sufficiency require a mode of self-love and self-esteem which can only with difficulty be derived from relations to the other. For digital erotics, beauty is only skin-deep, for there is nothing inside the skin. The electronic dolphin in 'Killer' can then function as a signifier of desire, that free-floating, playful animal who leaps through the boundaries of the architecture, without reference to real dolphins – real desires as pure signifier. Nonetheless, it remains bound into the larger architecture of perspective. But while there are no other human partners visible in the tape, we might re-read this figure of desire as, again, narcissistic, but perhaps drawing on later philosophical statements of Freud's we could see a narcissism of a very specific kind: 'At the very beginning, all the libido is accumulated in the id, while the ego is still in process of formation or is still feeble. The id sends part of this libido out into object-cathexes, whereupon the ego, now grown stronger, tries to get hold of this ego-libido and to force itself on the id as a love-object. The narcissism of the ego is thus a secondary one, which has been withdrawn from objects' (Freud, 1923: 387).

What I am suggesting is that, through the formalised symbolic language of perspective, we are invited in 'Killer' to watch a process of self-sufficient masculinity drawing its own desire towards itself. Perhaps the most poignant figure in this rhetoric is that of outer space. One crucial aspect of space as a visual figure, or an imaginative one, is that it is timeless – for psychoanalysis an immediate clue to the presence of the unconscious,

which neither organises its contents chronologically, nor forgets (nor, for classical Freudians, changes, though this is a point that would be contested in cultural studies). The interest of the tape then seems to me to derive from its double function. On the one hand it tries to stage unconsciousness as the theatre in which fantasy can be mobilised, and viewers' interests claimed and held. On the other, it takes on the job of providing an image of a self-sufficient (and to that extent narcissistic) masculinity, proper to the conscious mind, the world symbolised here most powerfully in the architecture of perspective, even when troubled by the internal anomalies of perspective proposed by Escher.

That anomalous perspective is the saving grace of the tape, the leaky seam through which the plenitude of masculinity to itself seeps out. 'Killer' works through a dialectic of the inward – self-love, self-sufficiency, the unconscious, authenticity as a marker of depth – and the outward: distinction between (male) self and other, a kind of passivity in relation to the viewer through the attraction exerted by the tape's sheer watchableness and its symmetry, temporal and spatial. It works along a fault-line between autonomy and authority, between the complete man in need of nothing and the perspectives that structure him as visible, that shape his performance as desirable, that seats the viewer in a position of knowledge and power, while offering only knowledge of what is displayed, power only over what already, unchangeably, exists. The pleasure – my pleasure – derives from the impossible task it sets itself of colonising the unconscious. That's why Seal's posing induces laughter: 'Induced, of course, by the supposed infantilism of sensual pleasures, laughter can largely be accounted for by the mechanism of repression. Laughter is a defence against the forbidden fruit' (Adorno, 1991: 152n). Playing the rational utopia of scientific perspective against the play of unconscious desire makes for comedy, even if that comedy serves ultimately to maintain the status quo.

As we approach the wholly digital video, new variants on the issue of sexuality emerge. Our century has been dominated by the photomechanical media, photograph, film and the microphone, each linked, albeit in complex and shifting ways, to the function of reference, of responding in some way to what is 'given' in the world visually and aurally. At their most realist, the photomechanical media obscure their processes of production, the technological manipulation of sound and image, so creating a role for the camera and mike as both the guarantors of the illusion's truth and the invisible narrators of the fictions we watch and hear unfolding. In this way they act to replace the human agents who produce films and songs (subjects, in Benveniste's (1971) categorisation, of the énoncé) with an agency that appears to be implicit in the text itself (subjects

of the *énonciation*). But the increasing use of sophisticated processing – mattes, blue-screen, process cameras, multi-track recording – and the emergence of media wholly independent of reference have established the terms for a new kind of relation to the media, one in which illusionism need no longer be confined to reference to existing reality. The possibility emerges for a kind of creativity that has not previously existed in the moving-image media, a textuality centred on the subject of the *énoncé*. Photomechanical media have historically tended to privilege the illusion of reality as truth, using that as the link between the camera and the viewer, for example, as both, structurally, subjects of the *énonciation*. That is, both share, through reference to a third party, reality, a structuring 'truth' which centres the discourse of cinema as both a text and a viewing experience. Digital media, however, have no third reality to structure their interaction, so that the medium has no core of truth to which we are bound: in this sense, we are co-partners in the production of meaning, interactive creatures in a communicative world, subjects, then, of the *énoncé*, of the act of speaking. The new media offer a world limited only by the imagination, but as a result the limits of socially constructed imagination become more and more important.

In recent 'cyberdelic' tapes like Dr Devious's 'Cyberdream' (dir. Daz Jamieson, 1992, from the video album *VR: Dance in Cyberspace*, Prism Leisure) we get a collection of some of the clichés of current practice: Mandelbrot sets, running silhouettes, strong symmetry with the illusion of depth created through movement from the centre out, walking on water, solarised faces, starfields and stargate corridors. Skilful and certainly entertaining, 'Cyberdream' boasts itself a gateway to the New Age: 'Exterminate all rational thought. Reality ends here. You can dream in cyberspace' the inner sleeve slogans. But on the outside blurb we find: 'Let your host Dr Devious . . . escort and guide you through your dreams.' This is, of course, promotional puffery, not a statement of the tape's actual work or its relation to its audience. For those who believe that pop video somehow predetermined the response to the music (thought of as somehow pristine before made visible for the first time in promos), this may seem like a blessed relief. The centring of visuals on the singer is no longer *de rigueur*, since the vocals are as likely sampled (and therefore outside the cycle of authenticity that centres so many other tapes) as not.

We should be able to say that this has nothing to do with eroticism, or better yet that, freed of the necessity to represent the human body, that the erotics of 'Cyberdream' are polymorphous, no longer anchored in the social construction of erogenous zones. Surely this is utopia, a synaesthetic experience free of narrative, illusionism, speaking directly to the central

nervous system, an inner world free of the tyranny of the outer. But it is this last 'freedom' that is the clue to what is finally rather disappointing about this work. The familiarity of it is surprising enough: the same Renaissance perspective, the same rigid symmetries. This world reveals itself in geometric progressions, gives itself as an alternative nature, but one that nonetheless lays claim to the qualities of nature: self-sufficiency, coherence, an alternate rationality, but a rationality all the same, bringing the disparate into harmony not through narrative but repetition. Under the guise of timelessness (the quality necessary to universality and permanence of nature in ideology, just as it is in the unconscious that shapes its appeal), 'Cyberdream' restores a kind of cyclical time, a time that mimes totality through the device of rhythm. In its way, this kind of work is as totalitarian as the stadium rock it so profoundly critiques.

The tape mobilises, undoubtedly, some kind of eroticism. The coiling and uncoiling of lithe surfaces, the mesmeric pull of sheer vision, but perhaps most of all the presentation of the work to the viewer as her/his own dreams. This is a work that calls up an earlier narcissism than that addressed by the Seal tape. Where 'Killer' seems to speak to a moment at which the ego gathers up desire to itself, trying to force itself upon the unconscious as its love object for the first time, we are here in a moment before the 'ego-drives' (Ich-triebe) and the great pool of desire (Sexuallibido) are separated. In place of a representation of difference, a mise-en-scène of masculinity and its others, 'Cyberdream' presents itself as the other within, as an internal dialectic in which otherness is an interior dynamic. It evokes a moment at which the infant, long before speech, could understand itself in terms of an entirely internal world, but nonetheless a world already riven by difference.

We come again to one of the difficult moments of psychoanalysis where it must be argued that there is no utopian moment 'prior' to our complex and unstable adulthood. There is a myth, sustained by some feminist analysts, of a pre-Oedipal point of origin in which the infant, untouched by those differences that mark socialisation, at one with itself, its mother and its universe, innocent of the division of mind and body, inside and outside, synaesthetic, polymorphous, gurgles in the Babel of a pre-linguistic production of a somatic chora. The same style of analysis, associated in particular with early work by Julia Kristeva (see particularly Kristeva, 1974), claims that in avant-garde literature like that of Joyce, Mallarmé and Artaud, the binding of instincts to their social constructions can be liberated through a return to that primeval state. This return she marks with the French word jouissance, translatable as both 'bliss' and 'the pleasure of orgasm'.

310

Orgasm too is the object of myth in the West: myths of the loss of self-hood, at the precise moment, one might argue in reply, at which are enacted most powerfully the rituals of sexual difference. Nonetheless, the myth of regression to infantile pre-subjectivity in the adult act holds powerfully. It is this myth, a myth of narcissism, that is retold in Dr Devious's cyberdance visuals. And in the manner of Kristeva's analyses of 'the revolution of poetic language', it is quite possible to read the tape as engineering a release from structured sexuality, perhaps most of all from the tyranny of sexual difference. One could, of course, read some crude pseudo-Freudian symbolism into the tape. Rather more convincingly, I think, one could find, in the visual flip-flop that allows us to see the radiating segments of both surfaces and spaces, a dialectic at the point of disappearance of a mode of sexual difference, or rather of its symbolisation. One might even read the absence of human forms as a *fetishistic* denial or disavowal of difference. What is at stake is an imaginary relation, a representation of the self to the self, as a sexual but ungendered world.

If I call this 'totalitarian', it is because I am distrustful of the limits to such a pursuit of utopia that seem to curtail this exploration of the new media. The tape not only escapes the narrow confines of sexual difference, but actively produces a novel articulation of tape and viewer, a new screen relationship which moves us towards a regressive sublimation of an earlier relation with vision than that offered, say, by the classical cinema analysed by Mulvey. Here indeed is a masquerade, but one for all sexes and none. On the other hand, though, this also seems to work by denial, refusal, *Verneinung*, a denial that masks the repressed material that it wishes to assert. Here, for a simple instance, the juxtaposition of the fluid and the geometric, symmetry and asymmetry, is crude yet palpable, as palpable as the invitation to dance of the title and the music. Reproduction for eye and ear of the synaesthetic is, besides, a project doomed to failure, as is the attempt to produce a lasting Nirvana from a return to the purely somatic offered by the call to abandon rationality.

The new media are capable of all that this tape sets out to do and more. But the remaking of the relation between image and world cannot be undertaken at the expense of either. Neither singing the praises of the simulacral, nor taking up the ostrich position of the new Luddism is a solution to the conditions under which we must now operate as producers and consumers. Such conditions will not be limited to products of the new media alone, but as TV has altered the conditions of cinema, radio of recording and photography of engraving, so digital media establish new conditions for the consumption of the old. We will need a readiness to sacrifice beauty, harmony and peace of mind to this experiment.

Otherwise we will only carry over the old harmonies, the old beauties, with us into a future in which they will only be uprooted with difficulty. 'Cyberdream' is worth this spattering of vitriol because it gets well beyond the worst of the familiar, and begins to make something new. But we will need more than novelty. Nor can we change the world by ignoring it. Yet without change in the world, there will be no new imagination. These, as we are taught to say today, are not problems, but challenges and opportunities. But they are ones which, in redefining representation, may work in tandem with the redefinition of sexuality and the structures of dominance that derive from it. Last, we cannot simply turn our backs on the culture of narcissism. It too is part of the world opening up to us. But we should be wary of exploring it in terms of deriving from encrusted layers of dominant culture or from myths of primal innocence and wholeness. We need to investigate, live through, the landscapes of internal division and process opened up by the new media, without fear or prejudice, but aware that what we find may be less than pretty. For we are still the vassals of a global system which is well acquainted with the machinery of the imagination and how to deploy it. Changing our imaginations means changing the world, demanding the impossible.

To build a parallel universe which, however, shares with the ideological construction of our own a meticulous anchorage in coherence and wholeness is an imperfect response. As yet I know of no completely satisfying aesthetic strategies which can provide the terms for a perfect one: indeed, logically that seems a fallacious dream. On the other hand, there exist modes of working which do seem to challenge profoundly the aesthetics of coherence which exist in mutual dependency with the construction of meaning founded in sexual difference. One example of this is Stefan Dowsing's *Faces of Light*, an installation piece first shown at 'The Light Show' in the Walsall Museum and Art Gallery, August 1991. The installation is an asymmetric room, in one wall of which is built a back-projection screen illuminated by an unseen video projector. The tape unfolds a relentlessly abstract field of overlapping colours moving across the screen in a variety of horizontal and diagonal motions, building up a complex repertoire of visual effects and textures in the slightly aqueous tonality of video projection.

But the room is also a space in which we not only view but are viewed, a space of visuality, or rather a space for the investigation of the grounds of visuality. The screen illuminates the room and the viewer, casting its colours across the walls and the outer skin and clothing of the audience. We become players in the work by becoming self-consciously visible. What the work, the experience of the work, indicates is the pre-existence of a look,

prior to our vision, and the mutuality of vision – to look is also, and already, to be visible; and, as Lacan points out in his commentary on Merleau-Ponty, grounded in a fundamental split between the eye and the function of looking, the pre-existence to sight of the object of seeing (Lacan, 1973: 68–73). The phenomenological limits of seeing which Merleau-Ponty analyses focus in on the question as to the relationship between seer and seen, the look and things: 'How does it happen that my look, enveloping them, does not hide them, and, finally, that, veiling them, it unveils them?' (1968: 132). For the philosopher, the responses must be philosophical: there is a chiasmus between visible being and look-ing, a mutuality of horizons which delimit and define what each must be. For the psychoanalyst, that look 'only presents itself to us in the guise of a strange contingency, symbolic of what we find at the horizon and as the buttress of our experience, the constitutive lack of castration anxiety. The eye and the look: such is the split in which is manifested, for us, the drive at the level of the scopic field' (1973: 69–70).

Lacan reseats the phenomenological dialectic of vision – what is it to see, what is it to inhabit a world that offers itself to vision, which partner controls the field of looking? – in the corporeality of the body, but not naïvely. The anchorage of vision in the eye – a sexual instinct anchored in its erogenous zone – is brought about in the Oedipal dialectic, and is as profoundly shaped by it as any other mode of human life. In Dowsing's installation, both the limitation of vision to the single organ, and the sense that the eye is a window through which the world imposes its own forms, is contested. While the screen-work performs a range of virtual spaces and false perspectives, its by-product of light, so invisible in the cinema, becomes core to the experience of viewing. We are cast in the role of the visible, sharing the field of visibility with our objects. It is, in its own way, a profoundly narcissistic experience.

Which is precisely why it is so necessary. Materialist criticism has still its profound distrust for individuality, as explanatory framework and as an aspect of life. Neither selfishness nor bourgeois individualism have ever been socialist virtues. But we do need to embark on an exploration of selfhood, if only to understand better what its histories are, and how it appears to be mutating at present. For our bodies are themselves visible, seeing and seen, and sight, the sight of ourselves, is a constant oscillation between the roles of subject and object. But since subjectivity is clearly historically constructed, we must also be aware that seeing is constructed, and that objectivity too has its social and cultural roots. To see ourselves as individuals is not a natural and permanent given, and needs to be explored. In Dowsing's *Faces of Light*, precisely that exploration is begun.

Cinema, Mulvey argues, is an apparatus devoted to seeing oneself in the guise of an other. *Faces of Light* is devoted to seeing one's self in the guise of object, and initially as object of desire. The installation's sensuality, even its meditative and serene qualities of what we are constrained to call the 'spiritual', derive from this internal dynamic. Because the whole space and its contents are illuminated by the screen projections, the structures of viewing are unmade. The capture of subjectivity by perspective, the selection of objects, symmetry, geometry, is dispersed. In its place, we are invited into the field of vision as both sources and objects of illumination, in an environment in which all surfaces are reflective, a world without an origin for its light (since the projector itself is hidden, and its beam invisible). Vision is equated less with its objects than its medium – light. So that we begin to contemplate the diffusion of light as a mode of the diffusion of self, a gentle unravelling of self as defined in the dialectic of subjectivity and objectivity so harshly orchestrated in dominant regimes of visuality.

We are as much conscious of being seen as of looking, as conscious of our bodies as objects as we are of the more familiar organisation of looking centred on the eye. To look through your eyes is to become invisible: in cinematic looking, at its most highly organised. But *Faces of Light* extends the sense of vision across the face at least – since no one goes naked into the art gallery. Our movements are articulated with the slow passage of colour. There is an uncanny sense of lightness, weightlessness, associated with this dissociation of vision from the eye, a pleasant massaging of the sense of space. The experience has its own erotics, as it shifts the rôle of actor from object (screen) to subject (viewer): an erotics of narcissism, not simply because it slips away the anchors of selfhood as constantly remade in social interaction, nor because it allows for and encourages a drift of consciousness across the great divide of the epidermis, but because its pleasures are entirely grounded in rediscovering an ability to be uncentred. It is not that individuality as such is a bad idea, but that we have, in the West, insisted on tying it down so tightly to the symbolic rôle of the ego that we no longer recognise other dynamics at work in its formation. Psychoanalysis opens one set of speculations. Video media continue that theoretical work by other means.

The strength of Dowsing's work is that it addresses needs which, again, have been set aside by materialist analysis, but that it does so without recourse to atavism or to quack nostrums or technical sleight of hand. Several visitors I spoke to in Walsall used words like 'spiritual', 'mystical' and 'meditation' to describe their reactions: terms that we deploy today with trepidation. What I think they wanted to address was the set of needs which remain so deeply unanswered in modern (postmodern?) society

after the death of God. We demand, not so much life after death, as a full life before it. Constructions of sexual identity – ground in our society of any identity – are so shamefully shallow, so little like our experience of our selves, that we both yearn for and fear an engagement with depth. But for materialism, that depth has only one home: the human heart. There are no remedies, no charms, that can absolve this hurt. What we seek, what *Faces of Light* to some extent enables, is a pursuit of illumination. One that involves distrust, dislike and destruction of what we have been offered – the guilty, fractious, unhappy and harmful ego – the recognition and exercise of what we have – extraordinary talents for pleasure, for meaning, that shift and extend well beyond the tawdry confines of structured physicality, alienated mentation – and delight in the gradual discovery that we are not alone. Moving through the installation, you are aware that others are enjoying something both quite remote and yet deeply similar to your own sensations. These new modes of communications between viewers, seers and seen rediffused in the field of the visible, are the elementary particles of a new ecology.

Communication is fundamental to the human creature, as she has evolved in our world. But that communication has itself evolved under conditions structured by inequality and domination. As a result, we feel ourselves to be lonely outcrops of intelligence, doing endless battle with media of communications – language, video – that resist our messages, since, doomed to our own lack in being, we can never find the fullness we desire in the endless chains of signification. But here, in his little utopia, the artist experiments with light, with vision, in ways that suggest, if not the future, then a future, the possibility of other communications, other selves, other organisations of the self that will allow for other and more complex relations with our fellow humans, relations perhaps at last freed of the tyranny of sexual division.

Sexual difference is now only a method of governance: it has no charms for us as a culture: that is why it is so necessary for the dominant culture to repeat over and again the naturalness of heterosexism, the impossibility of anything else. We cannot, even for analytical purposes, pretend that this awesome social structure doesn't exist or need not be fought over. But we should also be aware that the electronic media have begun to afford practices of communication that already challenge, if only in circuitous and perhaps still regressive ways, the authority of the sexed self. The narcissistic tactic works now, but is already being contested by the dominant culture. We must then consider in particular the new avenues of communication opened up in these experiments, the sets of relations that may be available in the relationship between subjects of the *énonciation*, not of the *énoncé*. The

next step, then, would be: to think, not of what goes on on each individual screen, but to think of how the screen works globally, the world as video installation, as video ecology, as a global field of interweaving relationships that begin in the weird dynamics of the human psyche . . .

## REFERENCES

Adorno, Theodor W. (1984) *Aesthetic Theory*, trans. C. Lenhardt, ed. Gretel Adorno and Rolf Tiedemann, London: Routledge & Kegan Paul.

Adorno, Theodor W. (1991) 'How to Look at Television', in J.M. Bernstein (ed.) *The Culture Industry: Selected Essays on Mass Culture*, London: Routledge.

Becquer, Marcos and Gatti, Jose (1991) 'Elements of Vogue', *Third Text* 16/17 (Autumn/Winter).

Benveniste, Emile (1971) *Problems in General Linguistics*, trans. Mary Elizabeth Meek, Coral Gables: University of Miami Press.

Cubitt, Sean (1984) '"Maybellene": Meaning and Listening Subject', *Popular Music* 4.

Doane, Mary Ann (1982) 'Film and the Masquerade: Theorising the Female Spectator', *Screen* 23 (3/4): 74–87; reprinted in M.A. Doane (1991) *Femmes Fatales: Feminism, Film Theory, Psychoanalysis*, London: Routledge.

Freud, Sigmund (1911) 'Psychoanalytic Notes on an Autobiographical Account of a Case of Paranoia (Dementia Paranoides) (Schreber)' in *Case Histories II*, Pelican Freud Library Volume 9, trans. James Strachey, Harmondsworth: Penguin.

Freud, Sigmund (1914) 'On Narcissism: An Introduction' in *On Metapsychology: The Theory of Psychoanalysis*, Pelican Freud Library Volume 11, trans. James Strachey, Harmondsworth: Penguin.

Freud, Sigmund (1919) '"A Child Is Being Beaten": A Contribution to the Study of the Origin of Sexual Perversions', in *On Psychopathology*, Pelican Freud Library Volume 10, trans. James Strachey, Harmondsworth: Penguin.

Freud, Sigmund (1923) 'The Ego and the Id', in *On Metapsychology: The Theory of Psychoanalysis*, Pelican Freud Library Volume 11, Harmondsworth: Penguin.

Kristeva, Julia (1974) *La Révolution du langage poétique: L'Avant-garde à la fin du XIX$^e$ siècle: Lautréamont et Mallarmé*, Paris: Seuil.

Lacan, Jacques (1973) *Le Séminaire Livre XI: Les quatres concepts fondamentaux de la psychanalyse*, Paris: Seuil.

Merleau-Ponty, Maurice (1968) *The Visible and the Invisible*, ed. Claude Lefort, trans. Alphonso Lingis, Evanston, IL: Northwestern University Press.

Mulvey, Laura (1975) 'Visual Pleasure and Narrative Cinema', *Screen* 16(3): 6–18; reprinted in L. Mulvey (1989) *Visual and Other Pleasures*, London: Macmillan.

Rodowick, D.N. (1991) *The Difficulty of Difference: Psychoanalysis, Sexual Difference and Film Theory*, London: Routledge.

Straayer, Chris (1990) 'The She-man: Postmodern Bi-sexed Performance in Film and Video', *Screen* 31 (3): 262–80.

Williamson, Judith (1986) 'The Making of a Material Girl', *New Socialist*, October.

# Part V

# ANNOTATED BIBLIOGRAPHY

# 17

# SOURCES FOR FURTHER READING AND RESEARCH

As researchers into popular music, culture and gender are all too aware, it is often difficult to keep abreast of the range of texts that are currently emerging from such publishers as Routledge. One way of keeping up to date is to survey the relevant catalogues – Cultural Studies, Popular Music, Communications, Gender. Another is to read the reviews in such established journals as *Popular Music, Feminist Review, Cultural Studies, Screen*, etc. Essay reviews are particularly useful as they contain an overview relevant to the specialist discipline.

Each chapter in *Sexing the Groove* includes bibliographical material and this makes an obvious starting point for new researchers. At the same time, it is recognised that recent publications offer perspectives that may not have been incorporated into the analysis and, as such, each contributor has been invited to suggest texts which provide important perspectives on their own areas of research. These are incorporated into the relevant sections of this annotated bibliography. Not surprisingly, these include important introductory textbooks as well as innovative new anthologies, essay collections and paradigm-shifting research into gender and music.

## CULTURAL STUDIES

Billington, R., Stawbridge, S., Greensides, L and Fitzsimons, A. (1991) *Culture and Society*, London: Macmillan.
A good introductory text on the debates surrounding culture and method, art, imperialism, race, class, gender, education and media. Designed to 'make the study of culture more accessible for sociology and other students'.

During, S. (ed.) (1993) *The Cultural Studies Reader*, London: Routledge.
An introductory text presenting a selection of essays which cover theory and method, space and time, nation, ethnicity and multi-culturalism,

319

sexuality, carnival and utopia, consumption and the market, leisure and media.

Gray, A. and McGuigan, J. (eds) (1993) *Studying Culture: An Introductory Reader*, London: Edward Arnold.
A reader which comprises classic statements of culturalist, semiological, postmodern, feminist and ethnic-based perspectives outlining the general themes in the study of contemporary culture.

Jenks, C. (1993) *Culture*, London: Routledge.
An introduction to the concept of culture as it is located within various traditions of Western social theory.

Storey, J. (1993) *An Introductory Guide to Cultural Theory and Popular Culture*, London: Harvester Wheatsheaf.
Quite simply the best introduction to the subject currently available. The text discusses, in a very clear, concise and readable fashion, popular culture, the culture and civilisation tradition, culturalism, structuralism and poststructuralism, Marxism, feminism, postmodernism and politics..

Williams, R. (1988) *Keywords*, London: Fontana Press.
A dictionary/glossary type format which analyses the meaning of certain key cultural terms.

Williams, R. (1986) *Culture*, London: Fontana Press.
A cultural materialist sociology of the production, reproduction and innovation of culture in the West.

## CULTURE: POLICY AND POLITICS

Some of the important texts on the economic background to the production, consumption and expansion of Western popular music and its cultural significance.

Adorno, T.W. (1991) *The Culture Industry: Selected Essays on Mass Culture*, edited and with an introduction by J.M. Bernstein, London: Routledge.
An introduction to Adorno's thought on cultural questions, especially his contentious account of mass culture as an industry.

Attali, J. (1985) *Noise: the Political Economy of Music*, Manchester: Manchester University Press.
An important text which discusses how music has 'invaded our world and daily life' and how and why background noise has become increasingly necessary in giving people a sense of security. Useful insights into

categorisation, the death of historically grounded musical forms and how changes in the recording and reception of popular music have given rise to new forms that 'recreate the old codes in order to reinsert communication into them'.

Bennett, T., Frith, S., Grossberg, L., Shepherd, J. and Turner, G. (eds) (1993) *Rock and Popular Music: Politics, Policies, Institutions*, London: Routledge.
A collection of essays which explores the reasons for, and the ways in which governments have sought either to support or prohibit popular music in Canada, the USA, Australia and Europe. It also examines the impact of broadcasting policies in forming and shaping different musical communities, and the political issues of rock and popular music theory within the context of policy and institutional settings.

Burnett, R. (1995) *The Global Jukebox: The International Music Industry*, London: Routledge.
An account of the workings of the contemporary music industry which analyses the relationship between the 'big six' transnational music corporations, technological innovation and consumer demand in the production and consumption of music in a global market.

Eliot, M. (1990) *Rockonomics: The Money behind the Music*, London: Omnibus.
Exactly what it says . . . a discussion of the big business of rock.

Harker, D. (1980) *One for the Money: Politics and Popular Song*, London: Hutchinson.
A Marxist polemic on the politics of popular song and the industry that generates it.

Negus, K. (1993) *Producing Pop: Culture and Conflict in the Popular Music Industry*, London: Edward Arnold.
An analysis of the conflictual way in which pop music is produced, distributed, marketed and consumed in the West.

Sanjek, R. and Sanjek, D. (1991) *American Popular Music Business in the 20th Century*, New York, Oxford: Oxford University Press.
This provides a detailed history of the music business in the twentieth century and traces the technological and economic revolution which has accompanied popular music in the last ninety years. There are insights into the long-term relationship between movies and music from the earliest silent films, to such blockbusters of the 1970s and 1980s as *Saturday Night Fever* which sold 15 million copies in the United States alone. An important resource for anyone interested in how music is produced and marketed.

Wallis, R. and Malm, K. (1993) *Media Policy and Music Activity*, London: Routledge.
An in-depth examination of the relationships between policies governing the output of the music media and music activity in society. This book combines a practical base in case study material with a broad theoretical framework for understanding the music media.

## POPULAR CULTURE

### General texts

Chambers, I. (1986) *Popular Culture: The Metropolitan Experience*, London: Routledge.
Part Three provides the reader with a useful introduction to the sounds which have formed part of the urban experience in contemporary Western society.

Chambers, I. (1985) *Urban Rhythms: Pop Music and Popular Culture*, London: Macmillan.
Outlines the nature of the popular culture of leisure, youth and pleasure in contemporary Western societies. Useful for its historical overview of British popular music from the 1950s to the 1980s.

Fiske, J. (1989) *Reading the Popular*, London, Routledge.
An analysis of the 'texts and sites where people make their popular culture in capitalist societies'. It contains a useful introductory chapter 'Understanding Popular Culture' which examines the theories underpinning popular culture and, in particular, culture-making as a social process. 'Video Pleasures', 'Madonna' and 'Romancing the Rock' are recommended.

Fiske, J. (1989) *Understanding Popular Culture*, London: Routledge.
A companion volume which moves from theories to readings.

### Subcultural theory

Gelder, K. and Thornton S. (eds) (1997) *The Subcultures Reader*, London: Routledge.
This new text brings together writings on subcultures from the early work of sociologists of the Chicago School through to research undertaken at the Birmingham Centre for Contemporary Cultural Studies in the 1970s and up to the present. A useful guide to this interdisciplinary field.

Hall, S. and Jefferson, T. (eds) (1989) *Resistance Through Rituals*, London: Routledge.
The seminal text of subcultural theory and the most heavily theorised analysis of pop of its time.

Hebdige, D. (1979) *Subculture: The Meaning of Style*, London: Routledge.
Popular music studies first engaged with cultural theory through an analysis of style. Hebdige, as part of the University of Birmingham's influential Centre for Contemporary Cultural Studies, established the key parameters of subcultural analysis and this book remains a pivotal text in the analysis of style as *bricolage*, the use of signs and icons providing particular insights into what he calls 'semiotic guerrilla warfare'.

## GENERAL TEXTS ON THE ANALYSIS OF POPULAR MUSIC AND POPULAR MUSIC CULTURE

### Collections and compilations

Bangs, L. (1996) *Psychotic Reactions and Carburettor Dung*, London: Serpent's Tail.
This is a collection of Bangs's reviews drawn mainly from *Rolling Stone* and *Creem* and is edited by Greil Marcus. Bangs was particularly against the 'star-making machinery' of the music industry and this collection provides key insights into pop history.

Frith, S. and Goodwin, A. (1990) *On Record: Rock, Pop and the Written Word*, London: Routledge.
A useful compilation of seminal writings on rock and pop which contains a representative selection of ways of studying pop and rock. Part One: 'Groundworks', offers a perspective on the early years of popular music study; Part Two: 'From Subcultural to Cultural Analysis' includes Paul Willis's 'The Golden Age' and includes essays from Dick Hebdige's 'Style as Homology and Signifying Practice'. Part Three: 'The Organisation of the Music Business' explores the interrelation between music production and the promotion of pop via the mass media. In Part Four, 'The Creative Process' is examined through participant observation and interview material and includes Mavis Bayton's essay 'How Women Become Musicians'. Part Five, 'Musicology and Semiotics' is particularly useful in containing essays by Theodor Adorno 'On Popular Music' and Roland Barthes's 'The Grain of the Voice'. Part Six: 'Music and Sexuality' contains Frith and McRobbie's seminal article 'Rock and Sexuality'. Part Seven: 'Reading the Stars' presents contrasting readings of specific stars, and the book ends with extracts from Fred and Judy Vermorel's book, *Starlust*.

Gammond, P. (1991) *The Oxford Companion to Popular Music*, Oxford: Oxford University Press.
This covers a range of material including Anglo-American and European jazz, blues, ragtime, Country and Western, folk and pop. Although the main genres are clearly described there are some inaccuracies and notable omissions (e.g. Kraftwerk) and its main strength lies in its discussion of popular music styles and genres.

Hardy, P. and Laing, D. (eds) (1992) *The Faber Companion to 20th Century Popular Music*, London: Faber.
An A-Z of performers.

Larkin, C. (ed.) (1995) *The Guinness Encyclopaedia of Popular Music*, London: Guinness.
The closest thing to a definitive guide to popular music.

Murray, C. Shaar (1991) *Shots from the Hip*, London: Penguin.
A collection of writings including band profiles, articles, interviews and reviews dating from 1971 to 1990. These are mainly drawn from his articles in *Oz*, *Creem*, *New Musical Express* and *Q*. His *Illustrated Record Book* on David Bowie (written with Roy Carr) and the more recent *Cross Town Traffic* on Jimi Hendrix have also received general acclaim.

## History and analysis

Barthes, R. (1990) *S/Z*, trans. R. Miller, London: Blackwell.
This provides Barthes's own application of the five codes of S/Z to the analysis of music.

Barthes, R. (1987) *Image, Music, Text*, trans. S. Heath, London: Fontana.
This brings together Barthes's major essays on the structural analysis of narrative and issues on literary theory, the semiotics of photograph and film. The chapters on 'Musica Practica' and, in particular, 'The Grain of the Voice' are especially relevant.

Cohen, S. (1991) *Rock Culture in Liverpool: Popular Music in the Making*, Oxford: Clarendon.
This book makes a useful contribution to contemporary anthropologies of popular music and provides an in-depth discussion of two 1980s Merseybeat bands, The Jactars and Crikey It's the Cromptons. The last chapter 'The Threat of Women' is particularly interesting in its focus on the white male domination of the pop scene in Liverpool.

Longhurst, B (1995) *Popular Music and Society*, Cambridge: Polity Press.
Specifically written as a textbook for students studying popular music from
a sociological perspective. It examines the general theoretical debates sur-
rounding popular music before considering 'the ways in which popular
music is produced, structured as text, and understood and used by its
audience'.

Marcus, G. (1991) *Mystery Train: Images of America in Rock 'n' Roll Music*, 4th ed.,
London: Penguin.
The classic status of this book is unquestionable. In particular, the cele-
brated chapter on Presley is critical reading. Most significantly, the
extensive 'Notes and Discographies' section has been completely revised.

Middleton, R. (1990) *Studying Popular Music*, Milton Keynes: Open University
Press.
This is recognised as the standard text on popular music. It is compre-
hensive and, although not an easy read, it provides a critical analysis of the
most significant analytical approaches to the study of popular music.

Moore, A.F. (1992) *Rock: The Primary Text*, Buckingham: Open University
Press.
A musicological analysis of popular music, which the author argues should
be seen as the primary text in any appreciation. The book serves as a good
history of the differing styles of popular music in the West. The Glossary
is particularly useful for students.

Shepherd, J. (1991) *Music as Social Text*, Cambridge: Polity Press.
Situates music at the centre of an extended investigation into its signifi-
cance within the field of cultural studies. Shepherd is concerned with 'the
use of music in telling us about the nature of our relatedness to ourselves,
other people and the environment' and is aimed at an academic market. A
demanding but useful read.

Shuker, R. (1994) *Understanding Popular Music*, London: Routledge.
A readable general introduction to all aspects of the cultural world of pop-
ular music.

Whiteley, S. (1992) *The Space Between the Notes: Rock and the Counter-Culture*,
London: Routledge.
An investigation into the relationships between the 1960s counterculture
and psychedelic rock. The book combines musicology with socio-cultural
analysis and provides a case study approach to key British bands of the
period.

Wicke, P. (1990) *Rock Music*, Cambridge: Cambridge University Press.
An aesthetic history of the evolution of popular musical culture in the West.

## Standard texts on Black popular music and culture

Hebdige, D. (1987) *Cut 'n' Mix: Culture, Identity and Caribbean Music*, London: Routledge.
A history of Caribbean music, from the calypso and ska through to reggae and club culture. This is particularly useful for the analysis of the collective voice and the centrality of rhythm and percussion which sets African, Afro-American and Caribbean music apart from the European classical tradition. In particular, Hebdige examines the links between rhythm and speech, between cultures, histories and identities.

Oliver, P. (ed.) (1990) *Black Music in Britain: Essays on the Afro-Asian Contribution to Popular Music*, Milton Keynes: Open University Press.
This edited collection provides an initial survey of the history of Black music in Britain and serves as a reminder that Black musicians have been living and working in Britain for more than three centuries. The book is organised in two parts: part one covering the period from 1800 to 1950; part two, the 1950s to the present day. Two chapters on Asian musical traditions in Britain are included.

Rose, T. (1994) *Black Noise: Rap Music and Black Culture in Contemporary America*, Hanover, NH: Wesleyan University Press.
A discussion of rap and hip hop music as a cultural, political and musical force in contemporary American Society.

Stokes, M. (ed.) (1994) *Ethnicity, Identity and Music: The Musical Construction of Place*, Oxford: Berg.
Examines music as social practice and contains a collection of essays which focus on the significance of music in the construction of identities and ethnicities.

## Genre

The journal *Popular Music* has published some interesting work on genre as well as analysis of such individual performers as Jimi Hendrix (Sheila Whiteley, Vol. 9, No. 1), Hank Williams (Leppert and Lipsitz, Vol. 9, No. 3), Chuck Berry (Timothy D. Taylor) and the Smiths (Julian Stringer; both in Vol. 11, No. 1), James Brown (David Brackett) and Prince (Stan Hawkins;

both in Vol. 11, No. 3). Special issues on, for example, African music, Japanese popular music, etc. provide important source material and articles on genre (Country and Western, blues, jazz) are often included. Heavy metal, in particular, has provided the focus for several in-depth analyses. This is equally the case for more substantial texts. Of particular interest are:

Walser, R. (1993) *Running with the Devil: Power, Gender and Madness in Heavy Metal Music*, Hanover, NH: University Press of New England.

Weinstein, D. (1991) *Heavy Metal: A Cultural Sociology*, New York: Lexington.

## GENERAL TEXTS ON MASCULINITY AND CULTURE

Cornwall, A. and Lindisfarne, N. (eds) (1994) *Dislocating Masculinity: Comparative Ethnographies*, London: Routledge.
The writers draw upon anthropology, feminism and postmodernism to provide a study of gender difference which provides a radical critique of recent writings on and by men.

Easthope, A. (1992) *What a Man's Gotta Do: The Masculine Myth in Popular Culture*, New York and London: Routledge.
A series of investigative essays which draw on psychoanalysis and ideology and show how the masculine myth forces men to try to be masculine and only masculine.

Edwards, T. (1993) *Erotics and Politics: Gay Male Sexuality, Masculinity and Feminism*, London: Routledge.
An interesting text which examines the connections between gay male sexuality and gender through a critique of masculinity. It examines a range of issues including AIDS and gay liberation.

Hearn, J. and Morgan, D. (eds) (1990) *Men, Masculinities and Social Theory*, London: Routledge.
A collection of essays which provides illustrative and critical perspectives upon the developing study of men and masculinities and its importance for sociological theory. The contributions are organised around the unifying themes of Power and Domination; Sexuality; Identity and Perception.

Holmlund, C. (1993) 'Masculinity as Multiple Masquerade: The "Mature" Stallone and the Stallone Clone', in S. Cohan and I.R. Hark (eds) *Screening the Male: Exploring Masculinities in Hollywood Cinema*, London: Routledge.
A useful article which tackles some of the difficulties with uses of the concept of masquerade. Although Holmlund's own analyses are related to

readings of feature films, her readings provide a useful point from which to consider more widely how masculinity is used in performance.

## GENERAL TEXTS ON FEMINISM AND CULTURE

Bryson, V. (1992) *Feminist Political Theory: An Introduction*, Basingstoke: Macmillan.
A comprehensive guide to feminism in the Western tradition, covering every school of thought and all the crucial debates. Invaluable for those who wish to locate feminist arguments in their historical and political context.

Collins, P.H. (1990) *Black Feminist Thought*, London: Routledge.
An excellent sociological overview of academic and non-academic Black feminist thought as interpreted by the Afro-American tradition.

Elam, D. (1994) *Feminism and Deconstruction: Ms. en Abyme*, London: Routledge.
Examines the relationship between feminism and deconstruction and provides a particularly useful first section on definitions, theories, movements, philosophies, etc.

Gunew, S. (ed.) (1990) *Feminist Knowledge, Critique and Construct*, London: Routledge.
A collection of essays which examines international feminism from a wide range of feminist viewpoints. Its usefulness lies in its investigative approach and the ways in which recent theories and writings have influenced feminist theory during the last decade.

hooks, b. (1992) *Black Looks: Race and Representation*, London: South End.
A personal account of the 'political consequences of contemporary representations of black men and women within our white supremacist culture' which situates debates within a discussion of popular music and film.

Tong, R. (1989) *Feminist Thought: A Comprehensive Introduction*, London: Routledge.
A useful text which examines the range of feminist thought from liberal feminism through to post-structuralism. In particular Tong provides a discussion of the key protagonists and the pros and cons of each underlying theory.

## TEXTS ON MALE, FEMALE AND QUEER SEXUALITY IN POPULAR MUSIC

Brett, P., Wood, E. and Thomas, G.C. (eds) (1993) *Queering the Pitch: The New Gay and Lesbian Musicology*, London and New York: Routledge.

A collection of essays which examines representations, performances and roles. Divided into three main sections, Part One examines 'Canons and Arias', Part Two 'Chronicles' – with an interesting essay on k.d. lang; Part Three, 'Consorts' with an intriguing insight into lesbian compositional process. Overall the book deals with such issues as what makes music pleasurable, and how it is shaped by notions of sexuality and sexual identity.

Griffin, G. (1993) *Outwrite: Popular/Rising Lesbian Texts*, London: Pluto Press.
A collection of essays discussing 'the complex relationship between lesbians as producers, consumers and subjects of popular culture covering literature, music and film'. Of particular interest is Barbara Bradby's 'Lesbians and Popular Music: Does it matter who is singing?'

Grosz, E. and Probyn, E. (1995) *Sexy Bodies: The Strange Carnalities of Feminism*, London and New York: Routledge.
This is an impressive and wide-ranging collection of essays on diverse cultural representations and conceptions of women, femininity and bodies, calling on the radicalism of queer theory to emphasise the notion of performativity and multiple identities. Many of the essays are concerned with lesbian bodies and identities, and are thus directly pertinent to k.d. lang.

McClary, S. (1991) *Feminine Endings: Music Gender and Sexuality*, Minneapolis, Oxford: University of Minnesota Press.
A collection of essays in feminist music criticism which addresses problems of gender and sexuality from the early seventeenth century through to rock and performance art.

Shepherd, S. (1989) 'A conversation about rock, politics and gays' (interview with Tom Robinson), in S. Shepherd and M. Wallis (eds) *Coming on Strong (Gay Politics and Culture)*, London: Unwin Hyman, pp. 275–86.
One of the essays in a collection which reflects upon the politics of gay culture: 'a book that the commissioning publisher didn't dare print'.

Schwichtenberg, C. (ed.) (1993) *The Madonna Connection*, Boulder, CO: Westview Press.
A collection of essays on the Madonna phenomenon and questions such as race, sexuality, gender and postmodernism.

Weil, K. (1992) *Androgyny and the Denial of Difference*, Charlottesville and London: University Press of Virginia.
There are surprisingly few sustained studies of androgyny that are of real interest, but this is an exception. Weil's study is primarily of the androgyne in literature, but the more widespread debates concerning biology, sexuality and gender are comprehensively covered in this book. Although

not directly concerned with music, this provides theoretical insights which can be usefully applied to such performers as Bowie and Lennox or to such bands as the Velvet Underground.

## FAN CULTURE

As *Sexing the Groove* has argued, the relationship between the fan and the performer is critical to an understanding of the power of popular music. *On Record: Rock, Pop and the Written Word* (Frith and Goodwin, 1990) contains a final section on fans but the key text here is:

Lewis, L.A. (1992) *The Adoring Audience: Fan Culture and Popular Media*, London: Routledge.
This is a collection of essays which examines fan culture, particularly as it relates to identity, sexuality and textual production.

## LITERARY THEORY, FILM AND VIDEO
### Theoretical models

As the reader will have observed, the analysis of popular music and gender draws on a range of theoretical models. Literary theory and film studies have provided specific insights into the analysis of gender, not least in the area of performance. The following have proved particularly useful.

Butler, J. (1990) *Gender Trouble. Feminism and the Subversion of Identity*, New York: Routledge.
This radical rethinking of difference and construction of gender is where many people think 'queer theory' began. Butler suggests, following on from past feminists such as Simone de Beauvoir, that not only is gender not fixed by sex, but it is mutable, responsive and performative. Butler's most radical and accessible idea is that of gender as a perpetual performance, that one can put on and take off genders much as one can clothes. Although her writing is sometimes hard going, Butler's most innovative book is worth the struggle.

Creed, B. (1993) *The Monstrous-Feminine: Film, Feminism, Psychoanalysis*, London: Routledge.
Creed's argument that man fears woman as castrator, rather than castrated, questions Freudian theories of sexual difference and existing theories of spectatorship and fetishism. Her analysis of the seven 'faces' of the monstrous-feminine provides a challenging rereading of classic and contemporary film and theoretical texts.

Gamman, L. and Marshment, M. (eds) (1988) *The Female Gaze: Women as Viewers of Popular Culture*, London: Women's Press.
A seminal collection of essays which examines the impact of feminism on representations of women in popular culture.

Griffin, S. (1981) *Pornography and Silence*, London: Women's Press.
A perceptive analysis of the pornographic/racist mind and the way in which it relates to a fear of bodily knowledge. Her discussion of Marilyn Monroe in 'Silence' provides a particularly apposite investigation for those interested in identity – an area of particular interest for researchers into male/female performance in popular music.

Mulvey, L. (1989) *Visual and Other Pleasures*, Basingstoke: Macmillan.
The classic text of film theory and scopophilia.

### Music videos

Cubitt, S. (1991) *Timeshift: On Video Culture*, London: Routledge.
A useful discussion of video culture which demonstrates a knowledge of both film and popular music.

Frith, S., Goodwin, A. and Grossberg, L. (eds) (1993) *Sound and Vision: The Music Video Reader*, London: Routledge.
A collection of established and innovative texts on music video. Of particular note are 'Popular Music and Postmodernism in the 1980s' (Will Straw, Part I, 'The Context of Music Videos') and Part III, 'Video Analysis'.

## POSTMODERNISM

Although many of the texts already cited include postmodernist critiques of culture and/or popular music, it is considered that current debates are sufficiently important to merit a section in their own right.

Goodwin, A. (1993) *Dancing in the Distraction Factory: Music, Television and Popular Culture*, London: Routledge.
This is the first book to combine textual analysis of music video with a comprehensive understanding of music television as a cultural industry. Goodwin combines perspectives from musicology, narrative analysis and star studies, towards exploring the interconnections of sound and image in music video. Readings of video texts are combined with an account of the history and production conditions of MTV, to produce an account of music television as a form of entertainment context. Goodwin concludes

by evaluating some problems in applying postmodern theory to music video. A very readable book.

Grossberg, L. (1992) *We Gotta Get Out Of This Place: Popular Conservatism and Postmodern Culture*, London: Routledge.
Although the book is concerned, overall, with the meaning, purpose and politics of cultural studies, Grossberg's section on 'Another Boring Day in . . . Paradise' will be of particular interest to those with an interest in what he calls the 'rock formation' and its specific conditions of possibility: economic, technological, sociological, cultural, political, ideological and experiential.

Kaplan, E.A. (1988) *Rocking Around the Clock: Music Television, Postmodernism and Consumer Culture*, London: Routledge.
An early study of MTV which considers the characteristics of music video and of music television as a cultural phenomenon. Kaplan's study is notable for the typology of music videos she offers, and can be used as a comparative framework for tracing the emergence of other categories of video. Although there are occasional lapses in the analysis of the musical text, this is a useful and informative text.

McRobbie, A. (1994) *Postmodernism and Popular Culture*, London: Routledge.
A readable book which examines postmodernity as a space for social change and political transformation through an investigation into everyday life as an eclectic arena for the interplay of different cultures and identities. Her chapter on the rave scene 'Shut Up and Dance: Youth Culture and Changing Modes of Femininity' is particularly relevant.

## JOURNALS

*Critical Quarterly*
Blackwell
108 Cowley Road
Oxford, OX4 1JF
Focuses on the vital relationship between creativity and criticism by bringing together criticism, new fiction and poetry.

*Cultural Studies*
Routledge
11 New Fetter Lane
London EC4P 4EE
Covers cultural studies, linguistics, literature, music, philosophy, media studies and women's studies.

*Feminist Review*
Routledge
11 New Fetter Lane
London EC4P 4EE
*Feminist Review* is published three times a year by a collective based in London. Founded in 1977, it is the major Women's Studies journal in Britain and presents informative contemporary feminist analysis.

*Hot Wire: The Journal of Women's Music and Culture*
Empty Closet
5210 N. Wayne
Chicago, IL 60640
Focuses on feminist-lesbian music and culture movement.

*Journal of Popular Culture*
Popular Press
Bowling Green State University
Bowling Green, OH 43402
Lively and discursive journal on aspects of popular culture.

*Literature and History*
Manchester University Press
Oxford Road
Manchester, M13 9PL
Covers research on literature and history.

*Media, Culture & Society*
Sage
6 Bonhill Street
London EC2A 4PU
Focuses on mass media within their political, cultural and historical contexts. Has expanded to cover effects of telecommunications and computing.

*New Formations*
Routledge
11 New Fetter Lane
London EC4P 4EE
Tackles questions of culture, politics and ideology, covering, for example, meaning and power, sexual and cultural difference, modernity and post-modernism, psychoanalysis and post-structuralism, democracy and civil society, aesthetics and style.

*Popular Music*
*Popular Music* is a multi-disciplinary journal which covers all aspects of popular music. It is published three times a year in January, May and October. Each issue contains substantial articles, shorter topical pieces, correspondence and reviews. Articles can be sent to Richard Middleton, The Open University, Northern Region, Eldon House, Regent Centre, Gosforth, Newcastle upon Tyne, NE3 3PW, England.

*Radical America*
Alternative Education Project
One Summer Street
Somerville, MA 02143
Independent journal exerting much influence on the democratic left, with balance between historical perspective and topical strategy.

*Screen*
Oxford Journals
Walton Street
Oxford, OX2 6DP
Contributions by leading critics, practising writers and film-makers, covering major developments in film theory from pop videos to film noir.

*Sociological Review*
Blackwell
108 Cowley Road
Oxford, OX4 1JF
Subjects and discussions related to sociology, with topical essays on health and work, job training, equal opportunities, family relationships.

*Textual Practice*
Routledge
11 New Fetter Lane
London EC4P 4EE
Covers cultural studies, linguistics, literature, music, philosophy, media and women's studies.

*Theory, Culture & Society*
Sage
6 Bonhill Street
London EC2A 4PU
Caters for the resurgence of interest in culture within contemporary social science.

*Women: A Cultural Review*
Oxford Journals
Walton Street
Oxford, OX2 6DP
Explores the past and present role and representation of women in the arts and culture.

## THE INTERNATIONAL ASSOCIATION FOR THE STUDY OF POPULAR MUSIC

IASPM is the most important source of communication for those with a real interest in contemporary research into popular music. It has an international membership, organises both national and international conferences and publishes its own journals. For more information contact: World Wide Web Site
http://xpress.comm.utulsa.edu/iaspm

## ACKNOWLEDGEMENTS

With thanks to Russell Griffiths and Andy Callen for their help in preparing this bibliography and to the contributors for their helpful suggestions.

# INDEX

Aaron, C. 54, 55
Abbate, Carolyn 261
abject 56, 60, 62
*Ablaze!* 239, 240, 247, 250, 251–2
abortion 238
acid house 243
Acker, Kathy 238
acoustic guitar 37, 38, 181
activism *see* riot grrrl
Adler, A. 106
Adlon, Percy 191, 192
Adorno, Theodor W. xv, 304, 308
Aerosmith 100
AIDS 203, 224
Albarn, Damon 9
Allen, Anisteen 143
Altamont xxi, 84–7, 88
alternative punk 210
alternative rock 15, 54, 58
Altman, Robert 194
Amphlett, Dave 288
analytical strategies xvii
Anderson, Laurie 304
androgyny/androgyneity xxi, xxvii, 75,
    92, 94–5; digital erotics and narcissism
    307; Madonna 270; *see also* lang, k.d.
Anger, Kenneth 79
'Angry Young Women' 53, 60
anti-rockism 12
Armatrading, Joan 192, 203
Arnold, Gina 217, 238, 247
*Art Strike Papers* 251
Artaud, A. 310
Arthur, Charlene xxiv, 147–8
artifice 52
Artist and Repertoire men (A&R) 19
asexuality xxiii
Ashtiany, Saffie 289
Atkins, Chet 147

Attali, J. 50
Au Pairs 214
audiences: physical contact 27; scene
    action 18; segregation by choice 23
Auerbach, Gene and Julian 147
authenticity xxiii, 52, 53; digital erotics
    and narcissism 299, 301, 305; and
    Liverpool scene 33; O'Connor, Sinéad
    180; Pet Shop Boys 130–1; rockabilly
    142; Springsteen, Bruce and masculinity
    101, 104, 108, 110, 111, 113; Take
    That videos 293
auto-eroticism 269, 270, 272, 299
Axton, Mae 148

Babes in Toyland 213, 230
Bacharach, Burt 8
back to Country movement 145–6
Baekeland, Frederick 5–6
Baez, Joan 38
Balfour, Ian 121
banality *see* Pet Shop Boys: musicology,
    masculinity and banality
band X 230
Banshees, The 214
Barrowclough, A. 240, 242, 243
Barthes, Roland 195, 211–12; codes of
    narratology xxxiii, 259, 262; codes of
    reading 261
Baudrillard, Jean 7
Baym, Nina 3
Bayton, Mavis xix–xx, 22, 28, 37–49,
    216, 218, 221
Beach Boys 13, 193
Bear Family Records 148
Beat Happening 212
beat music 37
Beatles 13, 25, 37, 69, 168; museum 27;
    *Sgt. Pepper's Lonely Hearts Club Band* 80, 81

Beauvoir, Simone de 198, 243
Beckerman, B. 278, 282
Becquer, Marcos 299
Beelzebub 81
Belk, Russell W. 4
Benveniste, Emile 308
Bergman, Jo 74
Berland, Jody 259
Berry, Chuck 68, 69, 144, 157
Biddulph, Stephen 101
Bikini Kills xxx, xxxi, 207, 210, 212,
    217, 223, 230, 231, 233, 234, 235,
    237, 238, 240, 241, 247, 248, 251
bisexuality xxiii, 75, 77
'Bitch Schirmish' 239
Blashfield, Jim 301
Blondie 213
blue-collar culture 103–4
blues xxv, 181; Chicago urban style 70
Blues Incorporated 69
blues queens see rockabilly
Bohemian Women's Political Alliance
    230–1
Bolan, Marc 205
Bon Jovi, Jon 100
Bonnie-Lou 161
Boul Jeloud 80, 81, 90
Bourdieu, Pierre xxxiv, 7, 271
'bourgeois bohemias' 57–8
Bowie, David 198, 205
Boyzone 293
Bradby, B. 31
Bradford, Percy 141
Bradley, Owen 150, 195
Brandt, Nicholas 291
Bratmobile 207, 210, 217, 230, 232
Brazos Valley Boys 156
Brecht, B. 282
Breeders 54
Briggs, Anne xxvi, 170
Brikaw, Chris 63
Brill Building songcraft 60
Brit awards 17
Britain 174; riot grrrl 214, 215, 233,
    236, 240, 246
British Folk tradition 170–2
Britpop xiv, 8, 26
Bronski Beat 125
Brown, B. 241
Brown, Eliza 141
Brown, James 68, 187
Brown, Ruth 155
Brown v. Board of Education 149

Bruce, Bryan 12
Brute, the 8
Bruzzi, Stella xvii, xxvii–xxix, xxxiii,
    191–206
Bufwack, Mary A. 145, 147, 152, 156,
    157, 159
Burns, Peter 23
Burroughs, William 80
Burston, Paul 118
Butler, Judith xvii, xxxiv, 33, 40, 52, 56,
    61–2, 197–8, 201, 281, 282, 283
Byrds 194
Byrne, D. 304

Campbell, Jo-Ann 152, 161
campness 67, 119, 123, 195, 298
Capital Records 145, 156, 157
Carby, Hazel 141–2
Carlisle, Belinda 213
Carnell, Stu 152
Carpenter, Mary Chapin 169, 175
Carroll, Lewis 248
Cash, Johnny 148
Cash, Roseanne 175
Cash, W.J. 138
Cast 17, 18, 19, 25, 26, 27, 29, 32
Cateforis, Theo 209–10
categorisation 60–1
Cavern Club 27
CBS 154
Cervenka, Exene 230
Chapel, Jean 152, 161
Chapman, R. 123–4
Chapman, Tony 69
Chapman, Tracy 220
Charles, Ray 145
Cherry, Neneh 170, 176
Chideya, F. 245
Chien, Irene 251
childbearing and motherhood xxv–xxvi,
    154, 169–70, 172–3, 173–4, 175, 176;
    O'Connor, Sinéad 182–3; see also female
    identity and the woman songwriter
China Crisis 25
Christian, Meg 219
City Paper 252
City Sound Production 220
Cixous, Hélène xxviii
Clark, Ossie 82–3, 87
Clark, Roy 157
Clarke, John 208
Clawson, M. 59–60
Cline, Patsy 191, 192, 194, 195

Closs, Larry 125
club culture 125
Coates, Norma xx, 50–63
cock rock xxi, 67; *see also* sexuality, style and image: Mick Jagger
Cocker, Jarvis 205
codes: of narratology xxxiii, 259; of reading 261; *see also* Madonna: sound and image in pop videos
Cohen, Paul 150
Cohen, Sarah xviii–xix, 17–35, 232, 241, 242, 243
Collins Kids (Larry and Lorrie) 140, 151–2, 154
Columbia 145, 151, 155
coming out 231; *see also* lang, k.d.
confessional 180
connoisseurship xviii, 20; *see also* gender and connoisseurship
Contractions 221
Cooper, Alice 90
Cornwall, A. xxxiv
Costello, Elvis 194
counter-culture 174–6
Country music xxvi, xxvii, 140, 144–6, 157, 158, 172–3, 181; lang, k.d. 191, 193, 194, 195, 197, 201
Country Music Association 146
'country rock' 175
Cox, Ida 141
Crack DC 231
Crawdaddy Club 69
Crawford, Cindy 200
Creed, Barbara 199
cross-dressing xvi; *see also* drag; transvestism
Cubitt, Sean xvii, xxxii, xxxiv–xxxv, 260, 295–316
cultural codes 259, 260, 261, 262, 263, 264
cultural identity xxvii
cultural studies xvii
culture xxi; blue-collar 103–4; *see also* popular; youth
Culture Club 125
Cummings, Sue 231
Curtis, Tony 197

Dadaism 236, 250
Daltry, Roger 72
dance xiv, 76–7, 90–2, 111; culture (1980s) 127; mode 287–8; *see also* Take That
Dandy, the 7–8

date rape 238
Davies, Ray 8
Davis Sisters 153
Day, Doris 153
De Lauretis, T. 52, 55
Dead or Alive 23, 25
Deal, Kim 54
debates: appropriation of musical signifiers xxvii; gender and sexuality xxvii; music as inner expression and music as saleable commodity xxxii; politics of image xxiii; sexual difference xxiii; of women in rock 249
Decca 88
Derrida, Jacques xxviii
Devious, Dr 309, 311–12
Diddley, Bo 69
*Die-Hard* 100
difference xxiii, xxvii, xxviii, 76; digital erotics and narcissism 298, 310; lang, k.d. 193, 196, 197; Pet Shop Boys 123, 131; riot grrrl 211, 214, 221; *see also* sexual
digital erotics and narcissism 295–316; 'And She Was' 301–4; androgyny 307; authenticity 299, 301, 305; autoeroticism 299; bafflement and avant-garde 304–5, 310; communication 315–16; 'Cyberdream' 309–12; difference 298, 310; eroticism 295, 309–10; *Faces of Light* 312–16; fantasy 298, 302, 305, 306, 308; femininity 296–7, 297–8, 299, 300, 307; fetishism 295, 301, 303, 311; gender 295, 298, 306; heterosexuality 295, 299, 300, 305, 315; homosexuality 299; image 296, 297; 'Killer' 306–8; knowledge and power 308; lesbianism 299; masculine identity 307; masculinity 300, 308, 310; masquerade 296, 297, 301, 311; orgasm 310–11; patriarchy 295, 296, 300, 305, 307; 'Rough Boy' 295–6; sexual difference 299–301, 303, 305, 307, 311, 315; sexual identity 315; sexuality 295, 298, 299, 300, 307, 308; transvestism 297; 'Vogue' 296–7, 300–3; voyeurism 295
disc jockeys 9–10
*Discharge* 236
Dischord 210
disco xxiii, 119
Dixon, Mary 141

Dixon, Willie 69
Dlugacz, Judy 219, 220
Doane, Mary Ann xxxiv, 208, 282, 296–7
Dobkin, Alix 218, 219, 222
dominant ideology 208–9, 211, 212, 220
domination *see* dominatrix; power
dominatrix 269; *see also* sexuality, style and
    image: Mick Jagger
Doors 13, 90
Douglas, Kirk 9
Downing, Big Al 157
Dowsing, Stefan: *Faces of Light* 312–15
drag 193–4, 196, 197, 199; *see also* cross-
    dressing; transvestism
dress *see* style
drugs 79, 81, 87; barbiturates 89;
    hallucinogens 81; heroin 81, 89; LSD
    79, 84, 89
dualism xxi
Duval Harrison, Daphne 142, 143
Dyer, Richard xvii, xxvi, 178, 179, 180,
    183, 287–8
Dylan, Bob 194

E-Street band 109, 110
East 17 293
Easthope, A. 75
Echo and the Bunnymen 25
Echobelly 45
electric guitar xix–xx, 28; *see also* women
    and the electric guitar
*Elle* 231
Ellis, J. 280
emotions xvi
empowerment xx, 212, 215; grrrl power
    235, 238, 247, 248
*England's Dreaming* 214
environmentalism 224
Erasure 125
eroticism xxxiv, 81, 124, 195, 267, 270;
    *see also* auto-eroticism; digital erotics and
    narcissism; homo-eroticism
Escher, M.C. 305–6, 308
Escott, Colin 153
Etheridge, Melissa 220
*Evening Standard* 242

Faithfull, Marianne 74, 77, 79, 89
*Fake* 251
false consciousness 51
fan magazines *see* fanzines
fandoms 12–13
fans 40, 113

fantasy 76; digital erotics and narcissism
    298, 302, 305, 306, 308; gratification
    67; imaginary xvi; Madonna 266, 267,
    270, 271, 272
fanzines 113, 215, 222
female as character 103–6
female identity xix, xxv–xxvi
female identity and the woman songwriter
    168–77; American Country music
    172–3; British Folk tradition 170–2;
    Folk revival 173–4; motherhood and
    childbearing 169–70, 172–3, 173–4,
    175, 176; narrative 172–3; pop
    mainstream 176–7; romantic love
    168–9; women's liberation and counter-
    culture 174–6; women's movement 173
female subordination 93
Females Being Independent 252
feminine xxvii; dualism xxi; Mick Jagger
    67; pop 52, 53; power and
    performance 32; rock music 30; and
    technology 42
femininity xxxiii, xxxiv; digital erotics and
    narcissism 296–7, 297–8, 299, 300,
    307; lang, k.d. 196, 197; Madonna
    270; notions of xxxiv; representations
    of xx; riot grrrls/grrrl power 210, 211,
    235–7, 241, 247; rock and the political
    potential of gender 56, 59; Take That
    videos 281, 282–3; women and the
    electric guitar 39–40
feminism xvii, xxvii, xxix, xxxi; critiques
    of connoisseurship xviii; digital erotics
    and narcissism 310; grassroots xxvi;
    Madonna 271; Pet Shop Boys 123;
    political potential of gender 61; politics
    and ideology xxx; and punk 14; radical
    xxviii; traditional mode of playing
    electric guitar 44–5; women's
    supporting role in music activity 22; *see
    also* feminism, 'subculture' and grrrl
    power *below*; riot grrrl: feminism and
    lesbian culture
feminism, 'subculture' and grrrl power
    230–54; anti-information 251–2;
    beginnings and development 233;
    British media networks 242–9; coming
    out 231; communication 236; context
    230–1; contradiction 251; debate of
    women in rock 249; delinquency
    240–1; display and spectacle 235–7;
    do-it-yourself ethos 237; empowerment
    235, 238, 247, 248;

feminism, 'subculture' and grrrl power –
contd
expression of dissent 247–8; feminine
dress codes 235–7; femininity 241,
247; gender 233–4, 241; gig
environment as place for debate 234;
'girl talk' 239; Girl's Night 233, 234,
237; herstory: location of riot grrrl
249–52; homophobia 232; image 246;
interview process 245; lesbianism 231;
Other 243; parody 246; patriarchy 233,
248; performance 233–5; punk rock
237–8; racism 232; revolution 248;
'revolution grrrl-style now!' 233; self-
reflexivity 250; semiotic signifiers
245–6; sexism 232, 233, 239, 243,
247; sexual aggression, victims of 235;
terminology 231–2; usurpation 245; as
youth subculture 240–1; zines 231,
233, 236, 238–40, 250–2, 253
Feminist Majority Foundation 231
fetishism 6, 121; digital erotics and
narcissism 295, 301, 303, 311;
Madonna 270; Take That videos 282
'Final Girls' 213
Fincher, David 296
Finley, Karen 238
Finnegan, R. 19, 21, 24, 32
Fiske, J. 111
Fiz 231
Fletcher, Jimmy 289
Flores, Rosie 154
Foley, Red 150
Folk music xxvi, 37, 173, 181, 219, 220,
222; revival 173–4
Fonarow, W. 23, 27
Foucault, Michel xxxiv, 52, 60, 149
4 Star Records 155
France, Kim 217
Frances Belle 41
Frankie Goes to Hollywood 23, 25, 125
Free Kitten 230
Freud, Sigmund xxvii–xxviii, xxxiv, 196,
208, 301, 302, 307–8, 311
Frith, Simon xiv, xxi, xxiii, 24, 28, 51,
72–3, 75, 94, 126–7, 179, 182, 183
Frizzell, Lefty 148
Fugazi 212, 235
Fund 231
funk 29

Gaar, Gillian 159, 220
Gabriel, Peter 11

Galas, Diamanda 213
garage psychedelia 12
Garber, Marjorie 193–4, 199
Garratt, S. 22, 24, 185
Garver, J. 51
Gatti, Jose 299
Gaultier, John-Paul 119–20
Gaunt, K. 187
gay xxi; culture 120; disco 126; erotica
121; sex xxix; see also homosexuality;
lesbianism; queer
Gaye, Marvin 202
Geertz, Clifford 108
Geffen Records 230
gender xxxiv; debate xxvii; digital erotics
and narcissism 295, 298, 306; dualism
124; electric guitar 40; lang, k.d. 195,
198, 201; and masculinity 67; and
music consumption 14; O'Connor,
Sinéad 179, 183, 184; performance of
xx; Pet Shop Boys 118, 119, 120, 124,
130; relations xix; riot grrrls/grrrl
power xxiv, 214, 221, 224, 233–4,
241; rock music 22, 30; rockabilly
138–9; roles xxviii; stereotypes 123,
185; technology of xx, 52; see also
gender and connoisseurship; gendered
identity; rock music and production of
gender; rock and the political potential
of gender
gender and connoisseurship: record
collections xviii, 3–15; acquisition and
obsession 10–14; knowledge 7–10;
male identities, taxonomies of 5–7
gendered identity xvii, xx, xxiii, xxiv,
xxxiii, xxxiv, 67, 68, 105–6, 191–2,
197; Pet Shop Boys 118, 120; Take
That videos 281
Gerry and the Pacemakers 25
Gershwins 202
Giacometti, Alberto 250
Gill, C. 183
Gill, John 125–6
Gillett, Charlie 138–9
Gilroy, P. 186, 187
Girl Pride 246
Girlfrenzy 248
Girlie Group 194
Girl's Annual 236
Girl's Night 233, 234, 237
glam metal 29, 94
Glamour 246
Glass, Philip 304

*Glimpses* 13–14
Glinn, Lilian 141
Glitter 94
Goad, D. 241
*Gogo Girl* 238
Gogos, the 213
Goldring Report 23
Goodwin, Andrew 259, 280, 284–5
Gordon, Kim 213, 230
Gottlieb, J. 55, 253
Grainge, N. 183
Grand Ole Opry 145, 147
Grant, Cary 197
Grateful Dead 90
Gray, Dorian 92
Green, Lil 23, 28, 32, 141
Greer, Germaine 243
Greig, Charlotte xxv–xxvi, 168–77
Grossberg, Lawrence xxii, 11, 51, 57, 85, 130–1
grrrl power *see* feminism, 'subculture' and grrrl power; riot grrrl
*Grunge Gerl* 238
*Guitar* 38
*Guitar School* 38
Guterman, J. 180, 187
Guthrie, Woody 155
Gysin, Brion 80

*Hair Pie* 239, 245
Hall, Jerry 93–4
Halsey, Jim 156
Hanna, Kathleen xxxi, 213, 218, 234, 238, 251
Harry, Debbie 213, 214
Harvey, Polly Jean 54, 197–8, 213
Hawkins, Martin 153
Hawkins, Stan xxiii
Hayes, D. 180, 183, 185
Heath, S. 281
Heavenly 44
Heavens to Betsy 207, 217
heavy metal 8, 28–9, 43, 56, 281
heavy rock 29
Hebdige, Dick 208–9, 242, 243
Hendrix, Jimi 13, 89, 90
Hepburn, Katherine 200
hermeneutic codes 261, 262, 264, 269
heterosexuality xxi, xxix, xxxv, 95; digital erotics and narcissism 295, 299, 300, 305, 315; lang, k.d. 193, 196; Madonna 270; Pet Shop Boys 121, 125; political potential of gender 58, 59;

Rolling Stones/Mick Jagger 67, 75, 77; Springsteen, Bruce and masculinity 114; of working-class culture xxi
Hi-NRG xxiii, 119, 121, 125, 127
*High Fidelity* 10–12, 13
hip hop 187, 217
hipness 9, 10
History of Art 250–1
Hodgson, Grant 285
Hole 213, 230
Holly, Buddy 69, 144
Holmlund, C. 282–3
Home, Stewart 247, 250
homo-eroticism 59, 121, 293
homophobia 61, 218, 220, 223, 225, 232
homosexuality xxvii, 95; digital erotics and narcissism 299; glam metal 29; lang, k.d. 202; Madonna 270; Pet Shop Boys 125; Rolling Stones/Mick Jagger 67, 75, 77; Take That videos 278; wearing knowledges 7; *see also* gay; lesbianism; queer
homosocial xviii
honky-tonk xxiv, 140, 145–6
Hornby, Nick 10–11, 13, 20
*Hot Skirt* 239
Hotchner, A.E. 74, 75
house scene xiv
Huggy Bear 207, 212, 231, 233, 234, 241, 242, 248, 252, 253
Hughes, Robert 77
Hunt, Linda 201
Hunter, Alberta 141, 144
Hynde, Chrissie 213

icon 68, 72
identity xxix, xxxii; fixed and unified of the 'natural' man xxii; fragmented xxiii; lang, k.d. 192, 203; lesbian xvi; local 33; new male xxiii; O'Connor, Sinéad 178–9, 182, 184–5; Pet Shop Boys 123; politics 62; riot grrrls 212, 221; Springsteen, Bruce and masculinity 103, 104, 105, 106, 108; superimposed xxviii; Take That videos 283; *see also* cultural; female; gendered; masculine; national
ideologies xix, xx; meaning xx; scene 28–31; *see also* dominant; riot grrrl: feminism and lesbian culture
image xxiv, xxv, xxvi–xxvii, xxxiii; digital erotics and narcissism 296, 297; hostility towards 23; *see also* sexuality, style and image: Mick Jagger

*Independent* 246
indie music 17, 18, 22, 23, 26, 29, 30,
    31, 214, 230, 240; riot grrrls 246
instinctuality 8–10
International Pop Festival 235
International Pop Underground
    Convention 233, 234
internet 224
*Intimate Wipe* 232
Irigaray, Luce xxviii, 237
Isaac, Chris 9

Jackson, Michael 259
Jackson, Wanda xxv, 140–1, 143, 153,
    155, 156–7, 159
Jagger, Mick xvi, xxi, 198; *see also*
    sexuality, style and image: Mick Jagger
Jamieson, Daz 309
Japenga, Ann 207–8, 231
jazz 21, 142; clubs 13
Jenson, Joli 86
Jett, Joan 213
*Jigsaw* 251
Johnson, Calvin 233
Johnson, Holly 23
Jones, Brian 68, 69, 70, 74, 80, 89, 90,
    91
Joplin, Janis 89, 90
Joyce, James 310
*Judge Dredd* 100
Juno, Andrea 13

K Records 210
Kamen, Nick 120
Kan, Liam 285
Kaplan, E.A. 283–4
Karren 233, 247, 250, 251–2
Kearney, Mary Celeste xxix–xxxi, xxxiii,
    207–29
Keightley, Keir 5
Kennedy, John F. 89
KERB 147
Kimmel, Michael S. 13
King 145
King, Martin Luther 88
King, Phillip 187
*Kingfish* 236
Kirby, Jack 138
Kleenex 215
Knopf, T.A. 232
knowledge xviii, 7–10, 20, 308
Kookie Monster's Free Peach Thingy 237
Korner, Alexis 69

KPLR 156
Kravitz, Lenny 263
Kristeva, Julia 310–11

L7 213, 230, 231
*L-Scene* 33
*L.A. Weekly* 222, 231, 241
Lacan, Jacques 280, 313
Laing, D. 27
Landau, Jon 115
Lane, T. 23
lang, k.d. xvi, xxvii–xxix
lang, k.d.: from cowpunk to androgyny
    191–206; androgyny 192, 198, 204,
    205; coming out 198, 201, 202, 204,
    205; difference 196, 197; drag 193–4,
    196, 197, 199; fandom 202; femininity
    196, 197; gender 195, 198, 201;
    gender identity 191–2, 197;
    heterosexuality 193, 196;
    homosexuality 202; 'honesty' and
    androgyny 199–205; identity 192, 203;
    image 192, 197–8, 203; interaction
    with Country 194–5; lesbianism 192,
    194, 195, 196, 202; masculinity 196,
    198–9, 200, 205; 'no difference at all'
    201–2; PETA commercial 191, 193;
    pop and mainstream 203; sexual and
    gendered difference 193; sexuality 195,
    201–2, 204, 205; spaces between the
    notes 193–9, 205; torch songs 191,
    203
Langford, Brad 285
Latham, William 306
LeBon, James 288
Lee, Brenda (Little Miss Dynamite) xxvii,
    140, 150–1, 161, 195
Lempicka, Tamara de 299
Lennon, John 69, 180
Lennox, Annie 197–8, 201
Leonard, Marion xxx–xxxi, xxxiii, 23,
    230–54
lesbianism xxiii–xxiv, xxvii, xxx; digital
    erotics and narcissism 299; identity xvi;
    Madonna 267, 270, 271; separatism
    xxix; *see also* lang, k.d.; riot grrrl:
    feminism and lesbian culture
Lewis, Jerry Lee 137, 144, 148
Lewis, L. 22
Lhamon, Jr., W.T. 140, 149
Lightning Seeds 17, 18, 19, 20, 25, 26,
    28, 29, 32, 33
*Lime Lizard* 231

Lindisfarne, N. xxxiv
Linus 245, 250
Lipsitz, George 160, 161
Little Richard 143, 157, 198
live performances xiv, xxxii, 27, 31, 67;
    see also in particular sexuality, style and
    image: Mick Jagger; Springsteen, Bruce
Liverpool see rock music and production of
    gender
Liverpool Music House 19, 20, 21, 22, 33
Liverpool popular music scene xviii–xix
'Liverpool Sound' 25
Lohan, Sinéad 39
Lomax 18, 20, 25–6
Lou, Bonnie 152
loungecore 12
Love, Courtney 58, 59, 62, 213
Lovett, Lyle 193, 194
Lowe, Chris 119, 127
Lucas, Tim 10–11, 12
Lucifer 68, 82, 83, 84, 85, 87
'Lucifer Rising' 79
Luecking, Juliana 234–5
Lunch, Lydia 213
Lush 47
Lynn, Loretta xxvii, 195
lyrics xv, 27, 28, 29

McCartney, Paul 69
McClary, S. 22, 31, 33
McDonald, Paul xvii, xxxii, xxxiii–xxxiv,
    277–94
McDonald, Skeets 157
McDonnell, Evelyn 222, 223
MacKaye, Ian 235
MacLaren, Malcolm 224
McRobbie, Angela xxi, xxiii, 24, 28, 51,
    72–3, 75, 94, 161, 182, 224–5, 243
Maddox Brothers 155
Maddox, Rose 140, 155–6
Madonna xvi, 170, 191, 197–8, 297–8
Madonna: sound and image in pop videos
    259–76; alternative sexuality 269;
    androgyneity 270; auto-eroticism 269,
    270, 272; bondage tableaux 267;
    childbearing and motherhood in songs
    176; codes of narratology 259, 262;
    codes of reading 261; cultural codes
    261, 262, 263, 264; as cultural
    phenomenon 296; dominatrix 269;
    established sexuality 265; fantasy 270,
    271, 272; femininity 270; feminism
    271; fetishism 270; gay/lesbian

eroticism 270; hermeneutic codes 261,
    262, 264, 269; heterosexuality 270;
    homosexuality 270; 'Justify My Love'
    xxxii, xxxiii; 'Justify My Love', analysis
    of 263–7; 'Justify My Love' – the video
    267–9; 'Justify My Love', questionnaire
    on 273; lesbianism 267, 270, 271;
    methodological approach 260–3; multi-
    gendering 270; notion of 'character'
    270–1; paradigmatic codes 259, 260,
    261, 262; patriarchy 272; postmodern
    theory 259; proairetic (narrative) codes
    261; rhythm and harmony 260–2; role
    reversal 272; sado-masochism 269,
    270, 271; semic code 261, 263, 264;
    sexual ambiguities 267, 272; sexual
    fantasy 266; sexuality 267, 270, 271;
    symbolic codes 261, 262, 263, 271;
    syntagmatic codes 261, 262; vocal
    timbre 265; 'Vogue' xxxiv; 'Vogue'
    video 298–9, 301; voyeurism 267,
    269, 270
magazines see fanzines; zines
Mail on Saturday 242
male body, performing see Take That
Mallarmé, S. 310
Malone, Bill C. 138
Man Ray 250
Manchester scene 33
Mann Act 144
Manning, S. 243
Mansfield, Jayne 151
Manson, Charles 83–4
Maphis, Joe 152, 157, 161
Marcella Detroit 39
Marcus, Greil 139
Martin, Janis xxv, 139, 140, 152, 153–4,
    162
Martin, Sara 141
masculine identity xxii, 5–7, 41, 307
masculine/feminine dualism 74, 76, 91–2
masculinism xviii; and connoisseurship
    15; dualism xxi; electric guitar 40–1;
    politics 5; rock music 30, 52; rock
    music and production of gender 20;
    and technology 42
masculinity xvii, xix, xx, xxii, xxxv;
    aggressive and uncaring 71; assertive
    celebration of 30; authentic xxi; codes
    xxxiv; contemporary xxxiv; digital
    erotics and narcissism 300, 308, 310;
    fictive 52; gender and connoisseurship
    5; hegemonic xxi, 74; hip 9;

masculinity – *contd*
    ideal 7; indie rock 29; lang, k.d. 196,
    198–9, 200, 205; multiple, diverse and
    contradictory 33–4; normative 67;
    notions xxxiv; pop videos xxxiii;
    production and performance of 34;
    representations of xx; riot grrrls 212,
    219; rock 28, 52; rock music and
    production of gender 23–4, 25; rock
    and the political potential of gender 52,
    53, 56–7, 59; Take That videos 283,
    293; and vulnerability 29, 30, 34;
    women and the electric guitar 40–1; *see
    also* gendered identity; Pet Shop Boys:
    musicology, masculinity and banality
masquerade 281–2, 296, 297, 301, 311
Masuak, Greg 278, 288, 289, 291
Matthewman, H. 246
Mayne, J. 280
Maysles brothers 87
means of representation *see* digital erotics
    and narcissism
Mecca Normal 212
media xvi, xxx, 29–30; *see also* fanzines
Medovoi, Leerom 5
Mel-O-Tones 25
mellow pop 191
*Melody Maker* 70, 209, 242, 243, 245, 246,
    249
Memphis Minnie 141
Men's Movement 100
Mercer, Koben 259
Merleau-Ponty, Maurice 313
Merseybeat 25
Meyer, Moe 195
MGM 154
Michaels, Alice M. 148
Michigan Womyn's Music Festival xxx,
    220, 221–2
Middleton, R. xiv
Mink, Ben
misogyny 50, 153; riot grrrls 212, 218,
    219, 223, 225
Mitchell, Joni xxvi, 37, 38, 169, 174–5,
    176
mods 243
*Mojo* 37
Monroe, Bill 144
Monroe, Marilyn 151
Moore, Rob 3
Moore, Sparkle 152
Morgan, David 106
Morrison, Jim 89, 90

Morrison, Toni 237
Morse, M. 111
Mort, Frank 120
Morthland, John 138, 150–1, 153, 155
Moss, P. 105
motherhood *see* childbearing and
    motherhood
Mothers of the Future 42
MS45 47
MTV 224
Muddy Waters 68, 70
Mudwimmin xxx, 222
multi-gendering 300
Mulvey, Laura xvii, 280, 297, 311, 314
Mungham, G. 240–1
music: acid house 243; beat 37; blues xxv,
    70, 181; Britpop xiv, 8, 26; funk 29;
    garage psychedelia 12; glam metal 29,
    94; Glitter 94; heavy metal 8, 28–9, 43,
    56, 281; heavy rock 29; hip hop 187,
    217; honky tonk xxiv, 140, 145–6; jazz
    13, 21, 142; mellow pop 191;
    psychedelic rock 79; race 57; rap 29;
    rave 243; rhythm and blues 69, 79; rock
    and roll 144, 149, 155, 158–9, 196;
    Space Age Bachelor Pad 12; strip-club
    12; surf 12; *see also* Country; Folk; Indie;
    punk; rock; rockabilly; underground
musical: analysis xv; codes xvi; structures
    xvi; text xv, xvi, xxiii
musicology xvii; *see also* Pet Shop Boys:
    musicology, masculinity and banality

narcissism xxxiv, 77, 91, 123; *see also*
    digital erotics and narcissism
narrative codes 261
narrative mode 290–2
Nation of Ulysses 212, 240
National Abortion Committee 174
national identity xxvii
National Womyn's Music Festival 220
Naylor, Liz 249
Neale, Steve 7
Near, Holly 219
Negus, Keith xvii, xxvi–xxvii, 17, 24,
    178–89
Nelson, Ken 137, 145
Nelson, Ricky 151
nerds/nerdishness 8, 9, 10, 14–15
'new Country' 175
*New Musical Express* 246
New York Dolls 14
*New York Rocker* 14

New York Times 209
Newsweek 209, 245
Newton, Ro 287
NME 18 33
Nureyev, Rudoloph 67
nymphettes xxiv–xxv
Nyro, Laura xxvi, 175

O'Brien, Lucy 50, 51, 213
obsession 10–14
Occult 78, 83, 84, 92
O'Connor, N. 187
O'Connor, Sinéad xxvi, 170, 178–89;
    authenticity 180; childbearing and
    motherhood 176–7, 182–3; gender
    179, 183, 184; identity 178–9, 182,
    184–5; interpretations 181–2; musical
    meanings, framing of 179–80; musical
    signifiers 187; sexuality 182, 183;
    visual image 179, 184–7
Oedipal dialectic 313
Oermann, Robert K. 145, 147, 152, 156,
    157, 159
O'Kane, M. 184
Oldham, Andrew Loog 69, 75
Olivia Records 219–20
Ono, Yoko 214
Oppenheim, Meret 250
Orbison, Roy 154
Orlando, Bobby 119
Other/Othering/Otherness xxi, xxiii, 59,
    60, 61, 76; riot grrrls 211, 212, 243;
    rockabilly 149; Springsteen, Bruce 105
Owens, Buck 157
Owens, Ruby Agnes see Texas Ruby

Page, B. 180
Pallenberg, Anita 74, 79, 89
Palmer, Gareth xxi–xxii, xxiii, 100–17
Panter, Nicole 230
paradigmatic codes 259, 260, 261, 262;
    see also cultural; semiotic; symbolic
Pariah 239, 248
Parker, Colonel Tom 147
Parsons, Gram 194
Parton, Dolly 172–3
party mode 288–90
patriarchy xix; digital erotics and
    narcissism 295, 296, 300, 305, 307;
    Madonna 272; Pet Shop Boys 118, 124;
    political potential of gender 55; riot
    grrrls 212, 218, 219, 233, 248;
    Springsteen, Bruce 100, 101, 104, 114

Pearson, G. 240–1
Pederson, Candice 233
Peelaert, Guy 78
performance 233–5; and power 31–4; see
    also live
performing gender xx, 281–3
Perkins, Lauri Lee 152, 161
Persephone's Network 233, 238
Pet Shop Boys: musicology, masculinity
    and banality xvi, xxii–xxiii, 118–33;
    authenticity 130–1; campness 119, 123;
    class and consumerism 124; difference
    131; eroticisation of male image 120–1;
    gendered identity 118, 120;
    heterosexuality 121, 125;
    homosexuality 125; identity 123;
    masculinity in 1980s 118–24;
    narcissism 123; patriarchy 118; politics
    and eroticism 124; politics of gender
    119; politics of pleasure, sexuality and
    power 126–30; power 119; production
    129–30; rhythm 129; satire 124;
    seduction 131; sexual ambiguity 124;
    sexual desire 118; sexual difference
    121; sexuality 118, 120, 125–6; style
    123, 124–6, 127; style and ideology
    130–1; vocal style 129; youth identity
    131
Pfeil, F. 113, 115
Phair, Liz 53–4
phallus/phallocentrism xviii; Jagger, Mick
    72, 73, 75; power xvii, 43, 45, 50–2,
    67, 93–4; Take That videos 283; see also
    electric guitar
Philips, Julianne 116
Phillips, Sam xxv, 152–3
Phoenix, Val 218, 220, 223
Pink Floyd 214
Pittman, Barbara xxv, 137, 140, 152–3
Plague your Eyes 250
Plant, Robert 72
pleasure xx–xxi, 126–30, 195
Poison Girls 42
politics 160; of gender 119; of pleasure,
    sexuality and power 126–30; see also
    rock and the political potential of
    gender
Poly Styrene 207, 214
polysexuality 300
pop video 26–7; Springsteen, Bruce and
    masculinity 110–13; see also digital
    erotics and narcissism; Madonna; Pet
    Shop Boys; Take That

popular culture 209, 212, 220
popular music xx, xxxi–xxxiv, 30, 37;
commercial 112, 169; mainstream
176–7
pornography 12
Porter, Cole 191, 192, 202
post feminism 223
post-structuralism 119, 221
postmodernism xxiii, 119, 131, 221, 259;
digital erotics and narcissism 298, 301
Potter, Sally 200
power xx, 53, 58, 73–4, 308; Madonna
267; patriarchal 10; and performance
31–4; Pet Shop Boys 119, 125,
126–30; political potential of gender
60; relations xxvi; and Rolling Stones
77; Springsteen, Bruce 101–2
powerlessness and insecurity 31
Pratt, Ray 159–60
Presley, Elvis xxiv, 72, 89, 137–8, 139,
156, 198; in the army 144; elimination
of sexual orientation 201; 'Heartbreak
Hotel' 148; sexuality 202
Press, Joy 223
Prince 43
proairetic (narrative) codes 261
Probyn, E. 201
psychedelic rock 79
psychoanalytic theory xxvii–xxviii, xxxiv,
280; digital erotics and narcissism 298,
301, 310, 314
punk 11, 14, 207, 208, 211, 220, 222,
231; alternative 210; Straight Edge 100;
underground 224; see also riot grrrl

queer 12; performers 217; politics xxvii,
xxix, 224; punks 222; reading of rock
58; use of term in activist politics 61;
see also gay; homosexuality; lesbianism
queercore bands xxx, 237
queercore movement 231
Quit Whining 234, 237

race music 57
racism 232
Raincoats 207, 214, 215, 216, 237
Rainey, Ma 141
Raitt, Bonnie 37, 169, 175–6
Ramones 14
Random Violet xxx, 222
rap 29
rave 243
RCA Victor Records 139, 147, 148, 154

Reagan, Bob 152, 161
Reagan, Ronald 115
rebellion xxii, xxiv, 102
Reclines 191
record collections see gender and
connoisseurship: record collections
Redwood Records 219
Reggae Chicken 248, 252
Reid, Jamie 236
Reynolds, Simon 223
rhythm and blues 69, 79
Richards, Keith 68, 83, 87, 88, 89
riot grrrl xvi, xxiii–xxiv, xxx, xxxi, 3, 54
Riot Grrrl 231, 240
riot grrrl: feminism and lesbian culture
55, 207–29, 231; activism 210, 211,
223, 223–4, 225; adolescence 210;
ageism 223, 225; and/as 'women in
rock' 212–15; classism 223;
commercialism 225; cultural expression
211; cultural and political identity 210;
debate on womyn's music 221;
difference 211, 214, 221; do-it-yourself
ethos 214–15, 218, 219, 223–4;
dominant ideology 208–9, 211, 212,
220; emergence and attempted
containment 208–11; empowerment
212, 215; exoticisation 211; fanzines
215, 222; femininity 210, 211;
feminist/lesbian politics and ideology
221, 222, 223; gender 214, 224;
gender dualism 221; homophobia 218,
220, 223, 225; identity 212, 221;
ideology 216; and lesbian separatists
218–21; mainstream media 209–10,
211, 212; masculinity 212, 219;
misogyny 212, 218, 219, 223, 225;
oppositional ideology 215; Other 211,
212; patriarchy 212, 218, 219; political
correctness 221–2; political ideologies
221; politics 216; press blackout
209–10; pro-women/anti-corporatist
idelogy 218, 219; punk ethos/feminist
ideology 215–17; as punks and
punkettes 211–12; queercore confronts
womyn's music 221–4; racism 223,
225; revolution 224–5; second-wave
feminism 223–4; separatist ideology
218; sexism 212; womyn's music 220;
youth culture 208–9, 210, 225
riot grrrl: audience desegregation 23;
politics xxix–xxx; punk 236, 237–8,
240, 242, 243; rock and the political

potential of gender 55; *see also* feminism, 'subculture' and grrrl power
Riot Grrrl Press 233
Ritt, Herb 200
Ritter, Tex 151
rivalries between bands 19, 32
rivalries between local scenes 33
Riviere, Joan 196, 281
Roach, Colin 186
Robbins, Marty 148
Robins, the 157
Rock for Choice benefits 231
Rock Dreams under the Boardwalk 78
rock music xv, xx, xxiii, 112; alternative 15, 54, 58; culture xvii, 11–12; heavy 29; and lesbian womyn's music 217; masculinity 56; and riot grrrls 219; *see also* rock music and production of gender; rock and the political potential of gender
rock music and production of gender 17–35; gender relations 21–4; power and performance 31–4; relationships 19–20; scene action 18–24; scene ideology 28–31; sensual scenes 24–8
rock and the political potential of gender 50–63; abject 56, 60; 'bourgeois bohemias' 57–8; categorisation 60–1; femininity 56, 59; masculinity 52, 53, 56–7, 59; Othering/Otherness 59, 60, 61; phallic power 50–2; riot grrrls 55; rock/pop distinction 52–3, 60; sexuality 58–9; women relegated singing role 59–60; women in rock 54, 61–2
rock and roll 144, 149, 155, 158–9, 196
rock/pop culture xix
rock/pop distinction 52–3, 60
rockabilly xxiv–xxv, 137–67; Arthur, Charlene 147–8; baby boom 148–9; black women, presence of 141–2; blues queens 140–1, 152, 154–6; Collins Kids 151–2, 154; Country music 144–6; Depression 143–4; gender-specific 138–9; generic and racial boundaries, crossing of 142–3; heiresses apparent 152–4; honky-tonk 145–6; Jackson, Wanda 140, 143, 155–9; Lee, Brenda 150–1; Maddox, Rose 155–6; Martin, Janis 139, 154; nymphettes xxxi, 150–2; politics 160; Shepard, Jean 145–6; Texas Ruby 145; Wells, Kitty 146; women's contribution 139–40

Rodowick, D.N. 297–8
Rohlfing, M.E. 60
*Rolling Stone* magazine 53–4, 63
Rolling Stones xxi, 168; phallic 51; political potential of gender 50, 51; *see also* sexuality, style and image: Mick Jagger
romance *see* Take That
Rooks, Margaret 234
Ross, Andrew 9
Roszak, T. 85
Rough Trade 214
Rowe, Dick 69
Roxy Music 63
Rudolph, Alan 201

sado-masochism 77–8, 93; Madonna 267, 269, 270, 271; Take That videos 292
Sandstrom, Boden 220
Sanjek, David xxiv–xxv, xxxi, 137–67
*sassy* 209, 236–7
Satanic image 78
Satanism 83, 85, 87, 89, 90
Savage, Jon 214
Sayles, John 112
scene 17, 32; action 18–24; daily and weekly rhythms 20; definitions and meanings bound up with 33; house xiv; identity of 33; ideology 28–31; local 20, 33; national and international 20; rivalries 33; sensual 24–8; venues 20, 25–6; visual 'scenescape' 25; visual style 26
Schönberg, A. 304
Schreber, Senatspräsident 302
Scott, Tony 137
Scritti Politti 304
Seal 305–6, 308, 310
Searll, Don 305
Sedgwick, Eve Kosofsky 7
Seeger, Peggy 173–4
*Select* 231
self-authorship xxvi
self-invention xvi
semic codes 259, 261, 263, 264
semiotic signifiers 245–6
sensual scenes 24–8
sexism xxvi, 160, 183; riot grrrls 212, 232, 233, 239, 243, 247; *see also* misogyny
sexual ambiguity 267, 272
sexual ambivalence 75, 95
sexual arousal 72

sexual articulation 125
sexual difference xvii, xxi, xxxiv–xxxv;
   digital erotics and narcissism 299–301,
   303, 305, 307, 311, 315; Pet Shop
   Boys 121
sexual division of labour 23–4
sexual identity 315
sexual innuendo 43
sexual politics xxiv, xxvi
sexual subjectivity xxiii
sexuality xvi, xxi, xxvii, xxxiv; ambivalent
   xxi; debate xxvii; digital erotics and
   narcissism 295, 298, 299, 300, 307,
   308; hostility towards 23; lang, k.d.
   xxix, 195, 201–2, 204, 205; Madonna
   265, 267, 269, 270, 271; mythicised
   58; normative xxiii; O'Connor, Sinéad
   182, 183; Pet Shop Boys 118, 119,
   120, 126–30; political potential of
   gender 55; power and performance 31;
   queer concept of xxviii; rock music 30;
   rock music and production of gender
   22; rock and the political potential of
   gender 58–9; rockabilly 150–2, 154; see
   also sexuality, style and image: Mick
   Jagger
sexuality, style and image: Mick Jagger
   67–99; aggressive sexuality 70, 71,
   72–3; Altamont 84–7, 88; androgyny
   75, 91, 92, 94–5; arrogance 70, 86;
   audience, integration of 74; bi-sexuality
   75, 77; cock rock 72, 73, 75, 89, 93,
   94; drug scene 78–81, 84, 87, 88–9;
   fantasy 76; fatalism 87, 89; from cock
   rocker to dominatrix 68–78; goading
   sexuality 71; heterosexuality and
   audience 75, 77, 95; homosexuality
   and audience 75, 77, 95; Honky Tonk
   woman 88–93; live performance 82–3;
   lyric content 74–5; masculinity and
   femininity 74; masquerade 76–7;
   narcissism 77, 92; otherness, sense of
   72; phallic power 72–3, 75, 93–4;
   power 73–4, 78; predictability 71;
   primitivism 80–1; private life 74, 83;
   sado-masochism 77–8, 93; satanic
   image: Lucifer 78–88, 90; 'sexy'
   performer 70; shock value 73; stage
   performance style 76–7; uncaring
   attitude 71
Shank, B. 20, 27, 33
Shepard, Jean xxiv, 145–6
Shepherd, Jean xxxii–xxxiii, 28

Shiner, Lewis 11, 13
Shocked, Michelle 220
Showalter, Elaine 91, 192, 200
Shrimpton, Chrissie 89
Sidi Bou Said 44
Simply Red 11
Sinatra, Frank 198
Siouxi Sioux 214
Siren 217
Slits 214, 237
Smax, Willie 288, 289, 290
Smith, Angie 287
Smith, Bessie 141
Smith, Clara 141
Smith, Jack 138
Smith, Mamie 141
Smith, Martha Nell 58–9
Smith, Patti 50, 51–2, 175, 207, 214
Snead, F. 231
Snow, Hank 203
social injustice xxvii
Society for Cutting Up Men 238
Soft Cell 125
Solanas, Valerie 238
songwriters see female identity and the
   woman songwriter
Sonic Youth 230
Space 13, 18, 19, 25, 26–7, 29–30, 33,
   82, 296, 307, 312
Space Age Bachelor Pad Music 12
spectatorship theory 280, 282
Spencer, Lauren 223
Spivey, Victoria 141
Sprague, D. 184
Springsteen, Bruce xxi–xxii, xxiii, 58–9
Springsteen, Bruce and masculinity
   100–17; authenticity 101, 104, 108,
   110, 111, 113; blue-collar culture
   103–4; Carnival 107; E-Street band
   109, 110; fan magazines 113; fans 113;
   fathers and sons 101–3; gender identity
   105–6; girls/family 103–6;
   heterosexuality 114; identity 100, 103,
   104, 105, 106, 108; performance and
   fans 108–16; pessimism 104; power
   101–2; representation of women 105;
   social issues 114–15; Tunnel of Love
   tour 108; videos 110–13; work 106–8
Stallybrass, P. 57–8, 59–60
Stapler, Pa 71
Stapler Singers 71
Starr, Lucille 152, 161
Stein, Seymour 191

stereotypes 28
Steward, S. 24, 185
Stewart-Baxter, Derrick 142
Stovall, Natasha xxxi
Straayer, Chris 298
Straight-Edge punk 100
Straw, Will xviii, 3–15, 20
Street, John 113
strip-club music 12
Strong Women in Music 231
style 235–7; indie rock 26; as rhetoric
    124–6; see also sexuality, style and
    image: Mick Jagger
sub pop 210
Sub Rosa 42, 46, 48
'subculture' see feminism, 'subculture' and
    grrrl power
success, quest for 19
Suleiman, Susan 200
Sun Ra 304
'supper club' singers 142, 144
Supremes 168
surf music 12
symbolic codes 259, 260, 261, 262, 263,
    271
syntagmatic codes 261, 262; see also
    hermeneutic; proairetic

T-Rex 63
Tagg, P. 28, 181
Take That videos: romance, dance and
    performing male body xxxiii–xxxiv,
    277–94; authenticity 293; dance mode
    284, 287–8, 290, 293; eroticised
    spectacle of male body 280–1;
    femininity 281, 282–3; fetishisation
    282; fictional identity 281; gender
    differences 282; gendered conventions
    in looking, disruption of 280; gendered
    identity 281; homoeroticism 293;
    homosexuality 278; identities,
    unconstructed authentic 283;
    'illustration' 284–5; lean body,
    naturalness and strength of 286; look
    and presentation of body 280–1;
    masculinity 283, 293; masquerade
    281–2, 293; narrative mode 290–2,
    293; party mode 287, 288–90, 293;
    performing gender 281–3; phallus 283;
    romantic video 284–5; sado-masochism
    292; spectatorship theory 280, 282;
    yearning mode 284–6, 287, 290, 293
Talking Heads 191, 301, 304

Tarantino, Quentin 8, 137
Tate, Sharon 89
Taylor, J. 27
Taylor, Lori 252–3
Team Dresch xxx, 222
techno 53
technologies of gender xx, 55
technophobia 42–3
Tennant, Neil 118, 119, 124–5, 126–7,
    129, 131
Terminator 100
Terry, N. 245
Texas Ruby xxiv, 145, 146, 161
Tharpe, Sister Rosetta 37
Theberg, P. 24
Thompson, Hank 156
Thornton, S. 31, 53, 243
3T 293
Throat Sprockets 10–12
Tosches, Nick 138, 156, 158
Total Guitar 38
transformation 218
transvestism xvi, 67, 93, 297
'trash' culture xviii
Travis, Geoff 214
Treacle 44, 47–8
Tribe 8 xxx, 221–2, 223, 240
Tsunami 237
Tucker, Tanya 152
Turner, Grant 147
Turner, Tina 67, 76, 78
Twist 45
Tyler May, Elaine 140

Udovitch, Mim 159
underground music 230, 231, 232, 237,
    240, 247
United States xxx, 14, 37, 174; riot grrrls
    208, 209, 214, 215, 222, 230, 233,
    236, 240, 242, 246
USA today 231

Vail, Tobi 237, 247
Vale, V. 13
Valens, Ritchie 144
vaudeville blues 142
Vega, Suzanne 220
Velvet Underground 14
venues 20, 25
verbal abuse 46–7
Vermorel, F. 40
Vermorel, J. 40
Very Good Rock and Roll Band, The 42

Vi Subversa 42, 45, 48–9
*Village Voice* 54
Vincentelli, Elisabeth 3, 14
violence xvi; *see also* Altamont
visual performance styles 28–9
vocal groups 37
Voodoo Queens 240
voyeurism 270, 295

Wald, G. 55, 253
Walker, Alice 237
Wallace, Sippie 141, 144
Wallendorf, Melanie 4
Walser, Robert 17, 28–9, 129, 281
Ward, Ed 148–9
Waterboys 187
Watts, Charlie 68, 69, 70
Waugh, D. 242–3
Wax Records 219
Weil, Kari 200
Weinstein, Deena 43
Weir, Peter 201
Weisbard, Eric 11–12, 15
Wells, Kitty xxiv, xxvii, 146, 148, 156, 159, 195
Wells, S. 245
West, Speedy 157
White, A. 57–8, 59–60
White, Emily 222, 241, 251
White, T. 180
Whiteley, Sheila xiii–xxxvi, 67–99, 259–76
Whiteside, Johnny 162
Wicke, P. 179, 183
Wild, D. 184, 185
Williamson, Chris 219
Williamson, Judith 296
Willis, Sharon 8
Wills, Bob 156
Wilmer, V. 21
Wilson, Edith 141

Winger, Debra 201
Wise, S. 22, 182
Wobble, Jah 187
Womack, Bobby 69
women: representation of 105; in rock 54, 61–2; role in supporting music activity 21–2
women and the electric guitar 37–49; acoustic guitar 37, 38; domestic commitments 48; female vocalists 37–8; femininity 39–40; lack of female role models 45; learning environment, lack of 40; male terrain of guitar shops 41–2; masculine mode of playing 43–5; masculinity 40–1; phallic power 43; sexism 46–8; shape of guitar not conducive for women playing 45–6; technophobia 42–3; trade magazines advertisements 38–9
'women in rock' 230
women's liberation 174–6
Women's Sound Inc. 220
womyn's music 218, 219
Woolf, Virginia 192, 200
Worly, Clarence 139
Wyman, Bill 68, 69, 70
Wynette, Tammy 193

X-Ray Spex 207, 214
XY magazine 101

yearning mode 284–6
Yokham, Dwight 194
Young, Neil 54
youth cultures xxx, 208–9
youth identity 131

*Zine, The* 231
zines xxx, xxxi; riot grrrl 231, 233, 236, 238–40, 250–2, 253
ZZ Top 295

# DISCOGRAPHY

Note: This discography does not include entries from the separate discography at the end of Chapter 8.

*Absolute Torch and Twang* 191, 193, 194–5, 199

*Advocate, The* xxvii

*All Change* 27

*All You Can Eat* 191, 192, 201, 202–5

*am I not your girl?* 180, 186

'And She Was' 301–4

'Angie' 73, 93

'Anything' 293

'Babe' 290–1

'Back for Good' 285–6, 287

*Bear Family* 153

'Beautiful Lies' 146

'Beetle Bug Bop/'Hush Money' 151

'Big-Boned Gal' 194

'Bitch' 89

*Black and Blue* 73, 93, 95

'Blue Moon of Kentucky' 144

'Bopalina' 196

'Born to Run' 104

*Born to Run* 114

'Born in the USA' 114–15

'Brown Eyed Handsome Man' 157

'Brown Sugar' 77–8, 84, 85, 89

'Burn That Candle' 147

'Candy's Room' 105

'Casino Boogie' 89

*Church of the New Rising Sun* 11

'Citadel' 81, 82

'Cocksucker Blues' 75

'Come On' 69

'Could It Be Magic' 289–90

'Crazy Blues' 141

'Cyberdream' 309–12

'Dancin' in the Dark' 110–11

'Dancing with Mr. D' 90

*Darkness on the Edge of Town* 105, 107, 114

'Dead Flowers' 89

'Death of Rock and Roll, The' 145

'Delta Dawn' 152

'Do What You Like' 287, 288

'Domino Dancing' 121–2

'Down From Dover' 172–3

'Drive All Night' 104

'Drugstore Rock and Roll' 154

*Even Cowgirls Get the Blues* 194

'Everything Changes' 289

*Exile in Guyville* 53

*Exile on Main Street* 89

*Faces of Light* 312–16

'Factory' 102

'Female of the Species' 26–7

'Five by Five' 69

'Fujiyama Mama' 140, 143, 156, 157

*Funky Drummer Part I* 187

'Gathering Rushes in the Month of May' xxvi, 170–2, 173, 176, 177

'Get it On' 202

*Get Yer Ya-Ya's Out* 88

*Ghost of Tom Joad* 115

'Goat's Head Soup' 82

*Goat's Head Soup* 90, 92

*Gone Again* 51

'Half As Good A Girl' 157
'Heartbreak Hotel' 148
'Hegemony' 304
*Hejira* 174
'Hey Baby' 236
'Honky Tonk Woman' 91
'Hot Rod' 151
'How Deep is Your Love' 290–2

'I am Stretched Upon Your Grave' 187–8
'I Can't Get No Satisfaction' 72, 74
*I do not want what I haven't got* 179, 186, 187
'I Forgot To Remember To Forget' 153
'I Found Heaven' 289
'I Got Woman' 145
'I Gotta Know' 157
'I Thought of You' 146
'I Wanna Be Your Man' 69
'I Will Survive' xxvii
'I'm on Fire' 110
'I'm Getting Better All The Time' 153
'I'm Sorry' 150
'In Another Land' 81
'In My Teens' 151
'Independence Day' 114
'Infinite and Unseen' 204
*Ingénue* xxvii, xxviii, 191, 192, 203
'Inner City Mama' 176
'It Only Takes a Minute' 290
'It Wasn't God Who Made Honky Tonk
    Angels' 146, 156
'It's All Over Now' 69
*It's Only Rock 'n' Roll* 92
'I've Got The Boogie Blues' 147

'Johnny Get Angry' xxviii, 194, 196–7
*Jollification* 26
'Jumping Jack Flash' 82, 92
'Justify My Love' xxxii, xxxiii, 259, 260,
    263–7, 267–9, 273

'Killer' 90, 305–8, 310
'King Bee' 71
'Kiss the Baby Goodnight' 147

'La Isla Bonita' 266
'Lantern, The' 91
'Last Time, The' 71
*Lavender Jane Loves Women* 219
'Let It Bleed' 74
'Let's Have A Party' 157

'Let's Spend the Night Together' 74
'Like a Prayer' 266
*Lion and the Cobra, The* 186
'Little Red Rooster' 69, 71, 73
'Long Black Veil' 194
'Love Ain't Here Anymore' 285
'Love it to Death' 90
*Love You Live* 93
'Lucky Town' 105
'Lullaby for a Very New Baby' 174

*Made in the Shade* 93
'Man We Had A Party' 157
'Mannish Girl' xxvii
'Mary, Queen of Arkansas' 105
'Maybe' 204
'Midnight Rambler' 84, 85, 86, 88
'Million Love Songs, A' 285
'My Boy Elvis' 139, 154
'My First Love' 151
'My Special Child' 182

*Nashville Skyline* 194
'Neanderthal Dyke' 221, 223
*Nebraska* 107
*Nested* 175
'Never Forget' 288
'Nick of Time' 175–6
'Nine-Month Blues' 174
'Not Fade Away' 69
'nothing compares 2 U' 186
'Nowhere to Stand' 194

'Oh, Andrew' 75
'On With the Show' 82
'Once You've Tasted Love' 288
'100 Years Ago' 92
'One Step Up' 110
'Ooby Dooby' 154
'Open Your Heart' 270

'Papa Don't Preach' 176
'Philadelphia' 112, 114
'Philadelphia Lawyer' 155
*Pipes of Pan, The* 80
*Plastic Ono Band* 180
'Pollyanne' 196
'Pray' 278–9, 284, 285
'Promises' 288
'Pulling Back the Reins' 199

'Racing in the Streets' 103
'Rebel Girl' 241

Red Hot and Blue xxviii
'Reins' 199
'Relight My Fire' 289
'Ridin' the Rails' 199
'Right Or Wrong' 158
'Riot In Cell Block No. 9' 157
'Rip It Up' 143, 157
'Rip This Joint' 89
River, The 104
'Rock's Off' 89
Rolling Stones, The 69
'Rough Boy' 295–6

Salmonberries xxviii
'Satisfied Mind, A' 146
'Scritlocks Door' 304
Sense 26
'Sexuality' 204
Sgt. Pepper's Lonely Hearts Club Band 79, 80, 81
Shadowlands xxvii, 195
'Sherry Darlin'' 104
'She's a Rainbow' 81
'Short and Curlies' 92
'Sing This Altogether (See What Happens)' 79, 80, 81
'Sister Morphine' 89
'Smile' 11
So In Love xxviii
'So In Love' 192, 199, 200
Some Girls 93
'Song for Sharon' 174–5, 176
Songs of a Love Affair 146
'Spare Parts' 105
'Stand by your Man' 193, 194
Stars Kill Rock 237
Sticky Fingers 89, 93
'Street-Fighting Man' 82, 88
'Sun City' 112
'Sure' 287, 288
'Sweet Nothin's' 150

'Sympathy for the Devil' 81, 82–3, 84, 85, 88, 90

Their Satanic Majesties Request 68, 79, 80, 82, 84, 91
'Then I Kissed Her' 193
'There's A Party Goin' On' 157
'Three Babies' xxvi, 176–7, 179–80, 181–2, 188–9
'Three Cigarettes in an Ashtray' 191, 192, 193, 194
'Till the Next Goodbye' 92
'Time Waits for No-one' 92
'To a Child' 175
'Tougher than the Rest' 109
'Town Hall Party' 152
'Trail of Broken Hearts' 199, 200
Trout Mask Replica 304
'2,000 Light Years From Home' 81–2
'2,000 Man' 82

'Ugly and Slouchy (That's The Way I Like 'Em)' 156
'Under My Thumb' xxi, 73, 74, 95

Very 127
'Vogue' xxxiv, 260, 296–7, 298–301, 302, 303

'Welcome To The Club' 147
'West End Girls' 126
'What About Tomorrow?' 148
'Whistle Bait' 151
'Why Can't I Wake Up with You' 285–6
'Wild Horses' 89
'Wild Side Of Life' 156
'Wild Wild Young Men' 155
'Will You, Willyum' 154
'World of Love' 204–5

'Yesterday, When I was Mad' xxiii, 127–8